CRITICAL
PERSPECTIVES
on ART HISTORY

CRITICAL PERSPECTIVES on ART HISTORY

John C. McEnroe

Deborah F. Pokinski

HAMILTON COLLEGE

Prentice
Hall

Upper Saddle River, New Jersey 07458

Library of Congress Cataloging in Publication Data

Critical perspectives on art history / John C. McEnroe, Deborah F. Pokinski, [editors].
 p. cm.
 Includes bibliographical references.
 ISBN 0-13-040595-7
 1. Art—History. I. Title: Critical perspectives. II. McEnroe, John C. III. Pokinski,
Deborah Frances.

N90.C75 2002
709—dc21

2001036549

Acquisitions Editor: Bud Therien
Editorial Assistant: Wendy Yurash
Marketing Manager: Chris Ruel
Manufacturing Buyer: Sherry Lewis
Cover Designer: Bruce Kenselaar

This book was set in 10 pt. Palatino by Pub-Set, Inc.
Cover was printed by Phoenix Color Corp.

Pearson Education LTD., London
Pearson Education Australia Pty. Limited, Sydney
Pearson Education Singapore, Pte. Ltd.
Pearson Education North Asia Ltd., Hong Kong
Pearson Education Canada Inc., Toronto
Pearson Educación de Mexico, S.A. de C.V.
Pearson Education—Japan, Tokyo
Pearson Education Malaysia, Pte. Ltd.
Pearson Education, Upper Saddle River, New Jersey

Contents

Foreword ix

Acknowledgments xi

PART 1: CLASSICAL

Chapter 1 Democracy and the Greek Ideal 1
Nicholas Gage, Introduction to *The Greek Miracle: Classical Sculpture from the Dawn of Democracy*, 2
Robert Hughes, *The Masterpiece Road Show*, 6
Eva C. Keuls, Introduction to *The Reign of the Phallus*, 10

Chapter 2 The Parthenon and Patrimony 14
Gavin Stamp, *Keeping our Marbles*, 15
Melina Mercouri, *1986 Speech to the Oxford Union*, 21

Chapter 3 The Classical Tradition 29
Michael Greenhalgh, *What is Classicism?* 30
Henri Zerner, *Classicism as Power*, 32

Chapter 4 Portraits and Politics 37
Sheldon Nodelman, *How to Read a Roman Portrait*, 39
Ann Marie Seward Barry, *Political Images: Public Relations, Advertising, and Propaganda*, 45

PART 2: MEDIEVAL

Chapter 5 The Gothic Cathedral 52
James Snyder, *The Meaning of Gothic*, 53
Michael Camille, *In the Margins of the Cathedral*, 56

**Chapter 6 Iconoclasm, Vandalism, and the Fear
of Images 65**
David Freedberg, *Idolatry and Iconoclasm*, 66
Robert D. McFadden, *Disputed Madonna Painting In Brooklyn
Is Defaced*, 75

Chapter 7 Iconography 79
Erwin Panofsky, *Jan van Eyck*, 81
Brendan Cassidy, *Introduction: Iconography, Texts, and Audiences*, 84
Lisa Jardine, Prologue to *Worldly Goods*, 90

Chapter 8 Anti-Semitism and Stereotypes 92
Henry Kraus, *Anti-Semitism in Medieval Art*, 93
Jan Nederveen Pieterse, Introduction to *White on Black:
Images of Africa and Blacks in Western Popular Culture*, 99

PART 3: RENAISSANCE AND BAROQUE

Chapter 9 The Renaissance Portrait 106
Bruce Cole, *Renaissance Images and Ideals*, 107
Patricia Simons, *Women in Frames: The Gaze, the Eye, the Profile
in Renaissance Portraiture*, 112

Chapter 10 The Female Nude 120
Kenneth Clark, *The Naked and the Nude*, 121
John Berger, *Ways of Seeing*, 127

Chapter 11 Viewing Michelangelo's *David* 132
Richard Leppert, *The Male Nude: Identity and Denial*, 134
John T. Paoletti and Gary M. Radke, *Florence: The Renewed Republic
and the Return of the Medici*, 138

Chapter 12 Women Artists 141
Paola Tinagli, *Women and Art during the Renaissance,* 142
Eleanor Dickinson, *Sexist Texts Boycotted:*
 Interview with H.W. Janson, 150
Camille Paglia, *The New Sexism: Liberating Art and Beauty,* 152

Chapter 13 Northern Art vs. Italian Art 155
Martin Kemp, *The Mean and Measure of All Things,* 156
Svetlana Alpers, *Art History and Its Exclusions:*
 The Example of Dutch Art, 161

PART 4: MODERN

Chapter 14 Gender and Representation 168
Carol Duncan, *Virility and Domination in Early Twentieth Century*
 Vanguard Painting, 171
Rosemary Betterton, *How Do Women Look? The Female Nude*
 in the Work of Suzanne Valadon, 175

Chapter 15 Modernist Architecture 185
Sigfried Giedion, *Social Imagination,* 186
Robert Hughes, *Trouble in Utopia,* 190

Chapter 16 Art and Popular Culture 199
Hilton Kramer, *The Varnedoe Debacle: MOMA's New 'Low',* 200
Mary Anne Staniszewski, *Art and Culture Today,* 204

Chapter 17 Postmodernist Art 207
Irving Sandler, Introduction to *Art of the Postmodern Era,* 208
Darby Bannard, *Excellence and Postexcellence,* 215
Deborah Solomon, *Questions for Jeff Koons; Puppy Love,* 218

PART 5: THE INSTITUTIONS OF ART

Chapter 18 Censorship 221
Andrea Dworkin, *Against the Male Flood: Censorship, Pornography,*
 and Equality, 222

Nadine Strossen, *The Sex Panic and the Feminist Split*, 226
Lynda Nead, *The Female Nude: Pornography, Art, and Sexuality*, 237

Chapter 19 Public Funding for the Arts 245
Paul Goldberger, *To Earn Subsidies, Must Art be Useful?*
 Must It Be Sweet? 246
Joseph Epstein, *What to do About the Arts?* 249

Chapter 20 The Museum 254
Carol Duncan, *The Art Museum as Ritual*, 255
Hilton Kramer, *The Assault on the Museums*, 261
Neil Harris, *The Divided House of the American Art Museum*, 264

Chapter 21 Culture Wars and the Canon 270
Dinesh D'Souza, *The Multicultural Challenge*, 271
Gill Perry, *What Is the Canon?* 277
Lucy Lippard, *Mapping*, 282

Chapter 22 The Art History Course 288
Scott Heller, *What Are They Doing to Art History?* 289
Roger Kimball, Introduction to *Tenured Radicals*, 295

Afterword 303

Foreword

This book of readings is intended to introduce students to the complexity of issues and approaches that increasingly characterizes the study of art history.

For the past thirty years, the so-called "new art history" scholarship has profoundly challenged most of the traditional tenets of our discipline. Many teachers of art history have been modifying the conventional survey format (which primarily traced stylistic development in high art forms) to include organizational strategies that help to demonstrate the complex and multilayered ways visual images work in societies.[1] In our own experience of re-designing courses, we found that available historical texts are not designed with this kind of flexibility. We turned to supplementary readings that form the basis of this book.

The readings we selected are meant to illustrate significant issues and themes—complementing style and formal analysis—which can be raised in the teaching of art history. They range from the power of visual images to shape the ways we know things to the political and policy debates about the place of the arts in our society. We want students to appreciate that art is a dynamic force, and that learning about it—even in an historical context—can inform issues in their own lives.

The topics focus on Western art history and their arrangement is keyed to chronology. In that sense this book is designed to be used in concert with standard introductory texts. Our strategy has been to select relatively short pieces and to pair them for each topic. The reasons for short pieces are pretty self-evident. Pairing allowed us to contrast differing perspectives or to foreground unexpected connections of issues across periods. Each topic (with paired readings) carries an introduction with a brief summary of the issues raised by the readings.

We have intentionally chosen a wide range of writers. In addition to art historians, this book includes works by literary scholars, critics, political figures,

historians, and journalists. Each brings a unique background and set of experiences to the issues at hand. Sometimes the writers demonstrate distinctly different methods of dealing with the material. At other times they fundamentally disagree with one another. Taken together, however, the resulting discourses are not simple polarized debates between two opposing factions, but a complex conversation involving many different voices.

There are several advantages to this approach. At a practical level we have found that it enhances the quality of student discussion in the classroom. More importantly, as Gerald Graff and others have shown, "teaching the conflicts" helps to relate the theoretical debates in art history to corresponding debates in other disciplines and in the world at large.[2] Acknowledging that there are differing perspectives on an issue or that ideas and experiences are not time bound encourages students to practice critical thinking—to get beyond "fact memorizing"—to become involved with the analysis of ideas and to participate in the actual processes of scholarship.

John C. McEnroe
Deborah F. Pokinski

NOTES

[1] Bradford R. Collins, Guest Editor, "Rethinking the Art History Survey," special issue of *Art Journal* 54 No. 3 (Fall 1995).

[2] Gerald Graff, *Beyond the Culture Wars. How Teaching the Conflicts can Revitalize American Education* (New York and London: W.W. Norton & Company, 1992); Mark Miller Graham, "The Future of Art History and the Undoing of the Survey," *Art Journal* 54 No. 3 (Fall 1995): 30–34.

Acknowledgments

We would like to thank all of our students, but especially Daniel Chapman and Brigitte Hunt, both of whom worked as research assistants in the preparation of the book.

Special thanks go to Eugene Tobin, President of Hamilton College, who gave both moral and monetary support by generously underwriting the cost of the reproductions used in the text.

We thank those at Prentice Hall who helped make this book a reality: Bud Therien, Executive Editor College Art and Music, for believing in the concept; Wendy Yurash, Editorial Assistant for Art for her unfailing patience and advice; and Dick Hamlin, our regional Sales Representative for making the first move. Comments from reviewers Matthew Looper, California State University-Chico, James H. Rubin, SUNY Stony Brook, Martha Peacock, Grand Valley State University, and David M. Sokol, University of Illinois at Chicago, were appreciated.

Thanks also to Lisa Rogers of Hamilton College's Information Technology Services who rescued us from several computer blunders.

Finally, we thank the authors of the readings included in *Critical Perspectives*. All have been generous and supportive.

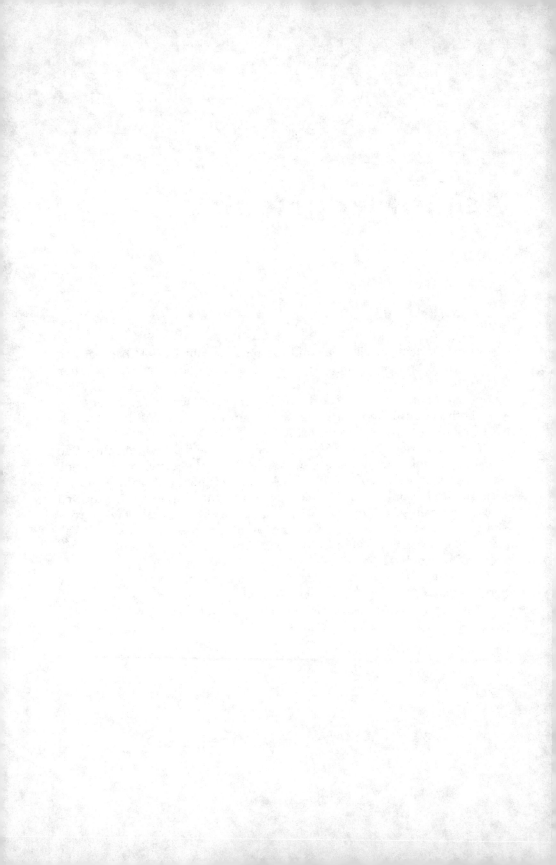

CRITICAL PERSPECTIVES on ART HISTORY

CHAPTER 1

Democracy and the Greek Ideal

In 1992–1993, a blockbuster show of classical Greek sculpture on loan from the Greek government was exhibited at the National Gallery in Washington and the Metropolitan Museum in New York. Contributors to the exhibition catalogue, including Nicholas Gage, rhapsodically describe Classical Greece as the birthplace of individual freedom, democracy, and the humanistic tradition and suggest that these new values underlie the remarkable transformation of Greek art that took place in the fifth century B.C.E.

In his review of the show for *Time*, Robert Hughes summarizes his opinion of those romantic hyperboles in a word: "hokum." Hughes was not the first to raise doubts about simplistic platitudes of the sort associated with the "Greek Miracle" exhibition. Several years earlier, Eva C. Keuls had pointed out that ancient Athenian society was not a democracy in any modern sense, but rather a rigidly elitist and deeply misogynistic slaveowning oligarchy that she dubbed a "phallocracy."

Introduction to *The Greek Miracle: Classical Sculpture from the Dawn of Democracy*

NICHOLAS GAGE

Nicholas Gage worked for many years as a foreign correspondent and investigative reporter. He is the author of several novels and works of nonfiction. His best-known book is Eleni *(New York: Ballantine Books, 1996). The book tells the story of his mother's attempt to organize her children's escape from Greece during the Civil War of 1946–1949 and of her tragic murder by Communist guerillas.*

First, there was the vision. In the fifth century before Christ, an unprecedented idea rose from a small Greek city on the dusty plains of Attica and exploded over the Western Hemisphere like the birth of a new sun. Its light has warmed and illuminated us ever since; sometimes obscured by shadows, then bursting forth anew as it did when our own nation was created on the model of the Greek original. The vision—the classical Greek idea—was that society functions best if all citizens are equal and free to shape their lives and share in running their state: in a word, democracy.

With this new day came an explosion of the creative spirit in Greece, producing the architecture, the art, the drama, and the philosophy that have shaped Western civilization ever since. Jason's harvest of armed soldiers, grown in a day from dragon's teeth, seems no more miraculous. "What was then produced in art and thought has never been surpassed and very rarely equalled," wrote the classicist Edith Hamilton, "and the stamp of it is on all the art and all the thought of the Western world."

The concept of individual freedom is now so much a part of our spiritual and intellectual heritage that it is hard today to realize exactly how radical an idea it was. No society before the Greeks had thought that equality and freedom of the individual could lead to anything but disaster.

The revolutionary notion that ordinary man could rule himself took root 2,500 years ago in the late sixth century B.C. after the Athenian lawgiver, Solon, extended power sharing beyond the aristocracy. It crystallized in the last decade

Reprinted by permission from Nicholas Gage, "Introduction," *The Greek Miracle: Classical Sculpture from the Dawn of Democracy*, ed. Diana Buitron-Oliver, exh. Cat., National Gallery of Art (Washington, D.C., 1992), 95–97.

of the century with the reforms of the statesman Kleisthenes, reforms that distributed political rights to all free citizens and established equality before the law.

Long before the Greeks, mankind realized that order was necessary for society to function, but it was always believed that order was impossible without autocratic rule. The great empires of the ancient world—Egypt, Mesopotamia, Persia—were all tyrannies. It took the small and unimpressive city-state of Athens to produce the idea that individual freedom and order are not incompatible.

The Greeks did not come up with that concept because they were naive optimists. They were, in fact, realists who understood very well that unlimited freedom can produce chaos. The principles they most revered were moderation, balance, self-control, all summarized by the words attributed to Solon carved in the stones of their holiest shrine, Delphi: "Nothing in Excess." The Greeks embraced this golden mean because they were a passionate, individualistic people, quick to vent their emotions, and they realized how difficult moderation is to achieve. Every Greek considered himself a battlefield where Apollo's reason and Dionysos' passions struggled for control.

The fact that the Greeks knew the extremes of passion so well was precisely why they placed such a high value on self-control. Knowing the dangers of excess, they struggled to restrain the impulses for unrestricted freedom that can make life in a community intolerable. Perikles said: "We are a free democracy, but we obey the laws, more especially those which protect the oppressed and the unwritten laws whose transgression brings shame." The faith of Greeks in every person's unique capacity to reason and to impose self-control from within was a major force in creating that peculiar Athenian experiment, the world's first democracy, which involved every farmer, shepherd, and tradesman in the government. "The individual can be trusted," Perikles said. "Let him alone."

Mortal man became the standard by which things were judged and measured. Buildings were built to accommodate the body and please the eye of a man, not a giant. Gods were portrayed as resembling human beings, not fantastic creatures. And the ruler—the lawmaker and judge—was for the first time the ordinary citizen. As Sophokles wrote in *Antigone*: "Wonders are there many—none more wonderful than man."

The ancient Greeks believed there is a divine spark to be found within every mortal. Their gods looked and acted like humans, complete with human foibles and weaknesses. This is an essential difference between the Greeks and all previous societies, which stressed that good behavior must be enforced upon men by the threat of retribution from outside, superhuman forces. It was no coincidence that the Greek discovery of individual worth and freedom produced the most profound advances in art and sculpture. If the spark of divinity is to be found in man, then the form and appearance of man would inevitably be the proper subject matter of the artist. The truth could be found in the natural world, including man's body and mind, not in some mystical, incorporeal world. While the artists and religious leaders of the East tried to

find truth by distancing themselves from the physical world, the Greeks studied the real, the physical, the natural in their search for truth and wisdom.

Before the Greek miracle, the great civilizations of the world produced art that was rigid, formal, symbolic rather than realistic. In Egypt life was ruled by overwhelming forces of nature: rain, wind, sun, drought. Egyptian sculpture and architecture, such as the sphinx and the pyramids, were equally colossal, beyond the ken of mere mortals who were tiny as ants in comparison. The Eastern artist was taught to consider the outside world merely an illusion and to withdraw from it through solitude, meditation, and chanting until he lost all consciousness of self and beheld the image of a god that would have no human shape. By banishing the flesh, the art of the East became mystical and supernatural; fantastic figures with multiple hands, arms, and breasts, whirling in ecstasy, were symbols of spiritual truth. In contrast, an artist who believes that man holds the spark of divinity, that there is "none more wonderful than man," will make the human form his object of study.

When reason and spirit fuse, as they did in the time of Perikles, the natural goal of the artist is to portray beauty in the image of man, but idealized. Like the philosopher and the scientist, the artist sought the essence of the thing, trying to strip away confusing details and variations to uncover the purest ideal of the human body, the perfect balance between flesh, spirit, and intellect. This, for him, was the best rendition of a god and of spiritual perfection. No symbols or special trappings of divinity were required beyond the figure's physical harmony. The most perfect beauty, to the Greek of the fifth century, was the pure and unadorned.

This miracle did not happen instantly. By studying the development of the human figure in Greek sculpture, we can see the perfection of naturalistic art emerging from the chrysalis of what went before. Archaic kouroi are stiff, stylized, portrayed frontally with their mystical smile. Like figures in the art of earlier civilizations, they are rigid as the stones from which they are carved. In the *Kritios Boy* [Figure 1] of the early classical period the human form takes a revolutionary step out of the block of marble, turning his head and escaping the restraints of centuries. He is a synthesis of *ethos* (noble character) and *pathos* (emotion) never before achieved. Within a stunningly brief period of time, the representation of the human figure achieved its finest expression, idealized yet completely natural, in a bronze masterpiece called the Zeus of Artemiseion, frozen in perfect balance in the instant before he hurls a thunderbolt. The Greek miracle was complete.

Why did this miracle spring from the soil of Attica rather than a mightier, richer, or more ancient civilization? No one can say for certain, but one reason may be the nature of the landscape of Greece. It is not a place of extremes. Greece is a land of unceasing variety, austere but beautiful, where everything can be taken in by the human eye and understanding. Ancient Greeks believed Mount Olympus touched the sky, yet it is only 9,750 feet high. Nature built Greece on a human scale and the Greeks followed suit, creating their gods

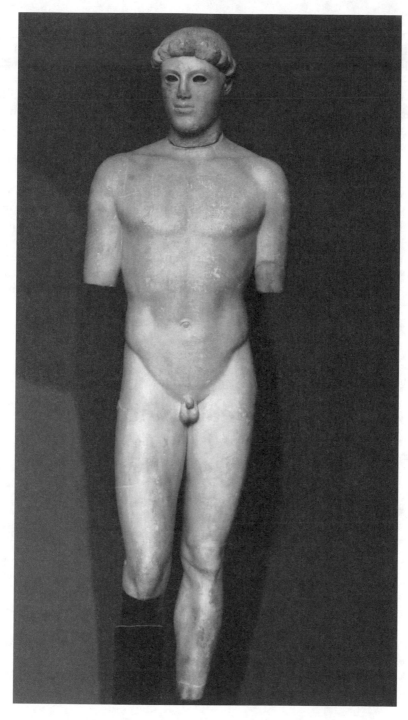

Figure 1. *Kritios Boy,* c. 480 B.C.E. Acropolis Museum, Athens, Greece.
Photo: Foto Marburg/Art Resource, NY.

and designing their temples to the measure of man. This idea of human proportion as the basic unit pervades Greek thought.

Another reason for the Greeks' unique vision may be that they lived at the crossroads of three continents, venturing from their land all over the Mediterranean world to trade and establish colonies. This gave them, with the explorer's boldness and the philosopher's yearning for basic truths, the opportunity to examine the ideas of other civilizations and compare them to their own. Ultimately their experiences and instincts led to the creation of the Greek miracle that astonished the world. Such greatness of art, literature, philosophy, and government set a standard for the civilizations that came after. For nearly a century, on the austere plain of Attica, men reached a level of excellence that has remained an inspiration for mankind, the mind and spirit in equilibrium as never before or since.

The objects in this exhibition are the most moving and vivid illustration of what the Greeks attained in that time and place. It is a unique privilege to experience them for the first time in our democracy that was modeled on theirs.

The Masterpiece Roadshow: An Exhibit of Ancient Greek Sculpture Is Used to Advance a Specious Political Argument

ROBERT HUGHES

Robert Hughes is an award-winning art critic and senior writer for Time *magazine. He has written several books including* American Visions: The Epic History of Art in America *(New York: Alfred A. Knopf, 1997) and the best-selling* The Fatal Shore *(London: Guild Publishing, 1986). Hughes also wrote and narrated the television series* The Shock of the New, 1980.

It must be said, straight off, that *The Greek Miracle: Classical Sculpture from the Dawn of Democracy*, now at the National Gallery in Washington (it goes to the Metropolitan Museum in New York City in March), is a very odd show. Largely composed of loans from the Greek government, it combines a number

of profound, exquisite and completely irreplaceable works of art, which wiser owners would not have exposed to the risks of travel, with an utter shallowness of argument about their social and ritual meanings. Insofar as an exhibition can assemble great sculpture and have practically no scholarly value, this one does.

The reason is that *The Greek Miracle* is an exercise in political propaganda, and has to embrace stereotypes that no classicist today would accept without deep reservations. First, the exhibit wants to indicate how Greek sculpture changed in the classical period, by showing its movement from the frontal, rigid forms of 6th century B.C. kouroi, whose ancestry lay in Egyptian cult figures, to the more naturalistic treatment of balance and bodily movement one sees in works such as *The Kritios Boy* [circa 480 B.C., Figure 1], which was found on the Acropolis. And it demonstrates this in considerable detail, through marvelous examples of 5th century sculpture that include the titanically grave and simple group of Atlas presenting the golden apples of the Hesperides to Herakles (from the Temple of Zeus at Olympia) and the famous low-relief carving of the armed goddess Athena, leaning on her spear, absorbed in thought, the body fixed in a space of almost pure geometry (from the Acropolis Museum in Athens).

As an orientation course for those who don't know much about classical Greek sculpture—and as a source of unalloyed aesthetic pleasure for those who do—this show ought not to be missed. But neither should its second premise be taken seriously: the idea that there was some causal connection between the advent of the classical style in sculpture and that of democracy in Athenian politics. Both happened at roughly the same time: in the late 6th century an Athenian aristocrat, Kleisthenes, made an alliance with the people of Athens in order to defeat another noble, Isagoras, and pushed through a number of democratic reforms that were permanently enshrined in the Athenian constitution.

These measures gave the vote and other rights to citizens who had not enjoyed them before, though not, of course, to slaves or women. But the idea that the beginnings of democracy in Athens changed the way that rituals, gods and heroes were represented is hokum: exactly the same changes of style occurred in cities, like Olympia, that were run by tyrants. The fact that modern Greeks apparently want to believe it—this being a time of super-chauvinism in Greece, as in other Balkan countries—means nothing, except in the scheme of simplistic politico-cultural fantasy. You might as well claim that Abstract Expressionism was "caused" by the election of Harry Truman. Nevertheless, such is the show's political motive, and it seems a poor pretext for taking great art and jetting it to America like so many getwell cards, for the sake of political p.r.

In its reflexive idealization, the show sets before us a notion of Greek antiquity that was conceived in the 18th century by the German archaeologist-connoisseur Johann Winckelmann and then elaborated into an all-pervading

imagery through the 19th. Balance, harmony, transcendence, sublimation—all are characteristics of great classical art, but not the whole story, and not one that would have been wholly intelligible to the ancient Greeks. It is as though the organizers of this show still felt obliged to believe in the division of the world claimed by the original Athenians. Here is Hellas, populated by people. Outside is the domain of *hoi barbaroi*, those who are not quite human: the superstitious Orientals, the treacherous mountain dwellers, the lesser breeds without the law. The Greeks, by contrast, stop just short of turning into marble statues of themselves—effigies of undying self-congratulation, picked up by later cultures to signify the reign of the past over the present.

It is true that since the image of classical Greece began to lose the power it had accumulated up to the end of the 19th century, many writers have found this marmoreal stereotype insufficient. "How one can imagine oneself among them," mused the English poet Louis MacNeice, no mean classicist himself, in his 1938 poem, *Autumn Journal*, "I do not know." And was this antiquity a world of heroes or something more like modern Athens?

> When I should remember the paragons
> of Hellas
> I think instead
> Of the crooks, the adventurers, the
> opportunists,
> The careless athletes and the fancy
> boys,
> The hair-splitters,
> the pedants, the
> hard-boiled
> sceptics,
> And the Agora and
> the noise
> Of the demagogues
> and the quacks; and the women
> pouring
> Libations over graves,
> And the trimmers at Delphi and the
> dummies at Sparta and lastly
> I think of the slaves.

No such doubts obtrude upon the archaic fantasy world set up by the writers in the catalog to this show. Slavery, as important an institution for Periclean Greece as for America's antebellum South, does not enter their vague lucubrations about the matched "miracles" of Art and Democracy. For them, all is idealism, naturalism, the world of formal purity, grace and refinement. Whatever speaks of demonism, fear, magic and irrational superstition is simply swept under the carpet; and yet these were colossally important elements

even in the "rational" Athens of the 5th century B.C., let alone in the rest of Greece. The naively optimistic idea expressed in Nicholas Gage's introduction, echoing a long succession of enlightened Hellenophiles from Winckelmann to Matthew Arnold, that "Mortal man became the standard by which things were judged and measured," simply does not fit the facts of classical culture. On the contrary: the Greeks of Pericles' time, like their ancestors and successors, were obsessed with the weakness of the dike that protected their social and mental constructions against uncontrollable forces. Their culture was webbed with placatory or "apotropaic" rituals, charms and images meant to keep the demons at bay.

This is why classical Greek sculpture, in its original form, was so very unlike the version made of it by Neoclassicists 2,000 years later, and recycled in this show. "No symbols or special trappings of divinity," writes Gage, "were required beyond the figure's physical harmony. The most perfect beauty, to the Greek of the 5th century, was the pure and unadorned." But classical Greek sculpture was neither pure nor unadorned; its décor has been lost or worn away. Were we to see it in its original state, we would find it shockingly "vulgar." All the great figures and sculpture were painted in violent reds, ochers and blues, like a seaside restaurant in Skopelos. The colossal figure of Athena inside the Parthenon was sheathed in ivory "skin." As for adornment, there were "real" metal spears fixed in the hands of marble warriors, brightly simulated eyes with colored irises set in the now empty sockets of *The Kritios Boy*. And far from rising above anxiety, classical Greek art pullulated with horrors: snakes, monsters, decapitated Gorgons, all designed to ward off the terrors of the spirit world. One sometimes wonders if ancient Greece, more lurid than white, so obsessed with blood feud and inexpungible guilt, wasn't closer to modern Bosnia than to the bright world of Winckelmann. But you cannot put that kind of "classicism" in a museum, or relate it to "democracy."

Introduction to
The Reign of the Phallus

EVA C. KEULS

Eva C. Keuls has written extensively on classical Greek literature and on ancient Greek vase painting. She has been a fellow of the Institute for Advanced Study in Princeton and is Professor Emerita at the University of Minnesota. Her latest book is Painter and Poet in Ancient Greece: Iconography and the Literary Arts *(Stuttgart: Teubner, 1997).*

In the case of a society dominated by men who sequester their wives and daughters, denigrate the female role in reproduction, erect monuments to the male genitalia, have sex with the sons of their peers, sponsor public whorehouses, create a mythology of rape, and engage in rampant saber-rattling, it is not inappropriate to refer to a reign of the phallus. Classical Athens was such a society.

The story of phallic rule at the root of Western civilization has been suppressed, as a result of the near-monopoly that men have held in the field of Classics, by neglect of rich pictorial evidence, by prudery and censorship, and by a misguided desire to protect an idealized image of Athens. As a Professor of Classics, I believe that an acknowledgment of the nature of this phallocracy will have the effect, not of disparaging the achievements of Athenian culture but rather of enriching our sense of them, adding yet another level to their meaning. In any case, the evidence cannot any longer be ignored.

Even to propose the concept of a phallocracy in ancient Greece may touch a sensitive nerve. In writing about Greek homosexuality Sir Kenneth Dover declared, "I know of no topic in Classical studies on which a scholar's normal ability to perceive differences and draw inferences is so easily impaired." As this introduction will make clear, Athenian male homosexuality was only one aspect of a larger syndrome which included men's way of relating to boys, wives, courtesans, prostitutes, and other sexual partners, and, in a larger sense, not only to people in Athens, but to other city-states.

First of all, what is "phallocracy"? Literally meaning "power of the phallus," it is a cultural system symbolized by the image of the male reproductive

organ in permanent erection, the phallus. It is marked by, but is far more particular than, the dominance of men over women in the public sphere. In historic times, at least, such dominance has been almost universal. Nor does phallocracy refer simply to the worship of the male organ, a practice considered bizarre by most Westerners but common in many parts of the world, especially in conjunction with worship of the female counterpart. Although cultures that revere sexuality are, like others, generally dominated by men, much of their art and rituals presents the phallus as a symbol of generativity and of union with, rather than dominance over, the female. Furthermore, phallocracy does not allude to male dominance solely within a private sphere of sexual activity. Instead, as used in this book, the concept denotes a successful claim by a male elite to general power, buttressed by a display of the phallus less as an organ of union or of mutual pleasure than as a kind of weapon: a spear or war club, and a scepter of sovereignty. In sexual terms, phallocracy takes such forms as rape, disregard of the sexual satisfaction of women, and access to the bodies of prostitutes who are literally enslaved or allowed no other means of support. In the political sphere, it spells imperialism and patriarchal behavior in civic affairs.

In speaking of "the display of the phallus," I am not referring, as Freudians do, to symbols that may remind us of the male organ, such as bananas, sticks, or Freud's own cigar. In Athens no such coding was necessary. As foreigners were astonished to see, Athenian men habitually displayed their genitals, and their city was studded with statues of gods with phalluses happily erect. The painted pottery of the Athenians, perhaps the most widespread of their arts, portrayed almost every imaginable form of sexual activity.

Painted History

In describing Athenian phallocracy, I rely heavily on pictorial evidence. As a source for history, vase paintings and other figured monuments have the advantage of coming directly from their period, unlike literary texts, which have had to pass through centuries of copying, selection, and censorship to survive into our time. Yet until the very recent past, most studies of Greek sex relations and other aspects of social history have either ignored these artifacts or used them essentially as illustrations of views derived from the written record.

Discovered during an era of sexual repression, "pornographic" Greek vase paintings were, in many cases, locked away in secret museum cabinets. When censorship was sufficiently liberalized, selections of the most sensational pictures were published in books apparently intended less for historians of sexuality or social customs than for devotees of erotica. Now it is time to study all the pictorial evidence for what it can teach us about the sexual politics of Classical Athens, and in particular about phallocracy. . . .

The reign of the phallus comprised nearly every aspect of Athenian life. Once alert to its implications, we can see it reflected in architecture, city planning, medicine and law. In the public sphere of men, buildings were massive and surrounded by phallic pillars, whereas private dwellings, largely the domain of women, were boxlike, enclosed, and modest. In law, we can trace the origins of the syndrome back to Solon, a founder of Athens and a father of its democracy. In the early sixth century B.C. the great legislator not only overhauled the Athenian political system but also instituted many controls over sexual and family life. He originated the principle of the state-controlled and price-controlled brothel, and passed, or singled out for perpetuation, "Draconian" laws for safeguarding the chastity of citizen women, including the notorious statute that a father could sell his daughter into slavery if she lost her virginity before marriage. He also may have instituted the Women's Police (*gynaikonomoi*), not securely attested in Athens until the post-Classical age but probably much older. At any rate, enough domestic legislation goes back to Solon to consider him a codifier of the double standard of sexual morality.

Women and Slaves

One of the most revealing aspects of Athenian society was the similarity of the positions of women and slaves: a considerable number of references and symbols connect the two categories. The legal term for wife was *damar*, a word derived from a root meaning "to subdue" or "to tame." When the bride arrived at the groom's house, a basket of nuts was poured over her head for good luck, a treatment also extended to newly purchased slaves. This was called the *katachysmata* or "downpourings." Like a slave, a woman had virtually no protection under the law except insofar as she was the property of a man. She was, in fact, not a person under the law. The dominance of male over female was as complete during the period in question as that of master over slave. As a result, the lives of Athenian women have been nearly excluded from the record. The women of the age of eloquence were silenced, and deprived of the form of immortality that Greek men prized above all others: that of leaving a record of their achievements. With unintentional aptness a scholar entitled a recent study of the Periclean age *Men of Athens* (R. Warner, 1973).

But men sat uneasily on the victor's throne. For there was a vital difference between women and slaves in the minds of the men who owned them. Slaves and their agonies could be excluded from one's consciousness, like the sufferings of animals, but women are men's mothers, wives, sisters, and daughters, and the battle of the sexes had to be fought over again in the mind of every male Athenian. Nevertheless, the institution of slavery provides the key to the understanding of the sexual and moral stances of the Athenian Greeks to be described. Without a grasp of its implications, these attitudes would not be comprehensible by the modern mind.

Judged by the ideals of modern Western society, life in the ancient world in general was brutal. Slavery brought the gruesome implications of man's victories over his fellow men into every home. Even so, household and other urban slaves were a privileged elite. What went on in the mines, quarries, and treadmills (with which the masters of comedy constantly threaten their slaves) must largely be filled in from imagination. We have no references to those practices from the Greek age, but from the Roman Imperial period the author Apuleius has left us this description of a treadmill where slaves were punished:

> Merciful gods, what wretched mannikins did I see there, their entire skin covered with bluish welts, their backs torn into bloody strips, barely covered with rags, some having only their genitals covered with a piece of cloth, all of them showing everything through their miserable tatters. Their foreheads were branded with letters, their heads half shorn, their feet stuck in rings. They were hideously pale, the dank vapors of the stinking hole had consumed their eyelashes and diminished their sight. Like wrestlers, who are sprinkled with a fine powder as they fight their bouts, they were blanched with a layer of dirty-white flour (*Met. 9, 12*)

Some Classicists argue that the ancient Athenians were mild masters to their slaves, thus echoing Aristotle, who wrote of the "customary gentleness of the Athenian people." Such evidence as we have, however, suggests that slavery was more unmitigated in Athens than in many other ancient societies. A telling detail of their customs was the use of an object called a "gulp preventer" (*pausikape*), a wooden collar closing the jaws, which was placed on slaves who handled food to keep them from eating it. The tortures of Tantalus were mirrored in everyday life.

A practice exclusive to Athens among Greek cities (with the possible exception of the Asian city of Miletus) was the routine torture of slaves in legal proceedings. A slave's testimony was admissible in court only if he gave it under torture, a provision that shows contempt for his character and disregard for his well-being. An owner could refuse to surrender his slaves to the opposition for questioning, but this would obviously cast a suspicion of guilt on him. If the slave was permanently injured during torture, the owner was entitled to damages. The state maintained a public torture chamber for legal purposes (*basanisterion*). The interrogations there were a form of popular entertainment: "Whenever someone turns over a slave for torture, a crowd of people gathers to hear what is said," Demosthenes reports. The Athenians were, in fact, inordinately proud of their practice of examination by torture, considering it, as one orator put it, "the justest and most democratic way" (Lycurg. 29).

Sexually, as in all other ways, slaves were at the mercy of their owners. In fact, we will see that slaves, whether owned by public and private brothels or by individuals, provided men's habitual sex outlets, a circumstance which in itself must have generated an equation of sex with domination. Those slaves who were also women carried a double burden of oppression and were the most defenseless members of society. . . .

CHAPTER 2

The Parthenon and Patrimony

In 1801, with the permission of the Turkish military governor, Lord Elgin began to systematically remove important sculptures from the Parthenon, the most famous monument of Classical Greece. Elgin shipped the sculptures to England, claiming that this was the only way to preserve them from the ravages of vandalism, war, and neglect.

Elgin's actions were controversial at the time and have since become even more hotly contested. Many, including the former Greek Minister of Culture, Melina Mercouri, have demanded that the Parthenon marbles be returned to Greece. The British architectural historian, Gavin Stamp, on the other hand, insists that the sculptures belong in the British Museum and that returning the sculptures would set a dangerous precedent that would undermine virtually all museums.

In our post-Colonialist era, debates like that surrounding the Parthenon marbles are taking place around the world. At issue is a fundamental question: To whom does the past belong, to the country of origin or to the world at large? Can we find a balance between the claims of ethnic or national identity and the homogenizing effects of globalization?

Keeping our Marbles

GAVIN STAMP

Gavin Stamp is an authority on British architectural history and on historic preservation. In addition to having written numerous scholarly books and articles, he contributes frequently to popular journals. Stamp is Professor of Architectural History at the Glasgow School of Art.

After a certain tactful delay since Miss Mercouri's histrionic visit to London earlier this year, the Greek government has now sent the expected formal request for the return of the Elgin Marbles to Athens. I note that, as far as I am aware, no similar official letter has arrived in Paris asking for the return of the fragments of the Parthenon in the Louvre, or in Bonn about the marble sculptures from the Temple of Athena at Aegina now in the Glyptothek in Munich. The Greek emotion in favour of the 'repatriation' of national art treasures seems very selective in its application, but the Greeks well know that the British are a wonderfully soft touch over this sort of thing. Traditional Hellenophilia, inculcated for generations in our public schools, combined with post-imperial guilt, makes us pathetically anxious to please. It is a far cry from Lord Palmerston sending gunboats to threaten Piraeus in the dubious case of Don Pacifico.

Arguments in favour of retaining the sculptures from the Parthenon acquired by Lord Elgin have considerable force. Museums would be very dull places if they only contained national treasures—American museums would be almost empty—and the dispersal of cultural objects ought to help to promote international understanding. Certainly there is nothing dishonourable in our having the Marbles: they were bought not looted, and in the event poor Elgin made a considerable loss when he eventually decided to sell them to the British Museum for safe keeping and for public edification. Money talks, of course, and not always very pleasantly, but it is better to buy than to steal. The great collections in British country houses were all the results of purchase and, to be successful, a willingness to buy must be allied with a willingness to sell—as we are beginning to see in Britain with the threat of the alarmingly ample purse of the Getty Museum. The contrast with the Louvre, say, is marked. Napoleon was second only to the late Marshal Goering as a cultural magpie and when, after the downfall of the Emperor, the Allies demanded

Reprinted from Gavin Stamp, "Keeping Our Marbles," *The Spectator*, 10 December, 1983, 14–17. Reprinted by permission of the publisher.

the return of much of the French loot to Italy, it had to be protected in the Lourvre from further French theft by armed soldiers.

Miss Mercouri and the Greek government do not propose, it should be noted, to restore the Marbles to their original positions on the Parthenon; if they did their claim would be much more convincing. Rather, the Marbles are intended for a new air-conditioned building which is yet to be erected. Athens is so vilely polluted that Greeks are meant to drive their cars into the city on every other day and the Parthenon has suffered more damage in recent years from the filthy atmosphere than during several centuries of Turkish indifference. So the Marbles will merely be transferred from one museum to another, and from one where they are well displayed to one where they will have to be protected behind glass.

It needs to be pointed out perhaps—certainly to the British Museum's present Director—how very fine the setting of the Elgin Marbles is in London. Not only is Sir Robert Smirke's British Museum building itself, surely one of the finest Greek Revival structures in Europe, a tribute to the potency of the Greek ideal in Western culture, but the gallery in which the Marbles are now displayed is an excellent example of 20th-century Neo-Classicism. Given by Sir Joseph Duveen and built in 1936-38, the grand monumental room was designed by John Russell Pope, the American architect of the National Gallery in Washington DC [Figure 2]. The marbles can be seen, in the round and without intervening class, mounted on plinths which are in muted, austere sympathy. It seems to me that listed building consent should be needed for their removal.

But there are more fundamental reasons why the Greek government's claim to the Elgin Marbles is unimpressive. Modern Greece, after all, has very little connection with the nation and people who carved the Marbles and who designed that refined and sophisticated building in which they were once fixed. Modern Greek bears hardly any relation to Classical Greek and the formal written language using ancient Greek words which was invented in the 19th century has now been abandoned. And racially—as our 'High Life' correspondent often has had occasion to observe—the present inhabitants of Greece are not descended from the race of Pericles. As with the rest of Europe, the southern tip of the Balkan peninsula has seen many migrations and population movements over the last two thousand years.

The modern Greek state, to which the Marbles now seem to mean so much, is really a very recent invention: older indeed than Albania or Bulgaria, but no more respectable historically than, say, Belguim. Furthermore, this modern Greek state is, to a remarkable extent, a British invention. Complacent British liberalism is much to blame for those Romantic ideas of nationalism and self-determination which promoted the notion of Greek independence and which have caused so much trouble and bloodshed over the past two centuries. Romantic, philhellene Britons like Lord Byron went out to help in the struggle to end Turkish rule and it was the defeat of the

Figure 2. View of the Elgin/Parthenon Marbles in the Duveen Gallery, British Museum, London. Photo: Henry Lentz/Art Resource, NY.

Turkish and Egyptian fleet at Narvino in 1827 by a combined British, French and Russian force which finally secured Greek independence.

Byron began the campaign of denigration of Lord Elgin for his part in the removal of the Marbles from Athens, but both men were interested in them and in Greece for the very same reason: an obsession with the culture and civilisation of Ancient Greece. Byzantine Greek culture, which was still a living force in Turkish Greece, was of much less interest. It was not Greeks who began to explore, record and protect the antiquities of Classical Greece, but Westerners. The process begins in the 1750s with James 'Athenian' Stuart and Nicholas Revett undertaking the arduous and dangerous work of recording *The Antiquities of Athens* and their books allow us to appreciate how much these antiquities were damaged and in danger in the late 18th and early 19th centuries. Stuart and Revett were followed by a succession of British, French and German architects and archaeologists, and this active philhellenism culminated in both the struggle for Greek independence and the purchase of the Elgin Marbles by the British government (in 1815) and of the Aegina marbles by the King of Bavaria (in 1811).

The West re-invented Ancient Greece, an ideal with which the nascent modern Greek state eventually identified itself. It was this ideal of Greek culture and society of the past which inspired archaeologists, artists, architects, connoisseurs and politicians, rather than the wretched actuality of Greece in the present. The enthusiasm generated by the revelation of the purity of Greek architecture and the sophisticated realism of the sculpture was quite extrordinary. The Elgin Marbles inspired artists like Flaxman; Greek temples became the ideal for a host of architects: Wilkins, Cockerell, Smirke, Hamilton, Playfair, Harrison, in Britain alone. The *museum* itself was a product of this obsession with the ancient world in the early 19th century, it is no accident that Smirke designed the British Museum, Schinkel the Old Museum in Berlin and von Klenze the Glypotheck in Munich all at the same time; and all are superb monumental essays in the Greek revival, tributes to the power of the ideal of Classical Greece. And this obsession with Greece affected politicians; being then learned and educated men they were persuaded both to support Greek independence and spend public money on Smirke's huge building, designed as a worthy receptacle for the antiquities of Greece, Rome and the ancient world. There is an artistic logic and historical justice in the Elgin Marbles being in the British Museum.

Perhaps it is fairer to say that modern Greece is an Anglo-German invention. Germans were very active in the exploration of Greece and, in the event, it was the Germans who made the new Greek state into a model of Greek ideals and Athens into a Neo-Classical city. The first Kind of Greece was Otto of Bavaria, younger son of King Ludwig who had bought the Aegina marbles. Otto was proclaimed king in 1832 and, soon after he arrived in Greece the following year, invited the great Schinkel to prepare designs for a palace on the Acropolis—Neo-Classical in style, of course. In the event it was the

King of Bavaria's architect, Leo von Klenze, who helped plan the new city and Friedrich von Gärtner, another Neo-Classicist from Munich, who designed the Royal Palace built below the Acropolis, while the Danes, Hans Christain Hansen and Theophillus Hansen, who were responsible for the magnificent group of University, Academy of Science and Library as well as other Greek Revival buildings in Athens.

Had the marble friezes, metopes and sculpture still been on the Parthenon in the 1830s, it is most unlikely that they would ever have been removed and exported. However, had not Elgin taken them away, during the period 1801–04, it is very likely that they would have been damaged, like much else, during the Turkish siege of insurgent Athens in 1826–27, or fallen victim to arbitrary vandalism, the result either of Islamic fanaticism or Greek indifference, of which there is a mass of contemporary evidence. Sculptures were sometimes burned to make lime, or destroyed by fanatical Turks because they gave pleasure to infidels. It is against this background that Elgin's activities must be judged. His purchase of the Marbles "was permitted by a *firman* from Constantinople and the removal of the sculptures was affected in a perfectly legal and careful manner.

The objection to Elgin's purchase that the Turks, as invaders, had no authority to dispose of the Marbles is typical of naive and sentimental English liberalism which ignores the realities of power and of European history. The Turks, I suppose, had as much right to be in Greece as the Romans in Britain, but both, while there, provided the only framework of law and order. And Greece, after all, had been part of the Turkish Empire for three and a half centuries when Elgin was British Ambassador at the Sublime Porte—a longer period than that enjoyed by the British Raj in India. And just as Britain left a positive legacy in India, so the Turks had a profound influence in Greece. Not only much of the language but many Greek customs are Turkish in origin and visitors to Istanbul will know that Greek coffee and food are merely provincial expressions of Turkish originals.

The Turkish Empire has had an unfair press. Though I thank God for the results of the Battle of Lepanto and the Siege of Vienna, I do feel that whether the issue is Turkey in the 19th century or Cyprus today, the British have a quite unjustified bias against Turkey and in favour of Greece, a country which has often been conspicuously unfriendly to us. In its later years, the Turkish Empire was capable of viciousness and cruelty such as is typical of any dying frightened empire, but Turkey would not have been able to hold its possessions on the Balkans and the Levant for so long and to leave such a marked influence if the Empire had not been intelligently and tolerantly governed. Although Islam was always encouraged and protected, the Turkish Imperial rule was maintained by a mixture of decentralised and religious tolerance. Certainly the Turkish Empire was infinitely more tolerant and less ruthless than the Spanish Empire in America.

In Greece, the Orthodox Church was not suppressed but allowed to survive and thus maintain independent Greek culture. The Turks did not find it necessary to deface and destroy Greek churches and the surviving monuments of antiquity were only removed for military reasons, as on the Acropolis which was a military garrison until 1833. It was certainly bad of the Turks to use the Parthenon as a powder magazine, but equally reprehensible for the Venetians to shell it in 1687. The resulting explosion half-demolished the building while the victorious commander, Francesco Morosini, then did further damage in his inept attempts to remove the pediment sculpture. The record of the Turks in Greece is certainly no worse than our own, remembering, for instance, how in 1885 the l5th-century Mohammedan glories of Herat were destroyed on British orders because of a suspected Russian invasion.

Nor is the record of the Greeks since 1829—when the Treaty of Adrianople recognised their independence—particularly impressive. Not only have three and a half centuries of visible Turkish influence been expunged but archaeologists were allowed to pick the Acropolis clean, removing not only Turkish mosques and buildings but also mediaeval fortifications in an attempt to restore it to Classical purity. Today the Acropolis is no longer a rich and complex historical monument exhibiting over two thousand years of change, but a clinical, academic museum. Meanwhile, in the last few decades, Neo-Classical Athens—more a part of modern Greek history than Classical Athens—has been ruthlessly spoiled. Athens is now one of the most unpleasant cities in the world, polluted and ugly. Nineteenth-century elegant stucco has been ripped down and replaced by 20th-century crude brick and concrete.

Athens is not a suitable home for the Marbles, for the Marbles today do not only belong to Greece, they belong to Europe, if not to the world. The culture, architecture and sculpture of Ancient Greece have had such a profound influence on Europe and the West that, in truth, they mean more to a Scotsman, a German or an American than they do a Greek. They happen to be in London, a most accessible place for any visitor to see them, and a much more convenient city than Athens. We, the British, have been their guardians for almost two centuries, a duty which we have performed conscientiously. There is only one other city, other than Athens, where they would be equally at home: Edinburgh, 'Athens of the North', and today a much finer Greek city than its sad, spoiled, jealous, namesake at the end of the Balkans.

1986 Speech to the Oxford Union

MELINA MERCOURI

Melina Mercouri was a Greek actress and political activist. She was the star of nineteen films and received the best actress award at Cannes for her role in Never on Sunday. *She was an outspoken opponent of the military junta that controlled Greece from 1967 until 1974. In 1974 she was elected Member of Parliament and later served nine years as the Minister of Culture. She died in 1994.*

Mr President, Honourable members, Ladies and Gentlemen.

At once let me thank the Oxford Union for introducing this resolution for debate, and thanks for inviting me. I think that it is good, that this evening a Greek voice should be heard. Even a voice with my poor accent. I hear it and I wince. I am reminded of what Brendan Behan once said of a certain broadcaster: "He speaks as if he had the Elgin Marbles in his mouth."

There are other thanks I need to make; to the many British citizens who have defended my government's position, to the Honourable Members of both Houses who have manifested interest and sympathy for the return, to the participants in tonight's debate, and of course, for its efforts to bring the truth to the English people, my deepest gratitude to the British Committee for the Restitution of the Parthenon Marbles.

And the Parthenon Marbles they are. There are no such things as the Elgin Marbles.

There is a Michael Angelo *David*.

There is a Da Vinci *Venus*.

There is a Praxiteles *Hermes*.

There is a Turner *Fishermen at Sea*.

There are *no* Elgin *Marbles!*

You know, it is said that we Greeks are a fervent and warm blooded breed. Well, let me tell you something—it is true. And I am not known for being an

Reprinted by permission of the Melina Mercouri Foundation.

exception. Knowing what these sculptures mean to the Greek people, it is not easy to address their having been taken from Greece dispassionately, but I shall try. I promise.

I have been advised by one of your eminent professors that I must tell the history of how the Marbles were taken from Athens and brought to British shores. I protested that this was too well known but was told that even if there were a single person in this audience who might be vague about the facts, the story must be told. So, as briefly as I can, here goes.

We are at the end of the 19th Century. Napoleon is pondering the risk of invading England. He decides that it is not a very good idea. Instead he invades Egypt, wresting it from Turkish authority. The Turks don't appreciate this at all. They break off diplomatic relations with France. They also declare war. Britain decides that this is a dandy time to appoint an Ambassador to Turkey.

Enter Lord Elgin. It is he who gets the job. He has just married pretty Mary Nisbett and is finishing his fine country house. Its architect tells him of the wonders of Greek architecture and sculptures, and suggests it would be a marvellous idea to make plaster casts of the actual objects in Athens. "Marvellous, indeed," says Elgin. He sets about organising a group of people who could make architectural drawings, headed by a worthy painter, who turns out to be Giovanni Lusieri, an Italian painter.

I can't resist stealing a moment for an anecdote. Elgin had previously approached Turner. Yes, *the* Turner. The young painter was interested. Lord Elgin sets down the conditions: every drawing and sketch that Turner made was to become his Lordship's possession. In his spare time he would give Lady Elgin drawing lessons. "Okay," says Turner "but then I would want £400 a year." No, no says Elgin, too much, much too much. So, no Turner. End of anecdote.

The Chaplain of Elgin's staff was the Reverend Philip Hunt. I shall not speak of him with much reverence. If I had to exclude Lord Elgin, the arch villain in the story, as I see it, was the Reverend Hunt. Of that a little later on. The Elgins are received with pomp in Constantinople. Lavish gifts are exchanged. The winds of war are favourable to the British and the Sultan is delighted. Now we shift to Greece, this Greece occupied for almost 400 years now by the Ottoman empire.

Elgin's staff of artists arrive in Athens. To control Athens the Turks have assigned two governors, one civil, the other military. Much has been said and continues to be said of what little concern the Turks had for the Acropolis treasures. Yet, it took six months for the Elgin staff to be allowed access. But they worked it out; five pounds a visit into the palm of the military governor. This inaugurated a procedure of bribery and corruption of officials that was not to stop until the marbles were packed and shipped to England.

Yet, when scaffolding was erected and moulds were ready to be made, suddenly came rumours of French preparation for military action. The Turkish governor ordered the Elgin staff down from the Acropolis. Five pounds a visit

or not, access to the Acropolis was *verboten*. There was only one way to get back up there again; for Lord Elgin to use his influence with the Sultan in Constantinople, to obtain a document, called a *firman*, ordering the Athens authorities to permit the work to go on.

The Reverend Hunt goes to Constantinople to see Lord Elgin. He asks that the document state that the artists—please, note this, are in the service of the British Ambassador Extraordinary. Elgin goes to see the Sultan. Elgin gets the *firman*. The text of the *firman* is rather tortuously composed. Let me read the orders given by the Sultan which are pertinent to our discussion. I quote:

> That the artists meet no opposition in walking, viewing, contemplating the pictures and buildings they may wish to design or copy; or in fixing scaffolding around the ancient temple; or in modelling with chalk or gypsum the said ornaments and visible figures; or in excavating, when they find it necessary, in search of inscriptions *among the rubbish*. Nor hinder them from taking away any pieces of stone with inscriptions and figures.

(The Hunt translation later presented to the Select Committee reads—*qualche pezzi di pietra*—some pieces of stone).

These instructions are given to the governors—and the point is made in the *firman*—because of the excellent relations between the two countries, and I quote again: ". . . particularly as there is no harm in the said buildings being thus viewed, contemplated and drawn."

No sooner was the *firman* delivered to Athens, than a feverish, terrifying assault is made upon an edifice that, until today, many consider the purest, the most beautiful of human creation.

When the Caryatid porch of the Erectheum was attacked, the fever mounted so high that the Reverend Hunt suggested that the entire building could be removed if only a large British Man of War could be dispatched for it. Lord Elgin was thrilled by the idea and asked for a ship to be sent. The request was not considered outrageous but at that moment no ship was available. (Imagine if it had been).

To relate all the horrors needs a great deal of time and a great deal of restraint. The words "pillage," "dilapidation," "wanton devastation," "lamentable overthrow and ruin" are not mine of the moment. They were spoken by Elgin's contemporaries. Horace Smith referred to Elgin as "the marble stealer." Lord Byron called him a plunderer. Thomas Hardy later on was to write of the marbles as "captives in exile."

My government has asked for the return of the Parthenon Marbles. We have been refused. Be it on record that we shall never abandon the request. Let me list the arguments that are perpetuated against the return and deal with them one by one.

First, the marbles were obtained by proper transaction. I ask if bribery and corruption of officials can be contradictory to "proper transaction". When the

Select Committee appointed was studying the proposition of buying the marbles from his Lordship, Elgin submitted an itemized account of his expenditure for their obtainment. Citing, and I quote him "the obstacles, interruptions and discouragement created by the caprices and prejudices of the Turks," he lists an item of £21,902 for presents to the authorities in Athens. Well at least it's a proper sum. And, of course, it must be asked: is it proper to transact with the Turks for the most reassured of Greek possessions when Greece is under Turkish invasion and subjugation?

A second argument that is maintained despite its being angrily refuted by numerous British travellers in Greece at the time is that: ". . . the ignorant, superstitious Greeks were indifferent to their art and their monuments."

This, of course, implies that they were eyeless, conscienceless, and heartless. Who? These Greeks who, long after Pericles, created the miracles of Byzantine art? These Greeks who even under Turkish occupation created entire schools of arts and techniques? These Greeks who despite 400 years of Turkish rule grimly maintained their language and their religion? These Greeks who in their struggle for independence sent the Turkish soldiers bullets to be used against themselves. Yes, against *themselves.*

The Turkish soldiers besieged on the Acropolis ran short of ammunition. They began to attack the great columns to extract lead to make bullets. The Greeks sent them ammunition with the message: "Here are bullets, don't touch the columns."

After independence was gained, one of the first Acts passed by the Greek government was for the protection and preservation of national monuments. Indifference? We consider this accusation monstrous. You have surely heard, but let me repeat, what a heartsick Greek man said to members of the Elgin staff, and reported by J.C. Hobhouse. "You have taken our treasures. Please give them good care. One day we shall ask for their return." Are we to believe that this man was speaking only for himself?

Of late, a new theory has been proposed, this one is a beauty. Mr **Gavin Stamp**, I shall have the honour of meeting him tonight, proposes the notion that modern Greeks are not descendants of Pericles. Wow! Our marbles have been taken. Who will lay claim to the bones of our ancestors?

Minister of Culture, I hereby invite Mr Stamp to come to Athens. I will arrange prime time on television for him to tell Greek demographers and the Greek people who they are.

Argument number 3. If the marbles are returned, it will set a precedent that could lead to the emptying of museums. Forgive me but this is just plain blarney. Who is going to ask and who is going to permit the emptying of museums?

Let me state once more that we think museums everywhere are a vital social and cultural need and must be protected. I have repeated again and again that we are asking for the integral *part* of a structure that was mutilated. In the world over, the very name of our country is immediately associated with the Parthenon.

We are asking only for something unique, something matchless, something specific to our identity. And dear friends, if there were the shadow of a shadow of danger to museums, why would the International Council of Museums recommend the return, *as they have done.*

Argument number 4. This one, of more recent vintage. Pollution! Pollution over the Acropolis. How much sense does this make? When London was dealing with the severe problem of pollution, were there cries of alarm for the marbles? Of course not. For the simple reason that they were housed *inside* the British Museum. Now we don't make pretence that the sculptures can be reset in the frieze. We think it cannot be done, but my government has gone on record that the day that Athens sees the return of the marbles, there will be, ready to receive them, adjacent to the Acropolis for relevant context, a beautiful museum with the most developed systems of security and preservation.

May I add that we are proud of the ongoing work at the Acropolis. The exposition of this work was unveiled to a congress of the World's leading archaeologists who were invited to Athens. Their praise was unanimous, enthusiastic and gratifying. Since then it has been exhibited in major European cities. It was graciously received by the British Museum in London. *The Financial Times* wrote a report of the quality of this work and the exemplary skills of Greek restorers. I have asked that copies be made available here to those of you who might be interested.

The argument most perpetuated is that removing the marbles saved them from the barbarous Turks. To deny Turkish vandalism there would put me on weak ground. But the fact is that the Turks gave no permission to Elgin to remove sculptures from the works or the walls of the citadel, and with the blessing of the Reverend Hunt, barbarously they were removed. I quote from a letter from Lusieri to Elgin:

> I have, my Lord, the pleasure of announcing to you the possession of the eighth metope, that one where there is the centaur carrying off the woman. This piece has caused much trouble in all respects and I have been obliged to be a little *barbarous.*

In another letter he hoped, ". . . that the barbarisms that I have been obliged to commit in your service may be forgotten."

Edward Dodwell wrote:

> I had the inexpressible mortification of being present, when the Parthenon was despoiled of its finest sculptures. I saw several metopes at the south east extremity of the temple taken down. They were fixed in between the triglyphs as in a groove; and in order to lift them up, it was necessary to throw to the ground the magnificent cornice by which they were covered. The south east angle of the pediment shared the same fate; and instead of the picturesque beauty and high preservation in which I first saw it, it is now completely reduced to a state of shattered desolation. We cannot but execrate the spirit of barbarism which prompted them to

shatter and mutilate, to pillage and overturn the noble works which Pericles had ordered and the unrivalled genius of Pheidias and Iktinos had executed.

Another witness, Robert Smirke, writes:

> It particularly affected me when I saw the destruction made to get down the basso-relievos on the walls of the frieze. Each stone as it fell shook the ground with its ponderous weight, with a deep hollow noise; it seemed like a convulsive groan of the injured spirit of the temple.

Edward Daniel Clarke was among those witnessing the devastation. Clarke writes:

> Looking up, we saw with regret the gap that had been made, which all the ambassadors of the earth, with all the sovereigns they represent, aided by every resource that wealth and talent can bestow, will never again repair.

So much for barbarism.

In the year 1816 a Select Committee is appointed to study a proposal made by Lord Elgin. The marbles had been exhibited in various places and sheds. Lord Elgin has fallen on hard times and offers to sell the marbles to the government. The committee has to decide:

- By what authority the collection was acquired.
- Under what circumstances the authority was granted.
- The merit of the marbles as works of art.
- How much should be spent for an eventual purchase.

If you read the report you will see that the bulk of the testimony asked for, was how good were the marbles, and how much should be paid for them. But in order to recommend their purchase a tricky corner had to be turned; that the circumstances of the transaction were proper and that the marbles were obtained by Elgin, the private citizen and not by his influence as the British Ambassador.

I read to you from the Select Committee report:

> The Earl of Aberdeen in answer to an inquiry, whether the authority and influence of a public situation was, in his opinion, necessary for accomplishing the removal of these marbles, answered that he did not think a *private individual* could have accomplished the removal of the remains that Lord Elgin obtained.

(The Earl of Aberdeen, no mean treasure seeker himself, was in Greece at the time and in a position to know).

I read from the report:

> Doctor Hunt, who had better opportunities of information upon this point than any other person who had been examined, gave it as his *decided opinion* that a

British subject not in the situation of Ambassador could *not* have been able to obtain from the Turkish government a *firman* of such extensive powers.

I read from the report:

> The success of British arms in Egypt and the expected restitution of that province to the Porte wrought a wonderful and instantaneous change in the disposition of all ranks and descriptions of people toward our nation.

And yet, and yet, hear this from the Select Committee's conclusion:

> It cannot be doubted that Lord Elgin looked upon himself as acting in a character entirely distinct from his official position. But whether the government from whom he obtained permission did, or could, consider him so, is a question which can be solved only by conjecture and reasoning, in the absence and deficiency of all positive testimony.

(If this is not double speak, what is?)

Absence of positive testimony? Lord Elgin to the Committee: "I had to transact with the highest personages in the state."

Could the committee really believe that a simple citizen could get to transact with the highest personages of the Turkish state? Lord Elgin tells the Committee of his gratitude for having His Majesty's Ship to transport cases of the marbles. Could an ordinary citizen get a royal troopship at his service?

Question of the Committee to Reverend Hunt:

> Do you imagine that the firman gave a direct permission to remove figures and pieces of sculpture from the walls of the temples, or must that have been a matter of private arrangement with the local authorities?

Hunt's answer: "That was the interpretation which the governor of Athens was *induced* to allow it to bear."

Induced by whom? A private citizen? Absence of positive testimony? A private citizen or to an Ambassador? Well then, to the *firman* itself. Permission was granted to Lord Elgin ". . . due to the friendship between the Sublime and Ever Durable Ottoman Court and that of England."

Mr President, Honourable Members, Ladies and Gentlemen, with all apology, if needed, I submit to you that the Committee's ruling that Lord Elgin acted as a private individual is either the height of ingeniousness or of doubtful faith.

But that was one hundred and seventy years ago. This is a different England. There are different concepts of Empire and conquest. A different ethic prevails. It would be interesting to know what a committee today would conclude if they reviewed the evidence of those called before the committee—and the

judgements of those who were not called. I would make a small wager—even a large wager, that there would be a different outcome.

I have taken of your time and I know that the debate is the thing to catch consciences. I would hope that the debate evokes a few questions. I have a little list:

- Were the marbles seized wrongly? And if they were wrongly seized, can it be right that they be kept?
- If there was right in their being seized, is it wrong that they be returned?
- What value should be given to the argument that if Elgin hadn't taken the marbles, other Englishmen or the French would have done so?
- Does it matter that 95% of the Greek people might never see the finest of Greek creation?
- Is it conceivable that a free Greece would have permitted the removal of the marbles?

England and Greece are friends. English blood was shed on Greek soil in the war against fascism, and Greeks gave their lives to protect English pilots. Read Churchill, he tells you how crucial was the Greek role in your decisive desert victory over Rommel.

Last year there was a celebration of Shakespeare in the Amphitheatre at the foot of the Acropolis. Your Covent Garden brought the Verdi *Macbeth*. Your National Theatre came with Coriolanus. They were unforgettable nights. Not only for the high standard of performance but also for an extraordinary communion between British artists and the Greek audience. Ian McKellen will forgive me if I speak of his tears of emotion and those of his fellow artists as the audience stood cheering them. Those tears had to do with a rapport between two peoples, with friendship, with Shakespeare played on that sacred spot. It was beautiful, memorable. It is in the spirit of this friendship that we say to you, there was an injustice that can now be corrected.

You must understand what the Parthenon Marbles mean to us. They are our pride. They are our sacrifices. They are our noblest symbol of excellence. They are a tribute to the democratic philosophy. They are our aspirations and our *name*. They are the essence of Greekness.

We are ready to say that we rule the entire Elgin enterprise as irrelevant to the present. We say to the British government: you have kept those sculptures for almost two centuries. You have cared for them as well as you could, for which we thank you. But now in the name of fairness and morality, please give them back. I sincerely believe that such a gesture from Great Britain would ever honour your name.

Thank you.

CHAPTER 3

The Classical Tradition

We commonly use the terms "classic" art, "classical" music, the "classical" tradition, and the "classics." What do these terms mean?

Michael Greenhalgh writes that the classical tradition is characterized by the emulation of antiquity and the pursuit of a rational ideal. For centuries, at least until the authority of the "classics" began to be challenged in the nineteenth century, "classicism" was the predominant mode of Western art.

Perhaps, as Henri Zerner notes, the concept of "classicism" is more complex. Over time, our notions of what is, and what is not, "classical" have become more expansive—we can now speak of "classic" cars, "classic" comic strips, or "classic " rock and roll. Do these things have anything in common with what we have traditionally regarded as "classical?" At its root, Zerner concludes, the concept of the "classical" essentially means the assertion of power and authority.

"What is Classicism?"

MICHAEL GREENHALGH

Michael Greenhalgh has written numerous articles and books on the roles ancient Greek and Roman antiquities played in later European history. These include The Survival of Roman Antiquities in the Middle Ages *(London: Duckworth, 1978) and* The Classical Tradition in Western Art *(New York and London: Harper and Row, 1978). He is the Sir William Dobell Professor of Art History at the Australian National University in Canberra.*

. . . Classicism has certain basic features in art as in literature. Its concern is always with the ideal, in form as well as in content. Such is the case, it is true, with virtually all artists before Romanticism, but classical artists looked back to the ideal of Antiquity as well as to its varied styles. They were sure that art is governed by rules which are determined by reason. Beauty, which is one form of truth, must depend on some system of measurement and proportion, as Plato explained in the *Timaeus*; artists working from classical models made it their business to rediscover such a system in the works of art and buildings of Antiquity. Such an emphasis on measurement, allied to reason, is summarized in the Vitruvian figure of a man within a circle and a square, which expresses the concurrence between beauty, mathematics and Man. For the Renaissance artist, Man, within the circle of God, is the measure of all things, and he rules himself and his affairs by the application of reason. Antique art, centred on the depiction of a noble human mind in an ideal body, provides convincing models for imitation.

The depiction of the ideal entails certain formal as well as intellectual qualities. Clarity of subject-matter must be reinforced by clarity of style, for extraneous detail and secondary incident would detract from the precision and hence from the impact of the meaning. Simplicity is joined by understatement, 'expressing the most by saying the least', in portraying Man as he ought to be, 'raised above all that is local and accidental, purged of all that is abnormal and eccentric, so as to be in the highest sense representative', as Babbit writes in his *New Laokoon* of 1910. . . .

The imitation of the antique is therefore crucial to classical tradition. A good artist would aim to build upon work of acknowledged quality, and thereby to

Excerpted from Michael Greenhalgh, "What is Classicism?" *The Classical Tradition in Art* (London: Duckworth, 1978), 11–15. Reprinted by permission of the author.

rival Antiquity itself; such indeed, was the highest praise a Renaissance critic could bestow upon a modern production. Today we find it difficult to accept that art might progress by looking back for we automatically believe that most things fifty years old are out of date and irrelevant to us. Imitation seems to be a polite word for 'copying'. However, it is our perspective which is at fault. The richness of the classical tradition derives in part from the richness and variety of its antique sources, which are formed, not copied, by artists as original as their forebears. . . .

The stylistic implications of classicism's involvement with the art of Antiquity were extensive. Qualities of clarity, simplicity, harmony and understatement allied to imitation of the ancients produced a monumental grandeur more convincing than the other-worldly austerity of the Gothic or Byzantine manners. The example of the antique induced Renaissance artists with understanding of geometry to attempt in their art a reproduction of reality itself; in this they were encouraged by theorists like Alberti, who based himself upon Pliny. The view that art was 'the ape of nature' was to have a long life,[1] but the aims of classicism were rather to elevate reality to a higher plane, while making full use of those advances in perspective and the portrayal of emotion which helped to render works more convincing and effective.

Classicism has a bad reputation in a century which favours a more emotional and personal approach to art. Many would agree with Mark Twain that 'a classic is something that everybody wants to have read and nobody wants to read'. . . . The tradition began to decay with the political, social and artistic upheavals of the nineteenth century when Antiquity, the imitation of which had hitherto been considered the life-blood of culture, began to look like a heap of platitudes, preserved in artistic mortuaries (academies), and incapable of adaptation to modern world. Well before Courbet the ideal lost ground in favour of the real—of the world as it was and Man in it—and the rationality and optimism of classicism ceded to a neutrality or pessimism, and to a desire that art involve itself with the particular and with everyday activity. Thus disregarded classicism left the centre of the artistic stage.

In effect, the classical tradition survived as long as admiration for Greco-Roman civilization grew naturally out of the concepts of society. The horizons of the nineteenth century, both geographical and conceptual, were much wider than those of any previous age; artists were faced with a greater variety of different civilizations which all made claim upon their attention; Romanticism and then Realism assured the near destruction of the classical tradition founded upon what was by this time but one civilization out of many.

NOTE

[1] H. W. Janson, *Apes and Ape-lore in the Middle Ages and the Renaissance* (London: 1952), 287–325: "Ars simia naturae."

Classicism as Power

HENRI ZERNER

Henri Zerner is the curator of prints at the Fogg Art Museum and Professor of History of Art and Architecture at Harvard University. He has served as curator for numerous collections, and has published widely on French Renaissance art and modern art. He is the co-author (with Charles Rosen) of Romanticism and Realism: the Mythology of Ninteenth Century Art *(New York: Viking Press, 1984).*

There are many uses of the words "classical" and "classicism." Each of us may approve or disapprove of one or the other. What interests me here is as much their diversity—one might even say their incompatibility—as what they have in common.

Art historians understandably wish to be precise in their vocabulary. The term "classical" primarily refers to Greco-Roman antiquity, and it is extended to periods that draw their inspiration from this ancient classical world, especially the Italian Renaissance or the seventeenth century in France.

There has been an effort to refine the use of the term by narrowing its application. It used to be that all the art of antiquity from Myron to the late Roman Empire was considered classical. As late as the middle of the last century, Delacroix thought that the art of classical antiquity was a unity:

> The antique is always even, serene, complete in its details and of an ensemble which is virtually beyond reproach. One would think that its works were done by a single artist: the nuances of style differ in the various periods, but do not take away from a single antique work that peculiar value which all of them owe to that unity of doctrine, to that tradition of strength with reserve and simplicity which the moderns never attained in the arts of design nor perhaps in any of the other arts.[1]

Today we view the art of Greece and Rome as totally disparate. Historians tend to restrict the classical to the late fifth and early fourth century in Greece and to Roman art of the Augustan period. In Italy, it is only the High Renaissance that now qualifies, whereas many works of the fifteenth and sixteenth centuries are rejected as preclassical, Mannerist, or "classicizing" rather than properly classical. S. J. Freedberg has gone as far as anyone else towards

Excerpted from Henri Zerner, "Classicism as Power," *Art Journal*, 47 no.1 (1988), 35–36. Reprinted by permission of *Art Journal* and the author.

giving substance and precision to the concept of classicism in the case of the Italian Renaissance.[2] In the interest of precision he has narrowed the application to the point where there is little material that will fully qualify. Even among the works of Raphael—surely the prototypical classical artist—there are exclusions, like the *Borghese Entombment*, which appears proto-Mannerist, or even the *Transfiguration*, which is felt to go beyond the boundaries of the classical. . . .

The moment one attempts to generalize the notion of classicism outside a specific historical situation, it becomes even more unmanageable. Attempts at defining such a trans-historical classicism are generally unsuccessful and sometimes bizarre, not to say perverse. I once read a list of the features of classicism that included "archaism." Now many of us would think of archaism as antithetical to classicism by definition, the archaic being precisely that which precedes a mature or classical phase. The question here is not one of right or wrong—whether archaism is indeed a feature of classicism—but what it is that makes such an unexpected statement possible. I shall return to this question below.

In the meantime, however, let us turn to the language used to describe music, because it helps us to understand the situation. Historians of music use the term "classical" in a reasonably precise manner to refer to the art of the late eighteenth century and the beginning of the nineteenth even if they do not necessarily agree on the exact boundaries of the classical style. But most people mean something entirely different by classical music: they mean serious, high-class music if they like it or boring, pretentious music if they prefer rock. Whether it be Palestrina, Bach, Beethoven, or Stockhausen, classical music is what belongs to a specific tradition of music as "high art."

Although we do not use the same language in the visual arts, when we step outside the Greco-Roman lineage we tend to extend the term "classical" to the art that is at the top of a hierarchy, *any* hierarchy. And conversely, to call the art of ancient Greece and its aftermaths "classical" is to say that this is the best, the highest art of all—something that was in fact taken for granted over a long period. . . .

The classical is the ultimate attainment, the norm wherever a hierarchy is established or imposed. We may well scavenge through comic strips and decide which are the "great" ones. And when we say that Krazy Kat is a "classic," we may say it tongue-in-cheek and think we are being ironic, but in fact we might as well be in earnest. Indeed, Krazy Kat is a classic. Of course, there is a difference between having established classics and a concept of classicism. But once the classics are established, the step to classicism is not a very large one. It should not be too difficult to identify a classical phase of the comic strip, and at that point classicism is in place. We are, for instance, ready enough to talk about Mayan art or Assyrian reliefs as classical—which would have greatly puzzled a nineteenth-century critic. And with these examples in mind, we begin to see how archaism can be thought of as a possible feature of classicism.

One comes to feel that anything can be called classical. The concept of the classical implies the establishment of a norm, of a hierarchy; and what this takes is power. The connotation of class in the social sense in the word "classical" goes a long way back, and is as strong as the original one of the classroom—the classics being the great examples proposed to students. As a suprahistorical concept, then, there is no reason to believe that classicism has any meaning beyond this: the art of authority, authoritative art. The power that gives a chosen kind of art this authority can be at its inception, as in the art of Julius II or Louis XIV, but it can also come later, and appropriate a body of art that already exists. Impressionist painting, for instance, whatever its original status may have been, has become a kind of Park Avenue classicism. And where Brancusi is revered by the dominant culture, Cycladic sculpture appears as classical. The content, the forms involved, seems indefinitely extendable. So that if a hieratic and archaic type of art is dominant, there is no reason why it should not be considered classical in the wider sense of the word.

The fact remains that the art of Greece in the fifth century B.C. has been able, in its various aftermaths, to hold authority over long stretches of our culture. If the classical is simply the art that has authority and power, it is striking to what extent a particular type of art has been able to assume this role [Figure 3]. In modern times, in America especially, banks and government buildings have displayed the columns, capitals, and pediments of the Greco-Roman tradition with extraordinary assertiveness.

Why it is so remains an interesting question. Of course, one reason may be simply the lasting power of authority, and the association of this art with a glorious moment of Greek history. But this is not enough as an explanation because there have been times when the authority of Greek classicism disappeared. We need to understand how it could reassert itself. I believe it has to do with the development of a particular kind of naturalism in fifth-century Greece and that this kind of naturalism is able to make one believe that the authority of this art is grounded in nature. Then it should no longer surprise us that such an art would be resurrected under different circumstances. What should be better for a power in place than to make us believe that it is not simply there by an act of force, but that its authority is inscribed in nature herself? This rhetoric of nature is obviously present in the sculpture and painting of the Greco-Roman tradition, and it was always understood in its architecture as well. It is worth pointing out that in our century the one kind of architecture that was, at least temporarily, able to displace the Greco-Roman model—the modernist architecture sometimes called the International Style—makes a comparable claim to being grounded in nature, not as the representation of nature but as the direct result of the nature of the materials and the function of the building. Similarly, insofar as the painting of Mondrian made claims to a new kind of classicism, it was on

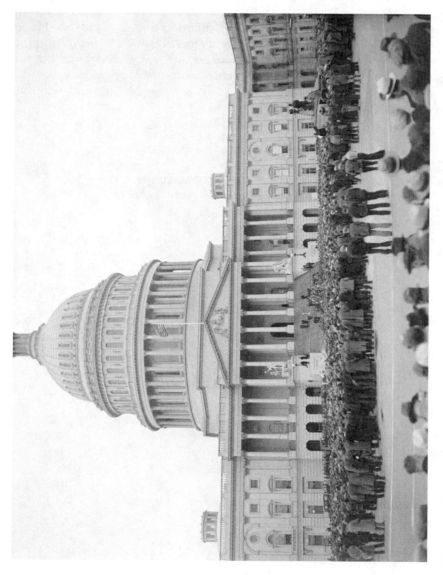

Figure 3. Hunger Marchers in front of the U.S. Capitol Building, 1932. Photo: © Bettmann/CORBIS.

the ground that it represented the underlying principles of nature, if not its appearance.

I would say this: as a descriptive term for specific historical phenomena, classicism has become narrower and narrower, while as a theoretical tool it has indefinitely expanded. It would be my contention that, as a universal category rather than a specific historical occurrence, classicism means nothing more than an assertion of authority, of power under whatever form. But the urge to naturalize power has favored certain forms of art, principally the kind of naturalism first developed in ancient Greece, and has time and again restored it to a position of authority.

NOTES:

[1] *The Journal of Eugène Delacroix*, trans. Walter Pach (New York), 1961, p. 619.

[2] S. J. Freedberg, *High Renaissance Painting in Rome and Florence* (Cambridge, Mass.), 1961, passim.

CHAPTER 4

Portraits and Politics

Portraits are unexpectedly complex images. Most viewers assume that the sole purpose of a portrait is to capture the likeness of the sitter, but portraits do much more than this. They not only record what people look like, but they also present us with information about who the people are and how they want to be seen by others.

One of the most interesting series of portraits in Western art was produced in Rome during the time of the Civil Wars in the first century B.C.E. Initially, modern viewers are struck by the remarkable realism of these works. However, in his article, "How to Read a Roman Portrait," Sheldon Nodelman suggests that beneath the realistic mask of each Roman portrait lies a carefully conceived political agenda.

These message-conveying portraits can be compared with modern political advertising. As Ann Marie Seward Barry points out, carefully constructed images in politics often create their own larger-than-life reality [Figure 6].

How to Read a Roman Portrait

SHELDON NODELMAN

Sheldon Nodelman writes about Roman Imperial portraiture and about modern art. His most recent book is The Rothko Chapel Paintings *(Austin: University of Texas Press, 1997). Nodelman is Professor of Visual Studies at the University of California, San Diego.*

Beginning in the first century B.C., Roman artists invented a new kind of portraiture, as unlike that of the great tradition of Greek Hellenistic art (whence the Romans had ultimately derived the idea of portraiture itself and a highly developed vocabulary of formal devices for its realization) as it was unlike that of their own previous Italo-Hellenistic local tradition. This new conception, conferring upon the portrait an unprecedented capacity to articulate and project the interior processes of human experience, made possible the achievement in the ensuing six centuries of what is surely the most extraordinary body of portrait art ever created, and forms the indispensable basis for the whole of the later European portrait tradition, from its rebirth in the 13th and 14th centuries to its virtual extinction in the 20th. No clear account of the nature of this reformulation of the structure of representation or of its historical significance has so far been given.

That the portraiture which it engendered is strikingly "realistic" in the sense of evoking the presence of an astonishingly concrete and specific individuality, to a degree previously unknown and rarely equalled since, has been the universal experience of every observer. But this question-begging term (first used to characterize Roman portraiture, in opposition to the "idealism" imputed to the Greeks, three quarters of a century ago by Franz Wickhoff, at the inception of modern critical studies of Roman art and not yet effectively superseded in modern scholarship) tells us nothing of the specific nature of the innovations responsible for this effect. Indeed, aside from the inadequacy in principle of such a term as applied to works of art, it seems particularly inappropriate to a form of portraiture such as the Roman, in which, as can easily be shown, abstract and conventional elements play so large a part.

In some important respects Roman portraiture, like Roman art in general, can fairly be described as a system of signs. Both the idea of deliberate address

Excerpted from Sheldon Nodelman, "How to Read a Roman Portrait," originally published in *Art in America*, Brant Publications, Inc. January/February 1975, 26–33. Reprinted by permission.

to the spectator with the aim of arresting his attention, and the intent to convey a message, a meaning, are contained in the Latin word *signum,* one of the commonest terms used to designate an iconic statue. The will to reach out actively into the world of on-going life and to accomplish specific purposes within it through psychological modifications imposed upon the observer is the central organizational principle of Roman art, notable, for example, in the condensed and forceful propagandistic language of the imperial reliefs and in the elaborate manipulation of the spectator's movements through spatial pressures in architecture.

Since the dominant function of the monumental portrait in Roman antiquity was the public commemoration of civic distinction, it is natural to search the realm of contemporaneous political and social ideas for themes which may enter into the context of particular portrait modes. These are regularly to be found. In this regard it is instructive to consider the so-called "veristic" portraiture of the first century B.C., in which, in fact, the new portrait conception makes its premier appearance, and which is usually considered both quintessentially Roman as a social expression and as the example *par excellence* of Roman "realism" [Figure 4]. This class consists exclusively of portraits of men in later life, often balding and toothless, upon whose faces the creases, wrinkles and blemishes inflicted by life upon aging flesh are prominently and harshly displayed with a kind of clinical exactitude which has aptly been called "cartographic." The insistent presentation of unflattering physiognomic irregularities, apparently, from their diversity, highly individualized, extends also to the representation of emotional states: the expressions of these faces are without exception grim, haggard and ungenerous, twisted by fixed muscular contractions. The emphasis accorded these contingencies of physiognomy and the resolute refusal of any concession to our—or, so it would appear, antiquity's—ideas of desirable physical appearance lead one easily to the conclusion that these portraits are uncompromising attempts to transcribe into plastic form the reality of what is seen, innocent of any "idealization" or programmatic bias. These are the portraits of the conservative nobility (and of their middle-class emulators) during the death-agonies of the Roman republic. There is no need to doubt that much of their character refers to quite real qualities of their subjects. These are men in later life because the carefully prescribed ladder of public office normally allowed those who followed it to attain only gradually and after many years to such eminence as would allow the signal honor of a public statue. One may well suppose that these hard-bitten and rather unimaginative faces closely reflect the prevailing temperament of the class and society to which they belong and the twisted and pained expressions surely testify in similar fashion to the terrible emotional strains of a society torn apart in the chaos of civil war.

Nevertheless, a moment's reflection upon veristic portraits as a class reveals such an insistent pattern of recurrence in the selection and handling of particular physical and characterological traits that all these apparently so

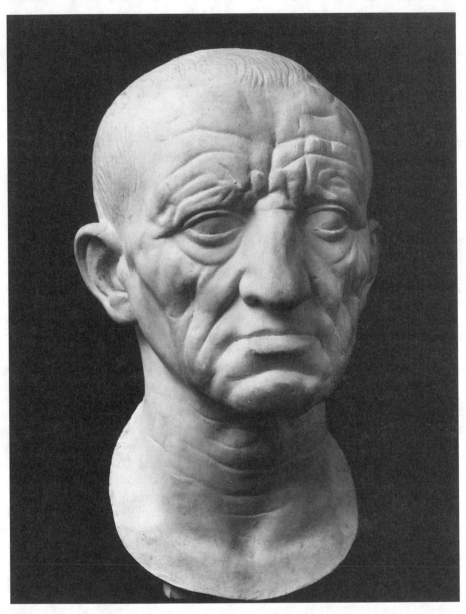

Figure 4. *Republican Portrait,* 1st century B.C.E. Rome Italy. Photo: Alinari/Art Resource, NY.

individualized portraits finally look very much alike, and it becomes clear that we are dealing with a conventional type, whose properties are dictated by ideological motives and—given the political function of the portrait statue—by the intent to convey a clearly drawn and forceful polemical content.

The nature of this content becomes clear as soon as the context of meanings available in the wider range of contemporary portraiture is examined. Through emphasis on the marks of age, these men call attention to their long service to the state and their faithfulness to constitutional procedures, in intended contrast to the meteoric careers and dubious methods of the individualistic faction-leaders—men like Marius and Sulla, Pompey and Caesar, later Antony and Octavian—whose ambitions and rivalries in the quest for personal power were rending the fabric of the republic. The portraits of these *duces,* when we can identify them, betray rather different tendencies than do those of the veristic group, drawing heavily upon Hellenistic elements for the dramatization of their personalities and the suggestion of a godlike superiority to circumstance. The seeming frankness and air of indifference with which the subjects of the veristic portraiture acknowledge—or, rather, proclaim—their physical ugliness is surely a defiant and formalized response to the propagandistic glamorization of physiognomy and character in the portraits of the quarrelling war-lords whose aspiration toward personalized, tyrannical power and brutal disregard of traditional constraints were scandalous affronts to inherited values. Against the portraits of the *duces,* the verist portrait asserts a self-conscious pride in down-to-earth pragmatism, an absence of illusions, a contempt for vanity and pretense. The grim restraint which twists these features and the harsh suppression of feeling stand in programmatic contrast to the emotional pathos, the exaltation of spontaneity which had illuminated Hellenistic royal portraiture and which the *duces* had in modified form incorporated into their own images. It is not individuality, imagination and daring which are celebrated here but stern self-discipline, shrewd calculation, unbending resolution, unquestioning acceptance of social bonds, painstaking conformity to those ancestrally sanctioned rules of conduct which the Romans called the *mos maiorum.*

The binding durability of this catalogue of old-Roman virtues of *gravitas, dignitas, fides,* which were the pride of the conservative aristocracy, may be read already, though without the defiant exaggeration of last-ditch resistance of a century later, in the stern features of one of the few surviving portraits of a Roman nobleman of an earlier age, the famed bronze of the second century B.C. known as the *Capitoline Brutus.* In the light of a work such as this, the "realism" of the veristic portrait is revealed for what it is: a set of conventions dictated by ideological motives—a highly selective assemblage of abstractions from suitable aspects of human appearance and character into an interpretative ideogram.

In the veristic portraiture of the first century B.C. the new image-structure which will determine the operations of the Roman portrait as a mode of

communication and which will be immensely enriched and developed over several centuries, is clearly evident. Such an image is not an indissoluble nexus of mutually referential properties conceived on the model of a natural organism and presenting itself as a self-contained and self-justifying totality, as had been the images of the Greeks. Rather it is a system of formalized conventional references whose specific content and polemical point are defined positively by the evocation of desired associations, and negatively by implied contrast with other image bearing an opposed content. Since the Roman viewer had necessarily, if perhaps only half-consciously, to recognize these references as such, their mutual independence as preconceived units of meaning had to be at least subliminally discernible within the overall context of the image, whose show of organic coherence after the Greek model could only be a superficial one and which effectively resembled more closely a collage, or better (in Eisenstein's sense) a montage.

Condensed into the image of a human face, these components are so fused as to be isolatable by the modern spectator only with a certain analytical effort. But an identical system of construction out of pre-existent and independently meaningful parts can be more easily seen in complete figures, such as the well-known statue of Augustus from Prima Porta [Figure 5]. A body-type derived from the Doryphoros of Polykleitos and exploiting rhetorically the noble equilibration of its pose is juxtaposed to a right arm quite independently conceived, whose gesture of address, possessed of a well-established meaning in Roman society, is lent a compelling emphasis through its abrupt breakage of the overall rhythm of the stance. The military costume, specifying the role of Augustus as *imperator* or commander and implicitly invoking the charisma of his martial successes as justification of his authority, is itself formalized into a separable unit of meaning rather than conceived as a simple fact, being, as it is, qualified or relativized by the noticeable omission of the boots which would normally complete it. The bare feet, forced to our attention by what would in a real-life context be their incongruity, are here a clear reference to the ideal nudity of heroic statues, and they inform us that the event represented takes place on a higher-than-mundane plane. The motives for this quasi-divinization are explained to us: first, in the reliefs which ornament the breastplate, illustrating against a cosmic panorama what Augustus sought to advertise as the crowning political success of his career, the return of the standards from Parthia (emblematically representing both a restoration of the natural order of things after the chaos of the civil wars and the elevation of Rome to a position of universal sovereignty); and second, by the little figure of a dolphin-riding Cupid, serving as a support beside the right leg, which reminds the viewer of Augustus' divine descent from Venus through Aeneas and hence of his inborn claim to rule over Aeneas' posterity, the Roman people.

At the magnified scale of this statue, both the conceptual independence of the components and their encoding through calculated juxtapositions and superimpositions into a single system of meaning are obvious enough. Such

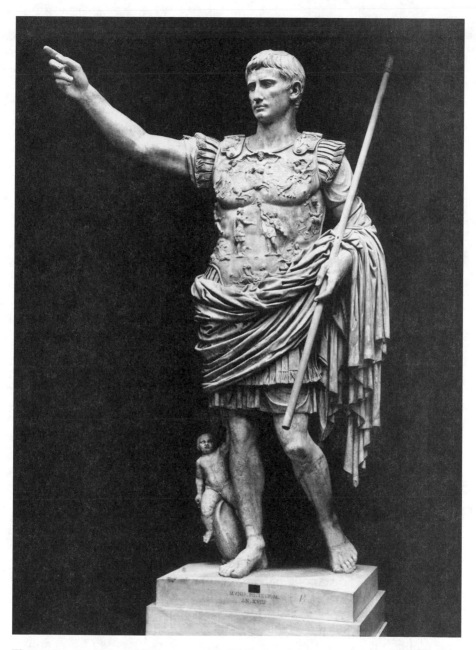

Figure 5. *Augustus of Primaporta,* 15 CE Vatican Museums, Rome. Photo: Alinari/Art Resource, NY.

an image manifestly exists not for itself, but for the spectator whose active intellectual cooperation is demanded and in whose synthetic mental act the image attains its unity and significance. Its status among other images, like that of its components among one another, is not so much inherent as positional—in a wider range of reference like individual words within a semantic field.

In Augustus' portrait head itself—as we see it in the Prima Porta statue—the iconographic system already posited in veristic portraiture reaches an astonishing richness and complexity of meaning. The godlike youthfulness of the face (as Caesar's heir, Augustus had seized a position at the center of Rome's political life, in defiance of the usual norms, at the age of 18, but his portraits retain youthful features through the rest of his long life) stands in deliberate and striking contrast to the tired and wizened faces of the old-school politicians whom the veristic style represents for us. Those exhausted faces, whose muscular spasms reflect the tangle of encumbering circumstances in which they were enmeshed, convey only hopelessness; by contrast, the new image of Augustus offers the freshness and boundless possibilities of youth, the freedom to make the world anew. Against their gazes blank with despair or sunken in bitter defiance, that of Augustus is brilliant and piercing, full of intellectual power; far-seeing, his face comprehends and dominates the *orbis terrarum* and the vast horizons of time and history. His electrical gaze, through which the force of the personality is poured out, is a device borrowed from Hellenistic royal portraiture where it had denoted the heroized, superhuman stature of the kings. But Augustus was too astute to attempt (as his unsuccessful predecessors, the would-be dynasts of the late republic, had to some degree done) to impose the formulae of Hellenistic portraiture with its emotional pathos, its exaltation of individual personality and will, upon a Roman public which reacted to such associations with deep resentment and distrust. Instead, the dominating gaze is incorporated into a facial mimetics which reflects—in the same traditional way as that of the *Capitoline Brutus*—the old-Roman virtues of rigorous self control and implicit acceptance of the binding force of social order. (When Greek sculptors in the East had occasion to copy Augustus' portrait, they rarely failed to restore to it, in conformity with their concept of royal representation, the dramatic emotionalism which he had so carefully purged.) Integrating all is the neo-classic style of the head, with its broad, clear planes and severely contrasted verticals and horizontals, whose harmony, balance and Apollonian intellectual order proclaim the animating principles of the new universal order which Augustus has miraculously brought to a tormented world. Here style, too, is reified into a separable meaning-unit (for it is not of course the style of the Classical age in its integral reality but a calculated reminiscence of it superimposed upon an underlying and profoundly different contemporary formal structure) which is invoked not only for its inherent expressive content but also for its associative value as emblematic of what was now revered as a past golden age—that

of the Athens of Pericles—whose luster might appropriately be borrowed to clothe the new.

The extraordinary synthesis of meanings accomplished in the portrait of Augustus, precisely calculated with reference to the play of contemporary hopes, passions and exigencies, made this work a political icon of matchless cogency and density of content. . . .

Political Images: Public Relations, Advertising, and Propaganda

ANN MARIE SEWARD BARRY

Ann Marie Seward Barry is Associate Professor of Communication at Boston College where she teaches courses in advertising, visual theory, and video. She is the author of Advertising Portfolio *(Lincolnwood, IL: NTC Business Books, 1990).*

The nation that expects to be ignorant and free expects what never can and never will be.

—Thomas Jefferson

Perhaps no single group has been more involved with image at all of its levels of signification than politicians—from the public conception of who the person is and what he or she "stands for," to the carefully constructed images disseminated to the media as "news," to the archetypal and nationalistic imagery used in political ads. Political imagery, in fact, cuts horizontally across the vertical currents of public relations, advertising, and propaganda. Nowhere

Excerpted from Ann Marie Seward Barry, "Political Images: Public Relations, Advertising, and Propaganda," *Visual Intelligence* (Albany, NY: State University of New York Press, 1997), 281–300. Reprinted by permission of the State University of New York Press.

is this more apparent than in the political images surrounding presidential campaigns, propaganda, and war. . . .

Political Advertising and Public Image

One of the more disturbing political uses of television apart from war coverage, but just as crucial to the workings of democracy, is the manipulation of political public image by advertising experts—people who know how to package and sell their product and how to use media effectively.

In 1952, the Republican Party made United States political history by becoming the first to use television spot ads to promote presidential ambitions—at a time when there were only about 19 million television sets in the country. In so-called "The Man from Abilene" spots, Dwight Eisenhower, from a podium in a studio, in low-angle shot, responded benevolently to questions posed by "ordinary citizens" below and to the left, who looked up at him admiringly. The spots were exceptional because prior to this, candidates had simply purchased half-hour segments of air time to explore issues and state positions; this time the political spots were done as commercials by a professional advertising agency—Batten, Barton, Durstine & Osborn (BBDO)—carefully shot in separate frames and edited together to achieve the desired effect. But what may be most notable is the fact that political audiences did not expect nor suspect the technical manipulation involved: Eisenhower was never in the company of the questioners, his television delivery technique was carefully choreographed, and the dramatic lighting and camera angles were professionally manipulated to give Eisenhower stature and credibility. His glasses were removed; his clothes were changed.

In short, techniques that had formerly been reserved for commercial sales had moved unsuspected into the political arena, and the result was a landslide victory. Rosser Reeves, one of the most influential advertising men ever in the business and the one who wrote the spots, commented later of Eisenhower, "The man is very good. He handled himself like a veteran actor."[1] Reeves believed in the power of the television image. He had previously tried to convince Thomas E. Dewey to use television advertising against Truman when there were fewer than half a million sets in the country. Dewey refused, thinking it would be undignified. If undignified, it was, however, effective. The Republican National Committee was so pleased by the results that it kept BBDO on retainer to dispense media advice as needed. BBDO subsequently continued to supervise visuals—including cue cards, charts, graphs—and rehearsed four cabinet officers for a television panel in the spring following the election.[2]

Although the "Man from Abilene" spots were a "first" for television, professional advertising men had been in fact actively involved in politics from

the turn of the century. In 1916, for example, a four page insert was placed in the *Saturday Evening Post* and other magazines by Erickson, the GOP's advertising agency, urging Theodore Roosevelt to run for president; by 1917, Congress was for the first time considering the regulation of political ads. In 1918, Albert Lasker, then a partner in the powerful Lord & Thomas ad agency, supervised publicity and speechwriting for Warren G. Harding and even acted as a "bag-man" in paying off one of Harding's mistresses before the election.[3] By 1940, so many admen were involved in political campaigning that Dorothy Thompson lamented that the advertising "hard sell" had become a staple: "The idea is to create the fear, and then offer a branded antidote."[4]

Twelve years after the "Man from Abilene" spots, this "hard sell" technique of getting a vote in less than a minute was perfected to the point where a political commercial caused so much controversy that, while it ran only once on September 7, 1964 during "Monday Night at the Movies,"—like the Orwellian 1984 Apple commercial on the 1984 Super Bowl—it was repeated over and over again in the context of "news." The ad generated by the Doyle Dane Bernbach (DDB) advertising agency for Lyndon Johnson was the now infamous "Daisy" commercial, which shows a little girl counting and plucking the petals from a daisy, and then looking up as an ominous voice-over counts down to a nuclear explosion. Johnson's own voice tells us that "we must love one another or die," and a voice-over announcer tells us that we should vote for Johnson because the "stakes are too high for you to stay home."

As Jeff Greenfield comments in *The Real Campaign*, "What the ad's creator, Tony Schwartz, had done was to demonstrate a power of television never applied to political commercials until then: the power to make implied arguments through the use of voice and image, without the need to argue those positions."[5] While Johnson's opponent, Goldwater, was never mentioned by name, nor any argument on the probability of Goldwater's policies resulting in nuclear war was presented, the message was devastatingly clear and effective, uniting three powerful images: child, daisy, and dreaded nuclear bomb mushroom cloud. Although the Democrats spent little more than half the Republican advertising budget of $16 million on their commercials, DDB's manufactured daisy/bomb image dominated the campaign combining "Kuleshov effect" and the advertising hard-sell at its best—and completely overpowered the earlier "In your heart you know he's right" ads for Goldwater done by the Leo Burnett Advertising agency.

Although political and advertising slogans had always resembled one another verbally, the "Daisy" commercial announced full force that it would now be *visual* rhetoric that would carry the day politically, and subsequent campaigns relied heavily on the same kinds of hard-sell images based on fear. Two of the most effective were the "red telephone" ad for Mondale run

in 1984 and the "Willie Horton" ads used by Bush against Dukakis in 1988. When focus groups held during the 1984 primary campaign revealed that in a recession they would prefer Gary Hart as President, but in an international crisis, they would prefer Mondale, the red phone as symbol of potential nuclear war with the U.S.S.R. was born, and the Hart campaign never recovered. The "Willie Horton" ads used by Bush against Dukakis tapped primal fears and drove home the image of a liberal whose prison furlough program was putting criminals back out on the street to prey on the public. Utilizing the image of a revolving door, the ad featured men walking into prison and directly out again. Both the ominous red telephone and the revolving door became symbols that touched the core of voters' political and social fears.

Reagan's 1984 campaign, which ultimately defeated Mondale, was also one of the most visual and successful political campaigns ever waged, utilizing almost $25 million, more than half the entire campaign budget, on high-production value political advertisements.[6] It was the most visual presidential campaign yet waged, one that succeeded in substituting national and archetypal symbols for a discussion of issues and images for information. The epitome of this approach is seen in the Republican National Convention's substitution of a political campaign film for the usual nominating speech, which—as part advertisement and part documentary—"marked the coming of age of the televisual campaign film."[7] The move to substitute the visual for the usual verbal rhetoric was daring and unprecedented, yet it clearly showed the faith which the Reagan campaign, under the guidance of the BBDO ad agency's "Tuesday Team" had in the power of images as visual rhetoric [Figure 6].

Written by Phil Dusenberry, BBDO's executive creative director and originator of the "Pepsi Generation" commercials, the film sequenced levels of images ranging from slice-of-life moments and documentary footage of political events to emotionally loaded cultural symbolism. In the film, interviews with the elderly are joined to clips from the attempted assassination of Reagan, footage of the Normandy invasion, images of the Statue of Liberty under repair, and American flags being waved, raised, saluted, and admired. Archetypal images reminiscent of those used in "Marlboro" ads also appear, with Ronald Reagan as the Marlboro Man riding his horse on his California ranch. The images move in visual cycles, beginning with idealized images of earth, developing into slice-of-life images of people at work, and closing in political images of Reagan mixing with the people, in the hospital or at the White House. The film's closing is a montage of images of the land, its people, its patriotic symbols, and finally Reagan himself with arms over his head in a victory sign.

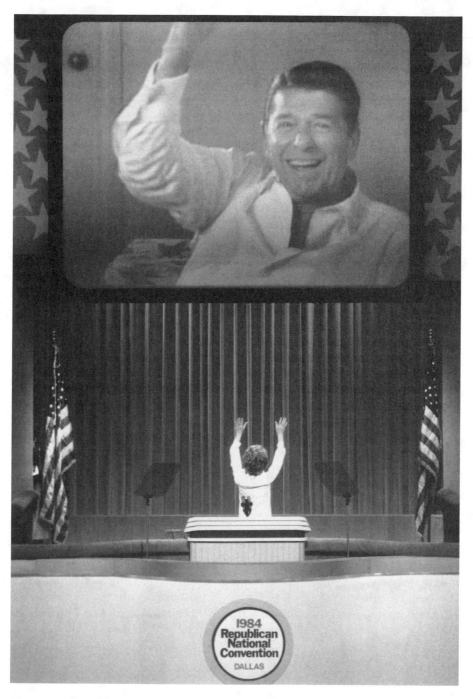

Figure 6. Republican National Convention, Dallas, TX, 1984. Photo: © Bettmann/ CORBIS.

Conclusion

Arguing that there is in fact an "old" print politics and a "new" politics that invests political messages with the personality and characteristics of electronic media, researchers Robinson and Sheehan in 1983 concluded that the electorate has come to see politics the way the networks present it, not the way it once appeared in traditional print. In their view "the media agenda becomes the public agenda; the tenor of the media influences the tenor of the times; exposure to television fosters a political response in keeping with its own style and substance."[8] Television thus changed political coverage not only by influencing the presentation of the message to accommodate the medium and then altering its content accordingly, but also by establishing its own issues, which in turn have been exploited by politicians, demagogues, and the military who understand both the medium and how to tap into its vulnerabilities.

Within the media-created political environment, political figures alter delivery styles to become more like credible anchor persons; action news-type "media events" dominate political coverage; media personalities become more like politicians with their own career agenda, just as politicians become more like media personalities, issuing VNRs that can be easily translated into news stories. These skills arising from visual awareness are generally unmatched by the viewing public, who still tend to treat what they see as truth, rather than as deliberate constructions driven by political or economic motivations. Even research analysis of news and political coverage still tend to ignore the significance of visuals, with the effect that often the visual substance of the message and its effects go unexamined. As Bruce Gronbeck noted even in 1978, "Historically, verbal acts have occupied most of the attention of communication analysts . . . [because] 'rhetoric' and 'communication' traditionally have been defined in terms of 'words' and . . . 'political communication' has been dominated by researchers nurtured in speech communication departments in universities."[9]

Images from the Gulf War, however, reveal how manipulated images can exploit apparently objective news and documentary forms to produce a semblance of truth through "images of actuality" that "appear to be spontaneous and to reveal what really happens." Images from advertising and propaganda show how cultural and archetypal images and symbols can be used to tap the personal psyche, and while there gain strength and grow. The Third Reich showed how attitudes and behavior can be controlled at every level of personal, social, and political existence through the manufacture of visual images that bypass linear logic and convince by association.

Ultimately, all images are both political and personal, because their ramifications extend into both conscious and unconscious realms and affect every area of our existence: the nation that expects to be *visually* ignorant and free expects what never can and never will be.

NOTES

[1] Stephen Fox, *The Mirror Makers* (New York: Vintage Books, 1985), 310.

[2] Ibid., 310.

[3] Ibid., 308.

[4] Ibid.

[5] Jeff Greenfield, *The Real Campaign* (New York: Summit, 1982), 17.

[6] Richard Morgan and Dave Vadehra, "Reagan Leads Mondale in Ad Awareness Race," *Adweek*, 3 September 1984, 19. See also Joanne Morreale, *A New Beginning* (Albany: State University of New York Press, 1991), 4. Morreale's book analyzes Reagan's political film in detail and explores its symbolic forms and rhetorical devices as evidence of the need to "re-frame contemporary political discourse."

[7] Morreale, 3.

[8] M. J. Robinson and M. A. Sheehan, *Over the Wire and On TV: CBS and UPI in Campaign '80* (New York: Russell Sage Foundation, 1983), 262, 265.

[9] Bruce Gronbeck, "The Function of Presidential Campaigning," *Communication Monographs* 44 (November 1978): 276.

CHAPTER 5

The Gothic Cathedral

In the following two excerpts, James Snyder and Michael Camille refer to the iconographic studies of the French scholar Emile Mâle, which were originally written more than a century ago. For Mâle, the thousands of sculpted figures that were carved on the Gothic cathedrals were to be understood as an encyclopedic sermon in stone, a scholastic explication of the entire range of Christian faith.

Looking more closely at a Gothic cathedral, however, the viewer soon finds many images that are hard to reconcile with Mâle's chaste view of medieval art. On the roofs, in the corbels, and under the choir seats—on the margins of the Cathedral—is a vast menagerie of gargoyles, babewyns, fools, beggars, prostitutes, beasts, and bottom-sniffers. As Michael Camille points out, these characters from the margins of medieval society comprise a sculptural world that is as untidy, crude, complex, and energetic as medieval society itself.

The Meaning of Gothic

JAMES SNYDER

James Snyder was Fairbank Professor in the Humanities at Bryn Mawr College. He was the author of numerous books and scholarly articles on late medieval and northern Renaissance art, including Northern Renaissance Art *(New York and Englewood Cliffs, NJ: Harrry N. Abrams, Inc., and Prentice-Hall, Inc., 1989). Snyder died in 1990.*

. . . The highest achievements in Gothic architecture are realized in the mid-thirteenth century in and around Paris in northern France. It is precisely at this same time and place that the most profound statements of religious philosophy in the Latin West were formulated. The philosophy is known as Scholasticism, a school of reasoning based on highly intellectualized systems of logics and metaphysics—in part grounded in Aristotle—and the crowning achievement is the *Summa Theologica* written by Thomas Aquinas in Paris (a vast compendium of knowledge that forms the basis for most Catholic theology today). It is no wonder, then, that historians have sought out parallels between Scholasticism and the Gothic cathedral. To be sure, such relationships are misleading when carried to extremes, as often has been done, but certain analogies can be made that are instructive for our understanding of Gothic in general. . . .

Emile Mâle, in his brilliant study of Gothic iconography (first published in 1898!), found in the *Speculum majus* of Vincent of Beauvais (c. 1190–1264), priest and encyclopedist living in the monastery at Beauvais, the most complete statement for the interpretation of Gothic church programs in sculpture.[1] While Mâle was, no doubt, too zealous in claiming the authority of this work, the model is nevertheless instructive to review here. Containing some eighty books and nearly a thousand chapters, the *Speculum majus* ("Major Mirror"— the mirror being a familiar metaphor for knowledge in general) has four parts: (1) the *Speculum naturale*, or "Mirror of Nature," in which Vincent discusses creation in nature, beginning with the acts in Genesis and covering such esoteric subjects as the qualities of magnets used in navagation; (2) *Speculum doctrinale*, or "Mirror of Doctrine," that explains the roles of "works" and "knowledge" in the drama of man's redemption; (3) *Speculum historiale*, the "Mirror of History," wherein Vincent exhaustively recorded the pilgrimage

Excerpted from James Snyder, *Medieval Art* (New York and Englewood Cliffs, NJ: Harry N. Abrams, Inc., and Prentice-Hall, Inc., 1989), 344–349. Reprinted by permission.

of man from the Old Testament down to the lives of saints and contemporary events, a kind of grandiose *historia ecclesiae*; and (4) *Speculum morale*, or "Mirror of Morals," that is addressed to proper conduct, for example, the Virtues and Vices and the "active" and "contemplative" life. This last book is of dubious authorship and appears to have been a late addition to the original *Speculum majus*.

Of the four mirrors, that of history was by far the most important for the sculpture programs, and it is the history of the church—much as Saint Augustine recorded it in the *City of God*—that dominates the major areas of decoration. According to Mâle, a definite scheme applies. The foremost history, that of the life of Christ, is presented on the major portals of the western facade of a Gothic cathedral. The role of Mary in that history is usually relegated to the north transept portals, while the stories of the lesser (often local) saints in the Christian hierarchy are assigned positions on the southern doorways. A definite hierarchy of subject matter from the *Speculum historiale* thus moved about the cathedral.

The other mirrors—Nature, Doctrine, Morals—were appended like "footnotes," as it were, about the major representations in areas such as archivolts, socles, and doorposts. On the facade of the Cathedral of Amiens, for instance, the socles of the saints and angels on the jambs of the left doorway present us with images in relief of the zodiac over those of the calendar (labors of the months), illustrating the *Speculum doctrinale*. Under the apostles in the central portal, similar reliefs in quatrefoils represent the Virtues and Vices of the *Speculum morale*.

The model that Mâle proposed for the sculptures of French Gothic cathedrals is especially attractive and, in many ways, convincing, but it would be wrong to argue that the Gothic churchmen and builders had the *Mirrors* of Vincent of Beauvais at hand when they laid out the schemes for decorating their churches. For one thing, there are many variations and developments within the programs (which Mâle readily admits), and some programs were apparently planned *ad hoc* to serve local needs and interests. Furthermore, considering the adjustments and gaps in chronology, it is not likely that all three areas of the cathedral—the west front, the porches for the transepts— would have been planned as a whole from the start. In fact, only Chartres preserves such an ambitious set of portal sculptures. . . .

The analogies between Scholasticism and the Gothic cathedral discussed here are perhaps better sensed than understood in details, and the same is true of a wholly different sphere of religious philosophy that is embodied in the lofty interiors glowing with colored lights: *Mysticism*. This brings us to the subjective world of faith stimulated by our visual experiences and emotional responses to space and light that are not conditioned by aspects of thrust, counterthrust, articulated piers, or flying buttresses. One historian, Wilhelm Worringer, described it thus: "As the interior is all mysticism, so the exterior construction is all scholasticism."[2] Having once passed through the sculptured

portals of Chartres, one no longer responds to the intricacy of structure, the beauty of the many sculptures, or the fascinating stories in stone, but rather to the marvelous attraction of divine light filtering down from the high windows all about. In this twilight world one does not attend the mechanics of Gothic structure or the complexities of its imagery. What strikes us is the indescribable sensation of being engulfed in a vast, lofty space where the parts are hardly discernible.

The mystical aspect of the cathedral interior cannot be denied. It is true of the Early Christian basilica and the Byzantine domed churches as well. But in the Gothic interior, the contrasts between the rational, physical structure of the building and the otherworldly sensations of the "new light" of the interior—where the services take place—are even more extreme. Mysticism had not yet been codified as a means of worship (this occurred in the fourteenth century); there were as yet no prescribed aids for inducing a mystical experience (such as in rosary devotion), but it was an experience that could be achieved through the contemplation of colored lights. How frequently the term "light" occurs in descriptions of mystical revelation! Reason dissolves in mysticism; faith is lifted to the abstract realm of total absorption, as the mystics say, "to lift us out of our bodies."

There can be little question concerning the role of colored lights in this experience of the cathedral. Lights, whether they be created by great panes of colored glass in the tall windows or in the translucency and sparkle of precious gems set in bright golden objects on the altar, were the means of attaining a mystical union with God. The oft-quoted passage by Abbot Suger of Saint Denis concerning the beauty of the "wonderful" cross of Saint Eloy placed on the golden altar superbly conveys this sense of mystical exaltation: "Thus, when—out of my delight in the beauty of the house of God—the loveliness of the many-colored gems has called me away from external cares, and worthy meditation has induced me to reflect, transferring that which is material to that which is immaterial, on the diversity of the sacred virtues: then it seems to me that I see myself dwelling, as it were, in some strange region of the universe which neither exists entirely in the slime of the earth nor entirely in the purity of Heaven; and that, by the grace of God, I can be transported from this inferior to that higher world in an anagogical manner."[3]

It is this dramatic reconciliation in architecture of the two ways to Christian faith—through *reason and understanding* as achieved by the scholastics and through the *immediate experience* of divinity as revealed to us by the mystics—that gives meaning to the Gothic cathedral.

NOTES

[1] E. Mâle, *Religious Art in France, the Thirteenth Century: A Study of Medieval Iconography and its Sources*, translated by M. Mathews (Princeton, Princeton University Press), 1984 (also appeared

as *The Gothic Image*, translated by D. Nussey (New York, Harper and Row, 1958). Cf. the review of the Princeton edition by W. Sauerländer in the *Times Literary Supplement*, May 30, 1986, 594.

[2] W. Worringer, *Form in Gothic*, translated by H. Read (London, A. Tirauti), 1927, 161.

[3] Abbot Suger, *De Administratione*, XXXIII, translated in E. Panofsky, *Abbot Suger on the Abbey Church of St Denis and its Art Treasures*, 2nd ed. By G. Panofsky-Soerge (Princeton), 1979, 63–64.

In the Margins of the Cathedral

MICHAEL CAMILLE

Michael Camille is a medievalist specializing in manuscript illumination. His most recent books are Mirror in Parchment: the Luttrell Psalter and the Making of Medieval England *(London: Reaktion Books, 1998) and* The Medieval Art of Love: Objects and Subjects of Desire *(New York: Abrams, 1998). He is Professor of Art History at the University of Chicago.*

Them that are outside, God judgeth (I Cor. 9:12)

Unlike the monastery, which was opposed to the world, the cathedral stood within clamorous streets, a powerful Symbol of God's expanding business among the rising urban communities of the thirteenth century. Cities within cities, these vast structural complexes were ruled by a feudal magnate—the bishop—and were inhabited and maintained (except for some English monastic foundations, such as Canterbury and Norwich) by canons who, unlike monks, could own and bequeath property. Their margins were domains to be contested, like the *parvis*, or 'paradise', the narrow strip leading up to the west front, which at Amiens Cathedral was fought over by townspeople and clergy for two centuries.[1] It is the influence of a nineteenth-century nostalgic myth that leads one to think of these vast structures of stone, mortar and glass as expressing the social unity of the populace. More often than not, as at Amiens, Reims and Laon in France and Lincoln and Coventry in England, the economic strain of building a new cathedral aroused violent conflict between secular and religious powers, and the overtaxed populace frequently rose up against the clergy.[2] The French Capetian crown, one of the earliest centralized

Excerpted from Michael Camille, *Image on the Edge: The Margins of Medieval Art* (Cambridge, MA: Harvard University Press, 1992). Reprinted by permission of the author.

monarchies, was also an important impetus in the ideology of cathedral building that spread the Gothic style of the Ile de France throughout Europe. Although a number of great cathedrals were under way in the late twelfth century, the important event that to some extent ratified their power was the Fourth Lateran Council of 1215, in which the Church consolidated its hegemony over souls by excluding heretics, Jews and usurers from the sacred precincts and stipulated mass and confession at least once a year for every Christian. As the biggest edifices in existence, these vast mass-machines were not unlike the shimmering Postmodern towers of today's corporate headquarters; their advanced architectural and technical complexity was symbolic not only of the wealth within but also of the power to exclude those without.

The Gargoyle's Mouth

According to the *Oxford English Dictionary*, a gargoyle is 'a grotesque spout, representing some animal or human figure, projecting from the gutter of a building (especially in Gothic architecture), in order to carry rainwater clear of walls'. These carved devices were used on ecclesiastical buildings and also on townhouses. The late fourteenth-century English poet John Lydgate describes how 'every hous keuered was with lead / And many gargoyl and many hidous hed', although ecclesiastical control of urban space is evidenced in a document censuring a clerk of Arras for failing to obtain episcopal permission for placing 'gargouilles' on the façade of his house.[3] First recorded in a building document of 1295—'stones that are called *gargoules*'—the word derives from the roots *garge* (to gurgle) and *goule* (throat). Many of these functional monsters are indeed all mouth, spurting from gaping gullets both human and dragonish, but others invert the bodily topography of ejection and turn their bottoms out to the street. The gargoyle is all body and no soul— a pure projector of filth, the opposite of the angel whose body is weightless and orifice-less.

The use of animal heads as waterspouts was not all invention of the thirteenth century but can be traced back to Antiquity. Their elaboration in the Gothic period was a means of sustaining the monstrous margins of Romanesque buildings. . . . Part of their fascination must have been their 'function' as pseudo-fountains, animated by the forces of nature. This is how they are explained in the *Roman d'Abladane*, a 'classical' Romance written by a canon of Amiens cathedral, which describes a 'marvel' of the old city being two 'gargoules' on the city gates that spew nice or nasty substances upon people entering the city, depending on whether their intentions were good or bad.[6]

The meaning of these emetic engines has long been controversial. In the nineteenth century, when historians sought to give exact meaning to every creature in the crevices of the cathedral, they were thought to illustrate specific texts, such as Psalm 21:12, 'Therefore shalt thou make them turn their

back', or Psalm 22:13, 'They gaped upon me with their mouths, as a ravening and a roaring lion. I am poured out like water and all my bones are out of joint'. More outlandish suggestions include their being the depictions of dinosaurs dug up during the Middle Ages, planetary constellations and portraits of heretics. For one early iconographer, the abbé Auber, they represented devils conquered by the Church that were made to perform menial tasks.[5] In Joris-Karl Huysman's Symbolist novel of 1898, *La Cathédrale*, gargoyles are called 'hybrid monsters, signifying the vomiting forth of sin ejected from the sanctuary; reminding the passer-by, who sees them pouring forth water from the gutter, that when seen outside the church, they are the voidance of the spirit, the cloaca of the soul'.[6]

Emile Mâle, the most influential cryptographer of the cathedrals, disagreed. Anything that was not included in the text of Vincent of Beauvais' great encylopaedic *Speculum* was the meaningless product of pure fantasy:

> What do they signify—the prodigious heads that emerge from the façade of Notre Dame of Reims, and those funereal birds veiled by shrouds? . . . No symbolism can explain these monstrous creatures of the cathedrals. The bestiaries are silent. Such creatures came from the imaginations of the people. These gargoyles, resembling the vampires of cemeteries, and the dragons vanquished by ancient bishops, survived in the depths of people's consciousness, they came from ancient fireside tales.[7]

Mâle here, in fact, alludes to something that helps explain the popularity, at least, of the dragon form of gargoyle—the stories of the founding bishops of cathedrals who, like Marcellus at Paris and St Romain at Rouen, were famous for having rid their respective towns of such creatures.[8] In both cities these ecclesiastics were carved in triumph over the tamed monster on the portals of their cathedrals. At Rouen the serpent was known as the 'Gargouille', and its destruction by St Romain with the aid of a condemned prisoner was celebrated on his feast day every year, when a criminal would receive the 'privilege of St Romain' and be released. Then, too, the stone representations 'came to life' in an animated version of the beast that was paraded through the city in a re-enactment of the saint's power over slithering things.

By the thirteenth century the apotropaic power of the images of evil had been transformed into just such a civic show, replacing fear with fun. This loss of demonic association can also be seen in the widening reference of gargoyle sculptures to include the human as well as the monstrous. They become butts of satire, depicting such despicable trades as butchers, prostitutes and moneylenders, or universal sins, such as gluttony. Among England's richest array of gargoyles—on the fourteenth-century parish church at Heckington, Lincolnshire—is an elegantly dressed woman holding an open book. Traditionally, women were not supposed to take knowledge into their own hands, although this volume may contain illicit lighter reading, perhaps a Romance.

Other social sins are twisted into gargoyle functions, suggesting that the evils excluded from the Church are not only those of lay society. According to a sermon of the English preacher Bromyard, gargoyles are like the slothful clergy 'who complain of the least task'. Just as the animals at Aulnay satirized the clerical hierarchy of the day, the more diverse and unstable religious orders of the fourteenth century were mocked in the disorder of many a projecting sculpture. The rise of marginal imagery has been related to the vernacularization of religion in this period and the increasing role of preaching. Bromyard uses sculptural references as *exempla* in his sermons; for example, the old notion of images being illusory and useless is used to describe those that likewise pretend to be what they are not:

> At times, on these great buildings we see a stone displaying a grinning open mouth, and from other indications, appearing as if it supported the whole edifice. But nevertheless a plain stone hid in a corner does far more of the work; for the other is rather for show than for support. Such may well be compared to those persons who, when they hear the cry of poor beggars for alms . . . with open mouths bewail . . . but do not offer a helping hand.[9]

Laughter and fear are closely related, and as Ernst Kris noted in his essay, "Ego Development and the Comic,"

> the grinning gargoyles on Gothic cathedrals . . . intended to turn away evil . . . tend to become mere comic masks; by the fifteenth century the process is complete and, instead of threatening, they are intended to amuse.[10]

Like the French word *drôle*, or amusing, which has lost its original associations with the uncanny, the gargoyle's mouth becomes the clown's. Yet this process is also one of de-demonization and lays an increasing emphasis upon perversity and monstrosity. This runs parallel to the intensifying psychological emphasis upon sin and self-reflection after the Fourth Lateran Council. No longer did the onlooker see the gargoyle as a hideous primordial beast that had been put to flight by the local bishop or as a dark succubus of the Devil, it became a reflection of the possible perversity in oneself.

This process of the humanization of the diabolic does not occur with other creatures—the so-called chimeras—perched on pinnacles and buttresses that, strictly speaking, do not have the gargoyle's function. The most famous beak-headed and melancholy example on the north tower of Notre-Dame in Paris, popularized in Charles Meryon's etching *Le Stryge* ('The Vampire') of 1853, was, in fact, one of the Romantic recreations of the architect Viollet-le-Duc, who had restored the Cathedral in 1843. Gothic chimeras are Northern versions of the griffon, the fantastic beast-guardians found in Italian Romanesque portals and based on Classical sources. Extraneous to the architecture, they are carved to seem as though they had just alighted, like crows [Figure 7]. It was

Figure 7. *Chimera,* Nôtre Dame, Paris, 12th century. Photo: Lauros-Giraudon/Art Resource, NY.

these truly marginal additions of the cathedral that most intrigued observers of the last century in their quest for the 'spirit' of Gothic. It is likely they terrified medieval onlookers by their lack of human reference.

The third type of Gothic marginal sculpture consists of corbel-heads and capitals more clearly derived from Romanesque traditions. Sometimes the interior of the cathedral is invaded by their physiognomic mockery, as occurs in the nave and crossing of Wells Cathedral, c. 1220, where human heads of all types and social classes punctuate the rhythms of the stiff-leaf carving. In the South transept is a whole series of figured capitals: as well as Marcolf pulling a thorn from his foot and a complex scene of violent vineyard robbers is the famous so-called 'toothache sufferer' glowering down at the observer.[11] Although this is a variation on the face-pulling grimace, the attention paid to the month—the site of so many different kinds of sin—makes this sufferer an emblem of abject human pain. While the old idea that he is related to a nearby curative shrine has to be discounted, his placement in the lay peoples' area of the building is important. It is not surprising to find an eruption of 'low life' squabbling and suffering in the very spaces where, Churchmen complained, a lot went on besides devotion.

At the cathedral of Semur-en-Auxerrois in Burgundy, the appearance of chattering corbel-heads in the choir itself, which was built in the 1230s, is even more startling. Here, the lower course of corbel-heads around the east end represent nobles and clergy, while higher up are more scurrilous fools and twisted figures.[12] Both Wells and Semur are smallish structures, and their marginal images can be seen from ground-level quite easily. The soaring scale of many cathedrals, however, often makes it impossible to see the marginal sculpture from below, either within or outside the sacred structure. The deformed and base are ejected by being made invisible. But this did not prevent the carvers lavishing care on the minute delineation of the unseen.

The difference between the inchoate, monstrous corbel types of 1120 we find at Aulnay and those of only a century later that stud the shadowy and hidden interstices high up amid the gables and buttresses of Reims Cathedral is astounding. These later heads are completely human and so powerful in their physiognomic exactness that art historians have described them as portraits of the artisans who made them or as case histories of certain mental illnesses.[13] Nowhere else in thirteenth-century sculpture does the carver get to display his skill at animating the human face, the slobbering mouth and the glinting eyes as he does here in these corner creations. Carved in the mason's yard, these hidden faces, when fitted into place, were not visible from far below, suggesting that they were, perhaps, sites of practice. Skill was important to the carver, for we know from later documents that the cost of spoiled stones was taken out of their wages. In this sense the freedom they exhibited in this one type of undictated, unseen and unauthorized sculpture emerges as rage, jeering and tongue-showing that mocks the edifice and its authorities. Disordered fragments of human personalities stuck onto the edges of the Heavenly

Jerusalem, they disrupt our notion of the cathedral as the 'Bible in stone', since they refer to no biblical personage or text. A side-show of abnormality and ugliness, unknown until photographers were able to scale the buildings on scaffolding a century ago, they are the most human, and the least divine, forms on the sacred edifice. Their liminal status widens the gap between sacred and profane rather than smoothing it over. Being neither the angels that curve around the external choir buttresses at the 'head' of the edifice nor the beaked terrors that perch on the west front, they are squeezed somewhere in-between, somewhere within the world of humanity. . . .

Misericords and Posteriors

For centuries the choir of even the smallest parish Church had been the site of one of the most fertile of the marginal genres that Bakhtin has called 'the lower bodily stratum', carvings hidden from all but the eyes of the canons and choristers who sat or leaned upon them—the misericords. The name is thought to have derived from the idea of a 'mercy seat' that provided some support for the older and infirm monks and canons during the long hours of services. When in the up position a misericord provided a ledge to lean back on, and when down, a proper seat. 'Hidden from the eye of mischief', in the words of Edward Prior, one of the earliest historians of English medieval sculpture, its art was on the underside in more ways than one. In the small field not visible when the seat is in use, the woodcarver had a chance to develop the marginal repertory found in manuscripts into three-dimensional woodcarvings.[14] But the compositions need not always have been derived from manuscripts. At Rouen Cathedral, for example, there is a marvellous set of misericords—ordered in 1467 by Cardinal Guillaume D'Estouteville—that was copied from the babewyns of the Portail des Libraires.[15] This suggests that nearly two hundred years after the monstrous carvings in stone had been made, they were still valued by artists and patrons as a repertory of imaginative and respectably riotous babewynerie.

The variety of subject-matter, the freshness and grainy earthiness of the carving and the intimate scale of misericords have attracted countless popular and scholarly treatments (we all have our favourites). But what is often not emphasized enough is the relative position of this art and its meaning, as regards the low subject-matter. A number of French examples have a distinctly 'popular' aspect, depicting riddles, pastimes and folk tales in a dynamic and often derogatory style. Here in the very centre of the sacred space, the marginal world erupts. Why this became a fashion, and why it was allowed, has to be related to the way in which these carvings were literally debased and made subservient to those 'above' them. The peasants labouring in the fields, the foolish merchant who carries his horse across a stream, the fox preaching to the geese—all are blotted out by the bottoms of the clergy. Sometimes this

is actually reflected in the carver's design, as at Saumur, where a figure is pinned with his nose reaching up to the choir-stall seat—literally the posterior of the sitter.

The censorship of the 'low' realism of these scenes by the portly canons' behinds during the divine services was the obliteration of one social group by another. The ribald subject-matter was clearly visible to the clerical élite, since laypeople, even in small churches, were not allowed to enter the sanctuary. This might explain the popularity, especially in England, of misericords showing scenes from popular romances, such as *Tristan and Isolde*, and other courtly subjects—not for the elevation of these themes, but literally to squash them. Although some misericords do display religious subjects, such as the Judgement of Solomon at Worcester and Noah's Ark at Ely, these are not the central Christological subjects, but scenes that allow, like the Mystery plays, anecdotal details and the depiction of social manners. Especially popular were the antics of Reynard the Fox and other animal fables, but also subjects of human labour that included scenes of self-reference showing carvers at work.[16] Three misericords from a single set now in London are especially interesting since they show the development of marginal images within this 'marginal genre' itself, using the 'ears' of the central bracket. Alongside scenes of the harvest and human labour are monstrous grylli and cloth-draped monsters with beakheads picking the grain. These have been described as representations of the monstrous races of the East, when, in fact, they would have been visible in many fourteenth-century villages at harvest time. They are clearly depictions of men in the mumming and hobbyhorse costumes used in folk rituals.[17]

Just as the misericords, while representing a wide social panoply, put people in their place in the human hierarchy, the cathedrals, as image-complexes, positioned people in relation to God and the Judgement. This does not mean that we must view all the hilarious or disturbing inversions of misericords, gargoyles and other three-dimensional marginal forms I have briefly discussed here as the crude image of predetermined 'official' ideology. The lay carvers who created these animated figures gave them eyes that glint with vivacity, and pert poses that are lacking in the simulacres of sanctity, that stand rigid beside them. . . .

NOTES

[1] A. E. Brandenburg, *La Cathédral* (Paris), 1989.

[2] B. Abou-el-Haj, "The Urban Setting for the Late Medieval Church Building: Reims and its Cathedral between 1210 and 1240," *Art History*, XI (1988), pp. 17–41.

[3] Cited in L. Randall, *Images in the Margins of Medieval Manuscripts* (Berkeley, 1966), p. 5; For gargoyles, see L. Bridham, *Gargoyles, Chimeras and the Grotesque in French Gothic Sculpture* (New York, 1930).

[4] L. Flutre, "Le Roman d'Abladare," *Romania*, XCII (1971), 469–97; M. Camille, *The Gothic Idol: Ideology and Image Making in the Middle Ages* (Cambridge, 1989), p. 251.

[5] L. Bridham, op. cit., xiv.

[6] J.-K. Huysmans, *La Cathédrale*, English Trans. (London, 1922).

[7] E. Mâle, *Religious Art in France of the Thirteenth Century: A Study of Medieval Iconography and its Sources*, trans., H. Bober (Princeton, 1984), p. 59.

[8] J. LeGoff, "Ecclesiastical Culture and the Folklore in the Middle Ages: St Marcellus of Paris and the Dragon," *Translatio Studii: Manuscript and Library Studies hounouring Oliver L. Kapsner*, ed., J.G. Plante (Collegeville, Minn., 1973).

[9] R. Owst, *Literature and the Pulpit in Medieval England* (Oxford, 1966), p. 238.

[10] E. Kris, "Ego Development and the Comic," in *Psychoanalytic Explorations in Art* (New York, 1974), p. 213.

[11] A. Gardner, *Wells Capitals*, 5th edn. (Wells, 1978).

[12] C. Gaignebet and J.-D. Lajoix, *Art profane et religion populaire au moyen âge* (Paris, 1985), pp. 271–275.

[13] P. Richer, *L'Art et l'médecine* (Paris, 1918), p. 168; H. Wiegert, "Die Masken der Kathedrale zu Reims," *Pantheon*, XIV (1934) pp. 246–50.

[14] E. Prior and A. Gardner, *An Account of Medieval Figure-Sculpture in England* (Cambridge, 1912), p. 533; C. Grossinger, "English Misericords of the Fourteenth and Fifthteenth Centuries and their Relation to Manuscript Illuminations," *Journal of the Warburg and Courtauld Institutes*, XXXVIII (1975), pp. 97–108.

[15] J. Adeline, *Les sculptures grotesques et symboliques* (Rouen, 1879), p. 65.

[16] See F. Bond, *Woodcarvings in English Churches: Misericords* (London, 1910); G. Renmant, *A Catalogue of Misericords in Great Britain* (Oxford, 1969); For French examples, see H. and D. Kraus, *The Hidden World of Misericords* (New York, 1975); C. Gaignebet and J.-D. Lajoix, *Art profane et religion populaire au moyen âge* (Paris, 1985).

[17] Tracy describes them as Marvels of the East: C. Tracey, *English Medieval Furniture and Woodwork* (London, 1988); Compare peasant labour and play as juxtaposed in the Luttrell Psalter.

Iconoclasm, Vandalism, and the Fear of Images

In an excerpt from *The Power of Images*, David Freedberg suggests that there may be a connection between the isolated attacks on works of art by apparently insane vandals and broader iconoclastic movements such as those of Byzantine iconoclasm, the Protestant Reformation, or the French Revolution.

A recent attack on a controversial painting raises the question again: Was this an isolated act of an unbalanced person, or was it a political statement (or both)? Are such violent attacks random and meaningless, or are they dramatic confirmations of the power images have to shape viewers' reactions?

Idolatry and Iconoclasm

DAVID FREEDBERG

David Freedberg has written extensively about the art of the Netherlands in the fifteenth and sixteenth centuries. His studies of issues such as censorship and iconoclasm explore the complex ways images are viewed in society. Freedberg is Professor of Art History at Columbia University.

(The following excerpt begins in the midst of Freedberg's discussion of the wave of vandalism that swept through the Netherlands in the sixteenth century.)

. . . To tell of the desperation into which many people fell in the winter of 1565–66, and of how they hearkened to the field preachers who could easily point to the wealth of the Church as embodied by images (as well as insisting on their own spiritual places, for the word of God alone, in which Protestants could worship), would be to tell an oft-repeated tale.[1] To tell of how the organized bands, as well as individuals, assailed images would make no less exciting and disturbing a history; so would the many stories of the hysterical and bad-tempered destruction of images—as well as the cool, deliberate, and sober (if not downright cold and vengeful) acts of iconoclasm.[2] One could do the same for the ever-increasing number of individual assaults on painting and sculptures in recent years.[3] If nothing else, such an examination would illustrate a surprisingly unstudied aspect of everyday psychopathology and everyday violence—or perhaps of the sublimation and enhancement of emotions that otherwise might be or would be suppressed. But illustration alone would be insufficient. It used to be thought that the theoretical background to iconoclasm, at least in sixteenth-century Europe (and possibly in Byzantium), was irrelevant to what actually happened; but this can no longer be held to be the case.

The Netherlandish episode was one in which the arguments for and against images were brought to the fore with greater density, repetitiveness, and sophistication than ever before. The number and complexity of the arguments are stupefying, in their pedantry, profundity, scope and—above all—in their quantity. Everyone then had some idea of the major arguments, and although we have forgotten their origins, they have profoundly entered the mainstream of all Western thinking about images. But they embody ideas which were present in antiquity, evolved in the hands of significant movements

like Neo-Platonism in later antiquity, merged with Judaeo-Christian currents, and came to the fore again in the astonishing episodes of Byzantine iconoclasm between 726 and 787 and 815 and 843—by which time Islamic thinking about images could also join the ever-broadening stream.[4] The anxiety about images continued throughout the Middle Ages, stimulated and enhanced by thinkers and authorities who ranged from Saint Bernard to Saint Thomas Aquinas. Saint Thomas may have justified images as a means for the instruction and edification of the uneducated faithful and as an aid to memory; but he also was only too aware of the dangers of the emotional involvement that springs from sight. Bernard was much more critical. Images were too splendid and too irrelevant: why beasts in churches; why demons on floors, devils on capitals, animals everywhere? The money spent on adornment was better spent on the poor.[5]

After a few centuries of comparative quietness—despite the development and proliferation of forms like panel-painting and increasingly lifelike sculpture—European iconoclasm flared up again, fiercely, in the sixteenth century. Combined with the early Christian and Byzantine strains, the medieval ideas came to a head in the Reformation polemic. In the seventeenth century, England succumbed again, thanks to parliamentary and Puritan reaction to the Catholic inclinations and aesthetic excesses of a negligent king (Charles notoriously devoted excessive time and money to his magnificent collections of high art). For all the specific context it is both striking and wholly unsurprising to notice the recurrence of some of the oldest arguments in a country by now well insulated from Catholic thought. Perhaps not so much old argument as action based on old concept. Or on satire? In a remarkable inversion of the deeds performed by Gregory the Great as destroyer of pagan idols, the West Cheap Cross in London (which had already been assaulted by iconoclasts in 1581) was replaced with something utterly pagan: a pyramid instead of the finial cross, and a half-naked statue of Diana instead of the Virgin. A recent commentator has suggested that this was done in order to make the monument "safe" in Puritan eyes; more likely an acerbic parallel was intended to be drawn between heathen goddess and Blessed Virgin.[6]

During the French Revolution the Virgins were thrown out too. They had to be, since they shored up the symbols of royalty. The new symbols came from a variety of sources; but Diana was present again, with her companions from classical antiquity. Indeed, in the Feasts of Reason that replaced the old feast days of the Church, image destruction led to an inventive new iconography, in which, among its other aspects, the themes from classical "pagan" history were reclaimed from the realm of the aphoristic secular into which they had been relegated by the Reformation critics. The advent of Neo-Classicism—for style was theme and theme style—was not adventitious. With the Russian Revolution the statues of the czars went, and were in due course replaced by those of the heroes of the revolution. Neo-Classicism came to symbolize the old order, especially in its architectural monuments; and so it gave way to more modern

styles, and finally to ones self-consciously of the future—until a more repressive order prevailed again. Indeed, in the fascist regimes of the twentieth century, such styles are visual proof of the authoritarianism that appeals to purity. But this is another story.

With Nazi Germany we come full circle to a central paradox. The lovers of art are the destroyers of art. The collecting impulses of the Nazi leaders were directed toward objects which had acquired the status of the highest art and toward the life-enhancing returns of fetishism. The art they encouraged was an art of crass representationality, of a vulgarly evident realism that stipulated careful reflection of the portrayed object or being, healthy bodies in a dull technique, bodies that must rouse and produce the ideal Aryan creature: do we speak of the perfection of the best Greek statues or of Lessing's monsters? That which cannot engender the perfect being is corrupt. In Weimar Germany and in the early years of the Nazi regime, there were still many forms which disrupted the easy transition from life to art. These were the forms that could be seen in the great displays of *Entartete Kunst* of the 1930s, especially 1937.[7] Once one had got rid of degenerate art, then one could seek out the degenerate artists too. The old notion that pure art can only be produced by pure artists is once again in the vested interests of authority, and of regimes that would keep their government pure and their people undistracted by the wrong things. The work of degenerate artists, even if their art conforms, must go. As for the Jews, who should not be making art anyway, their fat and golden calves must be the first of all idols to be melted down and strewn upon the waters.

Even in these briefest of summaries we see some of the deep paradoxes of iconoclasm. We love art and hate it; we cherish it and are afraid; we know of its powers. They are powers that, when we do not destroy, we call redemptive. If they are too troubling they are the powers of images, not of art (except in the newspeak of criticism, to which we will return). It is true that no general account of iconoclasm in the West could cover every one of its episodes, particularly when one considers how frequent are the isolated, apparently individualized acts—especially now, when art and images are more widespread and accessible than ever before. But although most educated people in the West have heard of each of the events and periods I have swiftly surveyed, art historians have shied away from the evidence they provide of the relations between images and people; and in so doing they reveal yet another aspect of the way in which we repress what is most troubling about images. . . .

"The assailant and his motives are wholly uninteresting to us; for one cannot apply normal criteria to the motivations of someone who is mentally disturbed." This is what the director of public relations at the Rijksmuseum in Amsterdam is reported to have declared after the knife attack on Rembrandt's *Nightwatch* on 14 September, 1975.[8] It was the third attack on the picture in the century. Aside from the evident psychological interest of all such cases, and aside from the odd confusion of the second half of the statement[9], the most telling aspect of this claim is the vehemence of its denial. Someone who

responds so powerfully to the picture that he assaults it is here held to be un-interesting (at least to the museum official). He is not interesting, one gathers, because he tests the limits of normality. This is how we lay aside and sup-press that with which we cannot deal. Such a claim is all too characteristic; what it amounts to is an expression of the fear of plumbing psychopatholog-ical depths that we prefer not to acknowledge—not only because we are fright-ened by the behavior of others, but because we recognize the roots of and the potential for such behavior in ourselves. The whole framework of denial is of a piece with the massive fortifications of repression with which we seek to protect ourselves from the powerful emotions and the distracting and troubling behavior that we sometimes experience in the presence of images: especially ones we strongly like and strongly hate. Sometimes those fortifications are so strong that they are never breached, and we feel well protected.

Consider some examples of individual iconoclasm in the twentieth cen-tury.[10] A man attacks *The Nightwatch* in 1911 with a pocket knife because (he says) he is disaffected with the state (he has been laid off from his job as a cook in the navy). So when he walks into the Rijksmuseum one afternoon and sees the state's most prized possession—*The Nightwatch*—anger wells up in him and he attacks it.[11] In 1975 a man again attacks *The Nightwatch*, with a knife he has stolen from a restaurant in which he just lunched. The museum officials profess to be uninterested in his motives. But the newspapers dis-cover that he had been acting in an odd manner just previously (especially in church the weekend before) and had gone about declaring that he would shortly make front-page news and be on the television. As in so many other cases like this one, he is institutionalized shortly thereafter.[12]

Closer examination of the damage he wrought, however, suggests that his attack was not entirely wild. The slashes seem to be more deliberately directed than that would imply. It transpires that he felt (or said he felt) that Banning Cocq, at whom he directed most of his slashes, was the personification of the devil (Cocq was dressed in black), while Ruytenburgh, dressed in yellow and gold, was the angel.[13] The man may have been completely beyond the pale, but he was not completely out of control. The deliberate element in such ap-parently spontaneous or crazed acts should give one pause for thought. It happens more frequently than one might think.

But there is also the messianic aspect of the man's claims. When he created the disruption in the church the weekend before, he maintained that he was Jesus Christ and that God had commanded him to do the deed, and that he had been called by the Lord to save the world.[14] The messianic impulse is shared by many attackers of images. They claim that they are Jesus Christ, the Lord, or the Messiah, come to save the world. Such delusions were voiced by the man who struck off the arm and nose of Michelangelo's *Pietà* with a hammer in 1972 [Figure 8]. They were also voiced by the author of a series of pornographic booklets who, when apprehended for throwing acid at Rubens's *Fall of the Damned* in 1959, insisted that he had been subject to a systematic

Figure 8. Lazlo Toth after attacking Michelangelo's *Pieta*, May 21, 1972. Photo: ©
Bettmann/CORBIS.

campaign of literary suppression and that his aim was to bring peace to the world and to end all wars.[15] The impulse may be deluded and seriously pathological, but we may pause again to reflect on the appropriateness of the subject of the picture he assaulted. It cannot be accidental, given the little we know of his biography, that he should have chosen to throw acid at a picture of the damnation of one of the greatest and most brilliant assemblages of lusciously naked flesh in all of Western art.[16]

All iconoclasts are aware of the greater or lesser publicity that will accrue from their acts. They know of the financial and cultural and symbolic value of the work they assault. The work has been adored and fetishized: the fact that it hangs in a museum is sufficient testimony to that, just as the hanging of pictures in churches is testimony to religious forms (or less overtly secular forms) of adoration, worship, and fetishization. Furthermore—especially in the twentieth century—the better the art, the greater the commodity fetishism. So destruction is especially shocking to those normal people who adore art and art objects. When Eratostratos burned down the great temple of Diana at Ephesus, he did so specifically in order to ensure that posterity would not forget his name; and all attempts to erase it from history failed, since someone, in the end, leaked it.[17] Both the 1911 assailant of *The Nightwatch* and the man who threw acid at a series of paintings throughout Germany in 1977 declared that they had to destroy what other people cherished.[18] Like latter-day Eratostratoses, each of them also made grandiose claims about their need to be famous, to appear in the newspapers, and to be the Messiah who had come to save the world.

In 1914 a young suffragette—subsequently known as "Slasher Mary"—hacked at Velazquez's *Rokeby Venus* in the National Gallery in London in order to draw attention to the women's cause in general and to the plight of the suffragettes in Holloway Prison in particular. "The most beautiful woman on canvas was as nothing compared to the death of one woman in prison," Mary Richardson claimed in a 1952 interview, speaking of Emmeline Pankhurst.[19] Such motivation, of course, is an activist extension of the egocentric desire for publicity. To attack a well-known picture may bring immediate notoriety to the attacker, but he or she is usually forgotten. More long-lasting and more immediately clamorous is the publicity that attaches to a cause when a well-known image, one which has become totemic in one sense or another, is attacked, mutilated, or even stolen. Hence the many instances where the letters of political organizations are incised, scratched, inscribed, and chalked on pictures, sculptures, and murals. Such actions go beyond the publicity that accrues from inscription or emblazonment on the waiting space.

Once again, though, the subject of the picture assailed by the suffragette seems peculiarly fitting. It is not entirely surprising that when Mary Richardson reflected on her youthful deed some forty years later, she added, "I didn't like the way men visitors gaped at it all day long."[20] Indeed not; and indeed they might have. Moralizing disapproval is thus joined to political motivation,

but it is also coupled with fear of the senses. This is the basis for countless attacks on images, from the earliest times on—from Louis of Orleans's terrible mutilation of Correggio's *Leda and the Swan* to the destruction in 1987 of posters of overly revealing bathing suits on bus shelters in Israel. Of course such actions have their private roots, or their religious motivations; but the underlying similarities are undeniable, and they are not factitious. Such examples occur with increasing frequency in our own times, as images multiply and as their mutilation becomes more or less legitimized and current. . . .

Of course one can find social and political motives for each of the individual acts described here. Of course they may be rooted in the psychopathology of each of the individuals concerned, who are usually judged to be deranged in one way or another. We, on the other hand, do not seek to take out our vengeance on the state in this way, to destroy what disturbs our libido, or to gain massive publicity on the scale envisaged by several of the iconoclasts. Usually we keep such disturbances and such ambitions under control; we keep them vastly more modest. If they exist (so the usual account would run), we more profitably and beneficially sublimate such psychological motions.

There is no denying the political, the social, or the psychopathological background to the motivations for each of these acts. Nor can it be gainsaid that many iconoclasts are bitterly disappointed individuals, and that they seek to draw attention to their unfair plight by violently attacking objects which are admired by the rest of society and are regarded as of great financial, social, or cultural value.[21] There is no question that there are many other psychological factors mixed up in all the delusions and impulses that are predicated on perceiving the object as a present body, as the living leader, as the embodiment of unfairly spent wealth, as a temerarious creation. Who is to say what exactly these disappointments and senses of failure or delusions of grandeur might be? It would be wholly presumptuous to unravel such factors, and it has not been my purpose to do so.

The theorist and the individual may object to a picture or sculpture and may even censor or assault it on the grounds that it is a distraction from higher things, an intolerable and offensive vanity. Such an objection may rationalize another motivation altogether, but it nevertheless provides further testimony to the fear of the senses that arises from the fetishizing gaze. Even if only rationalization, it amounts to theoretical acknowledgment—at the least—that this is what happens with paintings or sculptures. The sailor who attacks *The Nightwatch* realizes the commodity fetishism on which the value of works of art are based, so he attacks the most valuable work he knows. The attacker of a picture like Rubens's *Fall of the Damned* realizes the fetishism that turns the picture into something that is threatening to his libido, so he subverts the possibility of fetishism by destroying, mutilating, or otherwise ruining it.

The slashing of representations of nudes provides further evidence of the investiture with life as the basis of response. What would the danger be of leaving it whole if it were simply dead to begin with? It would be easy to

answer by claiming that the fear is that the representation is suggestive. There is nothing wrong with this answer; it is just that it is incomplete. Suggestive it may be, but the imagination that lingers is the imagination that reconstitutes, and reconstitution is constantly referred back to the representation and projected onto it, so that the mind not only sees the mental image but strives toward materiality and the investment with life. Similarly, whatever the symbolic component of an iconoclastic act may be held to be, one would be evading the realities of action if one only had recourse to notions of pure or conventional symbolicity.

The Virgin of Michelangelo's *Pietà* looks too beautiful, so the man, for all his messianic impulses, breaks those parts which make her beautiful and therefore make her seem desirable. He destroys her face by breaking her nose [Figure 8], in the same way that the image of Shirin in the grotto of Tâq-i-Bustân was disfigured. Not only does she threaten the senses, she is also the Mother of God. She should not rouse carnality in the ways ordinary women do, the women of this earth. Again one encounters the old resistance to confusing profane and sacred, which also lies at the root of the recurrent objections to confusing the everyday with the sacred. Here it is important to reemphasize not only the aspect of the neurotic's motivation that can be considered under the rational heading, but also his avowed messianism. This too has its parallels in the messianic and soteriological motives of reform movements that purify their houses of representations of the genuinely unknowable Messiah, whom they alone can make known to the world. Their word (and sometimes their images) will replace "false" images of the real Messiah. The awareness of the publicity that accrues from the destruction of a cherished object in its turn constitutes a part of the social glamor of iconoclasm and part of the motivation for the organizers and instigators of group iconoclasm.

In these ways we insert the individual act into its social context; thus we engage the interest of the deed that is generally regarded as beyond the pale, and thus we see the truth that lies within the apparently crazed deed of the isolated iconoclast. It is not hard to understand why we should want to repress our kinship with such people, or why we should want to repress the disturbances that images cause and that, in their turn, make us understand why the iconoclast might behave the way he or she does. If we grasp *that*, and if we accept the disturbances, we may then begin to talk about the power of images—even at the cost of reshuffling our preconceptions about the role and status of art in our lives, or of deriving illumination from the dark acts of those whom we dismiss as deranged and incalculably more troubled than we are. The aim is to seek the calculable. . . .

NOTES

[1] A good overview can be found in P. Mack Crew, *Calvinist Preaching and Iconoclasm in the Netherlands, 1544–1569* (Cambridge, 1978).

[2] For a summary of all these issues, see my general article of 1986, with more specific details in my Oxford D. Phil. thesis of 1973 entitled *Iconoclasm and Painting in the Revolt of the Netherlands, 1566–1609 (New York, 1987)*.

[3] As in Freedberg 1985.

[4] The relevance to the Byzantine ideas and episodes of Islam and Islamic ideas has been much discussed, from the famous edict of the Caliph Yazid on (see A. Vasiliev, "The Iconoclastic Edict of the Caliph Yazid II," DOP 9/10 [1956]: 23–47, and Beck 1975, pp. 13–14, n. 33, etc.).

[5] *Apologia ad Guillelmum . . . Abbatem*, in *PL* 182, cols. 915–17. See also Freedberg 1982, n. 56 for the Reformation descendance of this view.

[6] See J. Phillips, *The Reformation of Images: Destruction of Art in England, 1535–1660* (Berkeley and Los Angeles, 1973), p. 144. The event happened in 1600. Although Queen Elizabeth objected to the substitution, and immediately ordered the restitution of a cross, the city magnates demurred; but in the end agreed to her instructions. See Aylmer Vallance, *Old Crosses and Lychgates* (London and New York, 1920), pp. 102 and 106. It is worth noting that already in 1581 the Virgin had suffered greater indignities than the other sculptures on the cross, at least on its upper part (ibid., p. 102).

[7] See the *Führer durch die Ausstellung Entarte Kunst* (reprinted with additional texts, Munich, 1937). More useful material is found in B. Hinz, *Die Malerei im deutschen Faschismus: Kunst und Konterrevolution* (Munich, 1974). See also the important debate that has arisen between Hinz in *Kritische Berichte* 14 (1986), Heft 4, and C. Frowein, *Kritische Berichte* 15 (1987): 70–71.

[8] According to the *Neue Kronen Zeitung of 11 October 1975*. Cf. the immediate response of the Rijksmuseum curator who declared after the attack that "iedereen die de Nachtwacht aanvalt moet gestoord zijn" (*De Volkskrant*, 15 September 1975).

[9] Since all criteria are normative, what are the criteria that are not normal? Is the tacit proposal here that we should judge abnormal behavior by abnormal standards? In which case, presumably, abnormality becomes normality. It is only by the standards of normality that abnormal appears abnormal, and so on.

[10] In many of the cases from major museums mentioned here, I was allowed to consult the museum files on the relevant paintings; but by and large I have confined the references in the following notes to reports in the popular press.

[11] *Het Leven*, 17 January 1911.

[12] *De Telegraaf* and *Trouw*, 16 September 1975; also *Het Parool*, 15 and 16 September 1975.

[13] Freedberg 1985, pp. 12–13 and notes, as well as p. 50, n. 83.

[14] *De Telegraaf*, 16 September 1975, and *Neue Kronen Zeitung*, 11 October, 1975.

[15] For all these cases see Freedberg 1985, p. ii.

[16] Ibid., especially notes 33–34 for the assailant's history.

[17] Cf. inter alia, Valerius Maximus 8. 14.5; Aulus Gellius 20.6. 18; Aelian 6.40; Strabo 14.1.22, as well as W. Alzinger in *RE, supp.* 12, sp. 1666, s.v. "Ephesos."

[18] See *De Echo*, 17 January 1911, and *Die Welt*, 10 October 1977, as well as Freedberg 1985, especially note 103.

[19] See the interview with Mary Richardson in the London *Star*, 22 February 1952. Cf. her comment in the *Times*, 11 March 1914: "1 have tried to destroy the picture of the most beautiful woman in mythological history as a protest against the Government for destroying Mrs. Pankhurst, who is the most beautiful character in modern history."

[20] London *Star*, 22 February 1952.

[21] Exactly this applies to the case of the man who made the horrific acid attacks on three paintings by Dürer in the Alte Pinakothek in Munich in May 1988. He was the same man who in 1977 had thrown acid on paintings in Kassel, Hamburg, Düsseldorf, and elsewhere in Germany. Apparently further embittered by the court's judgment that his pension be reduced in order to pay for some of the damage, he decided to do a similar deed again. When the security guard who held him until the police arrived declared to his superiors: "This man destroyed the paintings," the man responded, "No, I destroyed three Dürers."

Disputed Madonna Painting In Brooklyn Show Is Defaced

ROBERT D. MCFADDEN

Robert D. McFadden is a journalist for The New York Times *and author of* Outrage: The Story Behind the Tawana Brawley Hoax *(New York: Bantam, 1990). He was awarded a Pulitzer Prize in 1996.*

A painting whose elephant dung and pornographic touches have incurred the wrath of Mayor Rudolph W. Giuliani and stirred a religious, cultural and political furor in the city was attacked at the Brooklyn Museum of Art yesterday by a man who smeared paint on it but did no permanent damage [Figure 9].

Feigning illness to lull a security guard, the man, identified by the police as Dennis Heiner, 72, of East 38th Street in Manhattan, leaned against a wall, darted behind a plexiglass shield, removed a plastic bottle from underneath his arm and squeezed white paint in a broad stroke across the face and body of the black Madonna in the painting, witnesses and museum officials said.

As the guard and several museumgoers watched in horror and shouted, "Don't!" and "Stop!" Mr. Heiner, the police said, smeared the paint over about a quarter of the surface of the 8- by 6-foot painting, "The Holy Virgin Mary," by Chris Ofili, a British artist of Nigerian descent.

"He covered the head and face down to the shoulders and then down to the breast line," said David Eigenberg, who witnessed the afternoon drama. He said he made a move to stop the man, but was told by the guard to stay back. Moments later, while the guard radioed for help, the man emerged from behind the plexiglass, his paint-smeared hands shaking nervously, but made no effort to get away, witnesses said. As other security officials raced up, the guard, whose name was not disclosed, asked, "Why did you do it?" "It's blasphemous," the man replied quietly.

James G. Kelly, the museum's security manager, said the guard had not halted the attack because he had been surprised. Mr. Kelly called the reaction appropriate under the circumstances. "They're here to truly observe and report," he said of the guards. "If they can come between someone in an act of aggression, they can stop it. But they're not peace officers and have no arrest powers."

Figure 9. Press preview of Brooklyn Museum's "Sensation" exhibit, September 30, 1999. Photo: UPI Photo Service.

Within minutes, the police arrived and arrested Mr. Heiner. He was charged with criminal mischief, a misdemeanor. He was being held at Central Booking in Downtown Brooklyn last night awaiting an arraignment today.

A woman who answered the phone at Mr. Heiner's residence, saying she was his wife, Helena, described her husband as a devout Roman Catholic who opposes abortion and believes that the painting, adorned with elephant dung on one breast and cutouts from pornographic magazines, is sacrilegious.

"The painting was offensive; he's absolutely right about that," the woman said. "This painting is your mother, the painting of the Blessed Mother, the mother of Christ. So he said, 'I will go there today and try to clean it.' "

Shortly after the attack, museum conservators removed the painting and within an hour had cleaned it before the white paint was dry, leaving the artwork apparently undamaged. "It's like a stain—the sooner you get at it the better your chances of removing it," said Sally Williams, a spokeswoman for the museum, who noted that the painting would be back on display today. The museum, in a statement, said trustees and staff members were "shocked and extremely saddened by this incomprehensible act."

The Ofili painting is part of an exhibition, "Sensation: Young British Artists from the Saatchi Collection," that has been one of the most successful, and controversial, in the 177-year history of the Brooklyn Museum. Charles Saatchi, the British advertising magnate, owns the paintings and sculptures and is the show's largest financial backer.

In September, a week before the exhibition's opening, Mr. Giuliani led a chorus of protests by various groups, including the Catholic League, objecting to the Ofili painting, a collage of paper, oil paint, glitter and resin on linen. It depicts the Madonna in blue robes, with a shellacked clump of dung on one breast and cutouts of female genitalia from pornographic magazines. Calling it "sick stuff" and offensive to Roman Catholicism, Mr. Giuliani denounced the exhibition, vowed to cut off the museum's $7.2 million annual city subsidy, withheld the subsidy payments for October and November and began proceedings to evict the museum.

A federal court battle ensued. The museum, backed by cultural organizations, noted that Mr. Ofili had often used elephant dung and other unusual materials in his work as a cultural reference to his African heritage, and contended that the mayor was violating the free-speech rights of the artist and the museum in attempting to suppress the exhibition. On Nov. 1, Judge Nina Gershon of United States District Court in Brooklyn sided with the museum and ordered the city to resume its subsidies and end its eviction proceedings.

Since the show's opening on Oct. 2, nearly 130,000 visitors have seen "Sensation," making it the most successful exhibition of contemporary art ever put on by the museum, Ms. Williams said. Because of the controversy surrounding the painting, the museum had wanted to post 21 guards for the exhibition, which features more than 90 items on the fourth and fifth floors. But requests by Mr. Saatchi, who put up $160,000 to mount the show, increased

costs, and the museum had to pare down the security staff to 10 guards. In addition, one museum official said, Mr. Saatchi objected to a piece of plexiglass that would have completely enclosed Mr. Ofili's painting. Instead, a piece slightly larger than the painting was hung from the ceiling, leaving gaps of several feet on either side and a four-foot separation from the surface of the painting.

Mr. Heiner, who the police said was arrested in 1990 on a charge of obstructing governmental administration during a protest, bought his $9.75 ticket to the exhibition yesterday and took an elevator to the fifth floor, where Mr. Ofili's painting is hung in a 12-foot-wide gallery between two larger rooms.

After walking through several galleries, Mr. Heiner approached a guard and said he was feeling dizzy and ill, said Mr. Kelly, the security manager. The guard advised him to sit down. He then approached the guard near the Ofili painting and again said he was dizzy and ill. He was clad in a brown tweed sports coat, necktie and dark trousers, and did not seem suspicious, Mr. Kelly said. "He was very dapper," the manager said. "He looked like a typical museum visitor." Mr. Heiner then leaned up against the wall beside the painting and suddenly darted behind the plexiglass, witnesses said.

Museum officials noted that metal detectors at the entrance might have been tripped if Mr. Heiner had brought the oil-based paint in an ordinary metal tube, but it was in a plastic bottle concealed under his arm, and before anyone knew what was happening he was squirting and smearing fast. Officials said a video camera captured the scene: the defaced painting, Mr. Heiner's hands and forearms caked with paint, his quiet demeanor as he emerged from behind the plexiglass and submitted to the guards. They said he seemed quite frail and not in need of restraint as he spoke, without apparent regret for his actions. "When we apprehended him, he was trembling," Mr. Kelly said. "He spoke very softly and very gently, but he was jittery."

A police official later quoted Mr. Heiner as saying he was "surprised that someone didn't do it sooner." But Ms. Williams, the museum spokeswoman, said there had been no previous attempt to deface any artwork in the exhibition.

CHAPTER 7

Iconography

Erwin Panofsky is primarily known for his investigations of iconography, the study of the meaning of images. Through painstaking research into documents and texts, Panofsky aimed to decode the symbolic meanings of images and to relate those meanings to the larger world-view of their time.

As Brendan Cassidy points out, the search for "disguised symbolism" has occasionally led some of Panofsky's followers to overinterpret images, making the pictures seem more scholarly than they probably were, but even today Panofsky's analysis of paintings like the *Arnolfini Double Portrait* [Figure 10] is so convincing that it seems almost inevitable: How else could we read this painting?

Lisa Jardine offers a short alternative description of the picture—Panofsky would have called it a "pre-iconographic" interpretation—in which the painting is grounded in the materialistic world of consumerism rather than in the transcendental realm of religious symbolism.

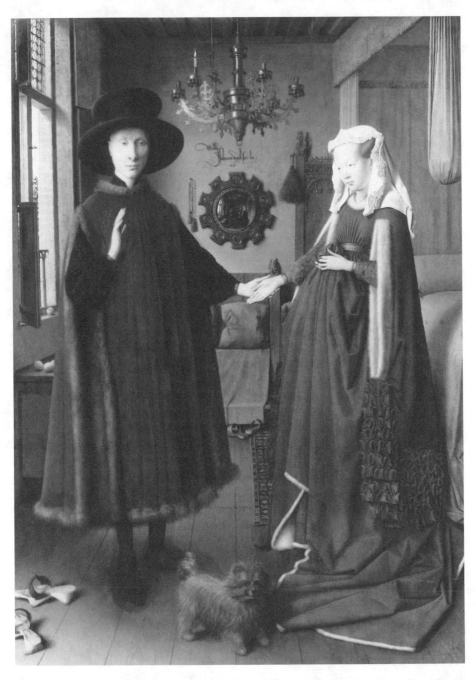

Figure 10. Jan van Eyck, *Arnolfini Wedding*, 1434. National Gallery, London. Photo: Foto Marburg/Art Resource, NY.

Jan van Eyck

ERWIN PANOFSKY

Erwin Panofsky was one of the most influential art historians of the twentieth century. After fleeing from the Nazi regime in Germany, he accepted a position at the Institute for Advanced Study at Princeton. He was the subject of Michael Ann Holly's Panofsky and the Foundations of Art History *(Ithaca and London: Cornell University Press, 1984). Panofsky died in 1968.*

. . . . In a comfortably furnished interior, suffused with warm, dim light, Giovanni Arnolfini and his wife are represented in full length (Figure 8). He wears black coat and hose, a black straw hat, and a sleeveless tunic of purple velvet trimmed with sable; she is less austerely attired in a blue dress, of which only the sleeves and a small part of the skirt are visible, and an ample green robe, lined and trimmed with ermine, which is fastened around the waist by a pink girdle.

The husband gingerly holds the lady's right hand in his left while raising his right in a gesture of solemn affirmation. Rather stiffly posed and standing as far apart as the action permits, they do not look at each other yet seem to be united by a mysterious bond, and the solemnity of the scene is emphasized by the exact symmetry of the composition, a central vertical connecting the chandelier with the mirror on the wall and the little griffon terrier in the center of the foreground.

This prochronistic masterpiece—not until Holbein's "Ambassadors" do we find a parallel in Northern painting—can neither be classified as a "portrait" nor as a "religious composition" because it is both. While recording the personalities of Giovanni Arnolfini and Jeanne Cenami, it glorifies the sacrament of marriage.

According to canon law, marriage was concluded by taking an oath, and this oath (*fides*) implied two actions: that of joining hands (*fides manualis*) and, on the part of the groom, that of raising his forearm (*fides levata*, a gesture still retained by our own legal procedure). This is what we see in numerous representations of the fourteenth and fifteenth centuries in which a marriage ceremony is depicted, no matter whether they show the marriage of David and Michal or of Perseus and Andromeda, as well as on tombs, mostly English, commemorating noble couples. And this is evidently what takes place in the

double portrait by Jan van Eyck. Here the fact that a marital oath is taken is further emphasized by the lone candle burning in the chandelier and obviously not serving for a practical purpose because the scene is staged in broad daylight. A burning candle, symbol of the all-seeing Christ, not only was, and often is, required for the ceremony of taking an oath in general but also had a special reference to matrimony: the "marriage candle" (*Brautkerze*), a Christian substitute for the classical *taeda*, was either carried to church before the bridal procession, or ceremoniously given to the bride by the groom, or—as is here the case—lit in the home of the newlyweds.

What distinguishes the Arnolfini portrait from other representations of marriage ceremonies—apart from the fact that Jan van Eyck, confronted with a problem of compressing two separate moments into one action, preferred to show the groom grasping the hand of the bride with his left and raising his right, whereas most other artists did the opposite—is that the participants are quite alone. This, however, is easily explained. According to Catholic dogma, the sacrament of marriage is the only one which is not dispensed by the priest but is bestowed by the recipients themselves. Two people could conclude a perfectly valid marriage in complete solitude, and it was not until 1563 that the Council of Trent condemned such clandestine weddings which had produced extremely awkward situations in the past if one of the partners subsequently denied the fact that a marriage had taken place. From then on, the Church required the presence of a priest and two witnesses; but even today, the priest acts not as a dispenser of the sacrament, as in a baptism or confirmation, but merely as a *testis qualificatus*.

Giovanni Arnolfini and Jeanne Cenami—he a native of Lucca, she born in Paris of Italian parents—had no close relatives at Bruges. They apparently considered their marriage as a very private affair and chose to have it commemorated in a picture which shows them taking the marital vow in the hallowed seclusion of their bridal chamber—a picture that is both a double portrait and a marriage certificate. And this explains that curious wording of the signature which has given rise to so much unnecessary discussion: "Johannes de Eyck fuit hic," "Jan van Eyck was here." No other work of art is signed in this peculiar fashion which rather reminds us of the undesirable epigraphs recording the visits of pilgrims or tourists to places of worship or interest. But here the artist has set down his signature—lettered in the flourished script normally used for legal documents—as a witness rather than as a painter. In fact, we see him in the mirror entering the room in the company of another gentleman who may be interpreted as a second witness.

With the subject thus identified, not as an ordinary portrait but as the representation of a sacrament, the atmosphere of mystery and solemnity which seems to pervade the London picture takes tangible form. We begin to see that what looks like nothing but a well-appointed upper-middle-class interior is in reality a nuptial chamber, hallowed by sacramental associations and often sanctified by a special *benedictio thalami*; and that all the objects therein

bear a symbolic significance. It is not by chance that the scene takes place in a bedroom instead of a sitting room, for the matrimonial bed was so sacred that a married couple in bed could be shown visited and blessed by the Trinity, and even the scene of the Annunciation had come to be staged in what was officially referred to as the *thalamus Virginis*. The crystal beads and the "spotless mirror"—*speculum sine macula*, here explicitly characterized as a religious object by its frame which is adorned with ten diminutive scenes from the Passion—are well-known symbols of Marian purity. The fruit on the window sill recalls, as in the "Ince Hall" and "Lucca" Madonnas, the state of innocence before the Fall of Man. The little statue of St. Margaret, surmounting the back of the chair near the bed, invokes the patron saint of childbirth. The dog, seen on so many tombs of ladies, was an accepted emblem of marital faith. And there is little doubt that the discarded pattens in the lower left hand corner are here intended, as possibly already in the case of the "Descent from the Cross" by the Master of Flémalle and certainly in the "Nativities" by Petrus Christus and Hugo van der Goes, to remind the beholder of what the Lord has said to Moses on Mount Sinai.

In the London Arnolfini portrait, then, Jan van Eyck not only achieved a concord of form, space, light and color which even he was never to surpass, but also demonstrated how the principle of disguised symbolism could abolish the borderline between "portraiture" and "narrative," between "profane" and "sacred" art.

(Editors' note: Because of limitations of space, we have omitted the notes that originally accompanied this excerpt.)

Introduction: Iconography, Texts, and Audiences

BRENDAN CASSIDY

Brendan Cassidy is Reader in the School of Art History in the University of St. Andrews in the United Kingdom where he specializes in Italian Renaissance art and iconography. Cassidy is the editor of The Ruthwell Cross *(Princeton: Princeton University Press, 1989) and the author of numerous scholarly articles.*

. . . "Disguised symbolism," the notion that details of seemingly straightforward images carried ulterior meanings, proffered enticements that many scholars were unable to resist. Not only was there the challenge of an intellectual puzzle, but the solution was to be found in the scholar's preferred haunt, the library. Panofsky's iconology was infectious. He swept up in his wake scores of eager young historians in thrall to the sheer intellectual excitement of his approach. In attempting to emulate the master's erudition many abandoned themselves to an orgy of text hunting in the indices of the *Patrologia Latina*, in search of that textual nugget that would reveal the secret of a Netherlandish triptych or an Italian fresco. The reader could follow the course of the hunt through a covert of impressively recondite footnotes whose length at times threatened to bundle the body of the text off the page. Perhaps not surprisingly, the scope for scholarly ingenuity and imagination that iconology offered was also the source of the disrepute into which it has fallen. Panofsky himself was to become aware of the preposterous conclusions to which the indiscriminate application of iconology could lead as he saw his approach travestied by many less gifted followers.[1] Recent years have seen a reassessment of such practices and of the presuppositions, particularly regarding "disguised symbolism," on which iconology was based.[2]

A unifying thread seems to connect the various criticisms made of iconography; texts, in one way or another, have been implicated in iconographical malpractice. Much that is unsatisfactory in iconographical writing has stemmed from an excessive reliance on and a misuse of texts. This may be understandable, since the written word provides the milieu in which academics, even art historians, are most comfortable. The visual is more intractable, offering only

Excerpted from Brendan Cassidy, ed., *Iconography at the Crossroads: Papers from the Colloquium Sponsored by the Index of Christian Art, Princeton University, March 23–24* (Princeton: Department of Art and Archaeology, Princeton University, 1993), 4–11. Copyright © 1993, the Trustees of Princeton University. Reprinted by permission.

ambiguous answers to many of the questions that the text-bound historian is inclined to ask. However, it is not the appeal to texts for clarification of the meaning of an image that is the issue, for iconography would scarcely be possible without texts. It is rather the tendency to reduce art to illustration of particular kinds of texts and the inclination to account for medieval and Renaissance images as if they were verbal statements made by non-verbal means. Equally problematic is the failure to appreciate the complexity of the relationships between words and images.[3]

A major failing of a certain kind of iconographical writing was that it adopted a method popularized by Panofsky in his study of certain types of painting and applied it indiscriminately to all kinds and periods of art. Among iconographers it became normative to attempt to discover a textual source that would explain what an image meant at the time it was made. This approach is inappropriate for many types of image.[4] In addition, the texts among which meanings were sought were predominantly the writings of medieval churchmen, and classical authors and their humanist admirers; again this approach is warranted only in some contexts. Imaginative sleuthing among the byways of theology and literature may be justified when dealing with the imagery created for Dominican chapter houses and the *studioli* of Italian noblewomen. But the large numbers of people who looked upon frescoes in their parish churches, the merchants who commissioned altarpieces, and the ladies for whom books of hours were made were not intellectuals with minds well-stocked with abstruse learning. These audiences would have viewed images within frames of reference that had little to do with the bookish learning of monks or humanists.

What is true of the audience is equally true of the artist. With some notable exceptions (Mantegna, Leonardo, and Rubens come to mind), artists were rarely scholars. It was not for their learning that they earned reputations. The proper object of their talents was to represent the characters and events of history, mythology, and religion in ways that were visually compelling. They would have made the same complaint to the overzealous iconographer that Turner made of Ruskin, "He knows a great deal more about my paintings than I do, he puts things into my head and points out meanings I never intended."[5] Only occasionally would artists have had to resort directly to written sources,[6] or receive from the often cited but rarely sighted humanist or theologian detailed instructions about the subjects they were expected to represent.[7] For most commissions they would have drawn from a common fund of oral lore and pictorial tradition. Late medieval painters would have *known* how to represent the *Flight into Egypt* and *Saint Francis Receiving the Stigmata*. Renaissance artists would have known the story of Diana and Actaeon. If they had to refresh their memories, a few popular texts would have provided for most iconographic eventualities: the Bible, the *Golden Legend*, and Ovid's *Metamorphoses*. But mostly their acquaintance with the stories would have been acquired in less deliberate, non-literary ways. And left to his own devices, the

artist's sense of what was important in, for example, the account of a martyr's life would have as much to do with the pictorial possibilities of the narrative as any moral that the author or narrator of the text intended to convey.

The search for a moral or for some profound intellectual significance in images has bedeviled the study of iconography.[8] It has less to do with the medieval and Renaissance view of art than with the prevailing modern view that the function of art is to express emotions and ideas.[9] Only at some times, in some places, and in particular cultural milieux, were images created to convey philosophical propositions or subtleties of Christian doctrine. Medieval artists would have concurred with Dr. Johnson's observation that the visual arts are not well suited to communicate non-visual information and abstract ideas.[10] Altarpieces and portal programs make poor substitutes for Aquinas's *Summa Theologiae*. Artists were aware of this; they relied on texts in the form of inscriptions to ensure that their figures and scenes were correctly identified.

Audience, artist, and the medium itself, therefore, would seem to conspire against the once widespread notion that the thoughts and opinions of intellectuals consistently provide the most appropriate access to visual iconography. It has become clear that the meaning of works of art should be sought in a much wider range of human experience. Texts remain fundamental as evidence of historical lives. But it is in the poetry and letters, the chronicles and inquisition records as much as in the dry abstractions of the scholastic treatise that the tastes and attitudes of people are revealed.

They may not be revealed directly, however, for texts, as we now know, are slippery. Authors often do not say what they mean or mean what they say. Sometimes what they do not say is more revealing than what they do say. Often they say what they say because others said it before them. And frequently the people whom they address do not agree about what is being said.[11] The unreliability of the written word should serve to undermine iconographers' confidence that when they have found texts which seem to account for visual themes or motifs that their work is complete. The connection between texts and images is more intricate. In the first place, the relationship between a text and the subject of a work of art is not the same as the relationship between a text and the art object itself. Texts rarely inspire works of art directly. And although they frequently provide art with its themes, the visual and textual explorations of these themes evolve along different tracks that seldom run parallel. Sometimes they converge when the turns taken by one tradition are followed in the other. Occasionally they might even meet.[12] But at other times the visual and the literary traditions lead quite separate existences, and their independence has not been sufficiently appreciated. Someone claiming that a text is the source of an image must also be prepared to demonstrate that their similarity is not simply adventitious. The Christian and classical traditions are sufficiently rich that they will rarely disappoint a conscientious researcher who looks hard enough in the corpus of texts for a reference to just about anything that a painter might have included in his picture.[13] Likewise it requires

to be demonstrated rather than assumed that the meaning a textual com-
mentator assigns, for instance, to an episode from the Old Testament, is equally
applicable to its illustration in a work of art. Biblical exegetes offered con-
flicting, even contradictory interpretations of what texts meant. A more rig-
orous system of checks and balances needs to be applied in crediting texts
with the inspiration for pictures.

The issue of textual sources for images raises another problem that has
been ignored. Iconographers make use of those editions of texts (or conve-
nient translations of them) that scholarly consensus has decided are the stan-
dard ones. Even assuming that early painters or their advisors did refer to
texts for guidance, it was certainly not to the versions brought to us by Migne
or Loeb.[14] A considerable distance often lies between the convenient editions
on which historians rely and the manuscripts that they ostensibly represent.
This may not affect interpretation significantly, since artists rarely if ever ad-
here scrupulously to a text even on those occasions when they have recourse
to one, but it should introduce a note of caution.

Where does all of this leave the historian? The essentially textual culture to
which the scholar belongs stands at some remove from the essentially oral
and pictorial experience of the early artist. Much of the common knowledge
shared by peoples of the past has since passed out of currency and now has
to be learned, and reading remains the principal means of acquiring infor-
mation. This constitutes the root of the iconographer's dilemma. Books, the
tools of the scholar's trade, do not always provide the most appropriate way
of approaching the shifting and not readily circumscribable world of the early
artist. To bridge the cultural gap requires a sensitivity to this fundamental dif-
ference in the mental landscapes. Scholars may have to avail themselves of
texts to gain entry to unfamiliar subjects or to reconstruct the contexts in which
works of art once made sense. But they must also know when to let go of their
texts and approach images on their own terms and on terms that would have
been familiar to their creators. The elements of style (composition, line, and
color) are themselves meaningful in ways that have been insufficiently ex-
plored. Historians must accept that those who live by the pen and those who
live by the brush or chisel work to quite separate agendas, and consider care-
fully before ascribing to works of art ideas that more properly reflect their
own scholarly predispositions.

What then has been the response to criticism of iconography? One thing
seems certain: the once dominant principle of 'find a text and you've found
the answer' is no longer thought sufficient. Texts, of course, still provide the
clavis interpretandi that allows historians to pick their way through the semi-
otic fields in which the mute images of past ages are embedded, but they are
being used more circumspectly now than before. In the papers in this volume
the authors have drawn upon the evidence of texts in a variety of ways to il-
luminate the iconographic issues that have attracted their interest. There is
no common thread uniting their approaches. However, some of the papers

display tendencies that have emerged in iconographic research as a result of current scrutiny of the methods of art history. A concern with the audience is more apparent now than before, and that audience is recognized for the heterogeneous mix of rich and poor, male and female, literate and illiterate, cleric and layperson, that it was. Also, the meanings of works of art are no longer assumed to be the product of scholarly cerebration; their meaningfulness is now just as likely to be sought in their social function. The ways in which images affected people's behavior and how they used and responded to them has become as research-worthy as the pursuit of intellectual and text sources.

The paradigm, the shared set of beliefs and suppositions, within which iconographic research takes place is gradually changing. The notion of the intellectual artist or his advisor conveying a specific message across the ages to be received by an equally intellectual and objectively-minded scholar is being replaced by the recognition that the medieval artist, his original audience, and his modern interpreter are captives of their time, their class, their gender, their education, their prejudices, and whatever else contributes to make a human personality and social being. With the deck so heavily stacked against us no one now should believe that when we attempt to write history we are recreating the historical facts of the matter.[15] In art history this loss of innocence has perhaps taken longer than in some other disciplines. But now, with ideas derived from anthropology, semiotics, and reception theory, iconography is refashioning itself. New kinds of contemporary texts, other than the theological or philosophical, are being deployed to provide the frames of reference within which various classes of people might have made sense of what they gazed upon. What individuals saw in works of art did not necessarily correspond to the orthodox points of view that church or state or even artist might have preferred them to find. Confident certainty about what works of art mean is beginning to give way to a more modest and realistic acceptance of their ineluctable ambiguity. Indeed, the exploration of that ambiguity, beginning with the artist's own 'heteroglossia' and tracking the subsequent history of his work's reception, should increasingly become a fertile area of research.[16] Turning a critical eye on themselves, scholars of medieval art are already investigating the ideological baggage that accompanied the ideas and assumptions they inherited from their precursors in the discipline.[17]

NOTES

[1] Panofsky regretted that his method had been so misused, See Bedaux, *The Reality of Symbols. Studies in the Iconology of Netherlandish Art 1400–1800*, The Hague, 1990, 14.

[2] See, for instance, C. Harbison, "Religious Imagination and Art-historical Method: A Reply to Barbara Lane's 'Sacred versus Profane,' " *Simiolus*, XIX, 1989, 198–205. Panofsky himself has been subjected to a barrage of often intemperate, and sometimes unjustifiable, criticism; see especially D. Preziosi, *Rethinking Art History: Meditations on a Coy Science*, New Haven and London, 1989, 111–121. Ironically, in France, the homeland of much of the theory which some scholars would like to see replacing traditional art historical methodologies, Panofsky continues to enjoy

considerable prestige as a theorist; see the papers by various authors published by the Centre Georges Pompidou. *Erwin Panofsky*, Paris, 1983. He has even been mentioned in the past alongside Saussure in the pantheon of early semioticians by G. C. Agran, "Ideology and Iconology," *Critical Enquiry*, II/2, 1975, 299, 303; see also the remarks of M. Bal and N. Bryson, "Semiotics and Art History," *Art Bulletin*, LXXIII, 1991, 174; and C. Hasenmuller, "Panofsky, Iconography and Semiotics," *Journal of Aesthetics and Art Criticism*, XXXVI 1, 1978, 289–301.

[3] The literature on the relationship between texts and images continues to proliferate. For particularly cogent general remarks, see M. Curschmann, "Images of Tristan," in *Gottfried von Strassburg and the Medieval Tristan Legend. Papers from an Anglo-North American Symposium*, ed. A. Stevens and R. Wisbey, London, 1990, 1–17.

[4] The significance of the intertwined beasts that decorate Insular carpet pages, for instance, is not to be found in texts. Their prime purpose was ornamental (whatever the atavistic impulse that might have accompanied their first use among the artists of the Dark Ages). They may have had connotations beyond the purely aesthetic, but they did not emerge from the artist's mind and hand because of something he read or had read to him. See on this issue most recently F. Kitzinger, "Interlace and Icons: Form and Function in early Insular Art," in *The Age of Migrating Ideas*, ed. J. Higgitt and M. Spearman, Edinburgh, 1993; and R. Bagley, "Meaning and Explanation," *Archives of Asian Art*, XLVI, 1993.

[5] Quoted in A. Wilton, *The Life and Work of J. M. W. Turner*, London, 1979, 222. Of course, Turner's remark begs many questions, but this is not the place to delve further.

[6] Among the few scraps of evidence of how late medieval artists dealt with unusual iconographies is a payment to Ciecho de la Gramatica for translating from the Latin into the vulgar tongue the life of the little-known San Savino that Pietro Lorenzetti was expected to paint. See P. Bacci, *Dipinti inediti e sconsciuli di Pietro Lorenzelli, Bernardo Daddi, etc. in Siena e nel contado*, Siena, 1939, 92.

[7] Skepticism about the role of intellectual advisors in determining iconographic programs has been expressed by C. Gilbert, "The Archbishop and the Painters of Florence," *Art Bulletin*, XLl, 1959, 83–85; idem, *Italian Art 1400–1500: Sources and Documents*, Englewood Cliffs, 1981, xviii–xxvii; and C. Hope, "Artists, Patrons and Advisors in the Italian Renaissance," in *Patronage in the Renaissance*, ed. G. F. Lytle and S. Orgel, Princeton, 1981, 293–343. For a documented instance of theologians' involvement see most recently E. Hall and H. Uhr, "Patrons and Painters in Quest of an Iconographic Programme: The Case of the Signorelli Frescoes in Orvieto," *Zeitschrift fur Kunstgeschichte*, LV, 1992, 35–56.

[8] See on this most recently C. Harbison, "Meaning in Venetian Renaissance Art: The Issues of Artistic Ingenuity and Oral Tradition," *Art History*, XV, 1992, 19–37.

[9] Umberto Eco makes the point that demands of form rather than expression were more to the fore in medieval artistic practice and, "medieval theories of art are invariably theories of formal composition, not of feeling and expression." See U. Eco, *Art and Beauty in the Middle Ages*, trans. H. Bredin, New Haven and London, 1986, 41 (originally published as Sviluppo dell'estetica medievale," in *Momenti e problemi di storia dell'estetica*, I, Milan, 1959, 115–229).

[10] Boswell records the following conversation with Dr. Johnson:

> When I (Boswell) observed to him (Johnson) that Painting was so far inferiour to Poetry, that the story or even an emblem which it communicates must be previously known, and mentioned as a natural and laughable instance of this, that a little Miss on seeing a picture of Justice with the scales, had exclaimed to me, "See there's a woman selling sweetmeats;" he said, "Painting, Sir, can illustrate, but cannot inform."

See J. Boswell, *The Life of Samuel Johnson*, Everyman ed., London, 1906, vol. 11, 540. Pictures can, of course, convey information about the visible world much more satisfactorily than texts, but the thrust of Johnson's remark is surely correct.

[11] Theoretical writing on the reception of texts has become a growth industry. One of the clearest expositions of the question is R. Chartier's "Texts, Printing, Readings," in *The New Cultural History*, ed. L. Hunt, Berkeley and Los Angeles, 1989, 154–175.

[12] When, in the 1370s, for example, the *Visions of St. Bridget* began to circulate in manuscripts a new pictorial formula for the Nativity of Christ appeared in Italy. The motifs found in some of the paintings so closely mirror details of Bridget's description of Christ's birth that here the new iconography clearly owes its genesis to a text. On the influence of Bridget's Vision, see H. Cornell, *The Iconography of the Nativity of Christ*, Uppsala, 1924.

[13] The same point is made by Michael Baxandall, *Patterns of Intention*, New Haven and London, 1985, 132.

[14] See the remarks of S. Nichols, "Philology in a Manuscript Culture," *Speculum*, LXV, 1 1990, 1–9; and the introduction of L. A. Finke and M. B. Schichtman in *Medieval Texts and Contemporary Readers*, Ithaca, 1987.

[15] This is not the place (nor am I the person) to prescribe what it is we are doing as historians, but Thomas Kuhn's notion that it is the scientific community that validates sound knowledge, not any appeal to the natural world, seems equally applicable to history. In writing history we are hoping to secure the agreement of others in the interpretive community that our reconstruction of a state of affairs based on the evidence available corresponds to their understanding of how it might have been. In Kuhnian terms, this would constitute historical truth (though he would not use the word). See T. Kuhn, *The Structure of Scientific Revolutions*, 2nd ed., Chicago, 1970 and idem, *The Essential Tension*, Chicago, 1977, especially his essays "The Relations Between the History and the Philosophy of Science," 3–20 and "Second Thoughts on Paradigms," 293–319.

[16] For Bakhtin's concept of heteroglossia, see G. S. Morson and C. Emerson, *Mikhail Bakhtin: Creation of a Prosaics*, Stanford, 1990.

[17] The recent meeting of the College Art Association at Seattle (1993) included a session on medievalists such as Focillon, Alföldi, Katorowicz, and Saxl, in which their ideas about medieval art were shown to be deeply influenced by their own personal histories and aspirations.

Prologue to *Worldly Goods*

LISA JARDINE

Lisa Jardine is the author of several books and a frequent commentator on British television and radio. Her most recent book, written with Jery Brotton, is Global Interests: Renaissance Between East and West *(London: Reaktion, 2000). Jardine is Professor of English and Dean of the Faculty of Arts at Queen Mary and Westfield College, University of London.*

. . . Jan van Eyck's double portrait (Figure 10)—probably a commission from the Italian merchant Giovanni Arnolfini to commemorate his betrothal or marriage to Giovanna Cenami—is packed with details of acquisitveness in fifteenth-century Bruges. It invites the viewer's eye to dwell on the oriental rug, the settle and high-backed chair with their carved pommels, and the red-canopied bed, whose hangings echo the cloth and cushions on the chairs. Our eye is

Excerpted from Lisa Jardine, *Worldly Goods: A New History of the Renaissance* (New York, London, Toronto, Sydney, Auckland: Nan A Talese, Doubleday, 1996) 13–15. Reprinted by permission of the author.

irresistibly drawn to the lovingly painted, heavily worked fabrics of the bride's sumptuous green gown with its fur-lined sleeves heavy with tucking and stitching, the crimping of her lavishly layered headdress, the rich velvet, fur-edged over garment of the bridegroom. The strongly illuminated, discarded pattens or clogs indicate that their wearers were above stepping in the muddy Flanders streets. Behind the sitters hang the much described convex Venetian mirror, its frame inset with enamelling and decorated with painted miniature scenes from Christ's Passion, and an ornate brass chandelier with a single flaming candle. At the feet of the couple the miniature lap-dog looks out at us with kitsch curiosity.

This is not a record of a pair of individuals; it is a celebration of ownership—of pride in possessions from wife to pet, to bed-hangings and brasswork. Such paintings have been called 'realistic portraiture', but surely this misses the point. Only the face of the male subject is (possibly) real—really a portrait. The woman's figure is a perfect stereotype, virtually identical to other female figures in other paintings, down to her face and expression. She is as much a model of womanhood(owned with pride by her wealthy spouse) as the carved saint on the pommel of the chair. Both can be matched in contemporary pattern-books—ledgers of commodities for future design and circulation. We are expected to take an interest in all this profusion of detail as a guarantee of the importance of the sitter, not as a record of a particular Flemish interior.

The composition is a tribute to the mental landscape of the successful merchant—his urge to have and to hold. . . .

CHAPTER 8

Anti-Semitism and Stereotypes

Art is not always about "truth and beauty." It often is about lies and ugliness. Throughout history, negative stereotypes have been created by dominant elements of societies as tools for use in maintaining power over people who are in some way different.

The excerpt from Jan Pieterse's *White on Black* deals with the way African Americans were stereotyped in nineteenth- and early twentieth-century America—an instance of stereotyping that is probably familiar to all of us. Henry Kraus introduces anti-Semitic stereotypes of the Middle Ages. The issue is essentially the same: By dehumanizing the people they represent, distorted images have often served to justify discrimination, violence, slavery, and even genocide.

Anti-Semitism in Medieval Art

HENRY KRAUS

Henry Kraus was a highly acclaimed journalist and historian of the American labor movement. He was also the author of four books on medieval art. The recipient of a prestigious MacArthur Foundation Fellowship, Kraus lived in Paris from 1956 until his death in 1995.

. . . The position of the Jews within the Christian community had been steadily deteriorating from its relatively favorable status earlier in the Middle Ages. Under Charlemagne and especially his successors, Jews had large acceptance in the social order. They were permitted to build synagogues and Christians were even said to have visited their services while priests discussed the Old Testament with rabbis.[1] In Southern France likewise the position of the Jews was excellent, stemming here, too, from the early friendliness of Charlemagne, to whom they had rendered important services against the Saracens. As a reward the emperor granted them one third of the city of Narbonne, from which they eventually operated a fleet. The Jews' right to own land in Languedoc—with full hereditary privileges—is documented as far back as the tenth century[2] and was still referred to with pride, in 1170, by Benjamin da Tudela, the famous traveler and diarist, who told of one wealthy Jew of Narbonne, who owned landed property "of which nobody can deprive him by force."[3]

This situation in Southwest France continued into the thirteenth century though the Albigensian "crusade" was fated to cause a drastic deterioration. Jews in this area served as administrative officers for prelates and counts, enjoyed rights in the secular and ecclesiastic courts, and in contractual proceedings were allowed to take their oath on the Book of Moses.[4] Their culture flourished. They founded schools of their own and together with Moslem physicians established France's first medical faculty, at Montellier. Even in Northern France Jews owned land and vineyards and ran their own communities in the towns by elected provosts. They were admitted to the royal court and were befriended by scholars, Abélard telling in one of his letters to Héloïse of consulting a rabbi on the meaning of an obscure passage in Kings.[5]

Though theological reasons are usually emphasized for the rise of medieval anti-Semitism, there is little doubt that strong economic and even political motives were also at play. In Carolingian times, when Western Europe was all but landlocked, the Jews had an essential economic role, serving as virtually

Excerpted from Henry Kraus, Chapter VII: "Anti-Semitism in Medieval Art," *The Living Theatre of Medieval Art* (Philadelphia: University of Pennsylvania Press, 1967), 146–62.

the sole trading tie with the outside world. The swift economic development of the West beginning in the eleventh century radically changed this situation. In manufacturing and commerce, the Christians, who represented the overwhelmingly dominant segment of the population everywhere began to take the lead. Wherever Jews had an entrenched position, as in Italian silk manufacturing, they were assailed by discriminatory taxes or simply confiscated out of competition. Their participation in the fairs and markets of Northern France was finally restricted to money changing and selling old clothes.[6]

This steady attack on the Jews' economic position was accentuated by the Crusades. The enormous cost of these undertakings caused the eyes of their leaders to turn almost automatically to the Jews, who possessed much liquid wealth. In England, in preparation for the Third Crusade (1189–1192), they were asked to contribute the then immense sum of 60,000 pounds; the whole of the rest of the country, only 70,000.[7] The violently anti-Semitic sentiments stirred up during each Crusade furnished the appropriate setting for this spoliation. During the Second Crusade Pope Eugene III had ordered a moratorium on interest payments for debts owed to Jews by those taking the Cross. Peter the Venerable, abbot of Cluny, urged rulers to go even further and despoil Jews of all their property "so that the money of those cursed ones may at least serve a useful purpose in helping to combat the Saracens."[8] But Peter himself was not above borrowing from the Jews when he was in financial straits, giving them as security "precious objects from the sacristy, in particular the gold plate coverings of a crucifix."[9]

Philippe-Auguste followed Peter's counsel to the letter, declaring debts owed to Jews forfeit, but he charged the debtors twenty per cent for their deliverance. In 1181 he expelled the Jews from the royal domain, confiscating all their real property, including their synagogues which he turned over to Bishop Maurice de Sully. One of these, consecrated to Mary Magdalene, served for hundreds of years as one of Paris' leading churches. After this expulsion the Jews paid for their reentry some years later, thus beginning that pathetic cycle of confiscation, expulsion, and paid readmission that served the kings for generations until their victims were mulcted of their substance.

In certain areas of Western Europe, particularly along the main pathways of the Crusades, violent physical attacks on the Jews were added to their expropriation. This came close to genocide in West Germany, where during the First Crusade (1096–1099) within a few days an estimated 12,000 Jews were massacred.[10] Many more died by their own hand. In the Second Crusade (1147–1149) a Cistercian monk, Raoul, organized mass pogroms, inciting his followers with the cry: "We are marching a great distance to . . . take vengeance on the Moslems. Lo and behold, there live among us Jews whose forefathers slew [Jesus] and crucified him for no cause. Let us revenge ourselves on them first. . . ."[11] Raoul's mob incitement brought a blistering condemnation from St. Bernard, for which humanitarian act Jews are said to have expressed their gratitude by naming many of their sons after the great ascetic.[12]

The social status of those Jews who remained alive was profoundly degraded during this period. The walled ghetto became generalized and the Jews' confinement inside it during important Christian holidays was as much protective as discriminatory. Even so, Christian youngsters were allowed to climb the ghetto walls on Good Friday and throw stones at the Jews, a "right" that Bishop Guillaume of Béziers remitted, in 1160, in return for the payment of an annual tax. The "droit du soufflet," or privilege of slapping Jews on. Easter, was also bought off in various places, as in Toulouse, by payment of an impost and the "gift" of forty-four pounds of wax for Good Friday candles at the church of Saint-Étienne.[13] The Jews at Arles, in 1178, won protection by pledging to finance the building of a bridge.[14]

Discriminatory practices against the Jews were formalized, under the encouragement of Pope Innocent III, at the great Lateran Council of 1215, where a special mode of dress and an identifying emblem were prescribed for them. Thus originated the infamous yellow wheel, which was to be worn for six centuries.[15] If the yellow wheel was left off by Jews, St. Louis had the clothes confiscated and given to the person who reported the violation. Philippe-le-Hardi, his son, added the pointed hat to the prescribed attire, bringing the Jews further insults and attacks. Not daring to go on the road thus clothed, they were eventually allowed to buy off the requirement when away from home.[16]

This broad program of isolation and eclipse ended by almost completely divorcing Jews from the Christian community. They had been merchants, vintners, coiners, innkeepers, masons, tanners, bakers, tailors, butchers, goldsmiths, glaziers. In the East Benjamin da Tudela had found them manufacturing handicrafts in Salonika, silk cloth in Constantinople, and the "far-renowned Tyrian glass" at New Tyre. The Jewish communities in the Holy Land, now quite small, almost all practiced the dyer's trade, this careful observer reported.[17] But most of this variety in Jewish economic activity was to disappear before the end of the Middle Ages and the status of the petty usurer was imposed upon the Jew. Reflecting this trend, he was depicted in art as point-hatted and bearded, hook-nosed and meanly clad, his recognizable image that continued to be used all the way into modern times [Figure 11]. . . .

The Jew was rendered repulsive in medieval art either by physical distortion or by his role, or by both. His caricatured stereotype goes far back in Christian annals, the early Greek Father, St. John Chrysostom, having devoted eight virulent sermons to this purpose in the fourth century. He accused the Jews of sacrificing their sons and daughters to devils and of committing other unspeakable outrages, for which God rejected them. "When it is clear that God hates them, it is the duty of Christians to hate them too," he declared. It has been said that Chrysostom's savage description of the Jews was meant to discourage Christians from being friendly with them and this seems to have been a perennial preoccupation with ecclesiastics.[18]

It was later on in the Middle Ages that the actual plastic image of this caricature began to take form, such as we find it in Hildegarde of Biingen's famous

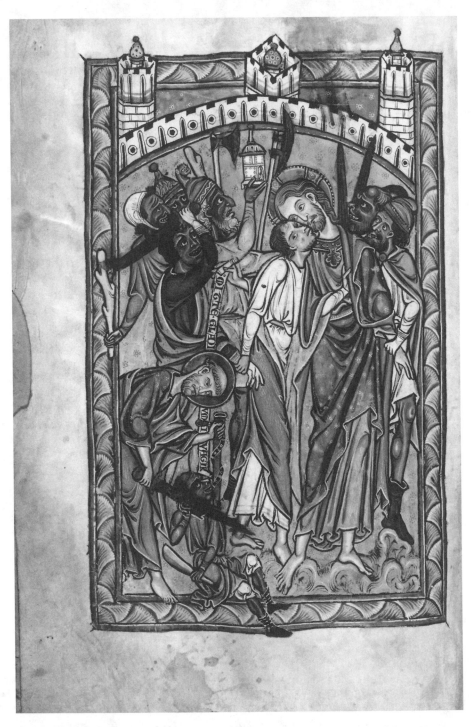

Figure 11. *Betrayal and Arrest of Christ*, Chicester Psalter, MS Lat, 24 folio 150 verso. The John Rylands University Library of Manchester, Manchester, England.

manuscript or in the Forest Roll or Essex, where a Jew is presented in a sketch as a hooded, mean, bearded little man with a hooked nose that arches over to his lip. He is handled in much the same way in editions of the *Biblia Pauperum*, the popular Bible in Pictures that began appearing in the late thirteenth century.[19] More important, however, was the art in the churches which was open to the gaze of all.

The story of Christ presented a number of other episodes in which animosity to the Jews could be underscored. In his Expulsion of the Tradesmen from the Temple, for example, a Jewish money changer is often shown (as at Saint-Gilles) raising his coin bag jeeringly toward the Savior. In the Taking of Christ on the Mount of Olives, Judas is not the only Jew accompanying the Romans to their prey. There are others, too, with murder in their wild eyes [Figure 11]. . . .

Tolerance for the "crimes" of Judaism did not characterize the Church during the Middle Ages. Whatever the views held as to the ultimate fate of the Jews nothing could erase from Christian consciousness the belief that they had been responsible for the Savior's sufferings and death.[20] Church art and liturgy certainly never allowed the faithful to forget this. Even when accepting the doctrine that the Jewish people must be preserved so that they could illustrate "the living words of the Scripture,"[21] the idea might be advanced that only "a few" of them were needed for this purpose. And the Jews were not to win honor by this consideration, moreover, but rather only "to give living witness of their own shame and their crime in spilling the divine blood of Christ."[22]

This terrifying accusation, which runs like a black thread through so much of medieval Christian thought, was given a strong contemporary accent at sessions of the recent Ecumenical Council. A Church spokesman there, Cardinal Bea, while calling for the formal abandonment of this accusation, referred candidly to "the old and extremely strong anti-Semitic tradition in the Church," which had allowed Nazi propaganda to insinuate itself "even among Christians," thus facilitating the murder of "hundreds of thousands of Jews."[23]

Among the various elements that have had a share in fostering these anti-Jewish sentiments among Christians, the role of medieval art has been far from negligible. Much of it is great and moving art in other respects but the anti-Semitic content is often so familiar, so taken for granted, that it is easily overlooked, contributing in this manner to those automatic responses, which have for many centuries remained tragically unchanged.

NOTES

[1] Joshua Trachtenberg, *The Devil and the Jews* (New Haven: Yale University Press, 1943), p. 165.

[2] Gustave Saige, *Les juifs du Languedoc antéement au XIV sécle* (Paris: A. Picard, 1881), p. 64.

[3] *The Itinerary of Rabbi Benjamin of Tudela*, ed. And transl. A. Asher (London and Berlin: A. Asher, 1840–41), p. 32.

[4] Saige, p. 53.

[5] J. G. Sikes, *Peter Abailard* (Cambridge, England: The University Press, 1932), p. 30.

[6] Israel Abrahams, *Jewish Life in the Middle Ages,* (London: Macmillan, 1896), p. 241.

[7] Salo W, Baron, *A Social and Religious History of the Jews,* IV (New York: Columbia University Press, 1957), p. 81.

[8] Hitsch Grätz, *Histoire des juifs,* IV (Paris: A. Lévy [A. Durlacher], 1882–97), p. 102.

[9] Georges Duby, "Le budget de l'abbaye de Cluny entre 1080 et 1144," *Annales: Ecomomies, Sociétes, Civilisations,* VII (1952), p. 155–72.

[10] Grätz, pp. 75 ff.

[11] Baron, p. 102.

[12] *The Letters of St. Bernard,* No. 393.

[13] Saige, p. 11

[14] Victor Mortet et Paul Deschamps, *Receuil de textes relatifs a l'histoire de l'architecture et à la conditiondes architects en France au moyen-âge, XII et XIII sècles,* II (Paris: A. Picard, 1929)Document, LXI, 134–135.

[15] Grätz, p. 168.

[16] Henri Sauval, *Histoire et recherches des antiquités de la ville de Paris* (Paris: L. Moette, 1724) p. 523.

[17] Abrahams, p. 218.

[18] James W. Parkes, *The Conflict of the Church and the Synagogue, a Study in the Origins of Anti-Semitism* (London:The Soncino Press, 1934).

[19] Joseph Reider, "Jews in Medieval Art," in *Essays on Anti-Semitism,* ed. Koppel S. Pinson (New York: Conference on Jewish Relations, 1946), p. 100; and Trachtenberg, p. 27.

[20] Weber, p. 63.

[21] *The Letters of St. Bernard,* No. 393.

[22] Raul Glaber, "Chronique," in F.-P.-G. Guizot, *Collection des mémoires relatifs à l'histoire de France,* VI, (Paris: Depot Central de la Librairie, 1824), pp 267–68.

[23] Henri Fesquet, "L'attitude des chréhtiens enver les juifs et envers la liberté religieuse a l'ordre du jour de Vatican II," *Le Monde* (November 21, 1963), p. 1.

Introduction to *White on Black: Images of Africa and Blacks in Western Popular Culture*

JAN NEDERVEEN PIETERSE

Jan Nederveen Pieterse is a sociologist who specializes in globalization and development theory. His recent publications include World Orders in the Making *(New York: St Martin's Press, 1998) and* Global Futures: Shaping Globalization *(London and New York: Zed Books, 2000). He is Associate Professor at the Institute of Social Studies, The Hague.*

In a world that is becoming smaller and societies that are becoming multicultural, it may be time for western culture to examine itself critically in terms of its view of other cultures. For how much of western culture is made up of prejudices about other cultures, how much of western identity is constructed upon the negative identity of others? Past fears and antagonisms are encoded in images and symbols, in sayings and rationalizations, which set self and other apart, in ways which may no longer be part of our mentality but which do form part of our ambience and cultural baggage. Is it not time, then, for a spring cleaning of intercultural images, of alienating images between cultures and 'races' which have long since outlived their relevance?

Decolonization in a political sense has occurred, and a process of intellectual decolonization has also taken place, in the sense that critical perspectives on colonialism have become more and more common (even though there are countercurrents to this trend as well)[1]. What remains to be addressed, however, is cultural decolonization. The legacy of several hundred years of western expansion and hegemony, manifested in racism and exoticism, continues to be recycled in western cultures in the form of stereotypical images of non-western cultures.

Since the rise of the American civil rights movement many stereotypes of blacks are no longer acceptable in the United States and have vanished from advertising and the media. Although no European country has ever experienced such a movement, or had so large a minority of blacks within its borders, this has begun to change since the postwar migrations. This does not

Excerpted from Jan Nederveen Pieterse, "Introduction," *White on Black: Images of Africa and Blacks in Western Popular Culture* (New Haven and London: Yale University Press, 1992). Reprinted by permission of the publisher.

mean that the problem is new to Europe or that Europeans have been justified in thinking that it was only an American problem. In a sense, America has all along been the arena of European racism: for it was the slaves of Europe who were put to work in the West Indies and America, in European colonies and on plantations. The racism that developed is not an American or European problem but a western one.

Momentous and tragic turns in history are often marked by monuments or commemorations which serve as beacons in social consciousness. What of the tragic episodes in relations between the West and the non-western world, notably in relations between Europe and Africa and between whites and blacks! Does the absence of any such commemoration mean that our awareness of our common humanity has simply not developed far enough?

White on Black

It has often been observed that 'race' is not a reality but a social construct. That is the point of departure of this book. In his study of the 'Jewish question', Jean-Paul Sartre wrote, 'Do not ask what the Jews are, but what we have made of the Jews'.[2] This applies equally to images of Africa and blacks. This book, to be precise, is not simply about images of blacks, but about white people's images of blacks [Figure 12]. Blacks might say of such images, they are about us, but from outside us. It is not that the images provide no information about blacks, but that the information is one-sided and distorted. They convey allegories of the relations between Europe and Africa, and between whites and blacks, viewed from the standpoint of Europeans and whites. The relations depicted are not those of dialogue but of domination. . . .

'White on Black' indicates a relationship, and the order of the terms identifies the dominant partner, the producers and consumers of the images in question. Accordingly, this study is quite different from what one titled 'Black on White' or 'Black on Black' would be. Images produced by Africans and blacks of Europeans and whites are occasionally mentioned, but not covered systematically in the discussion. Those are completely different topics.[3] They require an entirely different treatment, for they concern an altogether different type of historical relationship, which cannot be equated with white-black relations. The images produced by the subordinate party are of a different order from those of the dominant party; they too are stereotypes, but they carry different weight and meaning. Africans did not traffic in European slaves for three hundred years, nor have they occupied the dominant place in the world's political, economic and cultural system. Several hundred years of western hegemony lends western images a range, complexity and historical weight which images stemming from Africa and from blacks do not possess.

Figure 12. Hand fan from Club Plantation, St. Louis, MO. Private collection.

The question that keeps arising is, what interests of whites are being served by these representations? This refers not merely to measurable economic and political interests but also to relations of a subtler nature in cultural, emotional and psychological spheres, and to the various ways in which these relations figure in the phenomenon of subordination. Generally, in examining images of 'others', one has first to ask, who are the producers and consumers of these images, and only then to question who are the objects of representation. The key that unlocks these images is what whites have made of blacks, and why.

The phrase 'White on Black' refers to the whole spectrum of relations in which western interests were dominant—the trans-Atlantic slave trade, master-slave relations on plantations in the Americas, colonialism, the postcolonial era, and majority-minority relations in the western world. In each of these situations Europeans constructed images of Africa and blacks on the basis of selective perception, expedience, second-hand information, mingled with reconstructed biblical notions, and medieval folklore, along with popular 'scientific' ideas that were current at the time.

That this book concentrates on images rather than only on ideas or discourse gives it a different focus from that of other studies. On the one hand, images are situated in the midst of historical processes, of ideas and discourse; on the other, they tend by their individual character to be bold, telegraphic evocations by which many layers of meaning and cross-references are conveyed. From time immemorial, as religious art testifies, images have played a key role in the general transmission of culture.[4] In an age of communications media the role of images has become all the more potent.

A Study in Stereotypes

In the 1930s in the United States, white children were tested by being shown a picture of a library. After glancing at it they had to answer a number of questions, among them: What was the Negro doing? In fact, there was no negro in the picture, but the answers all ran: He is busy scrubbing the floor, He is dusting the bookcases. No one answered: He is reading a book.[5] From the same period dates an experiment in which the social psychologist Kenneth B. Clark gave black children two dolls, one white and one black, and asked them which they preferred. A large majority chose the white doll. In 1989 in Atlanta a follow-up research took place, in which black children were shown pictures of identically dressed children, one black and one white. Asked to say which of the two was clever and which was stupid, ugly or handsome, dirty or clean, the greater number pointed to the black children as the ugly, dirty and stupid ones.[6]

These are examples of the consequences of stereotyping. The first example illustrates the unconscious consequences of role expectations; the second

relates to consequences of the self-image of black people in white society. The follow-up study sought to measure the effect of the 'Black is Beautiful' episode, and the results seem to indicate that in this regard little has changed in the United States.

In cognitive psychology stereotypes are taken to be schemas or sets which play a part in cognition, perception, memory and communication.[7] Stereotypes are based on simplification and generalization, or the denial of individuality; they can be either negative or positive. Though they may have no basis in reality, stereotypes are real in their social consequences, notably with regard to the allocation of roles. They tend to function as self-fulfilling prophecies. The targets of stereotyping are maneuvered into certain roles, so that a vicious circle develops, in which social reality seems to endorse the stereotype. Social representation echoes social realities which are in turn modelled upon social representation.[8] A kind of societal typecasting is set up from which it is difficult to escape. Thus, as long as women are stereotyped as being more emotional than men and devoted essentially to child-rearing and cooking, they will not be given much leeway in social relations and institutions outside these role patterns. The present study is concerned with visualized prejudices held in the West about Africans and blacks, for instance that they are 'closer to nature', more emotional, sexually uninhibited, more musical, childlike, superior athletes, and so forth. Obviously, what is at stake in these representations is not just the images themselves but also their social ramifications.

Emancipatory movements are concerned not just with changing social realities but also changing representations. Women's movements oppose not merely inequality in social opportunities but the stereotypes that accompany and sanctify it. By the same token, the resistance to emancipation tends to be of two kinds: resistance to change in the present distribution of roles, on the grounds that certain stereotypical features are 'inherent' in group X; and dismissal of any criticism of the stereotypes by referring to the social realities which confirm them.

It is sometimes conceded that a particular stereotype or prejudice exists, but that it is widespread, that it has any effect, or that one subscribes to it oneself, is denied. Often the existence of stereotypes is denied, for from the point of view of the mainstream stereotypes appear to be 'normal' and the resistance to them as 'abnormal'. In as far as stereotypes form part of the psychological and cultural furniture of those in society's mainstream, to criticize them is to undermine the comforts of mainstream existence. From the point of view of the comfortable strata of society, and those who aspire to join them, no problem exists; there is a problem only from the point of view of those on the margins.

Sometimes stereotypes are held to be true, and in fact a kind of primal image or archetype, in other words, not an expression of prejudice but rather a reflection of the inherent essential characteristics of the group in question.

Thus, as some would say, is it not true that black people are musically and rhythmically gifted, can dance well, are cheerful, and are as it were closer to nature, which is logical in view of their tropical origins? Is it not true that blacks are different, not better or worse, but different? This kind of reasoning has peculiar consequences. In the first place, it transforms a negative stereotype into a positive one. A difference is promoted from being a stigma to becoming a badge of honour, but it remains a stereotype, based on simplification and generalization. In the second place, European images of Africa have, as we shall see, undergone numerous drastic modifications. In view of the multiplicity of stereotypes, which would be the archetype? The Ethiopian Eunuch or Superspade? The King of the Moors or Uncle Tom? Saint Mauritis or the Golliwog? To equate stereotypes with archetypes is to remove them from history; to do so means that the social conventions, the clichés of the day, must be taken to be profound truths. According to this logic, pin-ups and magazine centre-folds of women attest to the fact that seductiveness is the essence of femininity. Another fallacy of the view that equates stereotypes with archetypes is the same that holds for theories of race: while it is true that there are differences among groups, the differences *within* a group or category are greater than those *among* groups or categories.

Social representations arise out of a multiplicity of historical contexts and configurations, and therefore cannot be reduced to a few simple schemas. If one were to try to discern all underlying structure—for instance, 'nature and culture'—in the variety of images, the structure itself would turn out to be made up of many historical constituents, the meaning of which has been changing over time. For these reasons, in order to dispel the 'enchantment' of stereotypes, I emphasize in this study not their durability but their changeability, the historical relativity of social representations and the fact that images of blacks, like ideologies of 'race', are social constructions.

This book is a study of images and power, an enquiry into the social rhetoric of images. It is concerned with such questions as, how are relations of dominance constructed and reproduced in popular culture, how are they normalized and routinized in word and image? By what are they marginalized and subjected, identified, labelled, kept in their place? How do caricature and stereotype, humour and parody function as markers of social boundaries and devices of domination?

Stereotypes are but one link in the multiple chains of social hierarchy. Decoding social representations is a necessary but not sufficient condition for improving the position of stereotyped groups. The elimination of stereotypes in the public realm in the United States has shifted public norms, but social relations *vis-á-vis* racism have not radically changed. To achieve that will take more than a sanitisation of social representations. . . .

NOTES

[1] E.g., Fukuyama, F. "The End of History?" *The National Interest* IV summer 1989, pp. 3–18.

[2] Sartre, J-P., *Réflexions sur la question juive*, Paris, 1st ed. 1946.

[3] An exhibition devoted to African images of Europeans was held in the Munich Stadtmuseum in 1983; see Jahn, J. *Colon: das schwarze Bild von weissen Mann*, München, 1983. On African images of Africa, see e.g., Mazrui, A. A., *The Africans: A Triple Heritage*, London, 1986. On black on black, Harris et al., *The Black Book*, New York, 1974.

[4] See Gombrich, E. H., *Symbolic Images: Studies in the art of the Renaissance*, London, 1972.

[5] Described in Wertheim, W. F., *Het rassenprobleem: De ondergang van een mythe*, Amsterdam, 1948, p. 54. With thanks to the author.

[6] B. Carter, 'Black Americans Hold a TV Mirror up to Their Life', *New York Times*, 27 Aug 1989.

[7] A schema is a 'cognitive structure that represents an organized knowledge about a given concept or type of stimulus'. Fiske and Taylor, *Social Cognition*, New York, 1984, p. 140.

[8] Moscovici, "On social representations," in J.P. Forgas, ed. *Social Cognition: perspectives on everyday understanding*, London, 1981, 181–209.

CHAPTER 9

The Renaissance Portrait

Even a relatively simple painting such as Ghirlandaio's *Portrait of Giovanna Tornabuoni (née Albizzi)* [Figure 13] can be viewed in a variety of ways.

Bruce Cole, for example, locates the picture within the larger stylistic development of Renaissance portraits and relates its commemorative function to the celebration of individuality that was one of the hallmarks of Renaissance humanism.

To Patricia Simons, on the other hand, this passive, objectified image has little to do with individuality. She argues that such stereotypical images, created by men for men, were closely tied to the rigid social conventions of the day.

Renaissance Images and Ideals

BRUCE COLE

Bruce Cole is Distinguished Professor in the Henry Hope School of Fine Arts at Indiana University. He is the author of many scholarly articles and a dozen books on Italian Renaissance art. The recipient of numerous awards and fellowships, in 1992 Cole was appointed to the National Council on the Humanities.

Renaissance Images and Ideals

Liturgical, moral, decorative, political, dynastic—art was one of the chief conduits of the dreams and realities of the men and women of the Renaissance. It expressed individual ideals and expectations, it shaped public identities, it educated and instructed citizens, and, on occasion, it even performed miracles.

The Renaissance artist was an image maker in every sense: he both expressed and created the consciousness of society in his work. Nowhere can this be seen more clearly than in the art of portraiture. Beyond the individual and his or her appearance and position in Renaissance society, we can, from depictions of ancient and modern history and from representations of contemporary places and events, discover something about how the society of the Renaissance saw itself and how it viewed the past and the future.

The portrait was one of the most widespread and important types in the Renaissance.[1] Virtually extinguished in the long centuries after the fall of the Roman Empire, its renascence began in the early years of the fourteenth century, when historical and contemporary figures were represented with some frequency. These were not actual portraits of the individual's face, but rather depictions of types: old, middle-aged, handsome, ugly, and so forth, much in the way the saints were represented as stock characters. So, for example, Simone Martini's *Guidoriccio* is the representation of a type—a middle-aged soldier of fortune—rather than an accurate reproduction of the body and face of the individual.

This convention of portraiture started to change about the middle of the fifteenth century, when artists began to approximate the face of the sitter. Often idealized and usually highly schematized, nevertheless these early portraits

Reprinted by permission from Bruce Cole, *Italian Art 1250–1550. The Relation of Renaissance Art to Life and Society* (Boulder, CO: Icon Editions/Westview Press, 1987), 217–20. Copyright © 1987, Bruce Cole.

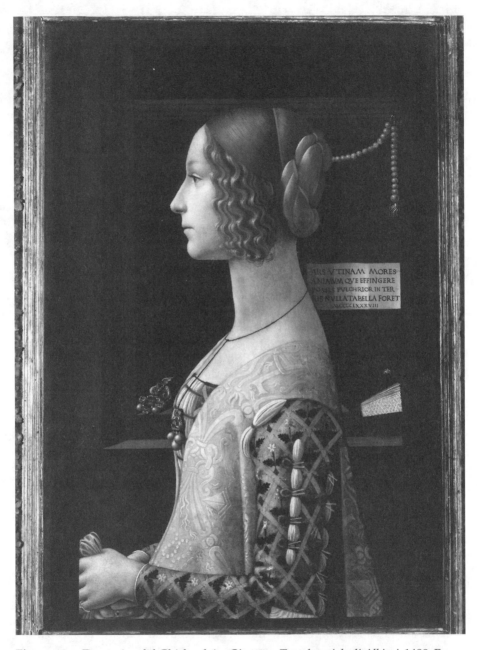

Figure 13. Domenico del Ghirlandaio, *Giovanna Tornabuoni degli Albizzi*, 1488. Foundation Schloss Rohoncz, Lugano, Switzerland. Photo: Alinari/Art Resource, NY.

strove to record the actual face. Of course, this was not the first time in the history of European art that realistic or quasi-realistic portraiture appeared. The Romans were fascinated with the face, as the hundreds of surviving portrait busts of Roman men and women, some of them unflinchingly realistic, demonstrate.[2] [See Chapter 4 and Figure 4.]

The reemergence of the realistic portrait had many impetuses. Certainly, it had much to do with a new awareness of the worth and uniqueness of the individual and a desire to leave a record of one's likeness. Little is known about the function of many of the early portraits, other than the fact that they were displayed in the home, but they often must have had a memorial purpose. Many of the portraits appear to have been painted after the sitter died, but even those done while he or she was alive must have been intended mainly to preserve the likeness of the person after his or her death. The early Renaissance believed intensely in the magic power of images; such portraits were thought to capture some of the spirit of the sitter.

A portrait of a young man, now in Chambéry, attributed to Paolo Uccello and probably painted about 1450, exhibits many of the characteristics of the early portrait type. Perhaps the most conspicuous feature of this portrait is its strict profile, used by the artist to make a pattern of the outlines of the face, turban, and tunic. The artist delighted in these abstract shapes and was, in fact, more interested in them than in a realistic portrayal of the young man's face. No doubt we would recognize the man from his portrait if we met him on the street, but much of the stereotypical, formulaic qualities of the earlier, nonrealistic types remain.

In fact, the Chambéry portrait gives us only the barest essentials of the man it portrays. If one compares it to a Flemish portrait of the same period that presents the sitter full face, a striking difference between the two is evident at once.[3] A northern portrait intimates the sitter's mood and something of his personality and the way his mind works, often in a highly detailed, resolutely realistic representation. The early Florentine portraits, instead, are more like anthropomorphic coats of arms; they are images of the sitter's face and clothes reduced to their most essential qualities. They tell us what the sitter looked like, how he dressed, and, from the clothes and the occasional inscription, something about his social station. The strict profile prevents us from meeting the sitter face to face and, consequently, from learning much about him as a person.

In many cases, the strong emphasis on form produces portraits of extraordinary, almost abstract beauty. In Domenico Ghirlandaio's portrait of Giovanna degli Albizzi [Figure13], painted about 1490, the shape made by the face functions in the same way as the pattern on the costly dress or the severe rectangle of the window. Once again, we would recognize the face; but we would have little clue as to what this lovely young woman was like.

Much of the aloofness we so strongly sense in this superb portrait comes from the artist's keen understanding of its memorial function. In 1488, Giovanna died in childbirth; Ghirlandaio's portrait of her, taken from a similar

image in a fresco cycle he did in the Florentine church of Santa Maria Novella about 1490, is posthumous. The inscription behind Giovanna reads "O art, if you were able to depict the conduct and the soul, no lovelier painting would exist on earth," and it is dated 1488, the year of her death.

Certainly, then, this is a memorial portrait, a splendid visual record of the essential features of the commemorated woman. It must have been valued for its beauty, but its major function was as an object preserving something of Giovanna's appearance for future generations, a fragment of immortality.

During the second half of the fifteenth century, an important change in portraiture took place. The face of the sitter turned from a strict profile to a three-quarter or a full face. This development took place slowly and sporadically, but it is seen in many examples of the type. Apart from its formal implications, the shift from profile to three-quarter or full face marks a dramatic change in the meaning and purpose of the portrait.

The new positions of the sitters bring them closer to the viewer; they begin to make eye contact with those who look at them. A new and more personal relation is achieved as the spectator begins to glimpse the personality and mood of the painted person. The history of the portrait, both painted and carved, from mid-century onward is, generally speaking, one of increasing contact between the sitter and viewer, and the emotions and personality of the sitter are often keenly felt.

The developments in painted portraiture can be traced in sculpture as well. The carved stone portrait became increasingly popular after the middle of the fifteenth century. Such portraits had not been made in the Italian peninsula since late-Roman times, and, in fact, their revival may have been partially motivated by the Renaissance passion for the antique. In imitation of the Romans, who revered portraits of their ancestors, Renaissance citizens from bankers to popes commissioned sculptors to carve likenesses of themselves and their relatives.

The bust of Battista Sforza, duchess of Urbino, by Francesco Laurana, is a three-dimensional translation of the spirit and aesthetic of the early painted profile portraits [Figure 14]. The same highly stylized, almost obsessive rendition of flesh into shape is seen in many of the carved busts from the second half of the fifteenth century.[4]

But Laurana's bust is much more than an elegant form. It is the transformation of a mortal being into an icon. Like the tragic Giovanna in Ghirlandaio's painted portrait, Battista Sforza is a beautiful but remote image. The perfection of her highly abstracted and delicately carved face, with its nearly pictographic features, gives her a serene, almost mystical, otherworldly beauty. This is a memorial to the spirit rather than to the flesh. In fact, it was carved about 1475, after the sitter's death: Laurana probably based his image on a painting by Piero della Francesca. . . .

Laurana's image of Battista Sforza almost certainly came from a painted portrait; but other artists used death masks to create memorial images. Death (and life) masks were cast directly from the face by applying a coat of plaster

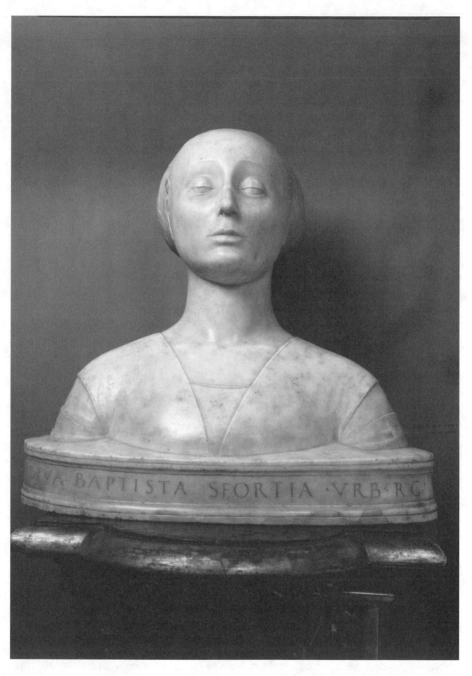

Figure 14. Francesco Laurana, *Battista Sforza*, c. 1473. Bargello, Florence. Photo: Scala/Art Resource, NY.

over the skin. Such masks were made with some frequency in the Renaissance, and their existence testifies to the same sort of memorializing impulse that lies behind the carved and painted portrait. It is not known if these masks were displayed; however, many of them may have been made to serve as models for later painting and sculpture.[5]

Regardless of its abstraction and formal refinement, the bust of Battista Sforza confronts the viewer face to face and assumes therefore a different relation with him than does the profile portrait; it is this face-to-face, eye-to-eye confrontation that also begins to appear in painted portraiture about 1450. . . .

NOTES

[1] Renaissance portraits: J. Alazard, *The Florentine Portrait*, New York, 1968; J. Pope-Hennessy, *The Portrait in the Renaissance*, Princeton, 1976.

[2] Roman portraits: R. Hinks, *Greek and Roman Portrait Sculpture*, London, 1935; R. Brilliant, *Roman Art*, London, 1974.

[3] Northern Portraits: J. Pope-Hennessy, *The Portrait in the Renaissance*, Princeton, 1976.

[4] Carved portraits: J. Pope-Hennessy, *Italian High Renaissance and Baroque Sculpture*, London, 1970; J. Pope-Hennessy, *Italian Renaissance Sculpture*, London, 1971; J. Pope-Hennessy, *The Portrait in the Renaissance*, Princeton, 1976.

[5] Masks: see note 4.

Women in Frames: The Gaze, the Eye, the Profile in Renaissance Portraiture

PATRICIA SIMONS

Patricia Simons writes about the representation of gender and sexuality in Renaissance and Baroque art. She is Associate Professor in the Department of History of Art and the Program in Women's Studies at the University of Michigan.

Studies of Renaissance art have had difficulty in accommodating contemporary thinking on sexuality and feminism. The period which is presumed to have witnessed the birth of Modern Man and the discovery of the World does

Excerpted from Patricia Simons, "Women in Frames: The Gaze, The Eye, the Profile in Renaissance Portraiture," *History Discourse: A Journal of Socialist and Feminist Historians*, 25 (Spring 1988): 4–30. Reprinted by permission of the author.

not seem to require investigation. Renaissance art is seen as a naturalistic reflection of a newly discovered reality, rather than as a set of framed myths and gender-based constructions. In its stature as high culture, it tends to be either applauded or ignored (by the political right or left respectively) as an untouchable, elite production. My work on profile portraits of Florentine women attempts to bring theories of the gaze to bear on some of these traditional Master theories, thereby unmasking the apparent inevitability and neutrality of Renaissance art. . . .

In this paper, profile portraits will be viewed as constructions of gender conventions, not as natural, neutral images. Behind this project lies a late-twentieth century interest in the eye and the gaze, largely investigated so far in terms of psychoanalysis and film theory.[1] Further, various streams of literary criticism and theory make us aware of the construction of myths and images, of the degree to which the reader (and the viewer) are active, so that, in ethnographic terms, the eye is a performing agent. Finally, feminism can be brought to bear on a field and a discipline which are only beginning to adjust to a de-Naturalized, post-humanist world. Burckhardt again looms here, for he believed that "women stood on a footing of perfect equality with men" in the Italian Renaissance, since "the educated woman, no less than the man, strove naturally after a characteristic and complete individuality."[2] That the "education given to women in the upper classes was essentially the same as that given to men" is neither true, we would now say, nor adequate proof of their social equality.[3]

Joan Kelly's essay of 1977, "Did Women Have a Renaissance?," opened a debate amongst historians of literature, religion and society, but art historians have been slower to enter the discussion.[4] A patriarchal historiography which sees the Renaissance as the Beginning of Modernism continues to dominate art history, and studies of Renaissance painting are little touched by feminist enterprise.[5] Whilst images of or for women are now beginning to be treated as a category, some of this work perpetuates women's isolation in a separate sphere and takes little account of gender analysis. Instead, we can examine relationships between the sexes and think of gender as "a primary field with which or by means of which power is articulated."[6] So we need to consider the visual construction of sexual difference and how men and women were able to operate as viewers. Further, attention can be paid to the visual specifics of form rather than content or "iconography," so that theory can be related to practice.

The body of this paper investigates the gaze in the display culture of Quattrocento Florence to explicate further ways in which the profile, presenting an averted eye and a face available to scrutiny, was suited to the representation of an ordered, chaste and decorous piece of property. A historical investigation of the gaze which has usually been discussed in psychoanalytic terms, this study might be an example of what Joan Scott recently called for when she worried about "the universal claim of psychoanalysis." She wants historians "instead to examine the ways in which gendered identities are substantively constructed and relate their findings to a range of activities, social organizations,

and historically specific cultural representations."[7] So my localized focus could be a supplement, perhaps a counter, to Freudian universalizing, and to neutered generalizations previously made about Renaissance portraiture. On the other hand, I would prefer to attempt a dialogue rather than a confrontation between historical and psychoanalytic interpretations. Here an interdisciplinary foray will characterize the gaze as a social and historical agency as well as a psychosexual one.

The history of the profile to ca. 1440 was a male history, except for the occasional inclusion of women in altarpieces as donor portraits, that is, portraits of those making their pious offering to the almighty. But from ca. 1440 nearly all Florentine painted profile portraits depicting a single figure are of women (except for a few studies of male heads on paper, probably sketches for medals and sculpture when they are portraits and not studio exercises). By ca. 1450 the male was shown in three-quarter length and view, first perhaps in Andrea Castagno's sturdy view of an unknown man whose gaze, hand and facial structure intrude through the frame into the viewer's space.[8] Often this spatial occupation and bodily assertion were appropriately captured in the more three-dimensional medium of sculpture, using either relatively cheap terracotta or more prestigious, expensive marble. The first dated bust from the period is Piero de' Medici's, executed by Mino da Fiesole in 1453.[9]

For some time, however, women were still predominantly restricted to the profile, and most examples of this format are dated after the mid-century. Only in the later 1470s do portraits of women once more follow conventions for the male counterparts, moving out from the restraining control of the profile format, turning towards the viewer and tending to be views of women both older and less ostentatiously dressed than their female predecessors had been. Such a change has not been investigated and cannot be my subject here, which is to highlight the predominance of a female presence in Florentine profile portraits.

Painted by male artists for male patrons, these objects primarily addressed male viewers. Necessarily members of the ruling and wealthy class in patrician Florence, the patrons held restrictive notions of proper female behavior for women of their class. Elsewhere in Italy, especially in the northern courts, princesses were also restrained by rules of female decorum but were portrayed because they were noble, exceptional women.[10] In mercantile Florence, however, that women who were not royal were recognized in portraiture at all appears puzzling, and I think can only be understood in terms of the visual or optic modes of what can be called a "display culture." By this I mean a culture where the outward display of honor, magnificence and wealth was vital to one's social prestige and definition, so that visual language was a crucial mode of discourse. I will briefly treat the conditions of a woman's social visibility and then, having considered why a woman was portrayed, turn to the particular form of the resultant portrait.

To be a woman in the world was/is to be the object of the male gaze: to "appear in public" is "to be looked upon," wrote Giovanni Boccaccio.[11] The

Dominican nun Clare Gambacorta (d. 1419) wished to avoid such scrutiny and establish a convent "beyond the gaze of men and free from worldly distractions."[12] The gaze, then a metaphor for worldliness and virility, made of Renaissance woman an object of public discourse, exposed to scrutiny and framed by the parameters of propriety, display and "impression management."[13] Put simply, why else paint a woman except as an object of display within male discourse?

Only at certain key moments could she be seen, whether at a window or in the "window" of a panel painting, seen and thereby represented. These centered on her rite of passage from one male house to another upon her marriage, usually at an age between fifteen and twenty, to a man as much as fifteen years her senior.[14] Her very existence and definition at this time was a function of her outward appearance. . . .

The age of the women in these profile portraits, along with the lavish presence of jewelry and fine costumes (usually outlawed by sumptuary legislation and rules of morality and decorum), with multiple rings on her fingers when her hands are shown, and hair bound rather than free-flowing, are all visible signs of her newly married (or perhaps sometimes betrothed) state. The woman was a spectacle when she was an object of public display at the time of her marriage but otherwise she was rarely visible, whether on the streets or in monumental works of art. In panels displayed in areas of the palace open to common interchange, she was portrayed as a sign of the ritual's performance, the alliance's formation and its honorable nature.

An example of a father's attention to his daughter before marriage, however, also points up attitudes taken to a woman's public appearance.[15] Whilst Giovanni Tornabuoni granted jewelry to his daughter Ludovica as part of her lavish dowry, his will of 1490 nevertheless stipulated that two of the valuable, carefully described items ultimately remain part of his male patrimony, for they were to return to his estate upon her decease. A cross surrounded by pearls, probably the "crocettina" mentioned in Giovanni's will, hangs from Ludovica's neck in her portrait by Domenico Ghirlandaio within the family chapel at Santa Maria Novella, decorated at her father's expense between 1486 and 1490. She also wears a dress richly brocaded with the triangular Tornabuoni emblem. So, at the time when she was betrothed but not yet married, not long before she passed beyond their confines, she is displayed forever as a Tornabuoni woman, wearing their emblem and wealth.

Ludovica is also represented as a virginal Tornabuoni exemplar, attendant at the *Birth of the Virgin* and with her hair still hanging loose, as it had in her earlier medal, where a unicorn on the reverse again emphasized her honorable virginity. In the chapel fresco Ludovica is presented as the perfect bride-to-be, from a noble and substantial family, about to become a child-bearing woman. Her father's solicitude and family pride oversaw the construction of a public image declaring her value and thereby increasing Tornabuoni honor. Soon her husband will conduct her on her rite

of passage, collect his dowry and appropriate her honor to the needs of his own lineage. . . .

A young Florentine patrician girl rarely became anything other than a nun or a wife.[16] In each instance she was defined in relation to her engagement with men, either marrying Christ or a worldly husband and eschewing all other men. Girls who entered a convent sometimes made their own choice, but often they were ugly, infirm or deformed, or else they might be surplus girls in a family overburdened by the potential costs of expensive dowries. When assessing future wives, the groom's lineage carefully weighed the ties of kinship (*parentado*) to be formed and the dowry's value, with other matters such as the woman's beauty and the purity and fertility of her female ancestors.[17] "Beauty in a woman," wrote Leon Battista Alberti,

> must be judged not only by the charm and refinement of her face, but still more by the grace of her person and her aptitude for bearing and giving birth to many fine children. . . . In a bride . . . a man must first seek beauty of mind (*le bellezze dell'animo*), that is, good conduct and virtue[18]

It is this "beauty of mind" which is displayed in the idealizing profile portrait as it was earlier exhibited (*mostrare*, to exhibit, is the verb)[19] to selectors before her marriage. Since Alessandra Strozzi and others spoke of the bride as "merchandise" ("who wants a wife wants ready cash," she said),[20] we can speak of an economics of display in fifteenth-century Florence. Alberti advised that the future groom

> should act as do wise heads of families before they acquire some property—they like to look it over (*rivedere*) several times before they actually sign a contract.[21]

The girl was an object of depersonalized exchange by which means a mutual *parentado* was established, a dowry of capital was brought by the girl and a husband's honor became hers to display. She also supplied an unsullied heritage and 'beauty of mind."

The late fifteenth-century Florentine bookseller Vespasiano da Bisticci also wrote of a woman's virtue as a possession or dowry. He ended his Life of the exemplary Alessandra de' Bardi exhorting women to

> realise that a dowry of virtue is infinitely more valuable than one of money, which may be lost, but virtue is a secure possession which may be retained to the end of their lives.[22]

Alberti has the elderly husband didactically address his new, very young wife in terms even more closely related to portraits:

> Nothing is so important for yourself, so acceptable to God, so pleasing to me, and precious in the sight of your children as your chastity (*onestà*). The woman's character is the jewel (*ornamento*) of her family; the mother's purity has always been a part of the dowry she passes on to her daughters; her purity has always far outweighed her [physical] beauty.[23]

Visually, the strict orderliness of the profile portrait can be seen as a surprising contradiction of contemporary misogynist literature. Supposedly "inconstant," like "irrational animals" without "any set proportion," living "without order or measure,"[24] women were transformed by their "beauty of mind" and "dowry of virtue" into ordered, constant, geometrically proportioned and unchangeable images, bearers of an inheritance which would be "precious" to their children. A woman, who was supposedly vain and narcissistic,[25] was nevertheless made an object in a framed "mirror" when a man's worldly wealth and her ideal dowry, rather than her "true" or "real" nature, was on display.

Giovanna Tornabuoni's portrait by Domenico Ghirlandaio [Figure 13] contains an inscription, with the date 1488, indicating that "conduct and soul" were valuable, laudable commodities carried by the woman.[26] Further, depiction strove for the problematic representation of these invisible virtues: "O art, if thou were able to depict the conduct and soul, no lovelier painting would exist on earth." Having died whilst pregnant in 1488, the now dead Giovanna née Albizzi is here immortalized as noble and pious, bearing her husband's initial, L for Lorenzo, on her shoulder and his family's simplified, triangular emblem on her garment. She is forever absorbed as part of the Tornabuoni heritage, displayed in their palace to be seen by their visitors and themselves, including her son, who bore their name.

Within the panel, she is framed by a simple, closed-off room; within the palace, we know from an inventory, she was actually framed in "a cornice made of gold" on show in a splendid "room of golden stalls."[27] Sealed in a niche like her accoutrements of piety and propriety, she is an eternally static spectacle held decorously firm by her gilded costume and by the architecture of her arm, neck and spine. Giovanna's very body becomes a sign, attempting to articulate her intangible but valuable "conduct and soul." The "dowry of virtue" is encased and contained within her husband's finery, each enhancing the other. Forever framed in a state of idealized preservation, she is constructed as a female exemplar for Tornabuoni viewers and others they wished to impress with this *ornamento*.

Profile portraits such as Giovanna's participate in a language of visual and social conventions. They are not simply reflections of a preexistent social or visual reality. Neither in the streets nor in the poetry of Renaissance Florence was a patrician woman like Giovanna capable of the sort of independent existence she might seem to have in her portrait. Invisible virtues, impossible to depict unless one were in paradise according to the poetry written by Petrarch and Lorenzo de' Medici,[28] are paradoxically the realm of these highly visible portraits on show in a display culture keen to engage in impression management. In these portraits a woman can wear cosmetics and extravagant decoration forbidden by legal and moral codes.[29] There this orderly creature was visible at or near a window, yet she was explicitly banished from public appearance at such windows.[30] There a dead wife or absent daughter or newly incorporated, deflowered wife was made an object of commemoration, as eternally alive and chaste. . . .

NOTES

[1] See, for instance, Laura Mulvey, "Visual Pleasure and Narrative Cinema," *Screen* 16, no. 3 (Autumn 1975): 6–18; Laura Mulvey, "Afterthoughts on 'Visual Pleasure and Narrative Cinema,' inspired by *Duel in the Sun*,"*Framework* 15–17 (1981); Mary Ann Doane, "Film and the Masquerade: Theorising the Female Spectator," *Screen* 23, nos. 3–4 (1982): 74-87; E. Ann Kaplan, *Women and Film: Both Sides of the Camera*, London, 1983; L. Mykyta, "Lacan, Literature and the Look: Woman in the Eye of Psychoanalysis," *Substance* 39 (1983): 49–57; Jacqueline Rose, *Sexuality in the Field of Vision*, London, 1986.

 Mulvey's essays are reprinted in her *Visual and Other Pleasures*, Bloomington, Indiana, 1989, where her "Changes: Thoughts on Myth, Narrative, and Historical Experience" (first published in *History Workshop*, Spring 1987) makes interesting adjustments to her earlier arguments. In general, the notion of "the gaze" is becoming a more complex, less binary one, and I tried to extend the range of possible masculine and feminine positions in an exhibition called "The Female Gaze" at the Museum of Art, University of Michigan, Ann Arbor, February 8–March 24, 1991.

[2] Jakob Burckhardt, *The Civilization of the Renaissance in Italy*, S. G. C. Middlemore, trans., London, 1960 (first published in German in 1860), pp. 240, 241.

[3] Ibid., p. 240. Studies on education relevant here include Margaret King, "Thwarted Ambitions: Six Learned Women of the Italian Renaissance," *Soundings* 59 (Fall 1976): pp. 280–304; Gloria Kaufman, "Juan Luis Vives on the Education of Women," *Signs* 3 (1978): 891–6; *Beyond Their Sex: Learned Women of the European Past*, Patricia Labalme, ed., New York, 1980.

[4] Joan Kelly, "Did Women Have a Renaissance?" in *Becoming Visible. Women in European History*, Renate Bridenthal and Claudia Koonz, eds., Boston, 1977, repr. in Joan Kelly, *Women, History and Theory*, Chicago, 1984. For an introduction to current thinking, with a few essays on art after the Quattrocento, see *Rewriting the Renaissance: The Discourses of Sexual Difference in Early Modern Europe*, Margaret W. Ferguson, Maureen Quilligan and Nancy J. Vickers, eds., Chicago, 1986.

[5] Svetlana Alpers, "Art History and Its Exclusions: The Example of Dutch Art," in *Feminism and Art History: Questioning the Litany*, Norma Broude and Mary D. Garrard, eds., New York, 1982; Patricia Simons, "The Italian Connection: Another Sunrise? The Place of the Renaissance in Current Australian Art Practice," *Art Network* 19–20 (Winter–Spring 1986): 37–42.

[6] Joan W. Scott, "Gender: A Useful Category of Historical Analysis," *American Historical Review* 91 (1986): 1069.

[7] Scott, "Gender," p. 1068. The interaction between psychoanalysis and history is a complex and controversial issue, see Elizabeth Wilson, "Psychoanalysis: Psychic Law and Order?" and Jacqueline Rose's response, "Femininity and Its Discontents," each reprinted in *Sexuality. A Reader*, Feminist Review, ed., London, 1987. The latter is also reprinted in Rose, *Sexuality in the Field of Vision*. And see Lisa Tickner, "Feminism, Art History, and Sexual Difference," *Genders* 3 (Fall 1988): 92–128.

[8] Fern Rusk Shapley, *Catalogue of the Italian Paintings*, National Gallery of Art, Washington, D.C., 1979, vol. 1, pp. 127–29; Marita Horster, *Andrea del Castagno*, Oxford, 1980, pp. 32–33, 180–81, pl. 93.

[9] John Pope-Hennessy, "The Portrait Bust," in his *Italian Renaissance Sculpture*, London, 1958. Irving Lavin, "On the Sources and Meaning of the Renaissance Portrait Bust," *Art Quarterly* 33 (1970): 207–26, by arguing that a presentation of *totus homo* was the aim of these busts, does not consider issues of gender.

[10] These portraits of women (mainly from Ferrara or Milan) are also usually in profile, as are several portraits of north Italian male rulers. A separate study could be done of the courtly, imported profile convention for such powerful aristocrats, and of the occasional use of the profile for male portraiture in fifteenth-century Venice, where very few women at all are portrayed before the sixteenth century.

[11] Giovanni Boccaccio, *The Corbaccio*, A. K. Cassell, trans., Urbana, Ill., 1975, p. 68.

[12] Richard Kieckhefer, *Unquiet Souls: Fourteenth Century Saints and Their Religious Milieu*, Chicago, 1984, p. 47.

[13] The last phrase is a major category used by the sociologist Erving Goffman in his *The Presentation of Self in Everyday Life*, Garden City, N.Y., 1959.

[14] Christiane Klapisch-Zuber, *Women, Family, and Ritual in Renaissance Italy*, Lydia Cochrane, trans., Chicago, 1985, especially pp. 19–20, 101ff., 110–11, 170.

[15] The following is drawn from Patricia Simons, "Portraiture and Patronage in Quattrocento Florence, with Special Reference to the Tornaquinci and Their Chapel in S. Maria Novella," Ph.D. dissertation, University of Melbourne, 1985, especially pp. 139, 299. Publications which appeared after my article would now enable a greater problematization of the relationship between fathers and daughters. See Lynda E. Boose, "The Father's House and the Daughter in It: The Structures of Western Culture's Daughter-Father Relationship," in L. Boose and Betty S. Flowers, eds., *Daughters and Fathers* (Baltimore and London, 1989), pp, 19–74; Heather Gregory, "Daughters, Dowries and the Family in Fifteenth-Century Florence," *Rinascimento,* ser. 2, no. 27 (1987): 215–37; Anthony Molho, "Deception and Marriage Strategy in Renaissance Florence: The Case of Women's Ages," *Renaissance Quarterly* 41 (Summer 1988): 193–217.

[16] Richard Trexler, "Le Célibat à la fin du Moyen Age: les religieuses de Florence," *Annales E.S.C.* 27 (1972): 1329–50.

[17] Paolo da Certaldo, for instance, advised that one check a woman's family, health, sanity, honor and "bel viso," or beautiful face: quoted in Giovanni Morelli, *Ricordi,* Vittore Branca, ed. (Florence, 1956), p. 210 n. 1, with other references.

[18] Leon Battista Alberti, "I libri della famiglia," in his *Opere volgari,* Cecil Grayson, ed. (Bari, 1960), vol. 1., pp. 110–11, translated in *The Family in Renaissance Florence,* Renee Neu Watkins, trans. (Columbia, S.C., 1969), pp. 115–16.

[19] For instance, Strozzi, *Lettere,* p. 445; B. Buser, *Lorenzo de' Medici als italienischer Staatsmann* (Leipzig,1879), p. 171.

[20] Strozzi, *Lettere,* p. 4; Baldassar Castiglione, *Le lettere,* Guido La Rocca, ed., (Milan, 1978), vol. I, p. 265.

[21] Alberti, "I libri della famiglia," p. 110; translated in *The Family in Renaissance Florence,* p. 115.

[22] *Renaissance Princes, Popes and Prelates. The Vespasiano Memoirs, Lives of Illustrious Men of the XVth Century,* William George and Emily Waters, trans., (New York, 1963), p. 462.

[23] Alberti, "I libri della famiglia," p. 224; translated in *The Family in Renaissance Florence,* p. 213. Paolo da Certaldo, *Libro di buoni costumi,* Alfredo Schiaffini, ed. (Florence, 1945), p. 129, said that "a good wife is a husband's crown, his honour and status *(stato)*."

[24] The phrases are from Paolo da Certaldo, *Libro,* p. 105 ("La femina è cosa molto," p. 239), Cennino Cennini, *The Craftsman's Handbook,* Daniel V. Thompson, Jr., trans. (New York, 1960), pp. 48–49, and Marsilio Ficino in David Herlihy and Christiane Klapisch-Zuber, *Tuscans and Their Families: A Study of the Florentine Catasto of 1427* (New Haven, Conn., 1985), p. 148.

[25] Boccaccio, *The Corbaccio,* passim, with other references to misogynist literature of the time.

[26] Philip Hendy, *Some Italian Renaissance Pictures in the Thyssen-Bornemisza Collection* (Lugano, 1964), pp. 43–45; Simons, "Portraiture and Patronage," pp. 142–45.

[27] Archivio de Stato, Florence, Pupilli avanti il Principato, 181, folio 148 recto.

[28] *Petrarch's Lyric Poems: The "Rime sparse" and Other Lyrics,* R. M. Durling, trans. (Cambridge, Mass., 1976), sonnets 77 and 78; Lorenzo de' Medici, " Comento" in his *Scritti e scelti,* Emilio Bigi, ed. (Turin, 1955), pp. 364ff.

[29] Boccaccio, *The Corbaccio,* passim; Diane Owen Hughes, "Sumptuary Law and Social Relations in Renaissance Italy," in *Disputes and Settlements: Law and Human Relations in the West,* John Bossy, ed. (Cambridge, 1983) ; Hughes, "La moda proibita."

[30] For instance, Diane Bornstein, *The Lady in the Tower: Medieval Courtly Literature for Women* (Hamden, Conn., 1983), pp. 24, 74. Doris Lessing's comment on another context might be pertinent here: "In Purdah women gaze out of windows and keep opening doors quickly a little way to see what might be happening on the other side; it is a place where you listen and watch for the big events going on outside the room you are imprisoned in": *The Wind Blows Away Our Words and Other Documents Relating to the Afghan Resistance* (London, 1987), p. 134.

CHAPTER 10

The Female Nude

A generation ago, one of the earliest battles between traditional humanistic art history and what came to be known as "the New Art History" centered on the female nude. For Kenneth Clark, the nude had little to do with the naked flesh of any actual individual, but was instead an idealized form of art, invented by the Classical Greeks and perfected in the Renaissance. Furthermore, Clark wrote, it was a form that was capable of conveying a broad range of profound thoughts and emotions.

In *Ways of Seeing*, John Berger responded to Clark by pointing out that far from being a purely aesthetic, disinterested form of art, the female nude was a subject grounded in social experience. Like later soft-core porn magazines and advertising images, the painted nude reflected and reinforced the subordinate role of women in Renaissance society.

The Naked and the Nude

KENNETH CLARK

Kenneth Clark was a distinguished British critic, curator, art historian, administrator, and writer. He was the prolific writer of books covering a broad range of subjects from the Renaissance to contemporary art. A self-proclaimed aesthete, Clark nevertheless succeeded in bringing the world of art to a broad audience through his 1969 television series, Civilisation. *In the same year, Clark was made a peer of the realm. He died in 1983.*

The English language, with its elaborate generosity, distinguishes between the naked and the nude. To be naked is to be deprived of our clothes, and the word implies some of the embarrassment most of us feel in that condition. The word "nude," on the other hand, carries, in educated usage, no uncomfortable overtone. The vague image it projects into the mind is not of a huddled and defenseless body, but of a balanced, prosperous, and confident body: the body re-formed. In fact, the word was forced into our vocabulary by critics of the early eighteenth century to persuade the artless islanders that, in countries where painting and sculpture were practiced and valued as they should be, the naked human body was the central subject of art.

For this belief there is a quantity of evidence. In the greatest age of painting, the nude inspired the greatest works; and even when it ceased to be a compulsive subject it held its position as an academic exercise and a demonstration of mastery. Velàsquez, living in the prudish and corseted court of Philip IV and admirably incapable of idealization, yet felt bound to paint the *Rokeby Venus.* Sir Joshua Reynolds, wholly without the gift of formal draftsmanship, set great store by his *Cymon and Iphigenia.* And in our own century, when we have shaken off one by one those inheritances of Greece which were revived at the Renaissance, discarded the antique armor, forgotten the subjects of mythology, and disputed the doctrine of imitation, the nude alone has survived. It may have suffered some curious transformations, but it remains our chief link with the classic disciplines. When we wish to prove to the Philistine that our great revolutionaries are really respectable artists in the tradition of European painting, we point to their drawings of the nude. Picasso has often exempted it from that savage metamorphosis which he has inflicted on the visible world and has produced a series of nudes that might have walked unaltered

off the back of a Greek mirror; and Henry Moore, searching in stone for the ancient laws of its material and seeming to find there some of those elementary creatures of whose fossilized bones it is composed, yet gives to his constructions the same fundamental character that was invented by the sculptors of the Parthenon in the fifth century before Christ.

These comparisons suggest a short answer to the question, "What is the nude?" It is an art form invented by the Greeks in the fifth century, just as opera is an art form invented in seventeenth-century Italy. The conclusion is certainly too abrupt, but it has the merit of emphasizing that the nude is not the subject of art, but a form of art.

It is widely supposed that the naked human body is in itself an object upon which the eye dwells with pleasure and which we are glad to see depicted. But anyone who has frequented art schools and seen the shapeless, pitiful model that the students are industriously drawing will know this is an illusion. The body is not one of those subjects which can be made into art by direct transcription like a tiger or a snowy landscape. Often in looking at the natural and animal world we joyfully identify ourselves with what we see and from this happy union create a work of art. This is the process students of aesthetics call empathy, and it is at the opposite pole of creative activity to the state of mind that has produced the nude. A mass of naked figures does not move us to empathy, but to disillusion and dismay. We do not wish to imitate; we wish to perfect. We become, in the physical sphere, like Diogenes with his lantern looking for an honest man; and, like him, we may never be rewarded. Photographers of the nude are presumably engaged in this search, with every advantage; and having found a model who pleases them, they are free to pose and light her in conformity with their notions of beauty; finally, they can tone down and accentuate by retouching. But in spite of all their taste and skill, the result is hardly ever satisfactory to those whose eyes have grown accustomed to the harmonious simplifications of antiquity. We are immediately disturbed by wrinkles, pouches, and other small imperfections, which, in the classical scheme, are eliminated. By long habit we do not judge it as a living organism, but as a design; and we discover that the transitions are inconclusive, the outline is faltering. We are bothered because the various parts of the body cannot be perceived as simple units and have no clear relationship to one another. In almost every detail the body is not the shape that art had led us to believe it should be. Yet we can look with pleasure at photographs of trees and animals, where the canon of perfection is less strict. Consciously or unconsciously, photographers have usually recognized that in a photograph of the nude their real object is not to reproduce the naked body, but to imitate some artist's view of what the naked body should be. . . .

So that although the naked body is no more than the point of departure for a work of art, it is a pretext of great importance. In the history of art, the subjects that men have chosen as nuclei, so to say, of their sense of order have often been in themselves unimportant. For hundreds of years, and over an

area stretching from Ireland to China, the most vital expression of order was an imaginary animal biting its own tail. In the Middle Ages drapery took on a life of its own, the same life that had inhabited the twisting animal, and became the vital pattern of Romanesque art. In neither case had the subject any independent existence. But the human body, as a nucleus, is rich in associations, and when it is turned into art these associations are not entirely lost. For this reason it seldom achieves the concentrated aesthetic shock of animal ornament, but it can be made expressive of a far wider and more civilizing experience. It is ourselves and arouses memories of all the things we wish to do with ourselves; and first of all we wish to perpetuate ourselves.

This is an aspect of the subject so obvious that I need hardly dwell on it; and yet some wise men have tried to close their eyes to it. "If the nude," says Professor Alexander, "is so treated that it raises in the spectator ideas or desires appropriate to the material subject, it is false art, and bad morals." This high-minded theory is contrary to experience. In the mixture of memories and sensations aroused by Rubens' *Andromeda* or Renoir's *Bather* are many that are "appropriate to the material subject." And since these words of a famous philosopher are often quoted, it is necessary to labor the obvious and say that no nude, however abstract, should fail to arouse in the spectator some vestige of erotic feeling, even though it be only the faintest shadow—and if it does not do so, it is bad art and false morals. The desire to grasp and be united with another human body is so fundamental a part of our nature that our judgment of what is known as "pure form" is inevitably influenced by it; and one of the difficulties of the nude as a subject for art is that these instincts cannot lie hidden, as they do, for example, in our enjoyment of a piece of pottery, thereby gaining the force of sublimation, but are dragged into the foreground, where they risk upsetting the unity of responses from which a work of art derives its independent life. Even so, the amount of erotic content a work of art can hold in solution is very high. The temple sculptures of tenth-century India are an undisguised exaltation of physical desire; yet they are great works of art because their eroticism is part of their whole philosophy.

Apart from biological needs, there are other branches of human experience of which the naked body provides a vivid reminder—harmony, energy, ecstasy, humility, pathos; and when we see the beautiful results of such embodiments, it must seem as if the nude as a means of expression is of universal and eternal value. But this we know historically to be untrue. It has been limited both in place and in time. There are naked figures in the paintings of the Far East; but only by an extension of the term can they be called nudes. In Japanese prints they are part of *ukioye*, the passing show of life, which includes, without comment, certain intimate scenes usually allowed to pass unrecorded. The idea of offering the body for its own sake, as a serious subject of contemplation, simply did not occur to the Chinese or Japanese mind, and to this day raises a slight barrier of misunderstanding. In the Gothic North the position was fundamentally very similar. It is true that German painters in

the Renaissance, finding that the naked body was a respected subject in Italy, adapted it to their needs, and evolved a remarkable convention of their own. But Dürer's struggles show how artificial this creation was [Figure 15]. His instinctive responses were curiosity and horror, and he had to draw a great many circles and other diagrams before he could brace himself to turn the unfortunate body into the nude.

Only in countries touching on the Mediterranean has the nude been at home. . . . This is part of our Greek inheritance, and it was formulated by Aristotle with his usual deceptive simplicity. "Art," he says, "completes what nature cannot bring to a finish. The artist gives us knowledge of nature's unrealized ends." A great many assumptions underlie this statement, the chief of which is that everything has an ideal form of which the phenomena of experience are more or less corrupted replicas. This beautiful fancy has teased the minds of philosophers and writers on aesthetics for over two thousand years, and although we need not plunge into a sea of speculation, we cannot discuss the nude without considering its practical application, because every time we criticize a figure, saying that a neck is too long, hips are too wide or breasts too small, we are admitting, in quite concrete terms, the existence of ideal beauty. Critical opinion has varied between two interpretations of the ideal, one unsatisfactory because it is too prosaic, the other because it is too mystical. The former begins with the belief that although no individual body is satisfactory as a whole, the artist can choose the perfect parts from a number of figures and then combine them into a perfect whole. Such, we are told by Pliny, was the procedure of Zeuxis when he constructed his *Aphrodite* out of the five beautiful maidens of Kroton, and the advice reappears in the earliest treatise on painting of the postantique world, Alberti's *Della Pittura*. Dürer went so far as to say that he had "searched through two or three hundred." The argument is repeated again and again for four centuries, never more charmingly than by the French seventeenth-century theorist, Du Fresnoy, whom I shall quote in Mason's translation:

> For tho' our casual glance may sometimes meet
> With charms that strike the soul and seem complete,
> Yet if those charms too closely we define,
> Content to copy nature line for line,
> Our end is lost. Not such the master's care,
> Curious he culls the perfect from the fair;
> Judge of his art, thro' beauty's realm he flies,
> Selects, combines, improves, diversifies;
> With nimble step pursues the fleeting throng,
> And clasps each Venus as she glides along.

Naturally, the theory was a popular one with artists: but it satisfies neither logic nor experience. Logically, it simply transfers the problem from the whole to the parts, and we are left asking by what ideal pattern Zeuxis accepted or

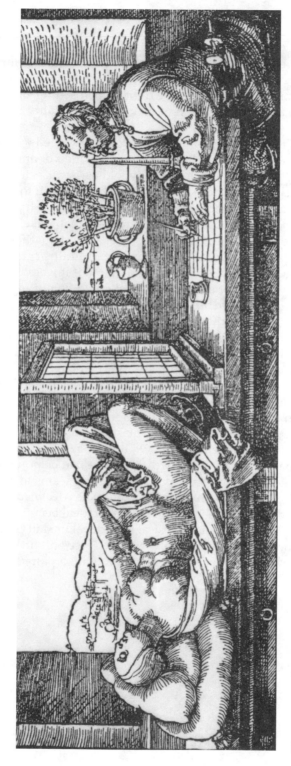

Figure 15. Albrecht Dürer, *Artist Drawing a Nude Model*, 1538. Photo: Foto Marburg/Art Resource, NY.

rejected the arms, necks, bosoms, and so forth of his five maidens. And even admitting that we do find certain individual limbs or features that, for some mysterious reason, seem to us perfectly beautiful, experience shows us that we cannot often recombine them. They are right in their setting, organically, and to abstract them is to deprive them of that rhythmic vitality on which their beauty depends.

To meet this difficulty the classic theorists of art invented what they called "the middle form." They based this notion on Aristotle's definition of nature, and in the stately language of Sir Joshua Reynolds' *Discourses* it seems to carry some conviction. But what does it amount to, translated into plain speech? Simply that the ideal is composed of the average and the habitual. It is an uninspiring proposition, and we are not surprised that Blake was provoked into replying, "All Forms are Perfect in the Poet's Mind but these are not Abstracted or compounded from Nature, but are from the Imagination." Of course he is right. Beauty is precious and rare, and if it were like a mechanical toy, made up of parts of average size that could be put together at will, we should not value it as we do. But we must admit that Blake's interjection is more a believer's cry of triumph than an argument, and we must ask what meaning can be attached to it. Perhaps the question is best answered in Crocean terms. The ideal is like a myth, in which the finished form can be understood only as the end of a long process of accretion. In the beginning, no doubt, there is the coincidence of widely diffused desires and the personal tastes of a few individuals endowed with the gift of simplifying their visual experiences into easily comprehensible shapes. Once this fusion has taken place, the resulting image, while still in a plastic state, may be enriched or refined upon by succeeding generations. Or, to change the metaphor, it is like a receptacle into which more and more experience can be poured. Then, at a certain point, it is full. It sets. And, partly because it seems to be completely satisfying, partly because the mythopoeic faculty has declined, it is accepted as true. What both Reynolds and Blake meant by ideal beauty was really the diffused memory of that peculiar physical type developed in Greece between the years 480 and 440 B.C., which in varying degrees of intensity and consciousness furnished the mind of Western man with a pattern of perfection from the Renaissance until the present century. . . .

Ways of Seeing

JOHN BERGER

John Berger writes essays, short stories, plays, novels, and art criticism. His influential 1972 BBC television series, Ways of Seeing, *was, in part, a Marxist feminist response to Kenneth Clark's* Civilisation *series, which had aired three years earlier. Recently Berger has been living in rural France, writing a trilogy on modern peasant life.*

According to usage and conventions which are at last being questioned but have by no means been overcome, the social presence of a woman is different in kind from that of a man. A man's presence is dependent upon the promise of power which he embodies. If the promise is large and credible his presence is striking. If it is small or incredible, he is found to have little presence. The promised power may be moral, physical, temperamental, economic, social, sexual—but its object is always exterior to the man. A man's presence suggests what he is capable of doing to you or for you. His presence may be fabricated, in the sense that he pretends to be capable of what he is not. But the pretence is always towards a power which he exercises on others.

By contrast, a woman's presence expresses her own attitude to herself, and defines what can and cannot be done to her. Her presence is manifest in her gestures, voice, opinions, expressions, clothes, chosen surroundings, taste—indeed there is nothing she can do which does not contribute to her presence. Presence for a woman is so intrinsic to her person that men tend to think of it as an almost physical emanation, a kind of heat or smell or aura.

To be born a woman has been to be born, within an allotted and confined space, into the keeping of men. The social presence of women has developed as a result of their ingenuity in living under such tutelage within such a limited space. But this has been at the cost of a woman's self being split into two. A woman must continually watch herself. She is almost continually accompanied by her own image of herself. Whilst she is walking across a room or whilst she is weeping at the death of her father, she can scarcely avoid envisaging herself walking or weeping. From earliest childhood she has been taught and persuaded to survey herself continually.

And so she comes to consider the *surveyor* and the *surveyed* within her as the two constituent yet always distinct elements of her identity as a woman.

She has to survey everything she is and everything she does because how she appears to others, and ultimately how she appears to men, is of crucial importance for what is normally thought of as the success of her life. Her own sense of being in herself is supplanted by a sense of being appreciated as herself by another.

Men survey women before treating them. Consequently how a woman appears to a man can determine how she will be treated. To acquire some control over this process, women must contain it and interiorize it. That part of a woman's self which is the surveyor treats the part which is the surveyed so as to demonstrate to others how her whole self would like to be treated. And this exemplary treatment of herself by herself constitutes her presence. Every woman's presence regulates what is and is not 'permissible' within her presence. Every one of her actions—whatever its direct purpose or motivation—is also read as an indication of how she would like to be treated. If a woman throws a glass on the floor, this is an example of how she treats her own emotion of anger and so of how she would wish it to be treated by others. If a man does the same, his action is only read as an expression of his anger. If a woman makes a good joke this is an example of how she treats the joker in herself and accordingly of how she as a joker-woman would like to be treated by others. Only a man can make a good joke for its own sake.

One might simplify this by saying: *men act* and *women appear*. Men look at women. Women watch themselves being looked at. This determines not only most relations between men and women but also the relation of women to themselves. The surveyor of woman in herself is male: the surveyed female. Thus she turns herself into an object—and most particularly an object of vision: a sight.

In one category of European oil painting women were the principal, ever-recurring subject. That category is the nude. In the nudes of European painting we can discover some of the criteria and conventions by which women have been seen and judged as sights.

The first nudes in the tradition depicted Adam and Eve. It is worth referring to the story as told in Genesis:

> And when the woman saw that the tree was good for food, and that it was a delight to the eyes, and that the tree was to be desired to make one wise, she took of the fruit thereof and did eat; and she gave also unto her husband with her, and he did eat.

> And the eyes of them both were opened, and they knew that they were naked; and they sewed fig-leaves together and made themselves aprons. . . . And the Lord God called unto the man and said unto him, 'Where are thou?' And he said, 'I heard thy voice in the garden, and I was afraid, because I was naked; and I hid myself. . . . Unto the woman God said, 'I will greatly multiply thy sorrow and thy conception; in sorrow thou shalt bring forth children; and thy desire shall be to thy husband and he shall rule over thee'.

What is striking about this story? They became aware of being naked because, as a result of eating the apple, each saw the other differently. Nakedness was created in the mind of the beholder.

The second striking fact is that the woman is blamed and is punished by being made subservient to the man. In relation to the woman, the man becomes the agent of God.

In the medieval tradition the story was often illustrated, scene following scene, as in a strip cartoon. During the Renaissance the narrative sequence disappeared, and the single moment depicted became the moment of shame. The couple wear fig-leaves or make a modest gesture with their hands. But now their shame is not so much in relation to one another as to the spectator. Later the shame becomes a kind of display.

When the tradition of painting became more secular, other themes also offered the opportunity of painting nudes. But in them all there remains the implication that the subject (a woman) is aware of being seen by a spectator.

She is not naked as she is. She is naked as the spectator sees her. Often—as with the favourite subject of Susannah and the Elders—this is the actual theme of the picture. We join the Elders to spy on Susannah taking her bath. She looks back at us looking at her.

In another version of the subject by Tintoretto, Susannah is looking at herself in a mirror. Thus she joins the spectators of herself [Figure 16].

The mirror was often used as a symbol of the vanity of woman. The moralizing, however, was mostly hypocritical. You painted a naked woman because you enjoyed looking at her, you put a mirror in her hand and you called the painting *Vanity*, thus morally condemning the woman whose nakedness you had depicted for your own pleasure.

The real function of the mirror was otherwise. It was to make the woman connive in treating herself as, first and foremost, a sight.

The Judgement of Paris was another theme with the same inwritten idea of a man or men looking at naked women. But a further element is now added. The element of judgement. Paris awards the apple to the woman he finds most beautiful. Thus Beauty becomes competitive. (Today The Judgement of Paris has become the Beauty Contest.) Those who are not judged beautiful are *not beautiful*. Those who are, are given the prize.

The prize is to be owned by a judge—that is to say to be available for him. Charles the Second commissioned a secret painting from Lely. It is a highly typical image of the tradition. Nominally it might be a *Venus and Cupid*. In fact it is a portrait of one of the King's mistresses, Nell Gwynne. It shows her passively looking at the spectator staring at her naked.

This nakedness is not, however, an expression of her own feelings; it is a sign of her submission to the owner's feelings or demands. (The owner of both woman and painting.) The painting, when the King showed it to others, demonstrated this submission and his guests envied him.

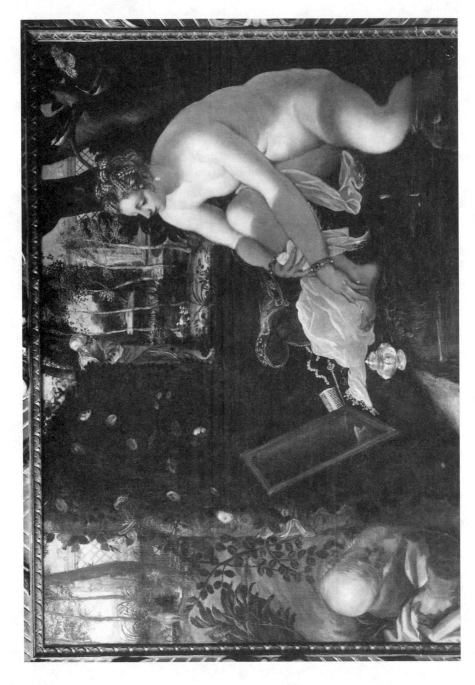

Figure 16. Tintoretto, *Susanna and the Elders*, 1555–56. Kunsthistorisches Museum, Vienna. Photo: Alinari / Art Resource, NY.

It is worth noticing that in other non-European traditions—in Indian art, Persian art, African art, Pre-Columbian art—nakedness is never supine in this way. And if, in these traditions, the theme of a work is sexual attraction, it is likely to show active sexual love as between two people, the woman as active as the man, the actions of each absorbing the other.

We can now begin to see the difference between nakedness and nudity in the European tradition. In his book on *The Nude* **Kenneth Clark** maintains that to be naked is simply to be without clothes, whereas the nude is a form of art. According to him, a nude is not the starting point of a painting, but a way of seeing which the painting achieves. To some degree, this is true—although the way of seeing 'a nude' is not necessarily confined to art: there are also nude photographs, nude poses, nude gestures. What is true is that the nude is always conventionalized—and the authority for its conventions derives from a certain tradition of art.

What do these conventions mean? What does a nude signify? It is not sufficient to answer these questions merely in terms of the art-form, for it is quite clear that the nude also relates to lived sexuality.

To be naked is to be oneself.

To be nude is to be seen naked by others and yet not recognized for oneself. A naked body has to be seen as an object in order to become a nude. (The sight of it as an object stimulates the use of it as an object.) Nakedness reveals itself. Nudity is placed on display.

To be naked is to be without disguise.

To be on display is to have the surface of one's own skin, the hairs of one's own body, turned into a disguise which, in that situation, can never be discarded. The nude is condemned to never being naked. Nudity is a form of dress.

In the average European oil painting of the nude the principal protagonist is never painted. He is the spectator in front of the picture and he is presumed to be a man. Everything is addressed to him. Everything must appear to be the result of his being there. It is for him that the figures have assumed their nudity. But he, by definition, is a stranger—with his clothes still on. . . .

CHAPTER 11

Viewing Michelangelo's *David*

The following two excerpts deal with one of the most familiar monuments in European art history, Michelangelo's *David.* This colossal statue originally stood in the main town square of Florence before being moved to the Accademia Gallery in 1873 [Figure 17].

Although the two discussions of the statue are quite different, they share, to some extent, an interest in the role the viewer plays in shaping the meaning of works of art. Richard Leppert proposes that male viewers look at this giant nude male differently from the way female viewers do. Similarly, John T. Paoletti and Gary M. Radke imply that the Renaissance citizens of Florence, keenly aware of recent political events in the city, would have seen in the statue meanings that are not readily apparent to modern viewers.

Viewing a work of art, in other words, is not a purely optical event that is the same for all people at all times. Viewing is a dynamic, changing process that is conditioned by the experiences and knowledge that viewers bring to the image.

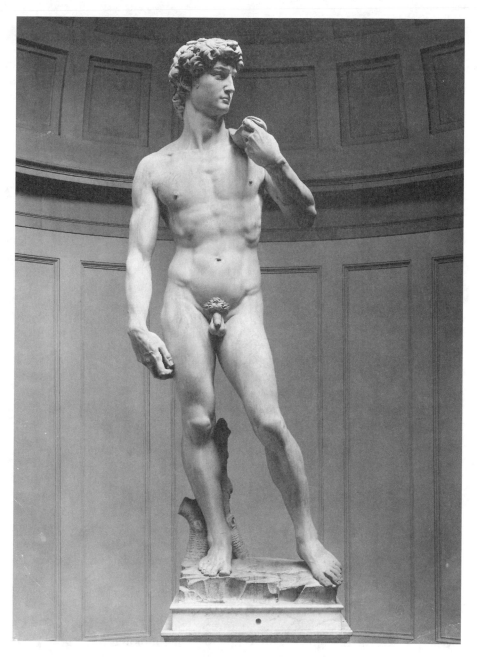

Figure 17. Michelangelo, *David*, 1501–04. Accademia, Florence. Photo: Alinari/Art Resource, NY.

The Male Nude:
Identity and Denial

RICHARD LEPPERT

Richard Leppert is Professor and Chair of the Department of Cultural Studies and Comparative Literature at the University of Minnesota. Much of his research is concerned with the social roles of music and visual images. His 1993 book, The Sight of Sound: Music, Representation and the History of the Body *(Berkeley: University of California Press, 1993), investigated evolving notions of identity in the modern period.*

For Western painting over the past several centuries, the nude male body has presented a host of problems that intersect with but are distinct from those attached to the nude female body. These problems have confronted not only artists and the original audiences for their work but also the academic discipline of art history, responsible for organizing the more or less "official" discourse on the subject.

A Perplexing Sight

In the West, nakedness is culturally associated with the shame that extends historically to the first precepts of the Judeo-Christian religion. Adam and Eve, having lost their innocence, covered themselves to hide their nakedness, about which they became self-conscious for the first time; and Noah's sons covered their father's nakedness, the result of drunken excess. Indeed, even the ancient Romans were at least officially critical of the nakedness associated with Greek practice in sport, despite the Romans' inherited taste for Greek statuary representing nudes. For the most part, nakedness is culturally marked as demanding privacy. When made publicly visible, nakedness functions as a magnet of attraction by violating a taboo whose strength varies in time and by geography.

Whereas the state of nakedness requires a specific, culturally learned etiquette of looking, or better yet, an etiquette of *not* looking, the *painted* nude

represents nakedness as a state specifically *made for concentrated looking.* Unlike, say, catching an accidental glimpse of someone without clothes, when there may be no intention either to display nakedness to others or for others to see it, the nude in art exists only to be seen naked. It invites not the averted eye, but the stare. Whatever the apparent rationale for the painted body to be without clothes, for example, taking a bath, the visible fact of nudity itself takes precedence. Nudity as such, in other words, overwhelms the image. Of course, nudity as an art subject is not nudity itself but nudity's representation. But whatever subject is represented providing justification, explanation, or logic for the state of nudity, the nude in art challenges the cultural proscription not of nudity itself but of voyeurism. To be effective as a painting of a nude, the image must make us *want* to look at the body in the manner represented. A principal means by which this is accomplished is for the image to focus its rhetorical energies to trigger the viewer's fantasies (the imaginary)—and desire.

What we commonly take the state of nudity to mean centers on the making visible of the body's sexuality. Nudity involves genitals. Thus in the parlance of movies, references to "full frontal nudity' roughly equates with "real" nudity; seeing someone's backside on the screen falls short of authenticity. Sexuality functions as a principal locus for our sense of *embodied* identity; it *is* us at the core of our sense of being. It is also the site of psychic and physical desire and erotic pleasure, as well as the source of anxiety and a host of other emotions. Regarding the painted nude generally, and the male nude especially, the viewer's interest is overdetermined to the extent that what the nude makes visible is the usually invisible site of deepest social and personal concern. Why so, especially in the male nude? The answer hinges in large part on the presumed audience, which, in most instances concerning painted nudes of *both* sexes before our own century, was explicitly, if not quite exclusively, male. To be sure, women saw such images, though their access was sometimes more limited by comparison to that of men, but nudes were not usually painted either by or for women. Men painted them and other men paid for them and also organized and largely controlled the sites where such images could be viewed. There were needs addressed by representing nude men *for men*—but always with a price to pay.[1]

For the male viewer, access to the sight of the nude female ordinarily serves as confirmation of male power, if only imagined. Access to the sight of the male nude is more complicated. If nudity is associated with shame, it is likewise associated with sexuality. Yet to be *looked at sexually* is to be consumed or taken *by sight.* Not for nothing is the gaze—the stare—said to be penetrating. The look per se is constituted wholly within the history of gender relations. Until recently if a man stared at a woman, she was expected to avert her eyes, thereby marking her awareness of his look and quickly deferring to its putative power, allowing herself to be taken in by him. But if one man stares at another, and the two are strangers, a confrontation is likely: "What are you looking at?" might be the query, uttered as a challenge, unless there is an

unspoken sexual interest that they share. The stare, in other words, functions—and is by men *expected* to function—as a challenge, and the historical constancy of this fact is evident in Western literature dating back to the ancients.

Let me begin with a nude so well known and so often reproduced that there is no need to illustrate it here, the sculpture *David* (1501–1504) by Michelangelo, in marble and eighteen feet high [Figure 17]. In the presence of this sculpture in situ in the Academy Gallery, Florence, it is nearly as interesting to watch the people looking as it is to gaze at the sculpture itself. What I have noticed is that women tend to take it in easily and comfortably and that men often do not. Viewers of both sexes seem to find the piece riveting, but men exhibit signs of being disconcerted. There is, of course, the simple fact that the sculpture is so profoundly different from what most men see in their bathroom mirrors. But there is more to the problem of looking than the male failure to measure up. Michelangelo virtually demands that viewers take pleasure in confronting David's body. Enormous, heroic, physically perfect, a technical tour de force to be sure, and—most of all—powerfully sexual. It is David's sexuality that Michelangelo demands that we acknowledge, though not specifically as a sign of David's male agency but as a pleasurable sight in itself. Set on a pedestal, viewers must literally look up to take in the figure. The space of its current setting is somewhat confined in light of the sculpture's size; the viewer cannot take it in without active eye movement. The eyes must sweep from the figure's feet to its head, and since it is freestanding, viewers may move entirely around it, taking it in from every possible angle. The polished white body is there to be cruised; it is a spectacle, and the sculpture's confronting power is radically increased by the setting—a separate gallery in the museum, in which there is nothing else to look at.

If the male viewer looks away from the sculpted David, he is forced to acknowledge and confront his own discomfort; yet to look is to take in what in normal circumstances cannot be looked at. In the locker room, males learn early where *not* to focus their eyes and therefore go to self-conscious lengths to avoid such looking (or at least to avoid being caught at it). In short, in the presence of *David* many men do not know what to do with their eyes. Michelangelo is powerfully adept at making us want to look, but in looking we are forced to acknowledge, and at least partly to violate, a taboo. In essence, men are culturally forbidden to take pleasure in the look of the body of their own sex, though they are culturally required, at least in the present moment, to make their own specific bodies pleasurable sights to themselves and, presumably, to women.

The long-standing, still-current model for the most desirable and perfect body specimen is not from life but from art, not really from *David* but from its antecedents in the ancient world, in Greece and Rome [Figure 1]. Yet from these beginnings the male body as an object of simultaneous emulation and desirability is also one of a contradiction that manifests itself in explicitly physical terms. As a sight, the ideal male body in art—and hence, so it would

seem, in life—conflates with some sense of the physically and spiritually heroic, an embodied state and spiritual virtue seldom made available to women. Yet throughout the history of art the sort of male body that has been designated as "ideal" is consistently and paradoxically infused with female characteristics.

Thus ancient representations of Hercules commonly provided him with extremely exaggerated musculature distinctly, if oddly, feminizing—not unlike that of modern bodybuilders who attempt to emulate Hellenistic sculpture not only by isolating and hyperdeveloping separate muscles that can be pumped up for posing, but also by shaving all (presumably) but genital body hair and oiling their skin to replicate the surface texture of polished marble. Accordingly, their bodies become object-sights *as such*. The "strength" that they possess is literally for show only. Pumping iron is in part an activity preparatory to one's *being looked at by other men*, who populate the audience in posing competitions (so it seems, if to confuse things further, mostly for "straight" men). In contrast, exhibiting the same effect by different means, many nineteenth-century paintings represent a distinctly soft, even slight, and explicitly feminized male as the ideal form. . . .

The affecting power of the male nude in art lies in its ability to produce tension *in the male viewer* who, when looking, is forced to acknowledge the power exerted on him by the ideal body of another male. Conversely, the non-ideal male nude in art is incapable of producing this tension, thereby transferring agency entirely to the viewer, who may look in contempt, not desire, on the body of the lesser male. Yet to exert this power, the idealized body must become an object of desire, a transformation that culturally feminizes both the figure represented *and* the male viewer, given the culturally established rules of gendered looking.

Until recently the academic discipline of art history has maintained a general silence on the male nude, except to treat it as a subject of formal or compositional interest. That is, the literature on the male nude has largely avoided (and seemingly claimed no investment in) the sociocultural and sexual issues that so powerfully inform the general subject. This is unquestionably a reflection of male art historians—like other men—being uncomfortable discussing the male body in a public forum, despite the centrality of the subject in the history of art. This situation began to change only with the development of feminist studies in the human sciences, and most recently, with the appearance of gay and lesbian studies. For example, well into our own century, the homosexuality of Michelangelo—let alone that of numerous other canonic artists of highest caliber—was barely acknowledged, as though it was an "unfortunate" and embarrassing fact best kept quiet, *especially* concerning its real or potential impact on his art. For example, when I studied art history as an undergraduate and graduate student in the 1960s, sexuality was seldom discussed even when it was the very subject of an artwork. And the sexuality of artists themselves was presumed, it seemed, to be irrelevant, or perhaps, as

students, none of our business. The homoeroticism evident in much of Michelangelo's work was a topic still more taboo than the sexuality of the artist himself. Yet Michelangelo's work enjoyed lavish praise and considerable attention in our slide lectures. The discipline, in other words, mirrored perfectly in its repressed discourse what the art itself so effectively referenced. The refusal to "say" acknowledged what Michelangelo achieved. He made us see, and *want* to see, what we were not supposed to. And I suspect we will continue to stare at *David*—Florence's principal tourist attraction—as long as the male body in reality is situated dead center in its own impossible mix of contradictions.

NOTE

[1] See remarks by Norman Bryson, "Géricault and 'Masculinity,' " in *Visual Culture: Images and Interpretations,* ed. Norman Bryson, Michael Ann Holly, and Keith Moxey (Hanover, N.H.: Wesleyan University Press, 1994), pp. 228–259, whose approach here is principally psychoanalytic but is read within a specific historical and cultural context.

Florence: The Renewed Republic and the Return of the Medici

JOHN T. PAOLETTI AND GARY M. RADKE

John T. Paoletti is Professor of Art History at Wesleyan University in Middletown, Connecticut. He has written a broad range of studies on Renaissance art, contemporary art, and contemporary art theory. Paoletti is Editor-in-Chief of The Art Bulletin, *published by the College Art Association.*

Gary M. Radke specializes in medieval and Renaissance Italian art. He is Professor of Fine Arts at Syracuse University and a Fellow of the American Academy in Rome. He recently published Viterbo: Profile of a Thirteenth Century Papal Palace *(Cambridge and New York: Cambridge University Press, 1996).*

In November 1494, after sixty years of *de facto* rule, Medici control of Florence came, temporarily, to an end. Having ruled for a mere two years, Piero de' Medici (known to history as "the Unfortunate," in marked contrast to his father,

Excerpted from: John T. Paoletti and Gary M. Radke, "Florence: The Renewed Republic and the Return of the Medici," *Art in Renaissance Italy* (Upper Saddle River, NJ: Prentice-Hall, 1997), 326–27. Reprinted by permission of the authors.

Lorenzo "the Magnificent") was forced by a mob of his fellow Florentines to leave the city. Politically inept, he had responded to threats from rival factions within the city and from the French by allying himself with Naples and then, when the French invader was on the doorstep, by allying himself with the French king, Charles VIII.

One of the strongest political voices in the city at this time was that of the Dominican friar Girolamo Savonarola (1452–98), abbot of the monastery of San Marco. As a member of the clergy and also a native of Ferrara, Savonarola could not hold office; yet his powerful preaching of Christian reform gave such a theological cast to republican reform that the meeting room of the Great Council was referred to as the Hall of Christ. In 1498, Savonarola's interventions in the workings of the state proved his undoing; in particular, his castigation of the notorious Pope Alexander VI had led to diplomatic difficulties between Florence and Rome. Savonarola was eventually forcibly hauled out of San Marco, tortured, tried as a heretic, hanged with two of his companions until they were nearly dead, and then burned at the stake. His ashes were later thrown into the Arno. Thus twice in a decade, in 1494 and in 1498, Florence had freed itself from what it perceived as tyranny.

The Republic as Patron

With Piero in exile and Savonarola dead, the citizens of Florence turned to the task of reconstructing their cherished republic and reinventing a visual mythology and stylistic language to express its ideals. The Signoria thus embarked on a number of commissions which were to transform the iconography of the Florentine state. These commissions for the renewed republic did two things. They provided the physical site of government with a powerful new series of images designed to establish an iconography of restored republican power, and they evoked the history of the earlier republican city, both in their iconography and in their placement.

Even before the new works were commissioned, the intentions of the new government were clear. In 1495, soon after Piero's forced exile, the Signoria ordered the removal of several works of art from the Medici Palace. Donatello's bronze *David* was placed inside the Palazzo della Signoria, joining his marble *David*, which had been moved there in 1416, and Verrocchio's bronze *David*, which Lorenzo and Giuliano de' Medici had sold to the Signoria in 1476. Donatello's bronze *Judith* was moved from the gardens of the Medici Palace to the platform immediately to the left of the main entrance of the Palazzo della Signoria. An inscription was added to the statue at that time which said that the citizens placed the statue there as an "exemplum" of public well-being. In both cases references to the protection of the state from tyrannical forces could not have been clearer. Paintings by Pollaiuolo of the *Labors of Hercules,* a civic hero central to the mythology of Florence, and by Uccello of the *Battle of San*

Romano, an important event in the political history of the state, were also taken to the Palazzo della Signoria from the Medici Palace.

Besides reclaiming civic imagery which had been appropriated by a private family, the placement of these sculptures and paintings at the Palazzo della Signoria initiated a program of state symbolism whose most memorable component is Michelangelo's *David* [Figure 17]. The statue was originally commissioned for the north tribune of the cathedral to continue the decorative program begun by Nanni di Banco and Donatello in 1408—during a golden age of the republic; but when completed in 1504 it was, instead, placed just to the left of the entrance of the Palazzo della Signoria, displacing Donatello's *Judith.*

The *David* is striking both for its realistic representation of the male human body and for the idealism that Michelangelo has projected onto the body. The figure is simultaneously understandable as an ordinary man, essentially free of attributes that would readily identify him (the sling being virtually hidden from sight), and as a hero. The colossal size of the figure—nearly three times life size—implies a link with colossal sculptures of antiquity, the greatness of Greece and Rome now is equalled by that of Florence. But concentration on the statue's formal classical antecedents misses the deliberate tension in the figure between real and ideal, the suggestion that the ordinary can be transformed into the extraordinary by a decisive moment of action.

Just as the figure is both real and ideal, it is also both *David* and other heroes as well. The nudity of the figure was unusual for the representation of *David.* Donatello's bronze *David* notwithstanding. Although the biblical text (I Samuel 17:38–39) leaves room for interpreting *David* as a nude, the pose of the figure, along with the nudity, suggests a Classical statue of Hercules. Moreover, the rocky terrain on which the figure stands, as well as the blasted tree trunk, behind David's right leg, suggests a tale with moral dimensions from the mythology of Hercules (who had appeared on the state seal of Florence since the end of the thirteenth century). Faced with a choice between virtue and vice, allegorically represented as, respectively, a sere and rocky landscape and a lush and flowering landscape, Hercules chooses the first. No one entering the Palazzo della Signoria could have missed the moral and political meaning of the statue. . . .

CHAPTER 12

Women Artists

By the twentieth century the names of women artists had all but disappeared from art history. Even as recently as 1985, for example, H. W. Janson did not include a single female artist in his highly influential 750-page *History of Art*. As Paola Tinagli points out, however, interest in women as both the subjects and the makers of art began to increase dramatically with the growth of the feminist movement.

Has the recent desire to include more women and minorities in our textbooks and museums resulted in lowering our standards? Camille Paglia, among others, believes that much of the recent attention to women artists is a form of reverse sexism. Rather than give in to political correctness, she insists, we must defend the notions of quality and standards.

This topic raises several important questions. What is "quality?" Who decides what constitutes "good" art? Is there a single, fixed standard by which we can measure all art? If not, does our notion of quality become so relativistic that we, in effect, abandon the very idea of greatness?

Women and Art during the Renaissance

PAOLA TINAGLI

*Paola Tinagli is an authority on the representation of women in Italian Re-
naissance art. She is the art-books reviewer for the* European Journal of
Women's Studies *and teaches at the Edinburgh College of Art in Scotland.
She is currently writing a book on Giorgio Vasari.*

*Women artists in the Renaissance:
sixteenth-century viewpoints*

In the fifteenth and sixteenth centuries, a woman artist was a rare phenome-
non indeed. Any discussion of the paintings or of the sculptures produced by
a woman could not be separated from the sense of wonder at the special talent
she possessed, which singled her out from the rest of women. Two literary
works which would have been known to educated men, Pliny's *Historia Natu-
ralis* and Boccaccio's *De Claris Mulieribus*, guided writers about the expression of
conventional terms of praise towards those few women who practised as artists.
Pliny listed six famous women painters from Greece and Rome. Boccaccio, in
his gallery of illustrious examples of female virtue and admirable behavior writ-
ten in the last decades of the fourteenth century, used Pliny as his source, and
mentioned three female artists from antiquity: Thamyris, Irene and Marcia.

In the second edition of his monumental work, the *Lives of the Artists*, which
was published in Florence in 1568, the painter, architect and historian, Giorgio
Vasari, introduced some biographical material about a small number of women
artists. Like Boccaccio, he praises them as a marvel of nature, and, remarking
that women have succeeded in all the areas where talents and skill are required
(*in tutte quelle virtù ed in tutti quelli esercizi*), he reminds the reader that women
in antiquity excelled in war, in poetry, in philosophy. Vasari then lists his female
contemporaries who 'have acquired the highest fame' as writers and poets,
and quotes the poet Ludovico Ariosto, agreeing with him that women have
reached excellence in all the arts they have cared to practise.[1]

Excerpted from Paola Tinagli, *Women in Italian Renaissance Art* (Manchester and New
York: Manchester University Press, 1997) ,11–20. Reprinted by permission of the author
and the publisher.

Vasari's words have been dismissed as a patronising rhetorical device which precludes any serious discussion of these artists and of their work. It is true, however, that for a woman to succeed as a painter or an engraver, or rarest of all, a sculptor, the circumstances in which she trained and then practised as an artist had to be exceptional indeed. The expressions of surprise from sixteenth-century writers like Vasari must have been in part the result of a sense of wonder sincerely experienced. Not only were women's intellectual capacities believed to be inferior to men's, and therefore little suited to overcome the difficulties of painting, but also the possibility of obtaining an adequate training without being able to follow the usual apprenticeship in a workshop presented considerable problems.[2] Most of these women had learned their craft from their fathers. In the *Life of Paolo Uccello*, Vasari mentions that the painter had a daugher, Antonia, a Carmelite nun, 'who could draw'. She died in 1491, and is identified as 'painter' (*pittoressa*) in the Death Register in Florence.[3] In Mantua, Vasari had seen the engravings of Diana Scultore, the daughter of an engraver and sculptor called Giovambattista, and wrote that her works were 'very beautiful, and I marvelled at them'. In Ravenna, in the house of a painter called Luca Longhi, Vasari had met his young daughter Barbara, who 'draws very well, and she has begun to colour some things with good grace and manner'. Barbara Longhi was praised by Maurizio Manfredi in a lecture given in Bologna in 1575: 'You should know that in Ravenna lives today a girl of eighteen years of age, daughter of the Excellent painter Messer Luca Longhi. She is so wonderful in this art that her own father begins to be astonished by her, especially in her portraits as she barely glances at a person that she can portray better than anybody else with the sitter posing in front.[4]

Together with his praise expressed within the conventional sixteenth-century notion of woman, Vasari also makes perceptive and precise remarks which show his keen and discriminating observation, and which make his accounts of the works of these women, however brief, very interesting reading. These remarks give us an insight into the difficulties and problems women artists had to face in their training and in their career. Describing the work of another nun, suor Plautilla Nelli, who was the abbess of the monastery of St Catherine of Siena in Florence and who was still alive at the time, Vasari notes that she did not have much experience in painting men. He felt that her heads of women were more skillfully carried out, because, he says, she has had occasion to see and study many more women than men. He judges that her copies from the works by other artists were more successful than her own original compositions because of her lack of sufficient training. He adds that her works show that she could have done wonderful things, 'as men are able to do', if she had been able to study and dedicate more time to drawing. In spite of these drawbacks, she must have been quite successful: Vasari notes that her paintings could be found in monasteries, in churches, and in innumerable private houses. Among suor Plautilla's works, Vasari mentions a 'much praised' *Adoration of the Magi* and a *Last Supper*,

which were in her own monastery. A large altarpiece with the Virgin and Child accompanied by St Thomas, St Augustine, Mary Magdalene, St Catherine of Siena, St Agnes, St Catherine of Alexandria and St Lucy, could be seen in the monastery of S. Lucia in Pistoia. In the cathedral of Florence, Santa Maria del Fiore, there was another of her works, a predella illustrating episodes from the life of one of the patron saints of Florence, St Zenobi. Among her private commissions were two Annunciations, which were in possession of two Florentine ladies.[5]

Some women, Vasari writes, have not hesitated to grapple with 'the roughness of marble and the harshness of iron' with their soft white hands. In his famous book of drawings, he had collected some examples by the only contemporary woman sculptor, Properzia de' Rossi from Bologna, who also worked as an engraver. He even dedicates a separate *Life* to her, accompanied by a portrait. As is often the case in his *Lives* of male artists, Vasari embellishes his information with anecdotes, curious details about her life and personality in order to create an interesting narrative. Properzia de' Rossi was considered by the citizens of Bologna as a *'grandissimo miracolo della natura'*. Vasari writes that she was very beautiful—an important physical trait for a sixteenth-century artist, male or female. She could play and sing better than any other woman in Bologna, and she was envied by both men and women because of her knowledge and skill. For the sculpted decoration of the portals of the Cathedral of Bologna, S. Petronio, Properzia de' Rossi made a marble relief illustrating the story of Joseph, escaping from the seductive embrace of the wife of Potiphar. Vasari adds that in this story she 'gave vent . . . to her passion' for a young man who, apparently, was not interested in her. Vasari adds that she was paid very little for her relief because of the machinations of an envious painter, Amico Aspertini.[6]

While the works of these women artists are only briefly mentioned, Vasari gives a more detailed account of the achievements of Sofonisba Anguissola [?1535–1625, Figure 18].[7] Germaine Greer takes Vasari to task for not treating the work of the Anguissola sisters seriously, and for not 'assessing their contribution to art.'[8] In fact, he certainly does take them seriously, as can be seen from the attention he pays to the paintings and to the Anguissola sisters' careers, even if, as he writes, he had seen only a few works by them. His descriptions of Sofonisba's paintings contributed to their fame throughout Italy and to the successful career of the artist. Sofonisba Anguissola was the most accomplished and well known amongst a group of sisters—Elena, Lucia, Minerva, Europa and Anna Maria—all painters, who belonged to a noble family in Cremona. Sofonisba's sister Lucia, who died one year before Vasari visited the Anguissola household in 1566, was also an accomplished portrait painter, as was another sister, Europa, in spite of her young age: at the time she probably was not yet twenty. Even the fifth sister, Anna Maria, who was still a child, showed great promise. Vasari writes that the house of Amilcare Anguissola 'seemed to me the house of painting, or in fact, of all talents'.

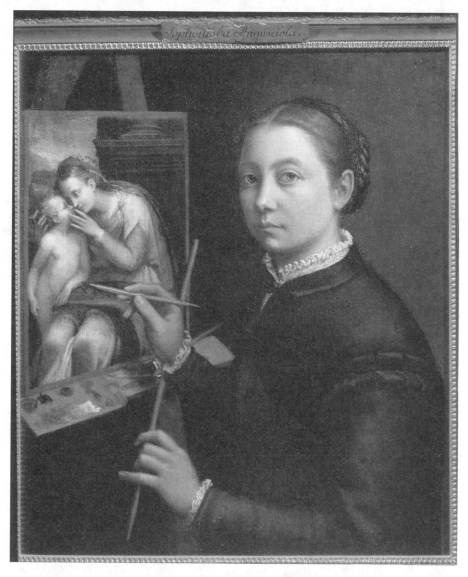

Figure 18. Sofonisba Anguissola, *Self Portrait at the Easel*, c. 1556. Muzeum Zamek, Lancut, Poland. Photo: Erich Lessing/Art Resource, NY.

With the constant help and encouragement from her father, Sofonisba trained with the Cremonese painter Bernardino Campi. Her career was remarkable: she was well known in Italy and abroad, and she received advice and encouragement from Michelangelo. By the time Vasari visited Cremona, where he went with the specific intention to see her paintings, Sofonisba had already left her native city. In 1559 she had been called to the Spanish court in Madrid as a lady-in-waiting to the young wife of Philip II, Isabella de Valois. There she painted a number of portraits of the Queen and of other members of the court. Vasari was enthusiastic about Sofonisba's paintings, which he described in a letter to his friend, the *letterato* Vincenzo Borghini, as 'wonderful'. In his *Lives,* Vasari mentions two group portraits by Sofonisba which he saw in her father's house. The first represents three of the Anguissola sisters sitting around a table, covered by an oriental carpet; two are playing chess, while the third one, together with an old woman of their household, looks on (Poznan, Museum Narodowe). In the other portrait, Sofonisba's father is shown sitting between her sister Minerva ('of rare accomplishments as a painter and as a writer') and her brother Asdrubale, against the background of a distant fantastic landscape moulded on Northern European examples (Nivaa, Nivaagaards Malerisamling). In the house of the archdeacon of Piacenza, Vasari saw the archdeacon's portrait and Sofonisba's own self-portrait, and he comments that 'both figures only lack speech'. Vasari praises the portraits with the terms he uses in relation to the works of great artists, saying that the figures 'seem to breathe, and look alive'.

Even Pope Pius IV wanted one of Sofonisba's works, a portrait of the Queen of Spain, which the artist sent with a letter, duly transcribed by Vasari together with the Pope's reply.[9] Vasari had in his own collection one of her drawings, representing a little girl laughing at a crying boy who has been bitten by a crayfish, which originally had been sent to Duke Cosimo de Medici by Michelangelo's friend, Tomasso Cavalieri, together with a drawing by Michelangelo. Sofonisba's drawing, wrote Cavalieri to the Duke, 'is not simply beautiful, but also exhibits considerable invention'. This is a great praise indeed, as *'inventione'* according to sixteenth-century theory was a distinctive intellectual quality related to the content of a work of art. Averardo Serristori, the Florentine ambassador to the papal court, agreed with this praise when he wrote in a letter to Duke Cosimo de Medici that Sofonisba's drawing was 'something quite rare'.[10] Various contemporary writers also concurred in this assessment of Sofonisba's work: in his *Ragionamento Quinto* of 1564, an imaginary dialogue between the Greek sculptor Phidias and Leonardo da Vinci, Giovan Paolo Lomazzo writes that all princes in Europe were astonished by Sofonisba's portraits. Alessandro Lamo comments, in his 1584 treatise *Discorso Intorno alla Scoltura e Pittura,* that Sofonisba is remarkable for her talent in painting as she is for the nobility of her spirit. The Anguissola sisters, he continues, are beautiful in mind and in body, and are adorned by ladylike qualities.[11]

Women artists in the Renaissance: recent historiography

In 1976 Ann Sutherland Harris and Linda Nochlin with their catalogue for the exhibition *Women Artists 1500–1950* brought to the attention of the public a large number of works by women artists. In a series of introductory essays, the catalogue provided much important information on the social and literary context of contemporary writing about women artists, and on the conditions in which these women lived, trained and worked. Short but comprehensive biographies for each of the artists selected for the exhibition complete the work.[12]

In *The Obstacle Race. The Fortunes of Women Painters and their Work* (1979), Germaine Greer set out to raise a number of questions about the contribution of women to the visual arts, including those concerning the conditions in which these women lived and worked, and the 'disappearance' of their works through the centuries. Useful as this book was in bringing together so much material, its polemical position painted a one-sided picture for the reader, who was invited to see the lives of these artists as beset by a series of obstacles (training, family, love, and so on) which targeted women as their principal victims. These are stories of unfulfilled aspirations, broken hopes, untold miseries which are peculiar to women because, Greer wrote, to women belongs that 'carefully cultured self-destructiveness.' The tales of these thwarted lives take precedence in Greer's book over analysis of the actual works.

While much work has been done in the last twenty years to rediscover and assess the works by nineteenth-century women artists, and to present afresh information about their lives and careers, the considerable problems surrounding research on sixteenth-century women artists have held back our knowledge of their achievements. These problems have not been helped by polemical and partisan positions taken by some writers, often intent upon demonstrating above everything else that women artists were not treated seriously by their contemporaries, and that their works have been, through the centuries, deliberately ignored. Other writers seem to be reluctant to abandon a romantic view of the artist driven by self-expression, in their desire to use biographical information which may highlight, in the works by women artists, a sense of 'otherness', a 'difference', an essentially 'feminine' way of painting.

What is really needed, instead, is some fundamental research. In many cases, when studying the careers of women artists, basic problems of attribution and of identification of the paintings, supported also by more archival research, need to be solved in order to have a better understanding of their work, or to establish a *corpus* of work for those artists who are, for the moment, mere names. A large group of paintings by Sofonisba Anguissola and her sisters, first shown in her native Cremona in 1994, and then the following year at the Kunsthistorisches Museum in Vienna and at the National Museum of Women in the Arts in Washington, has brought this artist to the attention of the

general public and to renewed scrutiny from scholars. It has also helped to answer some questions about the style and attribution of a number of portraits executed at the Spanish Court, and to assess Sofonisba Anguissola's place in the development of genre painting in Northern Italy in the late sixteenth century. The exhibition has also revealed the high quality of Lucia Anguissola's work.[13]

During 1994, the Museo Civico Archeologico in Bologna housed an exhibition dedicated to the most famous among the women painters from Bologna, Lavinia Fontana (1552–1614). Trained by her father, the painter Prospero Fontana, Lavinia produced works for private and public commissions: portraits, altarpieces, images of famous women, such as Cleopatra and Judith, and a painting representing a naked Minerva, executed in 1613 for Cardinal Scipione Borghese. The exhibition placed Lavinia Fontana within the context of late sixteenth-century painting in Bologna, and also explored the crucial factor of the particularly strong interest in women artists in that city. It also looked at the relationship between father and daughter by comparing paintings of similar subjects by Prospero Fontana and by Lavinia.[14]

NOTES

[1] Vasari's praise for women artists is at the beginning of the *Life of Madonna Properzia de' Rossi*, in G. Vasari, *Le Opere*, ed. G. Milanesi, 9 vols, Sansoni, Florence, 1906, repr. 1981 (henceforth Vasari—Milanesi), V, pp. 73–4, while the Ariosto quotation is on p.81.

[2] For a brief but very informative account of the cultural climate which saw the emergence of women artists in fifteenth- and sixteenth-century Italy, see A. Sutherland Harris and L. Nochlin, *Women Artists 1550–1950*, Alfred Knopf, New York, 1976, pp. 20–5 and 26–32. See also W. Chadwick, *Women, Art and Society*, pp. 59–86.

[3] For the daughter of Paolo Uccello, see Vasari—Milanesi 11, p. 217.

[4] The engraver Diana Scultore is mentioned in Vasari—Milanesi VI, p. 490, while the scarce information on Barbara Longhi is in VII, p. 421. On this artist, see a brief article on her Madonna and Child paintings, by L. De Gerolami Cheney, 'Barbara Longhi of Ravenna', *Woman's Art Journal*, 9, 11, Spring–Summer 1988, pp. 16–20. Vasari does not mention the Bolognese painter Caterina Vigri (1413–63), a nun in the convent of the Poor Clares, who was canonised in 1707. There are no works which can be attributed to her with certainty. On Caterina Vigri, see entries in V. Fortunati (ed.), *Lavinia Fontana 1552–1614*, exhibition catalogue, Electa, Milan, 1994, pp. 178–9. See also G. Alberigo, 'Caterina da Bologna dall'agiografia alla storia religiosa', *Atti e memorie delle Deputazioni di Storia patria per le province della Romagna*, XV–XVI, 1963–1964 / 1964–1965, pp. 5–23.

[5] On suor Plautilla Nelli, see Vasari—Milanesi V, pp. 79–80. Vasari also mentions the painter Lucrezia Quistelli, a pupil of Alessandro Allori and the wife of Count Clemente Pietra. Her paintings and portraits, he adds, are 'worth everybody's praise'. For Lucrezia Quistelli, see Vasari—Milanesi V, p. 80.

[6] On Properzia de' Rossi, see V. Fortunati Pietrantonio, 'Per una storia della presenza femminile nella vita artistica del Cinquecento bolognese: Properzia de' Rossi "schultrice" ', *Il Carrobbio*, VIII, 1981, pp. 168–77, and F. H. Jacobs, 'The Construction of a Life: Madonna Properzia de' Rossi "Schultrice" Bolognese', *Word and Image*, 9, 1993, pp. 122–32. Jacobs discusses Vasari's 'myth and fiction' constructed around the life of this artist. The relief by Properzia de' Rossi, *Joseph and the Wife of Potiphar* (Bologna, Museo di San Petronio) is discussed in the exhibition catalogue *Lavinia Fontana*, 1552–1614, pp. 179–80. See also the entries on a jewel decorated with peach stones carved with figures of saints, and on one, attributed to her in the exhibition, with a carved cherry stone, pp. 180–1. These miniature carvings brought her much praise from Vasari. Mary Rogers has noted

the importance that artists' beauty had during the sixteenth century in 'The Artist as Beauty' (unpublished paper delivered at the 22nd Annual Conference of the Association of Art Historians, Newcastle, 12–14 April 1996.)

[7] Sofonisba Anguissola is discussed in Vasari—Milanesi V, pp. 80–1, and, together with her sisters, in V1, pp. 498–502.

[8] Germaine Greer's comment on Vasari's treatment of Sofonisba Anguissola's work is in *The Obstacle Race. The Fortunes of Women Painters and their Work,* Seeker & Warburg, London, 1979, p. 69. Whitney Chadwick also misunderstands Vasari's comments when she writes that 'Vasari and other male writers responded to Anguissola and her sisters as prodigies of nature rather than artists'. See her *Women, Art and Society,* Thames and Hudson, London, 1990, pp. 70–7. Fredrika H. Jacobs gives a more accurate and penetrating account of Vasari's treatment of Sofonisba Anguissola placing it in the context of sixteenth-century theories on art and creativity ('Women's Capacity to Create: the Unusual Case of Sofonisba Anguissola' *Renaissance Quarterly,* 47, 1, Spring 1994, pp. 74–101). Jacobs points out that the kind of praise Vasari reserves for Sofonisba's portraits is in fact exceptional (pp. 78 and 91 ff.).

[9] Vasari quotes in full the letter from Pius IV as evidence of Sofonisba's talent: '*Pins Papa IIII. Dilecta in Christo filia.* Dearest daughter, we have received the portrait of the most serene queen of Spain, which you have sent to us. This was very agreeable to us, both because of the person it represents, whom we love very dearly because of her religious feelings and for the other beautiful qualities of her soul, and because it has been painted with such diligence by your own hand. We thank you for it, and we assure you that we shall keep it amongst our dearest possessions. We praise this talent of yours, which, even if it is so wonderful, is only the smallest among your many talents. And we send you again our blessing and wishes that Our Lord should keep you. *Dat. Romae, dic XV octobris* 1561' (Vasari–Milanesi VI, p. 500).

[10] The letters from Tommaso Cavalieri and Averardo Serristori to Duke Cosimo are cited by I. S. Perlingieri, *Sofonisba Anguissola. The First Greal Woman Artist of the Renaissance,* Rizzoli, New York, 1992, p. 72. On Tommaso Cavalieri's use of the term '*inventione*', see F. H. Jacobs, 'Women's Capacity to Create', pp. 95 ff.

[11] For the comments made by Lomazzo and Lamo, see *Sofonisba Anguissola e le sue sorelle,* exhibition catalogue, Leonardo Arte, Milan, 1994, pp. 404 and 405.

[12] Sutherland Harris and Linda Nochlin, *Women Artists 1550–1950.* The catalogue also provides very useful bibliographies for each artist. This is the most thorough among a number of books covering similar ground and structured in a similar way, which, however, abandon the standard of scholarship of Harris and Nochlin to follow a polemical line.

[13] On this exhibition, see the review by A. Bayer, *Burlington Magazine,* 137, March 1995, pp. 201–2. The excellent catalogue of the exhibition, *Sofonisba Anguissola le sue sorelle,* is an example of scholarly dedication and precision.

[14] See the catalogue for this exhibition, *Lavinia Fontana 1552–1614.* Particularly important is an essay by Angela Ghirardi on the typology of the self-portrait by women artists during the late sixteenth Century, 'Lavinia Fontana allo specchio. Pittrici c autoritratto nel secondo Cinquecento', pp. 37–51, which examines two self-portraits by Lavinia Fontana (one, signed and dated 1577, now in the Accadernia Nazionale di San Luca in Rome; the other, signed and dated 1579, in the Corridoio Vasariano in the Uffizi, in Florence), and compares them with the self-portraits by Sofonisba Anguissola.

Sexist Texts Boycotted: Interview with H. W. Janson

ELEANOR DICKINSON

H.W. Janson was Professor of Fine Arts at New York University. He wrote important studies of Renaissance art and the history of sculpture. His textbook, History of Art *(Englewood Cliffs, NJ, and New York: Prentice-Hall, Inc., and Harry N. Abrams, Inc.), first published in 1962, has been translated into a dozen languages and has introduced millions of students to the study of art. Janson died in 1982.*

Sex discrimination frequently clouds the vision of university administrators, gallery operators, and the art establishment in general. But this is only the most conspicuous way in which women are second-class citizens in the art world: Discrimination in any form reflects deep-seated attitudes and assumptions of the larger culture.

Since 1964, Horst Waldemar Janson's *The History of Art* has virtually monopolized the art-history field and when it comes to the transmission of attitudes regarding art, there are few vehicles as powerful. In Janson's book, women artists are quite literally invisible: Of some 3000 artworks presented in the tome, not one is attributed to a woman.

In protest, the Coalition of Women's Art Organizations has called for a boycott of Janson's book, as well as of Helen Gardner's *Art Through the Ages* (originally published in 1926, now in its sixth edition, having been revised in 1975 by Horst de la Croix and Richard G. Tansey).

CWAO has issued the following statement:

> We demand the end of the monopoly of the Janson and Gardner art-history textbooks. These books, purchased by the hundreds of thousands every year by students, continue even in recent revised editions to totally neglect women artists. We will seek such remedies as may be possible through negotiations with publishers, and we will distribute lists of remedial texts, articles, and catalogues to academics and other interested parties. We may also adopt strategies involving legislation, the courts, or boycotts, as may suit the occasion and our purpose.

From Eleanor Dickinson, "Sexist Texts Boycotted," *Women Artists News* 5, No. 4 (September–October, 1979), 12. © Midmarch Arts Press. Reprinted by permission.

In an interview with Eleanor Dickinson earlier this year, Janson reiterated his views published in *WAN (Women Artists News)* in May, 1978, defending his decision not to include women artists in his text. And again he avoided promising to correct the deficiency in future revisions. The following are excerpts from that interview:

ED: Dr. Janson, is there any hope for your including women in your textbook?

HWJ : Ask Linda Pommer [Linda Nochlin]. She is a prominent art historian who has written an article that explains why there have been no great women artists. Unless someone formally refutes Linda Pommer, I feel guided by the statement of Professor Pommer of Vassar.

ED: She was covering up to the early part of this century, and your book continues to 1978.

HWJ: That is right, and I may very well in the next edition include a woman artist, but at least until the most recent edition [1978] I have not been able to find a woman artist who clearly belongs in a one-volume history of art.

ED: But Mary Cassatt, or Frida Kahlo, or Kathe Kollwitz . . .

HWJ: They are all important artists, but they are not quite important enough to go into a one-volume history of art. . . . Of course, I keep revising [the book] every five or six years [Janson plans another revision for 1983 or 1984], and as things continue I may very well find a woman artist who does make the grade.

ED: Are you aware that the [CWAO] is starting a national boycott of your book?

HWJ: No *(laughing),* but this is a free country and they are certainly at liberty to do so. Anyway, there would be no problem putting in one woman artist as a token.

ED: But you don't consider that they are first-rank artists?

HWJ: Well, of course it depends what you mean by first-rate . . .

ED: Whatever terms you used in determining the ones you do have in the book.

HWJ: The works that I have put in the book are representative of achievements of the imagination, let us say, that have one way or another changed the history of art. Now, I have yet to hear a convincing case made for the claim that Mary Cassatt has changed the history of art.

ED: Kathe Kollwitz? Bridget Riley? Nevelson?

HWJ: They also haven't changed the history of art to that degree, you see.. . . . It is a matter of degree, because every artist does to some extent. It may be infinitessimal, but I'm trying to keep the same standards throughout, and there's no point, in fact I would consider it dishonorable, to engage in tokenism. I mean, I have no black [American] artists in there either. . . . Once you start with tokenism . . . then I'd also have to make sure that there's a lesbian artist. Mexican-Americans, and. . . .

ED: Do you feel that to include *any* woman artist would be tokenism?

HWJ: No, not at all. If the work of the woman artist comes up to my expecta-tion, of importance, I shall be only too happy to include her, but I don't want to go out of my way to include a woman artist just because there's a general demand from these women artists.

Janson and Gardner may dominate the art-history text market, but they do not have a monopoly on sexism in art books. According to *Women's Caucus for Art Newsletter,* other standard textbooks that mention no women artists in-clude: Albert Elsen's *Purposes of Art,* E.H. Gombrich's *The Story of Art,* Jan-son's *Key Monuments of the History of Art,* Robb and Garrison's *Art in the Western World,* and Seldon Rodman's *Converstations with Artists* (35 contem-porary artists). The situation begins to improve with John Canaday's *Main-streams of Modern Art,* which mentions five women artists; Frank J. Roos' *An Illustrated Handbook of Art,* which mentions four; and Wolf Stubbs' *Graphic Arts in the 20th Century,*which includes ten women. . . .

The New Sexism: Liberating Art and Beauty

CAMILLE PAGLIA

Camille Paglia is Professor of Humanities at the University of the Arts in Philadelphia. She is the best-selling author of Sexual Personae: Art and Deca-dence from Nefertiti to Emily Dickinson *(New Haven: Yale University Press, 1990),* Sex, Art and American Culture: Essays *(New York: Vintage Books, 1992), and* Vamps and Tramps: New Essays *(New York: Vintage Books, 1994). She is also a columnist for* Salon.com.

Washington had a sizzling hit show with "Walk the Goddess Walk: Power In-side Out," recently on view at the District of Columbia Arts Center and curated by artist Alison Maddex. The September 10 opening, featuring performance and video artists such as Manhattan drag queen Glennda Orgasm, drew a crowd of over a thousand.

From Camille Paglia, "The New Sexism: Liberating Art and Beauty," *Vamps and Tramps* (New York: Vintage Books, 1994), 113–16; originally published in *The Washington Post,* 26 September, 1993, C3. Reprinted by permission of the author.

Above all, "Walk the Goddess Walk" demonstrated that, in the current unadventurous Washington art scene, there is a great craving for excitement and the challenge of something new. I suspect that we were also seeing a rejection of the political correctness that is stunting the cultural development of a whole generation of young women emerging from elite American colleges and universities.

Like Maddex, with whom I collaborated in the show, I have despaired about the tendentiousness, ignorance, and mediocrity of feminist attitudes toward art and beauty. Issues of quality and standards have been foolishly abandoned by liberals, who now interpret aesthetics as nothing but a mask for ideology. As a result, the far right has gained enormously. What madness is abroad in the land when only neoconservatives will defend the grandeur of art?

Ironically, today's fashion magazines and supermodels, embodying the cult of beauty for a mass audience, are in the main line of art history. Cultural authenticity has shifted to them and away from the establishment ideologues like those running the Whitney Museum in New York, who are obsessed with a passé political agenda.

When Maddex and I toured the Whitney's rape exhibit this summer, we were appalled and incredulous. Visitors were wandering around with tears in their eyes, as rape victims recited their sorrows on a video monitor. When the offerings of a major museum are indistinguishable from the victimization soap opera of television talk shows, art has ceased to exist. The intelligent, courageous artist and curator would defy the rape hysteria, not surrender to it.

Danger signs are everywhere that we are sliding into a new era of the Red Guards. As I know from my visits to campuses across the country, abuse and intimidation await anyone who dares to reject the party line on sexual and political issues. There is a trend among followers of the ideas of Catharine MacKinnon which has resulted in vandalism of art works that fail to conform to feminist orthodoxy. The pro-sex wing of feminism sat around smugly for years, content that it had signed a list or two defending pornography and never realizing that its total silence on the date rape and sexual harassment issues facilitated MacKinnon's rise.

One of the many lies of women's studies is that European art history was written by white males and that feminism has conclusively rewritten that history by discovering and restoring major female artists excluded from the pantheon by patriarchal conspiracy. But European art history was not just written but created by white males. We may lament the limitations placed on women's training and professional access in the past, but what is done cannot be undone.

The last twenty years of scholarship have brought many forgotten women artists to attention, but too often their presentation has been marred by anachronistic feminist rhetoric. Nancy G. Heller's lucid, evenhanded *Women Artists* is a noteworthy exception to this depressing trend. Germaine Greer's *The Obstacle Race* regrettably veers again and again into agitprop, worst of all

on the last page, where Greer declares that the reason there have been no great female artists is that you cannot get great art from "mutilated egos." I would argue that great art comes *only* from mutilated egos.

Feminism, for all its boasts, has not found a single major female painter or sculptor to add to the canon. It did revive the reputations of many minor women, like Frida Kahlo or Romaine Brooks. Mary Cassatt, Georgia O'Keeffe, and Helen Frankenthaler were known and did not need rediscovery. Artemisia Gentileschi was simply a polished, competent painter in a Baroque style created by men.

Women's studies has not shifted the massive structure of art history one jot. It is scandalous that our most talented women undergraduates are being tutored in attitudes of juvenile resentment toward major male artists of the rank of Degas, Picasso, and Marcel Duchamp, who have become virtual untouchables. We will never get great art from women if their education exposes them only to the second-rate and if the idea of greatness itself is denied. Greatness is not a white male trick. Every important world civilization has defined its artistic tradition in elitist terms of distinction and excellence.

Now is the time for all pro-sex, pro-art, pro-beauty feminists to come out of the closet. Maddex and I have created what we call Neo-Sexism, or the New Sexism. It is a progressive feminism that embraces and celebrates all historical depictions of women, including the most luridly pornographic. It wants mythology without sentimentality and every archetype, from mother to witch and whore, without censorship. It accepts and welcomes the testimony of men.

The New Sexism puts sensuality at the center of our responsiveness to life and art. Rejecting the bourgeois feminist obsession with anorexia and bulimia, it sets food and sex into the same continuum of the pleasure principle. It calls for a new, vivid language of art criticism that reveres the art work instead of talking down to it. No more dead jargon and empty theory; no more ideology substituting for appreciation; no more moralism masquerading as politics.

All art belongs to its social context, but great art by definition transcends that context and speaks universally. Sex is one of the supreme subjects of art and literature of the last two hundred years. It deserves to be treated in a way that respects its mystery and complexity. That is what "Walk the Goddess Walk" tried to do. it was designed to overthrow the tyranny of false politics and to open the mind toward art—the spiritual and carnal record of mankind.

Northern Art vs. Italian Art

As Martin Kemp demonstrates, Italian Renaissance artists conceived of the picture as a window onto an ideal perspectival world, rationally laid out for the viewer who was its "mean and measure." This Italian model found its way into the later European academic tradition and became, in effect, the "mean and measure" by which painting was evaluated at least until the beginning of the twentieth century.

Svetlana Alpers points out that the acceptance of Italian art as the norm had the effect of marginalizing styles such as Dutch art that have quite different but not necessarily less important aims. Compared to the rational, orderly, controlling "masculine" art of the Italian tradition, Northern art has been regarded as an art that is merely descriptive rather than analytical—a lesser art that "will appeal to women."

The Mean and the Measure of All Things

MARTIN KEMP

Martin Kemp has written extensively about the connection between art and science. His books include Beyond the Picture: Art and Evidence in Italian Renaissance Art *(New Haven and London: Yale University Press, 1997) and* Visualizations: The 'Nature' Book of Art and Science *(Oxford and New York: Oxford University Press, 2000). He recently edited* The Oxford History of Western Art *(Oxford and New York: Oxford University Press, 2000). He is Professor of the History of Art at the University of Oxford.*

The old and much criticized cliché that the "spirit" of the Italian Renaissance can be identified with a new attitude toward man may still possess some value in our quest to characterize the arts of this period. The great humanist Leon Battista Alberti, in his innovative dialogues on private and public life entitled *Della famiglia,* which he composed between 1433 and 1441, provided a classic formulation of what we have come to see as the archetypal Renaissance attitude to man: "The Stoics taught that man was by nature constituted the observer and manager of things. Chrysippus thought that everything on earth was born only to serve man, while man was meant to preserve the friendship and society of man. Protagoras, another ancient philosopher, seems to some interpreters to have said essentially the same thing, when he declared that man is the mean and measure of all things."[1] Alberti quotes the same tag from Protagoras in his seminal treatise *Della pittura* (*On Painting,* 1435), when he explains how the human figure provides the essential frame of reference for the scale of all other forms in a perspectival picture.[2]

Alberti's neo-Stoic ideas appear to reveal a heightened and extended definition of man as the "purpose" of nature—as the being for whom nature was created and through whom the order of God's creation becomes apparent. Without man as a rational observer, such order would remain unseen. The perception of nature and intellectual command over its rules place human beings in a position of potential mastery within the physical world, giving them the means to make nature serve their purposes—even if these purposes are

Excerpted from Martin Kemp, The Mean and the Measure of All Things, *Circa 1492: Art in the Age of Exploration,* ed. Jay A. Levenson, Exh. Cat. National Gallery of Art (Washington, D.C., 1992) 95–97. Reprinted by permission.

ultimately dependent upon God's decrees. The exploitation of knowledge within the context of such admirable pursuits as scholarship and the various arts permits human beings to cultivate *virtù* (worth, talent, and will) as the means of combating *fortuna* (the whims of fate).

The expression of such ideas in the writings of Alberti and his fellow humanists provided the basis for the famous characterization of "Renaissance man" in Jacob Burkhardt's *Civilization of the Renaissance in Italy*, the classic study by the great Swiss historian, first published in 1860. At the start of the key section, "The Development of the Individual," Burkhardt painted a beguiling picture of the new consciousness. "In the Middle Ages both sides of human consciousness—that which was turned within as that which turned without—lay dreaming or half awake beneath a common veil. The veil was woven of faith, illusion, and childish prepossession, through which the world and history were clad in strange hues. Man was conscious of himself only as a member of a race, people, party, family, or corporation—only through some general category. In Italy this veil first melted into air; an *objective* treatment and consideration of the State and of all the things of this world became possible. The *subjective* at the same time asserted itself with corresponding emphasis; man became a spiritual *individual,* and recognized himself as such."[3] His equally crucial section, "The Discovery of the World and of Man," opens with a short essay on the "journeys of the Italians," which are epitomized by the adventures of Columbus. In Burkhardt's view, the voyages of discovery are prime symptoms of the Renaissance spirit. "Freed from the countless bonds which elsewhere in Europe checked progress, having reached a high degree of individual development and been schooled by the teachings of antiquity, the Italian mind now turned to the discovery of the outward universe, and to the representation of it in speech and form. . . . Columbus himself is but the greatest of a long list of Italians who, in the service of Western nations, sailed into distant seas. The true discoverer, however, is not the man who first chances to stumble upon anything, but the man who finds what he has sought. . . . Yet ever we turn again with admiration to the august figure of the great Genoese, by whom a new continent beyond the ocean was demanded, sought and found."[4]

Leaving aside the question of whether it was accurate to say that what Columbus found was the new continent he sought, modern historians no longer accept Burkhardt's characterization of the Renaissance enterprise even on its own terms. The polarities of attitude he used to demarcate the medieval and Renaissance periods have been crucially blurred, both by a greater understanding of medieval culture in its own right and by a greater awareness of the amount of medieval baggage carried by even the most progressive Renaissance thinkers. Moreover, there is a growing tendency to see the voyages of exploration themselves as a continuation of the travel and expansion that had begun to characterize Europe's relationship to Asia and Africa in the course of the preceding centuries.[5] Even more seriously, the underlying

assumption—that "man" and "nature" were in some sense waiting to be "discovered"—can be shown to be untenable, since every age has articulated its own special relationship to the world through selective perceptions that have disclosed that period's own "man" and "nature." This is not to say that we should necessarily expect the full range of these perceptions to be expressed in a transparent way in the works of art from each age, since the functional contexts for what we call the arts do not necessarily provide vehicles for their expression. Thus, the fact that perceptions of man and nature may be less striking in much of medieval art by no means indicates that such perceptions were not present in the consciousness of medieval thinkers.

Although we may no longer share Burkhardt's confidence in the picture he painted of Renaissance man, his intuition that profound changes were taking place in fifteenth-century Europe has not been entirely superseded. In the present context, it is worth emphasizing that not the least important of these was the changing scope of the arts, which came to articulate the relationship of man to nature in new ways through the transformation of their communicative means. Nor is Burkhardt entirely wrong in his conviction that shared aspirations can be discerned behind the geographical ambitions of those explorers who regarded the surface of the earth as a space for conquest and behind the representational endeavors of those authors and artists who disclosed "real" people in "real" space and "real" time.

The Rationalization of Space: Geometry and the Man-Made Environment

Renaissance thinkers did not hesitate to connect the ordering of space with the highest organizing principles of the universe. The humanist Alberti, who was an architect and theorist of art, as well as a writer, wrote a Latin satire, *Momus (The Prince)*, in which Jove searches, at first unavailingly, for a means to bring order into the chaos of earthly existence. This chaos had been orchestrated by Momus, the wayward son of Night, who had been expelled from the heavens was now reveling in his capricious rule on earth. The contradictory and sophistic opinions of the philosophers Jove consults in his quest provide him with no clear guidance on the best model for a new world order. The first signs of enlightenment come when he sees a stupendous architectural creation, a great Colosseum-style theater, whose harmonious design signals the rational system that should underlie the cosmos as a whole and its component parts. Jove laments his own earlier stupidity in "not having turned to the constructors of such an extraordinary work, rather than the philosophers, to plan the model of the world of the future."[7]

Alberti makes it equally clear in his short but seminal treatise *Della pittura (On Painting)*, written in Latin in 1435 and translated into Italian a year later, that painters play no lesser a role than architects in revealing the inherent

Figure 19. Anonymous. *View of an Ideal City*, 15th century. Walters Art Gallery, Baltimore.

order of nature as created by God.[8] The means through which painters were to effect this revelation was the acquisition of rational understanding and systematic skills. Alberti considered these attributes essential if their possessors were to have any hope of resisting the vagaries of fortune in human affairs. The kind of enlightenment that Alberti sought was disinterested in that the philosopher-creator was to be detached from corrupting entanglements in the hurly-burly of politics and commerce, but it was not completely separate from society, since it could be applied to the creation of actual structures for the benefit of human life. The vision of order formulated by Alberti, founded on the neo-Stoic doctrines of the Roman authors he admired, above all Cicero and Seneca, was very much that of the new urban intellectual class, for whom monastic withdrawal from society seemed as undesirable as unreserved commitment to the unprincipled outer world where human beings struggled for supremacy.

The new visions of space that appeared in the Late Middle Ages and the Renaissance, above all in Italy, and most especially in Florence, arose within urban societies and were expressed through new conceptions of the human environment—not only the environment that was actually constructed for the conduct of human affairs, but also the imagined worlds depicted by practitioners of the figurative arts [Figure 19].

NOTES

[1] *I Libri della famiglia,* trans. R.N. Watkins, *The Family in Renaissance Florence* (Columbia, S.C., 1969) 133–134.

[2] Martin Kemp, ed., *Leon Battista Alberti on Painting,* trans. C. Grayson (Harmondsworth, 1991), 53.

[3] Jacob Burckhardt, *The Civilization of the Renaissance in Italy,* trans. S. Middlemore (London, 1960), 81.

[4] Burckhardt 1960, 171–172.

[5] J.R.S. Phillips, *The Medieval Expansion of Europe* (Oxford, 1988).

[6] C.R. Mack, *Pienza, the Creation of a Renaissance City* (Ithaca, N.Y., 1987).

[7] Leon Battista Alberti, *Momo of del principe,* ed. R. Consolo (Genoa, 1985) 234–235.

[8] Kemp 1991.

Art History and Its Exclusions: The Example of Dutch Art

SVETLANA ALPERS

Svetlana Alpers is Professor Emerita at the University of California, Berkeley. She has written innovative studies of seventeenth and eighteenth century art and has served as the editor of several journals including Representations, The Raritan Review, *and* Word and Image. *Her 1988 book,* Rembrandt's Enterprise: The Studio and the Market *(Chicago: University of Chicago Press, 1988), won the Charles Rufus Morley Prize for the most distinguished book on art history by an American.*

It has been an assumption of feminist students of art history that their task is nothing less than to rewrite the history of art. The question, of course, is how it is done. What does it entail? . . .

My own understanding of this issue came about not through women's art but through my own field, the art of northern Europe from Van Eyck to Vermeer. The methodology that I was taught prepared me to deal with Italian art, but not with this. The rhetoric, the very language with which we talk about a painting and its history is, I would claim, Italian born and bred. This is a truth that art historians are in danger of ignoring in the present rush to diversify the objects and the nature of their studies. Italian art and the rhetorical evocation of it has not only determined the study of works, it has defined the practice of the central tradition of Western artists. This definition of art was internalized by artists and finally installed in the program of the Academy. This was the tradition to equal (or to dispute) well into the nineteenth century. It was the tradition which produced Vasari, who was the first art historian and the first writer to formulate an autonomous history of art. A notable sequence of artists in the West and a central body of writing on art can be understood in these Italian terms. Since the institutionalization of art history as an academic discipline, the major analytic strategies by which we have been taught to interpret images—style as proposed by Wölfflin and iconography by Panofsky—were developed in reference to the Italian tradition.

Excerpted from Svetlana Alpers, "Art History and Its Exclusions: the Example of Dutch Art," *Feminism and Art History: Questioning the Litany* (ed. Norma Broude and Mary D. Garrard (New York: Harper & Row, Publishers, 1982), 183–99. Reprinted by permission of the author.

When I refer to the notion of art in the Italian Renaissance, I have in mind the definition of the picture first put into words by Alberti. Though this dates from the fifteenth century, it remained, through what we have come to think of as several changes of style, the dominant notion of the picture in the West until the present century. Painting, and beyond that the fresco, is the ideal form. It is a unique, unreplicable creation as contrasted, for example, with prints. It is conceived of as a window onto a second world. The viewer, rather than the world seen, has priority. Alberti's picture originates with a viewer who is actively looking out at objects—preferably human figures—in space. Their appearance is a function of their distance from the viewer. We can let Dürer's rendering of perspective practice represent the making of the Albertian picture [Figure 15]. Though he was a northerner, Dürer's ambition here was to re-present the practice of the Italians he so admired. It is Alberti who instructed the artist to lay down a rectangle on the model of the window frame. The picture is the artist's construct, an expression in paint, as Alberti says, of the intersection of the visual plane at a given distance from the observer.[1] It could be argued that Alberti's greatest invention was this picture itself. The framed rectangle on the wall which became the basis of the art of painting in the West is distinct from the painted walls of Egypt, the scrolls of China, the pages of India or even the panels of Byzantium. The frame has priority in the ordering of the image which thus lends itself to formal (stylistic) analysis in its relation to its rectangular surround. Sight or vision is defined geometrically in this art. It concerns our measured relationship to objects in space rather than the glow of light and color. Finally, human figures are central. They dominate the world and, in the case of a Michelangelo at least, they exclude all other phenomena. Creation in such art is of man, not of the world as it is represented in the flora and fauna which crowd a Garden of Eden by the Flemish artist Roelant Savery.

The highest aim of such painting is to be like poetry. Artists elevated themselves from their craft status by allying themselves with privileged modes of knowledge: with mathematics on the one hand and with literature on the other. Iconography as a way of analyzing pictorial meaning, like the art itself, trusts basically to texts as a basis for all meaning. We look through the pictorial surface to the deeper meaning of the text. It is verbal meaning or the narration of stories that we take away from such pictures. In both the art and the analysis of it, completed composition is asserted over the craft and process of making, and meaning dominates over representation and its functions. In its ordering of the world and in its possession of meaning, such an art, like the analysis art historians have devoted to it asserts that the power of art over life is real. Many aspects of Renaissance culture—its painting, its literature, its historiography—are born of this active confidence in human powers. Dürer's woodcut tellingly reveals it in the relationship of the male artist to the female observed who offers her naked body to him to draw. The attitude toward

women in this art—toward the central image of the female nude in particular—is part and parcel of a commanding attitude taken toward the possession of the world.

Of course this tradition does not account for all that was going on pictorially in Italy at the time: chests were being decorated, tapestries woven, pottery painted, and books illustrated. Artists such as Pisanello were engaged in making an encyclopedic account of the myriad things in the world. But these kinds of making were pushed aside by Alberti's definition of the painting.[2] They have not been treated as central to what we call the history of art.

Now let us turn to the North. Though my remarks are largely based on seventeenth-century images, their pictorial mode is grounded also in earlier images in the North. It is commonly said that Northern art represents a different way of perceiving or looking at the world. But I want to emphasize that it constitutes also a different relationship to the world, a different mode of art. As an appropriate contrast to Dürer's artist demonstrating how to make a picture in the Italian manner, let us take two men observing the image made by a camera obscura as the model of Northern picture making. The men are in a dark room which is equipped with a lighthole fitted with a lens. They hold out a surface, a piece of paper perhaps, on which is cast the image of the landscape beyond. People, trees, boats on a canal are all brought inside, re-presented for their delectation. In the place of an artist who frames the world to picture it, the world produces its own image without a frame. Rather than a man possessing through his art the female he observes, the men attend to the prior world, the world as it existed before them. While Dürer's woodcut recalls the engagement of Italian art with the monumental female nude, the Northern image calls to mind Vermeer's *View of Delft* [Figure 20]. In Vermeer's painting, Delft seems neither ordered nor possessed, it is just there for the looking. It is as if visual phenomena are present without the intervention of a human maker.

The Dutch offer their pictures as descriptions of the world seen, rather than as imitations of human figures engaged in significant actions. It is the world, not the maker or viewer, which has priority. A pictorial image is not a window, but rather a mirror, or a map laid out on a flat surface. The maker is not posited prior to the painted world but is himself of the world. On rare (and telling) occasions, as in some still-lifes by Van Beyeren, he is even captured on a mirroring surface in the picture and seen as but one of many objects in the world. Related to this anonymous maker, eyes fixed on the world, is the fact that this is an art of replication and of repetition. Multiples are the normal condition of Dutch pictures. Bound up with this is the fact that it is hard to trace much stylistic development, as we usually call it, in the work of Dutch artists. Even the most naive viewer can see much continuity, not to say repetition, in Northern art from Van Eyck to Vermeer. But as yet

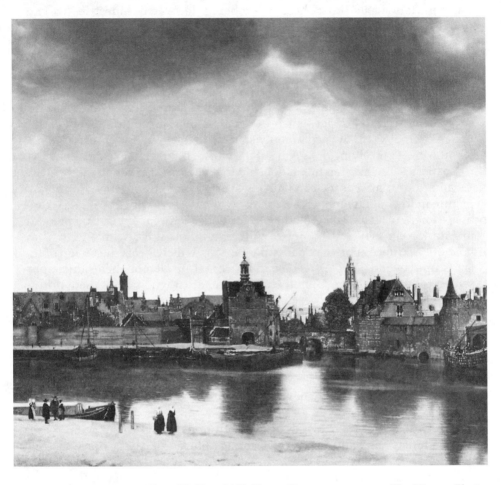

Figure 20. Jan Vermeer, *View of Delft*, c. 1660. Haags Gemeentemuseum, The Hague. Photo: Giraudon / Art Resoure, NY.

no history on the developmental model of Vasari has been written, nor do I think it could be. This is because the art did not constitute itself as a progressive tradition, it did not make a history in the sense that it did in Italy. For art to have a history in this Italian sense is the exception, not the rule. Most artistic traditions mark what persists and is sustaining, not what is changing, in culture. . . .

The problem is hardly new. The Italians in the Renaissance had difficulty dealing with Northern art and, significantly, one way in which they expressed it was to dub Northern art an art for women. Keeping in mind all that we have just seen about the difference between Northern and Southern modes of picturing, let us look once again at the oft-cited passage attributed by Francisco de Hollanda to none other than Michelangelo himself:

> Flemish painting . . . will . . . please the devout better than any painting of Italy. It will appeal to women, especially to the very old and the very young, and also to monks and nuns and to certain noblemen who have no sense of true harmony. In Flanders they paint with a view to external exactness or such things as may cheer you and of which you cannot speak ill, as for example saints and prophets. They paint stuffs and masonry, the green grass of the fields, the shadow of trees, and rivers and bridges, which they call landscapes, with many figures on this side and many figures on that. And all this, though it please some persons, is done without reason or art, without symmetry or proportion, without skilful choice or boldness and, finally, without substance or vigour.[3]

While reason and art and the difficulty involved in copying the perfection of God are on the side of Italy, only landscape, external exactness and the attempt to do too many things well belong to the North. The contrast is between the central and definitive Italian concern with the representation of the human body and the Northern concern with representing everything else in nature, exactly and unselectively. Northern art is an art for women because it lacks all reason and proportion. It lacks the human figure as a prior module or measure for the harmonious pictured world. The implication is clearly that Italian art is for men because it is reasoned and proportioned. But why cite women? As a gloss to this, we can turn to a fifteenth-century Italian handbook on painting, written by Cennino Cennini:

> Before going any farther I will give you the exact proportion of a man. Those of a woman I will disregard for she does not have any set proportion. . . . I will not tell you about irrational animals because you will never discover any system of proportion in them. Copy them and draw as much as you can from nature.[4]

To say an art is for women is to reiterate that it displays not measure or order but rather, to Italian eyes at least, a flood of observed, unmediated details drawn from nature. The lack of female proportion or order in a moral sense is a familiar sentiment from this time. What is suggested by de Hollanda is its analogue in a particular mode of art—an art not like ideal beautiful women but like ordinary, immeasurable ones.

Is it a fault not to be ordered, as the Italians claim, or is it simply the way things in the world are, as Dutch art seems to claim? How do we relate to this presence of the prior world seen? It is in the meditative works of Jan Vermeer that this basic problem of a descriptive art is faced. . . .

I am aware that there are familiar psychological terms in which we might confirm the female label that the Italian commentators put on northern European art, and by extension we could place a male label on Italian art. It is part of our Western culture to find this kind of patient contemplation, this giving in and adapting to the world rather than seizing it and making it one's own, to be weak, not strong; feminine, not masculine. To want to possess meaning is masculine, to experience presence is feminine. This sexual designation is, however, not biologically determined but rather a matter of culture. And in the makings of art—these marvelous, gentle, loving, strangely detached works by Vermeer, for example—we find a demonstration that the engagement of such modes of being is open to either sex. It is not the gender of makers, but the different modes of making that is at issue.

There is something more important than calling this or that feminine or masculine. It seems to me that the lesson we can draw from looking at Northern art as we have is that there are different modes of art which require different ways of looking and of understanding. We are today in the midst of a demystification of the definition and of the making of art. All kinds of activities and all kinds of functions for images are now being taken seriously. But it is time that we also demystify our methods of our history to let more in, to allow us to deal fully and intelligently with more ways of picturing and seeing. To offer another example: in the current storm of rhetoric rising about photography, I often feel that those who wish to deny its status as art come closer to the mark than do those who simply want to absorb it into the flow of art history as we know it. An attack on photography such as Susan Sontag's, which defines it as a totally different kind of image from painting, at least has the virtue of allowing and encouraging distinctions to be made and the positions from which we make such distinctions to be acknowledged.[5] The strategy I would recommend, therefore, is not just to insist that women be written into art history, but that art history itself—specifically its notions of what a work of art is, how it functions in society, and how we understand it—be rewritten.

NOTES

[1] Leon Battista Alberti, *On Painting*, trans. by Cecil Grayson, London, 1972, p. 49.

[2] Michael Baxandall has pointed out that prior to Alberti, the language of the humanists was most suited to praise and expound an artist such as Pisanello. See Michael Baxandall, *Giotto and the Orators*, London, 1971, pp. 89–120.

[3] Francisco de Hollanda, *Four Dialogues on Painting*, trans. by Aubrey F. C. Bell, London, 1928, pp. 15–16.

[4] Cennino d'Andrea Cennini, *The Craftsman's Handbook*, trans. by Daniel V. Thompson, Jr., New York, n.d., pp. 48–49.

[5] I am referring of course to Susan Sontag, *On Photography*, New York, 1977. As examples of studies which accommodate photography to the established history of painting, I have in mind Kirk Varnedoe, "The Artifice of Candor: Impressionism and Photography Reconsidered," *Art in America*, January 1980, pp. 66–78, and Peter Galassi, Before Photography, New York, 1981. In contrast, Rosalind Krauss, who is so at odds with Sontag in her evaluation of photography, shares with her the aim of defining its distinctive mode.

CHAPTER 14

Gender and Representation

Does it matter what gender an artist is? Does being a man or a woman in any way affect the subject an artist chooses or the ways in which he or she portrays that subject?

Art historians Carol Duncan and Rosemary Betterton both argue that an artist's work closely reflects her or his experience in society as either a woman or a man. Duncan finds that the young middle-class male artists of the early modernist movement were heavily influenced by their society's assumptions about male sexual identity, especially when they painted the female nude. In fact, she considers the whole modernist movement to be heavily biased toward the masculine. Betterton discovers that a woman artist trained in the same tradition approached the same subject with different results.

For Duncan and Betterton, the differences they see raise questions about gender itself. What do 'masculine' and 'feminine' mean? Are they biologically determined as so-called Essentialists propose? Or are they socially constructed categories? These were among the important new questions raised by feminist art historians in the 1970s.

Virility and Domination in Early Twentieth Century Vanguard Painting

CAROL DUNCAN

Carol Duncan writes on modern and contemporary art issues. Her books include The Aesthetics of Power: Essays in Critical Art History *(Cambridge and New York: Cambridge University Press, 1993) and* Civilizing Rituals: Inside Public Art Museums *(London and New York: Routledge, 1995). She teaches in the School of Contemporary Arts at Ramapo College of New Jersey.*

. . . According to all accounts, the decade before World War I was the heroic age of avant-garde art. In that period, the "old masters" of modernism—Picasso, Matisse, the Expressionists—created a new language and a new set of possibilities that became the foundation for all that is vital in later twentieth-century art. Accordingly, art history regards these first examples of vanguardism as preeminent emblems of freedom.

The essay that follows looks critically at this myth of the avant garde. In examining early vanguard painting, I shall be looking not for evidence of innovation (although there is plenty of that), but rather for what these works say about the social relations between the sexes. Once we raise this question—and it is a question that takes us outside the constructs of official art history—a most striking aspect of the avant garde immediately becomes visible: however innovative, the art produced by many of its early heroes hardly preaches freedom, at least not the universal human freedom it has come to symbolize. Nor are the values projected there necessarily "ours," let alone our highest. The paintings I shall look at speak not of universal aspirations but of the fantasies and fears of middle-class men living in a changing world. Because we are heirs to that world, because we still live its troubled social relations, the task of looking critically, not only at vanguard art but also at the mechanisms that mystify it, remains urgent.

Already in the late 19th century, European culture was increasingly disposed to regard the male-female relationship as the central problem of human

Excerpted from Carol Duncan, "Virility and Domination in Early Twentieth Century Vanguard Painting." Copyright © *Artforum,* December 1973. Revised and reprinted in *Feminism and Art History: Questioning the Litany,* ed. Norma Broude and Mary Garrard (New York: Harper and Row, 1982), 292–313.

existence. The art and literature of the time is marked by an extraordinary preoccupation with the character of love and the nature of sexual desire. But, while a progressive literature and theater gave expression to feminist voices, vanguard painting continued to be largely a male preserve. In Symbolist art, men alone proclaimed their deepest desires, thoughts, and fears about the opposite sex. In the painting of Gustave Moreau, Paul Gauguin, Edvard Munch and other end-of-the-century artists who grappled with this central question of existence, the human predicament—what for Ibsen was a man-woman problem—was defined exclusively as a male predicament, the woman problem. As such, it was for men alone to resolve, transcend, or cope with. Already there was an understanding that serious and profound art—and not simply erotic art—is likely to be about what men think of women.

Symbolist artists usually portrayed not women but one or two universal types of women.[1] These types are often lethal to man. They are always more driven by instincts and closer to nature than man, more subject to its mysterious forces. They are possessed by dark or enigmatic souls. They are usually acting out one or another archetypal myth—Eve, Salomé, the Sphinx, the Madonna.

Young artists in the next avant-garde generation—those maturing around 1905 in France and Germany—began rejecting these archetypes along with the muted colors, the langorous rhythms, and the self-searching artist-types that Symbolism implied. The Symbolist artist, as he appears through his art, was a creature of dreams and barely perceptible intuitions, a refined, hypersensitive receiver of tiny sensations and cosmic vibrations. The new vanguardists, especially the Fauves and the Brücke, were youth and health cultists who liked noisy colors and wanted to paint their direct experience of mountains, flags, sunshine, and naked girls. Above all, they wanted their art to communicate the immediate impact of their own vivid feelings and sensations before the things of this world. In almost every detail, their images of nudes sharply contrast to the virgins and vampires of the 1890s. Yet, like the previous generation, younger artists believed that authentic artistic content speaks to the central problems of life, and they continued to define these in terms of the male situation—specifically the situation of the middle-class male struggling against the strictures of modern, bourgeois society.

[Ernst Ludwig] Kirchner was the leader and most renowned member of the original Brücke, the group of young German artists who worked and exhibited together in Dresden and then Berlin between 1905 and 1913. His *Girl Under a Japanese Umbrella,*1909 [Figure 21] asserts the artistic and sexual ideals of this generation with characteristic boldness. The artist seems to attack his subject, a naked woman, with barely controlled energy. His painterly gestures are large, spontaneous, sometimes vehement, and his colors intense, raw, and strident. These features proclaim his unhesitant and uninhibited response to sexual and sensual experience. Leaning directly over his model, the artist fastens his attention mainly to her head, breasts, and buttocks, the

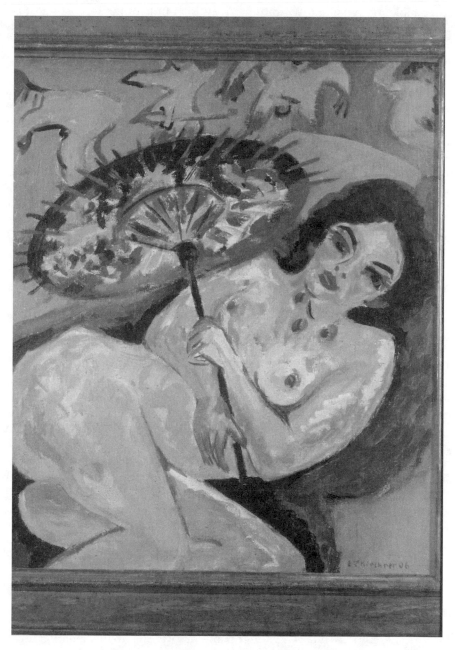

Figure 21. Ernest Ludwig Kirchner, *Nude Under a Japanese Umbrella,* c. 1909 Kunstsammlung Nordrhein-Westfalen, Düsseldorf. Photo: Erich Lessing/Art Resource, NY.

latter violently twisted toward him. The garish tints of the face, suggesting both primitive body paint and modern cosmetics, are repeated and magnified in the colorful burst of the exotic Japanese umbrella. Above the model is another Brücke painting, or perhaps a primitive or Oriental work, in which crude shapes dance on a jungle-green ground. . . .

The dichotomy that identifies women with nature and men with culture is one of the most ancient and universal ideas ever devised by man and appears with greater or lesser strength in virtually all cultures. However, beginning in the eighteenth century, Western bourgeois culture increasingly recognized the real and important role of women in domestic, economic, and social life. While the basic sexual dichotomy was maintained and people still insisted on the difference between male and female spheres, women's greater participation in culture was acknowledged. In the nineteenth century the bourgeoisie educated their daughters more than ever before, depended on their social and economic cooperation, and valued their human companionship.

What is striking and—for modern Western culture unusual—about so many 19th- and 20th-century vanguard nudes—is the absoluteness with which women were pushed back to the extremity of the nature side of the dichotomy, and the insistence with which they were ranked in total opposition to all that is civilized and human. In this light, the attachment of vanguard artists to classical and biblical themes and their quest for folk and ethnographic material takes on special meaning. These ancient and primitive cultural materials enabled them to reassert the woman/nature-man/culture dichotomy in its harshest forms. In Eve, Salomé, the Orpheus myth, and the primitive dancer, they found Woman as they wanted to see her—an alien, amoral creature of passion and instinct, an antagonist to rather than a builder of human culture. The vanguard protested modern bourgeois male-female relationships; but that protest, as it was expressed in these themes, must be recognized as culturally regressive and historically reactionary. The point needs to be emphasized only because we are told so often that vanguard tradition embodies our most progressive, liberal ideals.

. . . (W)hile the realm of woman is valued, it is valued *as* an alien experience. The artist contemplates it, but with full awareness of what it means to remain outside. For to enter it fully means not only loss of social identity, but also loss of autonomy and of the power to control one's world.

The same ambivalence marks the twentieth-century work I have been discussing, especially the many paintings of nudes in nature. In these images, too, the realm of woman/nature invites the male to escape rationalized experience and to know the world through his senses, instincts or imagination. Yet here, too, while the painter contemplates his own excited feelings, he hesitates to enter that woman/nature realm of unconscious flesh, to imagine himself *there*. He prefers to know his instincts through the objects of his desire. Rarely do these artists depict naked men in nature. When they do, they are almost never inactive. To be sure, there are some naked, idle males

in Kirchner's bathing scenes, but they are clearly uncomfortable and self-conscious-looking. More commonly, figures of men in nature are clothed, both literally and metaphorically, with social identities and cultural projects. They are shepherds, hunters, artists. Even in Fauve or Brücke bathing scenes where naked males appear, they are modern men going swimming. Unlike the female bather, they actively engage in culturally defined recreation, located in historical time and space. Nowhere do these men enter nature—and leave culture—on the same terms as women. Now as in the 1890s, to enter that world naked and inactive is to sink into a state of female powerlessness and anonymity. . . .

[Vanguard artists] advocated the otherness of woman and asserted with all their artistic might the old idea that culture in its highest sense is an inherently male endeavor. . . . From this decade dates the notion that the wellsprings of authentic art are fed by the streams of male libidinous energy. Certainly, artists and critics did not consciously expound this idea. But there was no need to argue an assumption so deeply felt, so little questioned, and so frequently demonstrated in art. I refer not merely to the assumption that erotic art is oriented to the male sexual appetite, but to the expectation that significant and vital content in *all* art and art-making presupposes and reveals the presence of male erotic energy.

The nudes of the period announce it with the most directness; but landscapes and other subjects might confirm it as well, especially when the artist invokes aggressive and bold feeling, when he "seizes" his subject with decisiveness, or demonstrates other supposedly masculine qualities. Vlaminck, although primarily a landscape painter, could still claim, "I try to paint with my heart and my loins, not bothering with style."[2] But the celebration of male sexual drives was more forcefully expressed in images of women. More than any other theme, the nude could demonstrate that art originates in and is sustained by male erotic energy. This is why so many "seminal" works of the period are nudes. When an artist had some new or major artistic statement to make, when he wanted to authenticate to himself or others his identity as an artist, or when he wanted to get back to "basics," he turned to the nude. The presence of small nude figures in so many landscapes and studio interiors—settings that might seem sufficient in themselves for a painting—also attest to the primal erotic motive of the artist's creative urge. . . .

That such content—the linking of art and male sexuality—should appear in painting at precisely the moment when Freud was developing its theoretical and scientific base indicates not the source of these ideas but the common ground from which both artist and scientist sprang. By justifying scientifically the source of creativity in male sexuality,[3] Freud acted in concert with young avant-garde artists, giving new ideological shape and force to traditional sexist biases. The reason for this cross-cultural cooperation is not difficult to find. The same era that produced Freud, Picasso, and D. H. Lawrence—the era that took Nietzsche's superman to its heart—was also defending itself

from the first significant feminist challenge in history (the suffragist movement was then at its height). Never before had technological and social conditions been so favorable to the idea of extending democratic and liberal-humanistic ideals to women. Never before were so many women and men declaring the female sex to be the human equals of men, culturally, politically, and individually. The intensified and often desperate reassertions of male cultural supremacy that permeate so much early twentieth-century culture, as illustrated in the vanguard's cult of the penis, are both responses to and attempts to deny the new possibilities history was unfolding. They were born in the midst of this critical phase of male-female history, and as such, gave voice to one of the most reactionary phases in the history of modern sexism.

Certainly the sexist reaction was not the only force shaping art and ideas in the early twentieth century. But without acknowledging its presence and the still uncharted shock waves that feminism sent through the feelings and imaginations of men and women, these paintings lose much of their urgency and meaning. Moreover, those other historical and cultural forces affecting art, the ones we already know something about—industrialization, anarchism, primitivism, the legacy of past art, the quest for freer and more self-expressive forms, primitivism, the dynamics of avant-garde art-politics itself, and so on—our understanding of these must inevitably be qualified as we learn more about their relationship to feminism and the sexist reaction.

Indeed, these more familiar issues often become rationalizations for the presence of sexism in art. In the literature of twentieth-century art, the sexist bias, itself unmentionable, is covered up and silently approved by the insistence on these other meanings. Our view of it is blocked by innocent-sounding generalizations about an artist's formal courageousness, his creative prowess or his progressive, humanistic values. But while we are told about the universal, genderless aspirations of art, a deeper level of consciousness, fed directly by the powerful images themselves, comprehends that this "general" truth arises from male experience alone. We are also taught to keep such suspicions suppressed, thus preserving the illusion that the "real" meanings of art are universal, beyond the interests of any one class or sex. In this way we have been schooled to cherish vanguardism as the embodiment of "our" most progressive values. . . .

NOTES

[1] For the iconography of late nineteenth-century painting, I consulted A. Comini, "Vampires, Virgins and Voyeurs in Imperial Vienna," in *Women as Sex Object*, ed. L. Nochlin, New York, 1972, pp. 206–21; M. Kingsbury, "The Femme Fatale and Her Sisters," in ibid., pp. 182–205; R. A. Heller, "The Iconography of Edvard Munch's *Sphinx*," *Artforum*, January 1970, pp. 56–62; and W. Anderson, *Gauguin's Paradise Lost*, New York, 1971.

[2] Vlaminck, in H.Chipp, *Theories of Modern Art*, Berkeley, Los Angeles, London, 1970 p. 144.

[3] Philip Rieff, *Freud: The Mind of the Moralist*, New York, 1959, Ch. 5.

How Do Women Look?
The Female Nude in the Work
of Suzanne Valadon

ROSEMARY BETTERTON

Rosemary Betterton's scholarly interests focus on the link between women artists and images of the female body. Her books include Looking On: Images of Femininity in the Visual Arts and Media *(New York: Pandora, 1987) and* An Intimate Distance: Women, Artists and the Body *(New York: Routledge, 1996). She teaches at the Institute for Women's Studies, Lancaster University in the U.K. She also writes and consults on regional planning in Britain.*

. . . (A) body of feminist work has been developed which analyses the position of the male spectator in relation to the female image as being one of power and control. This work has developed a powerful feminist critique of the ways in which women are represented in the visual media. It has constituted an important challenge to the notion that there can be a common experience of images across gender (and also race and class) divisions. However, an analysis of images which focuses exclusively on their relationship to a male spectator leaves certain problems unexplained and difficult to resolve. Centrally, it offers no explanation of how women look at images of women. It is this question which I want to develop here in two main ways. Firstly, what does it mean to look from a woman's point of view? And, secondly, how do women appear in images made by women?

. . . I want to argue that women can and do respond to images of themselves in ways which are different from, and cannot be reduced to, masculine 'ways of seeing'. The work of Suzanne Valadon (1865–1938) shows how a woman artist working within a male tradition of representation *could* produce images which disrupt the conventions of a genre. My starting point for looking at Valadon was a general interest in women artists working at the beginning of the century many of whom are perhaps known by name, but whose work is difficult to see either in reproduction or in exhibition.

Excerpted from Rosemary Betterton, "How Do Women Look? The Female Nude in the Work of Suzanne Valadon," *Looking On: Images of Femininity in the Visual Arts and Media*, ed. Rosemary Betterton. (London: Pandora Press, 1987) 217–34. Reprinted by permission of the author.

It was the discovery that she worked extensively on the female nude, a subject linked almost exclusively to male artists, which seemed to connect up with wider questions about the relationship of women to images of themselves. In particular it raised the issue of what kinds of pleasures are offered to women as spectators within forms of representation which, like the nude, have been made mainly by men, for men. . . .

Female sexuality is clearly a problematic area of representation for women artists to work on, given the bias of western culture towards fetishizing the female body. The nude in art has been enshrined as an icon of culture since the Renaissance, and epitomizes the objectification of female sexuality. For both these reasons it is peculiarly resistant to change by women artists. Suzanne Valadon is unusual as a woman artist in taking the nude as a central theme of her work. Her work therefore poses some interesting questions about the relationship of women to a 'masculine' genre. Does a woman artist necessarily produce a different kind of imagery from her male counterparts? Can a woman who is not a feminist produce work which is feminist? If the nude is embedded in a structure of gendered looking, based on male power and female passivity, is it possible for a woman artist to 'see' it differently?

I want to try to answer these questions by looking at those aspects of Valadon's experience as a woman and as an artist which made her relationship to the nude distinctly different from that of her male contemporaries. In her work, I will argue, we can see a consciousness of women's experience which challenges the conventions of the nude. . . .

So far I have written about a 'masculine' and a 'feminine' viewpoint as if these were unproblematically assumed by 'real' men and women whenever they look at an image. Both 'masculine' and 'feminine' are not essences, but social categories formed through changing social experiences. They are not only imposed from outside us, they are also experienced subjectively as part of our understanding of who we are. But in a patriarchal culture it is clearly the case that women are forced to adopt a masculine viewpoint in the production and consumption of images far more often than men are required to adopt a feminine one. Since gender relations are not equal, women, in looking at paintings or watching films, may indeed be placed in the position of adopting a voyeuristic gaze: but that position involves discomfort, a constant process of readjustment. For example, a woman looking at a nude could quite easily adopt a position of aesthetic detachment, since that is the way we are all taught to look at art in this culture. However, if she began to refer the image to her own experience of being treated as a sexual object (for example, of walking down a street past a group of staring men), the way she looked at the image could change her point of view. . . .

A woman artist cannot be assumed to have 'seen' differently from her male contemporaries, but it can be argued that the particular force of her experience produced work which was differently placed within the dominant forms of representation of her period. It is necessary therefore to look at how

Valadon's background and position as a woman artist affected her representation of the nude.

Artist as Model

Suzanne Valadon worked for about ten years as a professional artist's model. This is significant for her own work as an artist and for the ways in which her subsequent identity has been established. Modelling in the late nineteenth and early twentieth centuries signified a particular relationship of artistic practice to sexuality. The period of Valadon's working life from the 1880s to 1938 saw the popularity of Bohemia as a central myth of artistic life. At its core was the relationship between the male creator and his female model. Alfred Murger's *Vie de Bohème*, published first as short stories and then in book form in 1851, set a pattern for fictional accounts of young artists and doomed models. Clearly part of the success of Bohemia lay in its mobilization of existing ideologies of masculinity and femininity. In the artist-model relationship there seemed to be a 'natural' elision of the sexual with the artistic: the male artist was both lover and creator, the female model both his mistress and his muse. Some male painters explicitly connected their artistic powers with sexual potency. Auguste Renoir, for whom Valadon modelled in the 1880s, was alleged to have said: 'I paint with my prick.' . . .

The essential complement of the lusty artist was the female model, who was never seen as a contributor in the production of an image, but only as passive material to be posed and manipulated, subject to the transforming power of the artist. In popular myth, and sometimes in fact, the model's exploitation as the object of the artist's gaze led directly to her exploitation as his sexual object. In paintings of the nude by some modernist artists of the 1900s this connexion is represented explicitly, as for example in the various versions of *Artist and Model* by the German painter, Ernst Ludwig Kirchner.

The fusion of the sexual and the artistic in ideologies of art production clearly created problems for a woman artist. Painting from the female model formed part of the definition of what it meant to be an artist, but at the same time it had come to signify a sexualized relationship. For a woman to become a 'serious' artist then, a transgression of contemporary ideals of femininity was implied: yet if she kept to the 'safer' subjects of domestic scenes, flower paintings or landscapes, she risked relegation to the secondary status of 'woman artist'. In Frances Borzello's study of the artist's model it is suggested that the normative value of the male artist/female model relationship was such that it rendered all other relations between artist and model deviant.[1] . . .

Although the classes for women were available in Paris, for instance at the Académie Julien where nude male models were used, painting from the nude must still have been a relatively rare experience for women before 1900. It has

been taken for granted by most writers on women in art that institutional exclusion from study of the nude was damaging to women artists. But it is not clear what drawing from the naked body would have meant to a middle-class woman. What relationship could she have to the male iconography of the nude? Even viewed through the distancing veil of aesthetic values, the nude in painting was uncomfortably close to the sexually explicit discourses of pornography. The fact that both shared the same regime of representations meant that at any moment the image could become dangerously ambivalent, as did Manet's painting of *Olympia* in 1865. For a woman brought up within definitions of bourgeois femininity which tabooed the sight of her own body, let alone anyone else's, painting the nude must have been fraught with difficulty. Intervention in a genre bound up with the fundamental premises of male creativity involved problems far beyond institutional exclusion. It questioned the definition of femininity itself. It is therefore not surprising that few women artists working at the end of the nineteenth century made the nude a central theme in their work, despite increased access to life classes.

Yet Suzanne Valadon did just that. From her first drawings in the 1880s throughout her working life she produced images of the nude. What made this possible? The answer seems to lie in her background as a model which made her experience of art markedly different from the majority of both male and female artists. Her sexual identity was constructed outside bourgeois femininity and, by selling her body as a model, she entered the art world by an 'underground' route. Furthermore, her class background barred her from access to professional or academic training. As the illegitimate daughter of a part-time seamstress and cleaning woman, she occupied an extremely marginal position even within the working-class milieu of Montmartre.[2]

In the 1880s, the suburb of Montmartre was becoming a favoured area for artists looking for cheap studio space and picturesque views. Women in search of work stood in the Place Pigalle waiting to be viewed and picked out by artists in search of models. The parallels with prostitution are clear: a model also offered her body for sale, she was usually of lower-class origin and dependent upon her middle-class 'client', her rates of pay were low and established by individual negotiation. Even if a model led a blameless life, she was clearly defined outside the codes of respectable femininity.

By her own account Valadon was a very good model and extremely successful at it, and there is nothing to suggest that she felt exploited. But modelling placed her both outside the respectability which was still accepted by most women artists and at the opposite pole from their aspirations. She was situated between the harsh world of the exploitation of women's work in low-paid jobs, with prostitution as an alternative, and the Bohemian world of the artist. What made Valadon almost unique was her successful transition from one to another. This transition of Valadon's from model to artist was a hard process, both in terms of acquisition of technical ability and in the struggle to form a new identity as a professional artist.

In becoming an artist Valadon took on, and lived out, the characteristics of the male Bohemian stereotype: a succession of lovers, a scorn for money and a wild lifestyle. Yet it was not a role which, as a woman, she could inhabit without contradictions. This is evident in the complicated and difficult relationships she had with her mother and with her son, Maurice Utrillo, which created enormous tensions throughout her life. It is also evident in her work. While her early drawings used nude subjects, these were often based on her own body or that of her child. Her relationship to the nude therefore could not be the same as that of a male artist using female models, although she learnt to draw using conventions of representation common to artists of her period.

Her work was based on direct experience of the way her own body was used as a model, and it is clear from the self-portraits that she saw herself in an uncompromising and independent way. She is both subject and object, viewer and viewed, in her nude studies, in a way which begins to redefine and reconstruct the relationship of artist and model and, in turn, of spectator and image. Valadon's interest lies partly, then, in the way she combined roles of model and artist and by doing so disrupted the normative relationships of masculine creativity and feminine passivity. But she is interesting also because as a model she did not conform to the respectable image of the 'woman artist' and thus was able to work within the male-defined iconography of the nude. Valadon's disruption of those codes comes neither from a conscious feminist perspective nor from mere circumstance, but from the consciousness which she developed as a woman who experienced different but overlapping definitions of femininity and masculinity, creativity and class.

Model as Artist

When Valadon began to produce her first drawings during the 1880s the academic tradition of the nude was already fragmenting. During her working life as an artist the formal conventions of art were radically transformed by the modernist aesthetics of the Parisian avant-garde. But as **Carol Duncan** has pointed out, the modernist 'break' did not challenge the ideological assumptions embedded in the representation of the nude.[3] The social and aesthetic radicalism of avant-garde artists did not necessarily imply a critique of existing gender relations. In the work of Picasso or Kirchner the theme of male sexual dominance and female passivity is reproduced in an even more explicit and violent way. Valadon's work has to be situated in a complex set of discourses of modernist aesthetics and more traditional ideologies of gender relations.

I want to draw out one strand which is relevant to Valadon's choice of a particular mode of representing the nude. This was the desire in the second half of the nineteenth century to represent the 'modern' nude, no longer veiled in history or mythology, but the woman 'as she is', seen on the modelling couch,

in the studio and in a landscape. The notion of woman "as she is" in itself sig-
nifies an ideological construction at work. In the bathers of Renoir, Degas and
Cézanne and in Gauguin's women of Tahiti, for instance, can be seen the re-
working of the powerful myth of woman as nature. The nude in landscape in
particular came to signify an identification of women's bodies with the forces
of nature. Women could be seen as 'naturally' representing fertility and un-
threatening eroticism.

How do Valadon's drawings of the nude relate to this theme of the natural
woman? Clearly she too was concerned to represent the modern nude,
stripped of historical and mythologizing trappings. But her work departs sig-
nificantly from the repressive connotations of the work of her male precursors
and contemporaries. Her choice of theme—woman seen naked in the studio,
in domestic interiors and in landscape—suggests that she should be placed
with painters who sought to demystify the nude and develop new forms of
realism. Yet in her treatment of the theme women are not shown to be in-
stinctual and natural beings, but individuals engaged in social relationships
and activities.

What Valadon tried to capture in her drawing was the intensity of a par-
ticular moment of action rather than a static and timeless vision. This suggests
a conscious and deliberate attempt to change existing codes of representation
which, in the case of the female nude, emphasized beauty of form, harmony
and timelessness. She chose in her portraits and nudes to show women caught
in moments of action and engaged in relationships with each other. This choice
was not governed by an uncontrollable emotional urge, as some of her biog-
raphers have suggested, but by a thorough familiarity with the work of con-
temporary artists, in particular Degas and Toulouse Lautrec. It was these two
artists who recognized her drawing ability while she was still a model, and
who encouraged her to exhibit her work in the Salon de la Nationale for the
first time in 1894. Her work was shown alongside that of Degas and Lautrec
in private galleries in the 1890s and 1900s, and after 1909 she exhibited regu-
larly at the most important venues for modern art in Paris, the Salon d'Au-
tomne and the Salon des Indépendants. The social milieu she frequented
included most of the leading members of the Parisian avant-garde. Such a po-
sition suggests that Valadon was quite familiar with current discourses on art
and was capable of consciously transforming them. . . .

It is the combination of the visual style with the innovations Valadon makes
in the iconography of the nude which makes her work specifically different. The
naked woman is very frequently shown in a social relationship with another
woman, often clothed and older, a servant or mother figure. Valadon used her
own mother, as well as her son, friends and servants, as models for her draw-
ings in the 1900s. Both figures are shown engaged in some activity which im-
plies a moment in a series of relationships and activities, and also a kind of
communication between the women. The experiences represented are familiar
and banal ones, not mystified through representation into a timeless moment.

By doing this Valadon is not simply offering us another version of the nude, she is challenging a central truth which it embodies. This myth is of Woman who, changeless and unchangeable, is identified with her biological essence, identified with her naked body. One of the peculiar features of the nude in art from 1500 to 1900 is that it offers us a woman who remains essentially unchanged through a kaleidoscopic variety of sets and costumes, landscape or harem, Venus or prostitute:

> Thus against the dispersed contingent and multiple existence of actual women, mythical thought opposes the Eternal Feminine, unique and changeless.[4]

Valadon's nudes, in showing women's nakedness as an effect of particular circumstances and as differentiated by age and work, therefore challenge the idea that nakedness is essence, an irreducible quality of the 'Eternal Feminine'.

Taken as a sequence, Valadon's drawings from the 1890s and 1900s show a series of interactions between women and children. This theme of women's relationships is continued in her paintings, though more frequently here the naked woman is seen in isolation. Many show two women of different ages— as in the works on the theme of mother and daughter, *Little Girl at the Mirror*, 1909, and *The Abandoned Doll*, 1921. In both paintings a naked adolescent girl looks at herself in a hand mirror, while in the second her mother gently dries her back with a towel, the abandoned doll lying at her feet. The two pictures together suggest a narrative of the onset of puberty and the girl's awareness of her own sexual being. In the earlier work the older woman shows the girl her reflection in an almost violent gesture. In the later picture the girl herself twists away from the mother, and while their poses echo each other, the physical contact between them is broken by their separate glances. In such works Valadon is questioning the dominant tradition of the nude as spectacle for the male viewer by focusing upon women's sense of the relationship between their state of mind and their experience of their bodies in processes of changing and ageing.

In a series of paintings from the 1920s and 1930s she draws, in common with her contemporaries, on existing iconographic codes of the reclining nude, but her versions differ from theirs in the attention given to the individuality of the sitter. In some, women look discomforted by their nakedness, while in others they seem unaware of their bodies: but in either case, the viewer is made aware of the woman's face which is as strongly and individually delineated as her body [Figure 22]. Some critics have noted that Valadon brings together the two separate genres of the nude and portraiture:

> Everything is portraiture as far as she is concerned, and a breast, thigh, wrinkle are interrogated with no less attention than a facial expression. The models, often chosen for their ugliness, their commonplace nature—heavy breasts, sagging stomachs, wide hips, prominent buttocks, thick wrists and ankles—are depicted

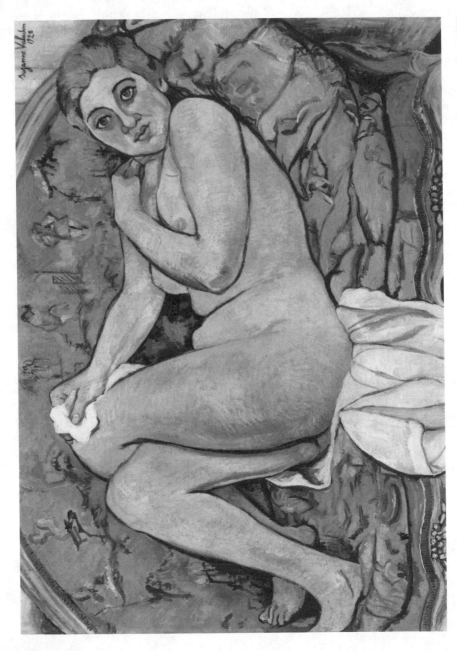

Figure 22. Suzanne Valadon, *Reclining Nude*, 1928. The Metropolitan Museum of Art, Robert Lehman Collection, 1975.

with a gift for individual characterization which we find in both individual and collective portraits.[5]

Dorival's comments are descriptively accurate while at the same time revealing his well-bred disgust for women who do not conform to the idealized, classless stereotype of the nude. Other male critics have found the stress on individual identities marked by class and age similarly difficult to take. One critic even accused Valadon of misogyny, of taking her revenge on women through a refusal to idealize their bodies.[6] Embedded within such critical confusions is the clear assumption that the aesthetic value of the nude is bound up with the sexual desirability of the model. Valadon's insistence on the individuality of her models, their differences in body size and shape, in age and in class, suggests relative indifference to conventional ideals of sexual attractiveness. Two of her own *Self Portraits,* painted when she was fifty-nine and sixty-seven respectively, show herself naked from the waist up, confronting the viewer with made-up face, jewellery and cropped hair. Th[is] painting . . . is disconcerting in its combination of self-image and nude form, and in Valadon's refusal to compromise with old age. Even more now than when it was painted, the image asserts the recognition of women's own view of their bodies against the tyranny of images of youth, beauty and attractiveness endlessly reflected in contemporary culture.

I am not arguing that more 'realistic' representations of women's bodies are necessarily better *per se,* but that Valadon ruptures the particular discourse of the fine art nude in which nudity = sexual availability = male pleasure. In doing so, she offers us a way of looking at the female body which is not entirely bound in the implicit assumption that all such images are addressed only to a male spectator.

Conclusion

Valadon's representation of the nude can be differentiated in a number of ways from the dominant imagery of female sexuality current in fine art in the early twentieth century. Although she worked within the category of the 'modern nude', and at times reproduced elements of its essentialist ideology of woman as nature, her work taken as a whole significantly departs from the norm. In showing naked women as diverse individuals engaged in daily social activities, the nude's primary signification as a sexual object for men is reworked as a site of different kinds of experience: of pleasure and embarrassment; of intimacy and sociability; of change and of ageing. In another way the formal characteristics of her drawing and painting deny the sensuous illusionism of the painted pin-up and render the woman's body less available to a voyeuristic gaze. If a male spectator's presence is always clearly signified in the traditional discourse of the nude, Valadon's work at least

makes it more difficult for a male viewer to assume such a position unconsciously, as the comments of the male critics quoted above would indicate.

I do not want to suggest that Valadon's work should be retrieved uncritically, to be dusted off for feminist consumption. Her acceptance of male definitions of art is undeniable, and so too is her success as an artist within those definitions during her own lifetime. But what she did do was to open up different possibilities within the painting of the nude to allow for the expression of women's experience of their own bodies. Although she worked within the given forms of her own period, she redrew their boundaries in order to represent and engage with a woman's viewpoint. Her work shows that it is possible for women to intervene even within a genre which has such a powerful tradition of male voyeurism as the nude in painting. . . .

NOTES

[1] F. Borzello, *The Artist's Model*, London, Junction Books, 1982.

[2] In references to Valadon's life her mother, Madeleine, is frequently described as a laundress. A reason for this mistake possibly lies in the popularity of the laundress as a stereotype of female working-class sexuality in late nineteenth-century French culture. For further details see Eunice Lipton, 'The Laundress in Late Nineteenth Century French Culture: Imagery, Ideology and Edgar Degas', *Art History*, vol. 3, no. 3, 1980. Valadon herself becomes a stereotype of sexual promiscuity in many biographical accounts.

[3] Carol Duncan, 'Virility and Domination in Early 20th Century Vanguard Painting', in Norma Broude and Mary D. Garrard (eds), *Feminism and Art History*, New York, Harper & Row, 1982. Modernist art movements in the 1900s were characterized by a rejection of the spatial illusionism, narrative and figuration of the European art tradition in favour of forms of art which used distortion of space and form and a greater degree of abstraction, and stressed the expression of subjective experience.

[4] Simone de Beauvoir, *The Second Sex*, Harmondsworth, Penguin Books, 1983, p. 283.

[5] Bernard Dorival, *Twentieth Century Painters*, New York, Universe Books, 1958, pp. 34–5.

[6] Jean Vertex cited in Jeanine Warnod, *Suzanne Valadon*, Switzerland, Bonfini Press, 1981, p. 73. No source given. An analysis of critical responses to Valadon's work requires a separate study in itself. Such comments reveal very clearly the patriarchal discourses of art history, which are incapable of dealing with women artists in other than stereotypical ways.

CHAPTER 15

Modernist Architecture

In the early part of the twentieth century, the dream of many modernist architects was to remake the world in an ideal, Utopian form. They believed the modern era had a destiny to fulfill in creating a better world where the individual and the community found a graceful balance. They believed good architecture in well designed cities could make good people.

Architectural historian, Sigfried Giedion, who wrote in the 1940s and 1950s, when the influence of modernist architecture was at its height, described the reforming aims of French architect, Le Corbusier. Le Corbusier, one of the most influential of the original modernist architects, embodied many of his ideas in the Unité d'Habitation, a high-rise apartment building in Marseilles. Giedion called it "a daring experiment both in the plastic sense and even more in the sphere of social imagination."

Nearly forty years later, critic Robert Hughes took another look at the Unité and Le Corbusier's larger plans for creating modern cities and found that in reality the Utopian dream had become a nightmare.

Social Imagination

SIGFRIED GIEDION

Sigfried Giedion studied architectural history in Europe before World War I. Following the war he became an enthusiastic proponent of International Style modern architecture and wrote a number of books on the subject. His most famous, Space, Time and Architecture: the Growth of a New Tradition, *first published in the United States in 1941, was enormously popular and influential with the post-World War II generation of American architects. He is also the author of* Mechanization Takes Command: A Contribution to Anonymous History *(New York: Norton, 1948). Giedion died in Zürich in 1968.*

. . . Between 1938 and 1953 small structures and one-family houses played no important role in Le Corbusier's development: during this period he became more and more the creator of large-scale designs.[1]

These projects coincided with general signs of a new humanization of urban life on the horizon. Man is no longer satisfied to remain a mere onlooker, whether at a football game or a television screen. His spontaneous reactions can be seen in every part of the world during moments in which the passive spectator has become transformed into an active participant.[2] There is a worldwide trend toward creating centers of social activity, and this calls for far more from the architect than just technical capacity. His task today is infinitely more complicated than that of his predecessors at the time when Versailles was built. They had but to give concrete form to an exact program placed before them by a clearly stratified society. Today the architect has to anticipate needs and to solve problems that exist only half consciously in the crowd. This involves a great responsibility. The architect has to have the rare gift of a peculiar sensitivity that we would like to term *social imagination.* . . .

The Unité d'Habitation, 1947–52

One of the few instances where social imagination has been given three dimensional expression is the "Unité d'Habitation," 1947–52 [Figure 23]—the residential unit—on the Boulevard Michelet in the outskirts of Marseille. The

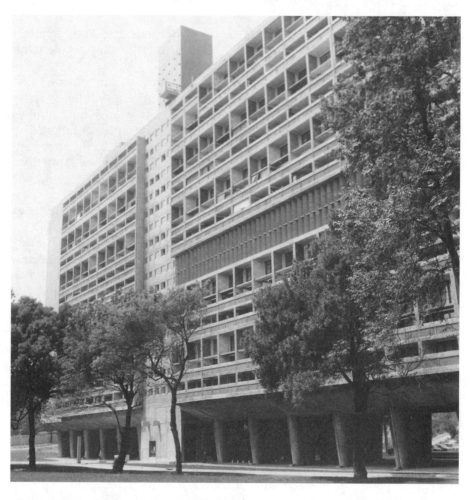

Figure 23. Le Corbusier, L'Unité d'Habitation, Marseille, 1946–52. Photo: Giraudon/ Art Resource, NY.

Marseillais call it simply "Maison Le Corbusier." That this daring building could be successfully completed during five difficult postwar years is due to the courage of M. Claudius Petit, the French Minister of Reconstruction, who defended it to the very last against violent attacks, and who on the opening day in October 1952 decorated Le Corbusier with the Legion of Honor upon the roof of the Unité d'Habitation.

The housing problem begins to take on a wider meaning. Both architect and planner are now working to rebuild the broken relationship between the individual and the collective spheres.

The boldness of the Unité d'Habitation does not consist in housing some 1600 people under one roof or even in providing twenty-three different types for its 337 apartments varying from one room up to dwellings for "families with eight children." Its boldness consists in its social implementation. The most interesting experiment in this residential unit was to take the shopping center from the ground and from the street and to place it on the central floor of the building itself. From outside, this central shopping street—*la rue marchande*—can be immediately identified by its two-story louvers. These, together with the vertical rows of square staircase windows in the middle of the block, vitalize and give scale to the whole front. The shopping street includes shops for groceries, vegetables, meat and fish, laundry and cleaning services, hairdresser and beauty shop, newspaper stand, post-office, cafeteria, and hotel rooms. On the seventeenth floor is placed the nursery for 150 children. A ramp leads directly to the roof terrace with its rest room on pilotis, its shallow pool, and some charming installations for the children, who are encouraged to decorate the walls with their own murals.

The other part of the 24 × 165 meter roof terrace is designed for social activities of the adults. There is an area for gymnastics, partly open and partly covered, and, at the north end of the building, a large slab which acts as a protection against the strong north wind—the *Mistral*—and also as a background for open-air theatrical performances. On July 26th 1953, when CIAM celebrated its twenty-fifth anniversary on the roof terrace of the Unite' d'Habitation, it looked like a painting of Paolo Veronese, for all the different levels were filled with people, and architecture was vibrant with life.

The features that make the Unité d'Habitation so rare an architectural spectacle are its plastic qualities. In the hands of Robert Maillart, reinforced concrete lost its rigidity and became almost an organic skeleton, where every particle throbbed with life. In the hands of Le Corbusier the amorphous material of crude concrete—*béton brut*—assumed the features of natural rock. He did not smooth away the marks and hazards of the form work and the defects of bad craftsmanship which, as Le Corbusier stated in his opening address, "shout, at one from all parts of the structure." The use of the natural imprints of wooden boards to vitalize a concrete surface was far from new, yet it had never been used so consistently to give ferroconcrete the properties of "a natural material of the same rank as stone, wood or terra cotta." Le Corbusier

continued: "It seems to be really possible to consider concrete as a recon-structed stone worthy of being exposed in its natural state."[3] In England, a few years later, there arose an architectural trend calling itself "the new bru-talism" that took this approach as its starting point.

The rough concrete surface is employed wherever it can strengthen plas-tic intentions, as in the herring-bone pattern of the huge supporting pilotis, left by the narrow boards that composed their wooden form work. On the roof the rough surfaces of the ventilator shafts and elevator tower, on which every change in the strong Mediterranean light plays with a peculiar intensity, help to transform these utilitarian objects into exciting plastic elements.

Strong, pure colors are used in this building, but Le Corbusier, the painter, refrained from using any colors directly upon the façade. He painted the side walls of the balconies red, green, yellow, but not the front. In this way they are made to gleam like vivid colors through gauze. Bright color is also used in all the artificially lit *rue-intérieures* and serves to lighten the dimness of these long corridors.

The Unité d'Habitation rises beside the road which leads to the Riviera and faces east and west. Each two-story apartment looks to both sides. To the east their view embraces an arena of the limestone mountains that can be found everywhere in Provence. To the west lie the blue waters of the Mediterranean; while directly below the eye can rest on tree tops interspersed with red-tiled southern roofs. If Cézanne was able to seize the soul of Provence in his pic-tures, Le Corbusier knew how to capture it within an architectural frame.

Le Corbusier, as well as everybody else, knew that the Unité d'Habitation was a daring experiment both in the plastic sense and even more in the sphere of social imagination. Even after its successful opening in the fall of 1952 the French government remained skeptical and dared not even to take the risk of renting the apartments and shops but demanded that they be sold outright, loading any risk upon the shoulders of the inhabitants and shopkeepers.

Yet there is no longer any doubt that this building has had an enormous in-fluence in shaping the mind of the younger generation. It has also helped to liberate the mind of the architect and planner from the conception of housing as a simple addition of single units and to expand it to the wider frame of the human habitat. . . .

NOTES

[1] For detailed information see *Le Corbusier, Œuvre complète, vol. IV (Zurich, 1949) and vol. V (Zurich, 1953)*.

[2] S. Giedion, "The Humanisation of Urban Life," in *CIAM, The Heart of the City,* edited by Tyrwhitt, Rogers, Sert (New York, 1952).

[3] *Le Corbusier, (Œuvre complète,* V. 191.

Trouble in Utopia

ROBERT HUGHES

Robert Hughes is an award-winning art critic and senior writer for Time *magazine. He has written several books including* American Visions: the Epic History of Art in America *(New York: Alfred A. Knopf, 1997) and the best-selling history of his native Australia,* The Fatal Shore *(London: Guild Publishing, 1986). Hughes also wrote and narrated the BBC/PBS television series* The Shock of the New, *1980.*

The culture of the twentieth century is littered with Utopian schemes. That none of them succeeded, we take for granted; in fact, we have got so used to accepting the failure of Utopia that we find it hard to understand our cultural grandparents, many of whom believed, with the utmost passion, that its historical destiny was to succeed. The home of the Utopian impulse was architecture rather than painting or sculpture. Painting can make us happy, but building is the art we live in; it is the social art *par excellence,* the carapace of political fantasy, the exoskeleton of one's economic dreams. It is also the one art nobody can escape. One can live quite well (in a material sense) without painting, music, or cinema, but the life of the roofless is nasty, brutish, and wet. . . .

One of the lessons of our century, learned slowly and at some cost, has been that when planners try to convert living cities into Utopias they make them worse. The famous words of the American officer in Vietnam—"We had to destroy that village in order to save it"—are their epitaph. But some of the greater minds of the twentieth century have thought otherwise, and from 1880 to 1930, when the language of architecture changed more radically than it had done in the preceding four centuries, the ideal of social transformation through architecture and design was one of the driving forces of modernist culture. Rational design would make rational societies. "It was one of those illusions of the 20s," recalls Philip Johnson, who with the architectural historian Henry Russell Hitchcock christened this new movement the International Style. "We were thoroughly of the opinion that if you had good architecture the lives of people would be improved; that architecture would improve people, and people improve architecture until perfectibility would descend on us like the Holy Ghost, and we would be happy for ever after. This did not prove to be the case."

Excerpted from Robert Hughes, "Trouble in Utopia," Chapter Four of *The Shock of the New,* revised ed. (New York: McGraw-Hill, Inc., 1991), 164–165; 187–191; 209–211. Reprinted by permission of the publisher.

Utopia was the tomb of the id. Within it, there would be no more aggression, and the conflicts of Mine and Thine would be resolved. It is worth remembering that one of Corbusier's aphorisms in the early twenties, when Europe was torn by radical unrest, was "architecture *or* revolution," as though all the impulses towards social violence came down to errors of housing. (Nevertheless, Corbusier's patrons, who included one or two of the largest capitalists in France, preferred on the whole to take their chances with revolution; grapeshot cost less than general rehousing.) In their belief that the human animal could be morally improved, and that the means of this betterment was four walls and a roof, the Europeans who created the modern movement— Walter Gropius, Mies van der Rohe, Bruno Taut, Antonio Sant' Elia, Adolf Loos, and Le Corbusier, to name only the best known among them—formed a concentration of idealist talent uncommon in architectural history. It expressed itself more in hypothesis than by finished buildings. The most influential architecture of the twentieth century, in many ways, was paper architecture that never got off the drawing board. And only in the twentieth century did earlier ideal schemes acquire such a retrospective importance. . . .

The lyric poet of this idea . . . was Charles-Édouard Jeanneret, better known by his nickname "Le Corbusier"—the crowlike one. (Doubtless this referred to his taut and beaky frame and inquisitive eye, rather than to his harsh, carking absolutism in argument; but it seems to suit both.) Corbusier (1887–1965) was, at the level of the single building, one of the most brilliantly gifted architects who ever lived—the Bramante or Vanbrugh of the twentieth century. He was also, on the scale of the town plan, one of the most relentlessly absolutist—a combination of Swiss clockmaker, Cartesian philosopher, and *roi soleil*. His manifesto of town planning, *The City of Tomorrow* (1924), has for its last illustration an engraving of Louis XIV ordering the construction of the Invalides, accompanied by Corbusier's remark that "this despot conceived immense projects and realized them. . . . He was capable of saying 'We wish it,' or 'Such is our pleasure.' " Nostalgic self-identification could hardly go further. In a way Corbusier was quite right to admire Louis, since only despotism could have swept away the zoning laws and rights of private property that impeded the construction of his own exemplary New Jerusalem, *La Ville Radieuse,* the "Radiant City." No designer in the history of architecture has been more possessed by an idea than Corbusier was. His own tragedy was that this idea was not fulfilled. But one may be quite sure that Corbusier's disappointment, grave as it was, could not have begun to compare with the misery and social dislocation the Radiant City would have inflicted on its inhabitants, had it ever been built.

Corbusier's Voisin Plan of 1925 was the most developed of his schemes for the rationalization of Paris. It developed from his irrefutable perception that the centre of Paris was too congested, crammed, and old to support the intense motor traffic that the early twentieth century was bringing; that many of its buildings were uncomfortable, dirty, and even dangerous; and that "urban

renewal," as understood by European city authorities in the early twenties, was inarticulate and patchy, where it existed at all. The Parisian street was a mediaeval relic—the "Pack-Donkey's Way," as he called it, the meandering fossil of pedestrian traffic between the old gates of Paris and its religious and commercial centre. For these clogged urban tubes and tripes, Corbusier's remedy was the knife. . . .

The Voisin Plan (so called because its research was underwritten by the car manufacturer Voisin, after Peugeot and Citroën turned it down) required the clearing of a 600-acre L-shaped site on the Right Bank; it would have involved the total destruction of the "particularly unhealthy and antiquated" areas around Les Halles, the Place de la Madeleine, the Rue de Rivoli, the Opéra and the Faubourg Ste-Honoré. From this *tabula rasa*, split east-west by a giant motorway, the new commercial and residential centre of Paris would rise in its cruciform tower blocks, surrounded by green space. "Imagine all this junk, which till now has lain spread out over the soil like a dry crust, cleaned off and carted away and replaced by immense clear crystals of glass, rising to a height of over 600 feet!" That Corbusier could dismiss most of Paris' historical deposit as a dry crust of junk is the measure of his fervour, and one would be quite wrong to think he did not mean every syllable of the tirades he directed against the sentimental *passéistes* who, in the name of memory and variety, opposed his "vertical city . . . bathed in light and air." He himself, he pointed out, was not bitterly opposed to the past, but he considered it civic duty to show that it *was* past by leaving its isolated memorials with nothing to do— "my dream is to see the Place de la Concorde empty once more, silent and lonely . . . these green parks with their relics are in some sort cemeteries, carefully tended. . . . In this way the past becomes no longer dangerous to life, but finds instead its true place within it." Such was Utopia's revenge on history. But Corbusier's particular enemy was the street, and on it he waged unremitting (if, mercifully, verbal) war. The idea that there could be alternatives to traffic congestion in old urban centres—like restricting the historical quarter to foot-traffic and routing the flow of cars round it, as has recently been done in Munich—never seems to have struck him. Corbusier's frozen perspectives of giant avenues crawling with coupés and humming with biplanes mean only one thing: a hatred of random encounter, which expressed itself in a city totally dedicated to rapid transit. "We watched the titanic rebirth of the traffic. Cars, cars! Speed, speed! One is carried away, seized by enthusiasm, by joy . . . enthusiasm over the joy of power." The car would abolish the street— and everyone in Utopia would own a car. The one thing nobody in *La Ville Radieuse* could expect to have was the *esprit de quartier,* the sense of variety, surprise, and pleasant random encounter that once made living in Paris one of the supreme experiences of urban man.

Le Corbusier himself got only one chance to build high-rise mass housing in France. That was his Unité d'Habitation (1946–52) [Figure 23], which stands a considerable way from the centre of Marseilles, on the Boulevard

Michelet. . . . It is one prototype unit of the Radiant City: an eighteen-storey block, 185 feet high, 420 feet long, and 60 wide, containing flats for 1600 people, the whole mass raised on concrete legs or *pilotis* above twelve acres of surrounding parkland. Surprisingly enough, the most successful and memorable part of this building is the roof. Corbusier meant it to contain a gymnasium, a paddling-pool for children, a palaestra for exercise and a bicycle track. Today the pool is cracked, the gymnasium closed (some optimist tried to resurrect it as a disco, which naturally failed), and the track littered with broken concrete and tangles of rusty scaffolding. Even so, in its decrepitude, it is one of the great roofs of the world: a metaphor of Corbusier's social alms, the concrete garden of ideal form, giving health to those who live in it. In the raking light of an early Mediterranean morning, it has a heroic sadness approaching that of a Greek temple. The Greeks, Corbusier wrote in *Towards an Architecture* (1923), had "set up temples which are animated by a single thought, drawing around them the desolate landscape and gathering it into the composition. Thus, at every point of the horizon, the thought is single."

Corbusier's career offered him only one site that compared with the bare singularity of the Acropolis, and it was this roof—bony grey hills behind, sea in front, and glittering air all around. In those days Marseilles was almost as clear as Athens, and the *massif* was bare of apartment blocks. The Unité stood alone, and Corbusier turned its roof into a magnificent ceremonial space, dedicated to the cult of the sun.

The problems begin under that slab. Corbusier had been deeply influenced by the doctrines of social reform elaborated by Charles Fourier (1772–1837). He did not imagine, as Fourier did, that in the coming Utopian age the sea would lose its salt and taste like lemonade, or that the world would blossom with 37 million playwrights, each one as good as Molière; but he was influenced by Fourier's notion of the ideal community, the "phalanstery" (a contraction of "phalanx" and "monastery"). The *phalanstère* was a profit-sharing commune of about one hundred families. Corbusier could not hope that the Unité would turn sixteen hundred rehoused Marseillais into communards overnight, but he declared that many of his ideas could be traced to the "prophetic propositions of Fourier . . . at the very birth of the Machine Age." Hence the extreme monasticism of the Unité. There is little privacy in this nobly articulated beehive of raw concrete; the children's rooms are hardly more than cupboards (Corbusier had no children of his own and apparently disliked them); and the ideal of communal self-sufficiency left its fossil in the form of a "shopping mall" on the fifth floor so that, in theory, nobody would need to leave the building to go to market. As everyone in France except Le Corbusier knew, the French like to shop in their street markets. So, the "shopping mall" remained deserted; later, it was turned into a spartan and equally empty hotel, the Hôtel Le Corbusier, where the sleepless guest may listen to the spectral whining of the mistral *inside* the building. Finally, none of the Marseillais who lived there could stand Corbusier's plain, morally elevating

interiors, so they soon restored the *machine à habiter* to the true style of suburban France. The flats of the Unité are crammed with plastic chandeliers, imitation Louis XVI *bergères*, and Monoprix ormolu—just the furniture Corbusier struggled against all his life. The man who wanted to assassinate Paris could not, in the end, ensure that a single concierge would buy the right rug.

Yet though he failed as a sociological architect, Corbusier was a great aesthete, and his power to invent form was extraordinary. He was in a sense the Picasso of architecture, because his designs provoke such strong sensations, contain such overmastering rhythms, and display such a muscularity of "drawing." His formal language was based on a passionate enjoyment of two systems of form which seemed diametric opposites but were, in his view, similar: classical Doric architecture, in all its lucidity, and the clear, analytic shapes of machinery. His famous comparison, in *Towards an Architecture,* is still startling: the flank of the Parthenon, with its regular rhythm of columns, and the bow-on view of a Farman biplane, with a similar rhythm set up by the struts between its wings. With such analogies, and in his own designs, Corbusier strove to celebrate what he called the "White World"—the domain of clarity and precision, of exact proportion and precise materials, culture standing alone—in contrast to the "Brown World" of muddle, clutter, and compromise, the architecture of inattentive experience. The art he practised, he declared, could be summed up as "the informed, correct and magnificent play of forms under light."

. . . Only one city in the West has ever been built from scratch along the strict, Corbusian schema of Utopian modernist town planning. In the 1950s, Brazil wanted a new capital: it was necessary, in the opinion of its leader—a narcissistic and touchy supremo named Kubitschek—to show the world some economic vigour by conspicuously "opening up" the interior. Bureaucrats hate ports. They are too open to influence, too polyglot, too hard to control; they have too much life. That is why the capital of Turkey is Ankara, not Istanbul, and why Australia is governed from Canberra, not Sydney. Brazil already had one of the liveliest ports in the world, Rio, a natural capital if ever there was one. Kubitschek accordingly established his seat of national government some twelve hundred kilometres inland, on a red-dirt plateau where nobody lived—or indeed wanted to. Le Corbusier's two most gifted South American followers designed it, under the more or less direct inspiration of the Formgiver. Lúcio Costa did the town plan, and the main ceremonial buildings were drawn up by Oscar Niemeyer. Brasília, as this place was named, was going to be the City of the Future—the triumph of sunlight, reason, and the automobile. It would show what the International Style could do when backed by limitless supplies of cash and national pride.

Between them, Niemeyer and Costa came up with a Carioca parody of *La Ville Radieuse:* the administrative buildings along one axis, and the main traffic artery sweeping across, with the workers' flats on stilts strung along it. The zoning was clear and rigid. One thing in one place. It looked splendid in

the drawings and the photographs: the most photogenic New Town on earth [Figure 24]. With its sweeping avenues and climactic dome, saucer, towers, and reflecting pools, Brasília seemed to be the reconciliation of Utopian modernism with the ceremonial State architecture that the Beaux-Arts had wanted to symbolize a century before. It had an excellent press, since Brazilian architectural critics did not dare criticize it, while most other critics, due to its excessive remoteness, have never actually seen it.

The reality of the place is markedly less noble [Figure 25]. Brasília was finished, or at any rate officially opened, in 1960, and ever since then it has been falling to bits at one end while being listlessly constructed at the other: a façade, a ceremonial slum of rusting metal, spalling concrete, and cracked stone veneers, put together on the cheap by contractors and bureaucrats on the take. It is a vast example of what happens when people design for an imagined Future, rather than for a real world. In the Future, everyone would have a car and so the car, as in Corbusier's dreams, would abolish the street. This was carried out to the letter in Brasília, which has many miles of multi-lane highways, with scarcely any footpaths or pavements. By design, the pedestrian is an irrelevance—a majority irrelevance, however, since only one person in eight there owns or has access to a car and, Brazil being Brazil, the public transport system is wretched. So the freeways are empty most of the day, except at peak hours, when all the cars in Brasília briefly jam them at the very moment when the rest of the working population is trying, without benefit of pedestrian crossings or underpasses, to get across the road to work.

Thus Brasília, in less than twenty years, ceased to be the City of Tomorrow and turned into yesterday's science fiction. It is an expensive and ugly testimony to the fact that, when men think in terms of abstract space rather than real place, of single rather than multiple meanings, and of political aspirations instead of human needs, they tend to produce miles of jerry-built nowhere, infested with Volkswagens. The experiment, one may hope, will not be repeated; the Utopian buck stops here.

And so Brasília is emblematical. The last half century, in architecture, has witnessed the death of the Future. Like the Baroque, or the High Renaissance, the modern movement lived and died. It produced its masterpieces, some of which survive, but its doctrines no longer have the power to inspire visions of a new world; and the Expressionist idea of the architect as "Lord of Art," which gave the modern movement its evangelical drive, is dead beyond resuscitation. "We are now at the close of one epoch," as the architect and critic Peter Blake wisely remarked in 1974, "and well before the start of a new one. During this period of transition there will be no moratorium on building, and for obvious reasons. There will just be more architecture without architects." One may take it for granted—or, at least, hope to do so—that people will always be moved and delighted by the Seagram Building, as they are by the Palazzo Rucellai or the Petit Trianon. A poetic conception as strong as Corbusier's vision of the "White World," as realized in the Villa Savoye, will almost

Figure 24. Oscar Niemeyer and Lúcio Costa, View of Brasilia/New Capital, c. 1960. Photo: © Bettmann/CORBIS.

Figure 25. Squatters' Shacks, Brasília. Photo: Carl H-ller.

certainly continue to give aesthetic inspiration to younger architects. . . . The crucial point, however, is that the lesson of modernism can now be treated as one aesthetic choice among others, and not as a binding historical legacy. The first casualty of this was the idea that architects or artists can create working Utopias. Cities are more complex than that, and the needs of those who live in them less readily quantifiable. What seems obvious now was rank heresy to the modern movement: the fact that societies cannot be architecturally "purified" without a thousand grating invasions of freedom; that the architects' moral charter, as it were, includes the duty to work with the real world and its inherited content. Memory is reality. It is better to recycle what exists, to avoid mortgaging a workable past to a nonexistent Future, and to think small. In the life of cities, only conservatism is sanity. It has taken almost a century of modernist claims and counterclaims to arrive at such a point. But perhaps it was worth the trouble.

CHAPTER 16

Art and Popular Culture

Modernist art has long been considered in a class by itself. Lauded for its daring innovations, exceptional quality, and profound content it was dramatically distinct and rose above the mundane images that glutted twentieth century culture: advertising, popular illustration, television, and kitsch. In the1960s this gulf was breached by the Campbell soup cans, comic strips, and billboards of Pop Art. Ever since, it has been difficult to redraw clear lines between so-called "high" and "low" art.

The controversial "High & Low" exhibition at the Museum of Modern Art in 1990 prompted critic Hilton Kramer to warn that merging art and popular culture would be the beginning of the end of quality in art. Across the divide, art historian Mary Anne Staniszewski raises questions about the role and relevance of "high" art in a society dominated by popular culture. If Vincent van Gogh is great, what are the Beatles?

Where does "high" art fit in contemporary culture? Who is its audience? Are the criteria that set it apart from the "low" still valid? Can it survive, or will so-called "low" art become our new "high" art?

The Varnedoe Debacle: MOMA's new 'Low'

HILTON KRAMER

*Hilton Kramer is a prominent conservative art critic and cultural commenta-
tor. He was chief art critic and art news editor for* The New York Times. *He
is currently Editor-in-Chief of* The New Criterion *which he founded and con-
tributes to other periodicals as well. His recent books include* The Twilight of
the Intellectuals: Culture and Politics in the Era of the Cold War *(Chicago:
Ivan R. Dee Publisher, 1999) and* The Betrayal of Liberalism: How the Dis-
ciples of Freedom an Equality Helped Foster the Illiberal Politics of Co-
ercion and Control *(Chicago: Ivan R. Dee, Publisher, 1999), an anthology of
essays from* The New Criterion *that he edited with Roger Kimball.*

With every passing day it becomes more and more apparent that the ap-
pointment two years ago of Kirk Varnedoe to the directorship of the Depart-
ment of Painting and Sculpture at the Museum of Modern Art has placed this
great institution in serious jeopardy. The evidence accumulates—and at an
alarming speed—that Mr. Varnedoe has launched MOMA's most important
department upon a course so disastrous that, if not promptly reversed, the
very reason for the museum's existence might soon be in doubt. . . .

Now with the debacle of the exhibition called "High & Low: Modern Art
and Popular Culture," which Mr. Varnedoe has organized in collaboration
with Adam Gopnik,[1] his former student at the Institute of Fine Arts in New
York and currently the art critic for The New Yorker, this roster of disasters that
have already been visited upon the museum in a very short time begins to
look like a mere skirmish in the war against modernism that is now in progress
at MOMA. Both in its conception and in its realization as well as in its reign-
ing ethos, the "High & Low" exhibition is the kind of full-scale event that sig-
nals a new era at MOMA—an era in which, among other things to be deplored,
the achievements of modern art are subordinated to a sociological analysis of
them. Taking his cue from the ideological initiatives that have lately reshaped
the study of all the humanities in our colleges and universities Mr. Varnedoe
has clearly set the museum on a course that conforms to the practice of sup-
planting aesthetic categories of thought with those drawn from the social

Excerpted from Hilton Kramer, "The Varnedoe Debacle: MOMA's New 'Low'," *The
New Criterion* 9, no. 4 (1990): 5–8. Reprinted by permission of the author.

sciences. By this approach, art becomes a mere coefficient of material culture, and is thus denied precisely that element of aesthetic autonomy and transcendence that has been one of the hallmarks of the modernist spirit.

What this means for museological practice is perfectly clear. The epoch of the anaesthetic curator is upon us. In the "High & Low" show we are given a vivid demonstration of what results from a view of art that is completely removed from aesthetic considerations. There is a great deal of intellectual passion at work in the exhibition and in the massive—and massively foolish—catalogue that accompanies it, but very little of this passion is guided by aesthetic intelligence.[2] At every turn in the history of their subject, the curators are so utterly agog over the minutiae of popular culture—so infatuated with what might be called the archaeology of it—that its role in shaping modern art ceases to make a primary claim on their attention and becomes a merely incidental aspect of a headlong compulsion to explore the archaeology itself. Not only modern art but art itself is accorded an indifferent and precarious status in this inquiry. All the energy is elsewhere engaged.

In standard academic fashion, moreover, the accumulation of detail acquires a life of its own and bears at times only a remote and tangential relation to the ostensible subject under review. As huge miscellanies of undifferentiated information pile up and indeed topple over, it is more and more borne in upon us that the minds in charge of this project are not really much concerned with the aesthetic aspects of their inquiry. What we are offered in "High & Low" is less an explanation of modern art than a preposterously distended taxonomy of certain cultural materials that have been used in some parts of it. Never has so much miscellaneous detail been marshaled with such paltry results—paltry, that is, if it is modern art and not the varieties and vicissitudes of popular culture that is our primary focus of interest.

Some of the artists represented in "High & Low" are among the greatest in this century—Picasso, Braque, Miró, and Leger, among others—yet in not a single case is our knowledge of these artists and their achievement in any way enlarged or altered by the kind of attention they are given on this occasion. The primary beneficiaries of "High & Low" aren't these classic masters of modern art, whose work is held hostage here in a project that is alien to their spirit, but the artists who came to prominence with the advent of Pop Art in the 1960s, and the even more dubious talents who have more recently won an unearned renown on the contemporary art scene—unearned, that is, if aesthetic merit is our principal concern. An exhibition that concludes in a celebration of the work of **Jeff Koons** and Jenny Holzer—as "High & Low" does—may have something to tell us about the decadence and the politics that have overtaken cultural life in the last decade of the twentieth century, but it is an exhibition that has vacated the study of modern art in favor of a very different enterprise.

It is an enterprise that nowadays goes by the name of postmodernism, which defines the juncture at which the academicization, the politicization, and the commercialization of what was once an avant-garde meet and prosper at

the expense of art itself. The key word in this enterprise is *context,* which can mean anything from a class analysis of the people who buy art to a race or gender analysis of the artists who create it and the institutions that support it. For obvious reasons—above all, because of its commodity function and its usefulness as a barometer of shifting tastes and values—popular culture is a subject dear to the hearts of the postmodernists, who can sooner or later be expected to "contextualize," as they say, every other aspect of cultural life until it comes somehow to resemble the objects of popular culture. As far as fine art is concerned, it is the purpose of this postmodernist mode of analysis to deconstruct every "text"—which is to say, every art object—into an inventory of its context, and thus remove the art object from the realm of aesthetic experience and make it instead a coefficient of its sources and its social environment.

There are also other, less theoretical reasons that popular culture is so dear to the hearts of the postmodernists: they like it so much more than they like real art, they are so much more at home with it, so much more at ease with its simplistic emotions and one dimensional ideas. It may be that an immersion in the world of popular culture induces an illusion of eternal youth in these postmodernist curators, scholars, and critics who have lately disfigured the study of modern art with the materials that are given priority in the "High & Low" show—graffiti, advertising, comic strips, et al. It was, after all, in the counterculture of the Sixties, with its idealization of youth and its disparagement of high culture, that this momentous shift in attitude has its origins. When we turn to the authors' acknowledgments in the catalogue and find the junior partner in this collaboration—Mr. Gopnik—praising Mr. Varnedoe, the senior partner, as "an incomparable learner," we know all we need to know about where the ideas governing this exhibition are coming from.

Context is, in any case, the idea that dominates "High & Low," and this, in turn, is a melancholy reminder of the degree to which context has so rapidly supplanted connoisseurship in the study of art. We now have an entire generation of academics and their students in the field of art history who, while they purport to know a great deal about the production and consumption of art, actually know almost nothing about how to look at a work of art. Quality is not a concept—or an experience—that has any meaning for the contextualists. It is as if, from this academic postmodernist perspective, the work of art isn't really *there* as a free-standing, autonomous object. Certainly there is no evidence of a connoisseur's eye at work in the selection of the objects in the "High & Low" exhibition. I had hoped never again to have to see James Rosenquist's meretricious Pop mural *F-111* (1964–65) on display in a major museum, but there it is in the "High & Low" show commanding an immense space, just as if it were on the same level with Leger and Stuart Davis and some of the other masters of modern art. From Rosenquist to the scribblings of Cy Twombly to that idiotic display of **Jeff Koons's** vacuum cleaners—that is the downward course that is traced for us in "High & Low" with a grin and a wink that can scarcely conceal the satisfaction that is taken at this triumphant victory for schlock.

What we are finally left with in the "High & Low" exhibition isn't so much a study of modern art as an assault on it—and an assault on the way our understanding of modern art has been painstakingly built up over a period of six decades at MOMA in its collection, its exhibition, its publications, and the standards of connoisseurship that shaped them. What we are left with, in other words, is the spectacle of the debacle that is taking place at MOMA under Kirk Varnedoe's leadership. No doubt there will still be some good shows coming up at the Modern in the decade ahead—I know of several important ones, the shows to be devoted to Matisse, to Popova, and to Ad Reinhardt, among others—but the agenda that Mr. Varnedoe has established is already heading in a very different direction, and we can no longer have any confidence that the integrity of the museum will survive his tenure.

NOTES

[1] "High & Low: Modern Art and Popular Culture" organized by Kirk Varnedoe and Adam Gopnik, at the Museum of Modern Art, October 7–January 15. . . . The exhibition traveled to the Art Institute of Chicago (February 20–May 12, 1991: and the Museum of Contemporary Art, Los Angeles (June 21–September 15, 1991).

[2] *High & Low: Modern Art and Popular Culture,* by Kirk Varnedoe and Adam Gopnik; the Museum of Modern Art/Abrams. 460 pages.

Art and Culture Today

MARY ANNE STANISZEWSKI

Mary Anne Staniszewski teaches and writes about modern and contemporary culture, especially the links among art, mass media, popular culture, and museum display. Her most recent book, The Power of Display: A History of Exhibition Installation at the Museum of Modern Art *(Cambridge, MA: MIT Press), was published in 1998. She teaches art history and critical theory at Rensselaer Polytechnic Institute in Troy, NY.*

. . . What is the role of Art today, when so many of the agendas associated with modern Art, particularly those of the twentieth-century avant-garde, have been realized on the other side of the great divide—popular culture? Since World War II, rock-and-roll (which developed in the 1950s postmodernist culture) has shared much of the legacy of modern Art. Like the international avant-garde, rock-and-roll is the creative product of a rebellious youth culture trying to reach a mass audience. Its artists embrace technological innovation. Their lives and personal styles are often counterculture. Many rock groups have appropriated creative strategies of modern art history: Some stage acts can be seen as Neo-Dada performance, others have lifted ideas from the Surrealists, the Situationists, and other art groups. Although pop music has its individual stars like Elvis and Madonna, most rock musicians, like the international avant-garde, work collaboratively, in bands. But however much a rock-and-roll group may initially appeal to a specific youth subculture, its potential for vast global audiences is different from that of fine art, which remains within the arcane reaches of high culture.

The recordings of the most universally famous group, The Beatles, continue to permeate our social landscape twenty-five years after they disbanded. Their music is part of the soundtrack of our lives. Whether an original recording or muzak, we hear Beatles songs in stores, on streets, in elevators, and in the privacy of our bedrooms—in India, New Zealand, California, and Norway. Similarly, the sounds and images of mainstream film, TV, and radio have become the universal languages of the modern world.

How should we evaluate the impact of Art compared to the power of popular culture? Can popular culture accommodate the radical critique that has

been the domain of modern Art? In Cindy Sherman's early "film stills," for example, she challenged patriarchal conventions both in her pictures (by photographing herself masquerading as vaguely familiar feminine stereotypes) and in her method (by being both creator and subject, director and actress, producer and product). But isn't that one of the things that Madonna does in her productions? Surely there are important differences between the work of Sherman and that of Madonna. Nonetheless, Madonna also deals with our culture's feminine stereotypes. She plays with them, exploits them, challenges them—and she does it with pop music and videos that millions of people want to see and hear.

Should we diminish the seductive "poetry" and the social critique of great rock music? Isn't one of the most trenchant and memorable statements on "desire" and consumer culture the Rolling Stones' hit "Satisfaction"? Isn't it time to leave behind criteria that equate "high" with Art and "low" with popular culture and commerce, considering the dominance of the market regarding the value of Art and the impact and eloquence of certain aspects of popular culture such as rap, World Beat, and the flood of pop and ethnic rock music that speak a language for both the masses and the margins?

Public Enemy's rap music is among the most eloquent and powerful creations dealing with the issues of race in America. Unfortunately, some of the individuals affiliated with P.E. have, at times, shown discouraging intolerance to other groups, such as gays and Jews. Their work nonetheless continues the tradition of the important artists of the international avant-garde.

Public Enemy's music video "Shut 'em down," directed by Stephen Kroninger, Mark Pellington, and Lewis Klahr, is a manifesto for cultural revolution. Fast-paced graphics reminiscent of those of the Situationist International feature images of great African-American leaders, film footage of blacks being beaten in race riots, racist cartoons, and tabloid news clippings which are interspersed with the lyrics of "Shut 'em Down," as well as messages such as "seize the time," "the black side of American history," "freedom," "knowledge," "vision," "wisdom," "education," "strength," "action," "justice," and "power." Chuck D., P.E.'s leader, writer, MC, and designer, raps about "the battle for the mind." He speaks of the racism of the past—and the present. Very much in the spirit of artists like Hans Haacke who make visible the workings of power, Chuck D. calls his audience to action and empowerment and then specifically speaks of their relation to corporate America:

> I like Nike but wait a minute
> The neighborhood supports so put some
> Money in it
> Corporations owe
> Dey gotta give up the dough
> To da town
> Or Else
> We gotta shut 'em down

Fine art does not reach as many people as popular culture does. It remains a leisure-time activity for a relatively circumscribed population, and its status as high-yield investment often takes precedence over its other functions. How has the meaning of Van Gogh's *Sunflowers* been altered, now that it was bought at auction for $40 million?

To raise these issues is not to say that fine art is not powerful. Despite the parameters of culture today, Art retains tremendous importance and visibility in our society. Art is one especially powerful subculture that, at times, intersects or conjoins with popular culture. At its best, Art provides eloquence, beauty, and rigorous social critique.

The most important artists of our time are visionary in that they continue to challenge us to see our world differently. They represent our culture in enlightened and, at times, beautiful ways. Artists prepare the mind and the spirit for new ideas—new ways of seeing. . . .

CHAPTER 17

Postmodernist Art

Today, nearly everyone agrees that Modernism is over and something called Postmodernism has replaced it, but just what is Postmodernist art? What does it mean in terms of art-making itself? Art historian Irving Sandler and artist Darby Bannard agree that Postmodernism is the complete rejection of Modernism, but they view its effects in very different ways.

Bannard admires the formal purity and high aesthetic standards of Modernism and laments Postmodernism's abandonment of essential values—its "anything goes" kind of attitude. Sandler suggests that the values of Modernism were too narrowly based in formalism and that in rejecting it Postmodernism has reopened art to reality and relevance.

Critic Deborah Solomon interviewed artist Jeff Koons, one of the most notorious of the postmodernist artists in the spring of 2000, when a version of his *Puppy* sculpture was installed in Rockefeller Center [Figure 26].

Introduction to *Art* of the *Postmodern Era*

IRVING SANDLER

Irving Sandler is an authority on late twentieth-century art. His multivolume history of the subject includes, The Triumph of American Painting: A History of Abstract Expressionism *(New York: Harper & Row, Publishers, 1970),* The New York School: Painters and Sculptors of the Fifties *(New York: Harper & Row, Publishers, 1978), and* American Art of the 1960s *(New York: Harper & Row, Publishers, 1988). He has written numerous exhibition catalogues and contributed articles and critical reviews to most of the leading art publications. He is Professor of Art History at the State University of New York at Purchase.*

. . . The aesthetics of [Clement] Greenberg, the most important art critic to emerge since World War II, were the fount of both formalist and minimal discourse. Greenberg maintained that in the modern era each of the arts—or the tendency that was modernist in each—had been progressing toward what is autonomous and irreducible in the medium or purely of the medium—toward "self-definition," as he put it. Intrinsic to painting are "the flat surface, the [rectangular] shape of the support, [and] the properties of pigment." Most important is flatness, for it alone is "unique and exclusive to pictorial art."[1] Modernist painting defined itself by purging everything that was not of the medium, for example, subject matter, which was in the realm of literature, and "tactile" elements, which were in the realm of sculpture.

Greenberg maintained that modernist art was the avant-garde mainstream within a broader stream, modern art, because it was progressive, verging toward ever-more-autonomous forms. The latest stage of its distinguished history was abstraction, and on the cutting edge was stained-color-field painting. The exemplary current modernist painters then were Louis, Noland, and Olitski.[2]

Greenberg also asserted that the artist's primary goal was to create art of quality, and that the art critic's goal was to recognize quality. As he summed it up in 1980: "Modernist with a capital M" is defined by "the 'simple' aspiration to quality, to aesthetic value and excellence for its own sake, as an end

Figure 26. Jeff Koons, *Puppy*, Rockefeller Center, New York City, July, 2000. Photo: Deborah Pokinski.

in itself. Art for art's sake, . . . nothing else."[3] Greenberg did not establish any necessary connection between quality and autonomy, or purity. Nor did he specify what constituted quality. But in his opinion the formalist painting of Louis, Noland, and Olitski obviously possessed quality. For him little else in current art did. . . .

Greenberg's dogmas did not go unchallenged in the 1950s and 1960s.[4] He was often condemned for narrowness and an arrogant refusal to take non-formalist art seriously. But, with the backing of a powerful coterie of artists; dealers; collectors; critics; historians; and museum directors, curators, and trustees, Greenberg managed to outlast all of his detractors. Oddly enough, when the art-critical tide turned against modernism in the 1970s, Greenberg's reputation only grew, for he became the foil—the esteemed foil—of a new breed of antimodernists or postmodernists. Ignoring other interpretations that rooted modernism in dadaism, constructivism, and surrealism—interpretations that stressed social and psychological concerns—they generally accepted Greenberg's definition of modernism as the operative one. Thus postmodernism could be characterized as anti-Greenberg-inspired formalism. . . .

In some measure Greenberg's critics were justified in singling out his modernist paradigm as they did, because it was the basis of the dominant art-critical theory and practice in the 1960s. And if it was to be challenged, a new postmodernist paradigm for considering and evaluating art would have to be formulated. One was.[5]

If the generative terms of the modernist paradigm were "autonomy" and "quality," the competing term was "relevance," attained by confronting social issues or expressing the zeitgeist. Modernists demanded that art be universal and transcendent; postmodernists wanted art to engage its specific social context. Instead of stressing the purely visual, they focused on topical subjects. They also substituted relevance for novelty—the emblem of the avant-garde prized by modernists. As the art critic Edit DeAk put it, postmodernist art produced "the shock of recognition instead of the shock of the new."[6]

Postmodernism called for a different sensibility from modernism, a different attitude toward formal elements and different criteria for judgment. Modernists believed that a work's content inheres in its form and that subject matter is incidental. Postmodernists emphasized subject matter and disregarded the form-content synthesis. Their different ways of seeing made it difficult for modernists and postmodernists to talk to each other. They were using different languages.

Postmodernists in the visual arts took their cues from their counterparts in architecture, who had earlier launched a sustained attack on the international style. This was initiated by Robert Venturi in his 1967 book, *Complexity and Contradiction in Architecture*.[7] Other critics, such as Charles Jencks, soon added their voices to Venturi's. Jencks identified modernist architecture with the modular, glass-walled, boxlike structures—he called them univalent—exemplified by the buildings of Mies van der Rohe. Such buildings seemed

identical wherever they were built and therefore were deemed to be lacking in content—that is, specific references to their function, the locale in which they were to be situated, or the mores of the people and the history of their building. Postmodernist architecture defined itself first of all in terms of what the international style was not. Thus Venturi and his partner, Denise Scott-Brown, looked for inspiration to vernacular building, such as the motel row, with its diverse styles, or Las Vegas, with its myriad signs.[8] As Venturi wrote:

> Architects can no longer afford to be intimidated by the puritanical moral language of orthodox Modern architecture. I like elements which are hybrid rather than "pure," compromising rather than "clean," distorted rather than "straight-forward," ambiguous rather than "articulated," perverse as well as impersonal, boring as well as "interesting," conventional rather than "designed," accommodating rather than excluding, redundant rather than simple, vestigial as well as innovating, inconsistent and equivocal rather than direct and clear. I am for messy vitality over obvious unity.[9]

The advocates of postmodernist architecture called for multiplicity or multivalence, inclusiveness, and eclecticism instead of the uniformity and exclusiveness identified with the international style. They repudiated modernism's obsession with the new, which had led to a break with the past, and they rehabilitated motifs, notably decorative, from premodernist styles, combining them with modernist motifs. Indeed, mixing the new and the old was considered "a sign that the architect recognizes the fallacy of seeking one reductive and universal truth, and holds instead to a broader and more tolerant vision of society's—and life's—complexities."[10] Postmodernist architects and theoreticians also rejected the internationalism and utopianism associated with modernist architecture. Because of the clarity of postmodernist polemics in architecture, and because their target was so clearly defined, they played a vital role in discourse in the other arts.

The postmodernist concern for relevance led growing numbers of artists and art professionals to question Greenberg's position on high and low art. . . . [T]he role of pop culture . . . was so pervasive and powerful as to "become, in every sense, the 'second nature' of modern life," as art historian Kirk Varnedoe and art critic Adam Gopnik claimed, and it also provided "a pool of possibilities that has expanded the language of modern art."[11] Moreover, as curator Lisa Phillips noted, kitsch could be a potent, edgy form of expression still capable of the kind of shock value that only vanguard art used to have."[12] [Steven] Westfall found "that kitsch and high culture . . . intermingle with little real damage to, and probably a great deal of reinvigoration of, the latter."[13] . . .

Neither Westfall nor Varnedoe, Gopnik, [nor] Phillips . . . would deny that high art was different from and superior to kitsch. High art depended on acts of discovery while kitsch produced easily consumed effects. Still, kitsch

had become a compelling realm of experience that stimulated artistic acts of discovery. Certainly in the 1980s the "impure" works of artists who mixed artistic mediums, embraced diversity, occasionally aspiring to be encyclopedic, and looked for inspiration to vernacular imagery, media, and commodities—whether by Jenny Holzer, Cindy Sherman, Barbara Kruger, **Jeff Koons,** Mike Kelley, David Hammons, or Elizabeth Murray—seemed much more vital than modernist painting or sculpture.

Formalist criticism was also rejected because increasingly it came to be viewed as specious. Formalist critics would analyze the formal syntax of formalist art and simply assume that formalist art was necessarily of transcendent and universal aesthetic quality without specifying what aesthetic quality was. Their assumption of quality served to give their formal analysis cachet.[14] Postmodernists rejected the formalist idea that quality was universal and transcendent. Greenberg himself maintained that there were no criteria for quality and then acted as if they existed—witness his mandarin dismissal of "critics and journalists who talk 'post-modern.' [There's] nobody among them whose eye I trust."[15] But then Greenberg rejected postmodernist art out of hand.[16] Postmodernists rebutted, asking why, if there were no criteria for judgment, they should accept Greenberg's or anyone else's claims of special insight into quality. Postmodernists also questioned Greenberg's Kantian belief in a special human faculty for the appreciation of art as art. Was human consciousness actually compartmentalized into separate faculties, each responsible for a particular kind of awareness? Greenberg's critics thought not. Moreover, as [Robert] Storr wrote, "the cult of 'quality' and the mystique of the 'eye' " absolved formalists "of the responsibility for examining . . . social issues," and other extra-aesthetic but relevant considerations.[17] There was more to the experience of art than the exercise of taste, important though that might be. Postmodernist art professionals insisted that the broader psychological, social, national, and cultural matrix of art could no longer be ignored. And so did leading artists, among them Judy Chicago, Nancy Spero, Sherrie Levine, Kruger, Holzer, and Hammons, who were intent on making social comments, constructive, critical, or iconoclastic.

In asserting that modernist art was progressing toward purity, Greenberg claimed to be empirical, but as he spelled it out, the progress of modernist art seemed to be dictated by historical necessity. That is, there was an implied historical narrative in formalist dogma—a linear mainstream, propelled by an inexorable historical force. The mainstream for Greenberg led to abstraction, which alone had opened up new vistas. All other styles were relegated to the dustbin of art history. Postmodernists rejected this deterministic and exclusivist notion. Instead of a mainstream, postmodernists posited the image of a delta, all styles, even traditional ones, getting a fair share of art-world attention. Indeed, the situation seemed to have become so open that the 1970s was often dubbed the pluralist era. This openness was exemplified in the growing catholicity of art publications, notably *Arts Magazine,* which seemed

to feature a different artist in a different style on every other page. But in retrospect the situation was not as democratic as it seemed then: Postminimalist styles received more than their share of attention.

The idea of artistic progress was undermined by a growing belief that the avant-garde was at an end. It appeared to an increasing number of artists and art professionals that the limits of art had been reached, or that if any further limit could be found, there had evolved a tradition of pushing to the limits. Or, to put it directly, carrying art to extremes had become a commonplace in the art world. In 1969 I wrote: "A limit in art is reached when an artist's work comes as close as possible to being nonart," and concluded that conceptual art had ventured as far as art could because it had systematically demolished every notion of what art should be—to the extent that it had eliminated what may be the irreducible conventions in art—the requirements that it be an object and visible.[18] With its 1970 exhibition, *Information,* the Museum of Modern Art put its establishment stamp of approval on conceptual art. Therefore it appeared to me, and I was not alone in this opinion, that the idea of a continuing avant-garde had ceased to be believable. The modernist era was over; it had become history—and had been replaced by a "postmodernist condition." . . .

. . . Modernism's idealistic vision, its messianic belief that the human condition was improving, became untenable in the wake of the cataclysmic horrors of the twentieth century, from "the irrationalities of World War I . . . to the still incomprehensible irrationality of the Holocaust," as Robert Morris remarked. "It is from this charred source that all post-Enlightenment appeals to Truth and Reason become covered with ashes."[19]

Many young artists who had ceased to believe in futuristic visions began to recycle images and forms from past art and the mass media. Indeed, appropriation, as this practice came to be known, was the primary sign of postmodernist art. There was also a concomitant denial of originality, experiment, innovation, and invention, valued by modernists. However, what was appropriated had to be provocative. But provocation was no longer equated with newness, as it had been when the idea of the avant-garde was still credible. Questions were soon raised about appropriations. Were they not mannerist and academic? Did the quoted fragments reveal ironically and even perversely that humanism was in tatters? Did this scavenging not prove that art was at an end, dead, in a zero zone? On the other hand, if much of postmodernist art seemed backward looking in style, this might also be forward looking, as art critic Kim Levin suggested: "After nearly a century of Modernism, art in Europe as well as America seemed to have reached a point where the only means left for radical innovation was to be reactionary."[20]

Above all, postmodernist artists and their supporters rejected modernist claims to universality. Indeed, cultural theorist Jean-François Lyotard attributed the emergence of postmodernism to the "suspicion of metanarratives"— that is, universal guiding principles of any kind. Postmodernism dissolved

"every kind of totalizing narrative. [It turned] hierarchy into heterarchy [and posited a] centreless universe."[21] The idea of a homogeneous international culture was called into question. Was not this culture really only Western, centered on Europe and the United States? Moveover, was it not the creation of middle-class whites and heterosexual males? Just as they stressed the differences in class and gender, so postmodernist artists stressed local, regional, and national character; race and ethnicity; and history, culture, and current events—in a word, the particular. . . .

NOTES

[1] Clement Greenberg, "Modernist Painting," *Arts Yearbook* 4 (1961): 103–4.

[2] Frank Stella, arguably the most influential abstract artist of the sixties, was generally included in the company of Louis, Noland, and Olitski by formalist critics, although Greenberg disliked his work. But, like Greenberg, Stella called for the creation of a selfsufficient art, clear and complete unto itself; witness his famous statement in Bruce Glaser, interviewer, and Lucy R. Lippard, ed., "Questions to Stella and Judd" (*Art News*, Sept. 1966, p. 59): "My painting is based on the fact that only what can be seen there is there. It really is an object." What you see is what you see.

[3] Clement Greenberg, "Modern and Post-Modern," *Arts Magazine*, Feb. 1980, p. 65.

[4] See Irving Sandler, *American Art of the 1960s*, chap. 5.

[5] Paul Richter, in "Modernism & After—2" (*Art Monthly*, Apr. 1982, p. 5), defined a paradigm in art as "an interrelated system of beliefs concerning the proper objects of aesthetic experience, the correct way in which these may be perceived. . . . An aesthetic paradigm functions by informing those who approach art under its influence, as to what to seek in works of art, how to seek this, how to recognize the relative values of those things that claim to produce it, and so on."

[6] Edit DeAk, "The Critic Sees Through the Cabbage Patch," *Artforum* Apr. 1984, p. 56.

[7] Robert Venturi, *Complexity and Contradiction in Architecture* (New York: Museum of Modern Art, 1966).

[8] Postmodern architects continued to use international-style elements, but considered them on a par with borrowings from older styles. Jencks claimed that postmodern architecture double-coded a modernist with a nonmodernist code, adding some different, often older, meaning.

[9] Venturi, *Complexity and Contradiction in Architecture*, p. 16.

[10] Kirk Varnedoe, *The Poverties of Postmodernism*, Slade Lectures, 1992, Oxford University, type-script, p. 17.

[11] Kirk Varnedoe and Adam Gopnik, *High & Low: Modern Art and Popular Culture* (New York: Museum of Modern Art/Harry N. Abrams, 1990), pp. 402, 407.

[12] Lisa Phillips, "The Greenberg Effect: Comments by Younger Artists, Critics, and Curators," *Arts Magazine*, Dec. 1989, p. 62.

[13] Stephen Westfall, "The Greenberg Effect," p.64

[14] Henry M. Sayre, *The Object of Performance: The American Avant-Garde since 1970* (Chicago: University of Chicago Press, 1989), p. 45. Norman Bryson deconstructed the connection between explicit formal analysis and the assertion of nonexplicit aesthetic quality in formalist reasoning. He pointed out that there was a gap between the two that had not been bridged.

[15] Greenberg, "Modern and Post-Modern," p. 66.

[16] Harold Rosenberg also had no interest in postmodernist art. He was reported to have said in the late 1970s that modernism had happened a long time ago and was all over. When asked what had replaced it, he replied: "I don't care."

[17] Robert Storr, "No Joy in Mudville: Greenberg's Modernism Then and Now," in Kirk Varnedoe and Adam Gopnik, eds., *Modern Art & Popular Culture: Readings in High & Low!* (New York: Museum of Modern Art, 1990), p. 180.

[18] Irving Sandler, introduction to *Critic's Choice 1969–70* (New York: New York State Council on the Arts/State University of New York, 1969), n.p.

[19] Robert Morris, "Three Folds in the Fabric and Four Autobiographical Asides as Allegories (or Interruptions)," *Art in America*, Nov. 1989, p. 150.

[20] Kim Levin, *Beyond Modernism: Essays on Art from the '70s and '80s* (New York: Harper & Row, 1988), p. 165.

[21] Steven Connor, *Postmodernist Culture: An Introduction to Theories of the Contemporary* (Oxford, England: Basil Blackwell, 1989), pp. 8–9.

Excellence and Postexcellence

DARBY BANNARD

Darby Bannard is a professional painter as well as lecturer, teacher, and writer. His work is in the collections of a number of major museums including the Whitney, Guggenheim, and Metropolitan Museums. He has taught at the School of the Visual Arts in New York and chaired the Department of Art and Art History at the University of Miami.

Modernism, as a working attitude over the past century and a half, has insisted that a work of art be valued for itself rather than for its usefulness toward another end. This is more-or-less what is meant by "Art for art's sake." It is characterized by a spirit of high aspiration for art value or "goodness" and is driven by an engine of internal self-criticism.

This has had certain consequences. If the creation of better art is unguided by criteria (how good or useful it is for something) and is specifically a result of individual effort then the art-making will inevitably become a matter of invention, and invention will inevitably be framed in terms of the craft and materials of the art as artists reassess the nature of their activity and question the usefulness of its ingredients. Eventually, over time, methods and conventions extrinsic to the art form will be discarded. This is one of the characteristics of Modernism and it has been documented, most notably by Clement Greenberg, who, like Freud and Darwin, was attacked for pointing to facts we were not willing or prepared to see.

Edited from a talk given by Darby Bannard to the Edmonton Contemporary Artist's Society, Edmonton, Alberta, Canada, October 9, 1999. Published in complete form on the Web site, newCrit (http://newcrit.art.wmich.edu/). Reprinted by permission of the author.

Ironically (or tragically, according to your point of view), Modernism, by its very nature, set the stage for its own destruction. Artists, by their very nature, do not like anything which looks like a set of rules, and they do not like hearing it from someone who writes with such obvious boldness and self-assurance. If we examine recent history we see that Greenberg was usually right and that he was high-minded and knew good art when he saw it, and we can see that most Greenberg-bashing is just "killing the messenger." We can regret this but we can't change it. Inevitably, a reaction formed against Modernism in all the arts and pointedly denigrated its chief spokesman in painting and sculpture. It came to be called Postmodernism.

Postmodernism, as distinct from Modernism, is aimless, anarchic, amorphous, inclusive, political, non-hierarchical and aims for the popular. It tends away from and basics, preferring pre-organized ingredients; hence installation, "happening," "content," "meaning," realist depiction and the invocation of "larger issues." It is, above all, allowing; it lifts the pressure off and lets us bask in the sunny notion that, in art, at least, everything is OK, that the very idea of value discrimination in art is not only expendable but somehow morally suspect, a cousin to the kinds of social discrimination all right-minded people must despise. And it uses the idea of "art," as such, as a kind of cover; anything, once you call it "art," must be taken seriously no matter how inherently ludicrous it might appear in any other context. In this sense Postmodernism can be seen as a form of late Modernism because it has rejected one more convention: the convention of esthetic value and the critical discrimination which comes in company with it. Whether this is an expendable convention remains to be seen.

In my view, Postmodernism, as it is manifested in current visual art, contains three inter-related fatal flaws.

First, the rejection of value discrimination is really just posturing because it is not carried through into the actual enterprise of Postmodernist art itself. The art business—and I mean all of it: artists, curators, dealers, collectors, museums—still operates in the same old good/better/best system of valuation; it always has, so it depends on the discriminatory premise of relative excellence whether it likes it or not. Value distinctions are still made, as always, but now a complex cover-language has grown up so that choices can be justified with more acceptable terminology. To do otherwise would threaten what is really important: the maintenance of an art market which has grown way past the limits of the supply of good art or good artists. Modernist limitations, if rigorously applied, would be crippling. I am not decrying hypocrisy here; I am observing that history tells us that internal contradiction in any healthy enterprise is usually exposed and destroyed. This undermines the general system of attitudes and ideas which make up what we know of as Postmodernism. If the Postmodernist market employs a vehicle of value discrimination which dares not to say its name, as it must, the fallacy will fester out and value will reassert itself. It will happen. After all, art without value is just that.

Second, Postmodernism betrays itself by its relentless proselytizing for "anything goes"—I'm OK, you're OK, it's OK. Human achievement is always narrow, limiting and discriminatory and operates within selected restrictions. This is just a fact. Everything good, true and valuable comes about as a result of structured behavior and workable form. Excellence is found when there are reasons for something to be excellent, and this means that the context for it to arise must be clear and intense and deliberately limited. I don't think it comes up in art much these days, but it certainly comes up in other forms of visual entertainment, such as digital special effects or professional sports. Human excellence in the making can take advantage of a relaxed and easy-going atmosphere but the manifestation of that excellence will be anything but. By persisting in this delusion Postmodernism simply offers itself as a vehicle for soft mainstream mediocrity and the maintenance of a market for it. When you break all the barriers you end up with a pile of rubble.

The third fatal flaw of Postmodernism is its rejection of nonreferential form as an instrument of value in art. Formal matters in art are never frivolous or inhuman, as Postmodernism maintains. Form always comes in company with content, and artistic value—Modernist or Postmodernist—must be a matter of form and content working together. Any construction of meaning and value in art must embrace formal considerations, and therefore any art must allow that this meaning or value resides in formal considerations. Real conviction in art can never be carried by content alone. It resides in form, which alone gives life to content. Once again, by its rejection of form as a vehicle for value, Postmodernism presents a value system for artmaking which exists to rationalize weak art rather than support strong art. It is a sheep in wolf's clothing.

But none of this, nor its stultifying academicism, witless obscurity, remoteness from reality and inherent dullness, keeps Postmodernism from being the reigning doctrine of the day. It is the art theology of the moment, the credo for a culture of "sensation." The show which goes by that name at the Brooklyn Museum is probably only another of Greenberg's "episodes in the history of taste," but it is interesting to look at in the context of these remarks.

There are two related points of discussion for the "Sensation" exhibit: the art and the controversy surrounding it. The controversy, however, is a political and sociological matter, not an artistic or esthetic one, interesting only because the art which provoked the hullabaloo is so retrogressive, derivative and tame. Everything there comes straight out of 30 or 40 year old art forms: body art, body parts, excretion, genitalia, blank-looking heads, loathsome things in vitrines, Arbuslike photos, Design 101 make-a-cast-of-something-different projects, flat popart surfaces, neoexpressionist bright-colored distortion, things lined up in rows, minimalist pop, issue-of-the-week content—this is the kind of dumbdown mockshock you urge your students to avoid because it has been done to death. English artists have always had a proclivity for appropriating and refurbishing; "Sensation" is a classic case of this and a type specimen of 90s art "controversy." Originality and artistic

vigor are beside the point because success depends on the lack of it; the show never would have happened in the first place if the art was really new. It has been our habit—at least since pop art went over 40 years ago—to insist that "controversy" come in predigested form and to overlook formally inventive art as "irrelevant." This is the new version of the ancient tradition of rejecting the best new art, and Postmodernism is the label it has assumed. And I am constantly reminded that I am right by those who talk about it: the eyeless "man-on-the-street" hates it, the eyeless "with-it" types love it, and the endangered species of serious art lovers who can see the difference heave an anxious sigh because they know when you deny value to art you deprive it of its sustenance and its life. There's not a damn thing anyone can do about it. We just hope Art is tough enough to come through alive.

Questions for Jeff Koons; Puppy Love

DEBORAH SOLOMON

Deborah Solomon is a regular contributor to The New York Times. *Her books include* Jackson Pollock: A Biography *(New York: Simon and Schuster, 1987) and* Utopia Parkway: the Life and Work of Joseph Cornell *(New York: Farrar, Straus and Giroux, 1997).*

Q: *So many art stars of the 80's disappeared, but your stock seems to be rising. Who expected to see your giant puppy covered with 60,000 flowers [Figure 26] in midtown?*

I'm very pleased to see "Puppy" at Rockefeller Center. It really feels like the center of the universe. You have NBC located there, so every day during the "Today" show, "Puppy" is on television. People in Oklahoma or California can see it in bloom.

Deborah Solomon, "The Way We Live Now: 6-25-00: Questions for Jeff Koons; Puppy Love," *The New York Times,* 25 June, 2000, section 6, p. 15. Reprinted by permission of the author.

What kind of dog is it?

A West Highland terrier. If I had done a poodle, it would have seemed very feminine. And if I had done a Doberman or a sheep dog, it would have come off as masculine. But a West Highland terrier seems neutral that way, which is good, because I don't want anyone in the audience to feel alienated. It's a very spiritual piece.

Since when did you start sounding like a choirboy? About a decade ago you were married to the Italian porn star Cicciolina and making paintings and sculptures that showed you copulating in every which position.

At that time, I wanted to make a body of work that was romantic in the tradition of Boucher and Fragonard. I don't think I would show those pieces today.

I'm not surprised. For a while, your divorce and custody battle got more attention than your artwork. Is all that settled?

My son and I received tremendous injustice from the Italian government. It's not in the interests of my son that he's in the custody of his mother. For the past six years I've gone to Italy every month to visit my son. I hope "Puppy" is a symbol of the rights of children. The rights of children are neglected.

That's quite a switch for an artist who began his career making consumerist fetish objects like floating basketballs and stainless-steel bunnies. Are you trying to distance yourself from the 80's?

As time goes on, the 80's artists will gain more support. I enjoy Julian Schnabel and David Salle. Andy [Warhol] did great work, too. But visually, I'm more stimulated by advertising than by the art I see in galleries. I like a lot of ice cream advertising. I like a lot of cereal-box advertising.

Are you saying that a box of Frosted Flakes is more compelling than any of the art in the Manhattan galleries?

Yes. Visually, it's just more exciting.

What's your idea of a great cereal box?

I've always enjoyed Cheerios. But all the breakfast-cereal boxes are exciting. The reason is they're trying to pump energy into people in the morning, make people feel good about the day.

Are you really this corny, or is it just a kind of Warholish pose?

I mean it. It's not a mask. So much art is very, very gloomy now. Cereal boxes are just the opposite. Art is obsolete now. New technologies are taking over.

You don't really believe that art is obsolete.

I do. There was a time when Picasso was the wealthiest man in France and Henry Moore was the wealthiest person in England, other than the Queen. There's no such thing as that anymore. Bill Gates and your technology leaders are the ones with money. Artists today—they're nothing within the landscape of economics.

How, then, have your interests changed?

I think my interests have remained the same. I'm interested in making objects that you would want to grab and take with you if your house was burning down.

You're kidding. Why would I want to grab a 42-foot-tall puppy covered with begonias if my house was on fire?

"Puppy" is a shelter. It's built out of stainless steel. It's like the fuselage of an airplane. You could live inside it.

If it had closets. Didn't you begin your career as a commodities broker who made millions of dollars a year?

I started selling commodities in order to support my art. But all I ever thought about was art. When I was at Smith Barney, instead of working I'd be speaking with Richard P. Feynman, the Nobel Prize physicist, asking how I could get the basketball to float in the water.

I'm glad to hear you're so involved with your art. You've often said that you let your assistants make your art for you.

I'm looking forward to the day when the flowers on "Puppy" can be planted without my involvement.

Do you have a dog yourself?

I have a bichon frise. They're nonallergenic. They don't shed.

CHAPTER 18

Censorship

Censorship has been around for a very long time, invoked throughout history on religious, political, and moral grounds. In the 1970s, the focus was pornography, ignited by a fierce round of debates within the women's movement [Figure 27]. Adamantly in favor of censoring it—for the sake of women's liberation—is feminist activist Andrea Dworkin. She considers pornography a tool of male domination aimed at subordinating and oppressing women—a clear issue of power and politics.

Nadine Strossen, President of the American Civil Liberties Union and also a feminist, argues, however, that antipornography laws are antithetical to constitutional guarantees of free speech. She warns that Dworkin's crusade actually hurts women by limiting their freedom of expression. For Strossen and others an important part of real liberation for women is finally to be able to deal with sexual themes. To outlaw sexual subject matter would be the same as suppressing this new freedom. Are Dworkin and Strossen arguing the same issue?

Art historian Lynda Nead reminds us that the female nude, in addition to being a central theme in pornography, is also one of the most celebrated themes of Western art and examines its relationship to pornography and sexual expression.

Against the Male Flood: Censorship, Pornography, and Equality

ANDREA DWORKIN

Andrea Dworkin is a radical feminist activist and writer. The main focus of her work has been pornography, about which she has lectured and written extensively. In collaboration with attorney Catharine MacKinnon she drafted a controversial antipornography ordinance that was passed by the Minneapolis City Council in 1983. Dworkin and Mackinnon also co-authored Pornography and Civil Rights: A New Day for Women's Equality *(Minneapolis; Organizing Against Pornography, 1988).*

. . . In the amendment to the Human Rights Ordinance of the City of Minneapolis written by Catharine A. MacKinnon and myself, pornography is defined as the graphic, sexually explicit subordination of women whether in pictures or in words that also includes one or more of the following: women are presented dehumanized as sexual objects, things, or commodities; or women are presented as sexual objects who enjoy pain or humiliation; or women are presented as sexual objects who experience sexual pleasure in being raped; or women are presented as sexual objects tied up or cut up or mutilated or bruised or physically hurt; or women are presented in postures of sexual submission; or women's body parts are exhibited, such that women are reduced to those parts; or women are presented being penetrated by objects or animals; or women are presented in scenarios of degradation, injury, abasement, torture, shown as filthy or inferior, bleeding, bruised, or hurt in a context that makes these conditions sexual.

This statutory definition is an objectively accurate definition of what pornography is, based on an analysis of the material produced by the $8-billion-a-year industry, and also on extensive study of the whole range of pornography extant from other eras and other cultures. Given the fact that women's oppression has an ahistorical character—a sameness across time and cultures

Excerpted from Andrea Dworkin, "Against the Male Flood: Censorship, Pornography, and Equality," *Letters from a War Zone* (New York: E. P. Dutton, 1988), 264–68. Reprinted by permission of the author.

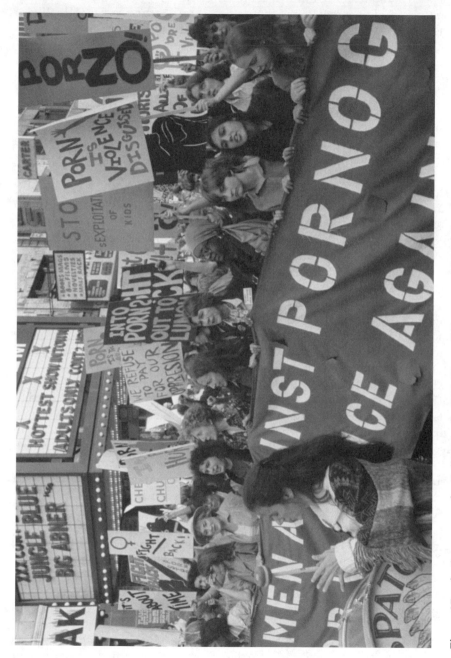

Figure 27. Anti-pornography Rally, March, 1979. Photo: © Bettmann/CORBIS.

expressed in rape, battery, incest, and prostitution—it is no surprise that pornography, a central phenomenon in that oppression, has precisely that quality of sameness. It does not significantly change in what it is, what it does, what is in it, or how it works, whether it is, for instance, classical or feudal or modern, Western or Asian; whether the method of manufacture is words, photographs, or video. What has changed is the public availability of pornography and the numbers of live women used in it because of new technologies: not its nature. Many people note what seems to them a qualitative change in pornography—that it has gotten more violent, even grotesquely violent, over the last two decades. The change is only in what is publicly visible: not in the range or preponderance of violent pornography (e.g., the place of rape in pornography stays constant and central, no matter where, when, or how the pornography is produced); not in the character, quality, or content of what the pornographers actually produce; not in the harm caused; not in the valuation of women in it, or the metaphysical definition of what women are; not in the sexual abuse promoted, including rape, battery, and incest; not in the centrality of its role in subordinating women. Until recently, pornography operated in private, where most abuse of women takes place.

The oppression of women occurs through sexual subordination. It is the use of sex as the medium of oppression that makes the subordination of women so distinct from racism or prejudice against a group based on religion or national origin. Social inequality is created in many different ways. In my view, the radical responsibility is to isolate the material means of creating the inequality so that material remedies can be found for it.

This is particularly difficult with respect to women's inequality because that inequality is achieved through sex. Sex as desired by the class that dominates women is held by that class to be elemental, urgent, necessary, even if or even though it appears to *require* the repudiation of any claim women might have to full human standing. In the subordination of women, inequality itself is sexualized: made into the experience of sexual pleasure, essential to sexual desire. Pornography is the material means of sexualizing inequality; and that is why pornography is a central practice in the subordination of women.

Subordination itself is a broad, deep, systematic dynamic discernible in any persecution based on race or sex. Social subordination has four main parts. First, there is *hierarchy*, a group on top and a group on the bottom. For women, this hierarchy is experienced both socially and sexually, publicly and privately. Women are physically integrated into the society in which we are held to be inferior, and our low status is both put in place and maintained by the sexual usage of us by men; and so women's experience of hierarchy is incredibly intimate and wounding.

Second, subordination is *objectification*. Objectification occurs when a human being, through social means, is made less than human, turned into a thing or commodity, bought and sold. When objectification occurs, a person is depersonalized, so that no individuality or integrity is available socially or in

what is an extremely circumscribed privacy (because those who dominate determine its boundaries). Objectification is an injury right at the heart of discrimination: those who can be used as if they are not fully human are no longer fully human in social terms; their humanity is hurt by being diminished.

Third, subordination is *submission*. A person is at the bottom of a hierarchy because of a condition of birth; a person on the bottom is dehumanized, an object or commodity; inevitably, the situation of that person requires obedience and compliance. That diminished person is expected to be submissive; there is no longer any right to self-determination, because there is no basis in equality for any such right to exist. In a condition of inferiority and objectification, submission is usually essential for survival. Oppressed groups are known for their abilities to anticipate the orders and desires of those who have power over them, to comply with an obsequiousness that is then used by the dominant group to justify its own dominance: the master, not able to imagine a human like himself in such degrading servility, thinks the servility is proof that the hierarchy is natural and that objectification simply amounts to seeing these lesser creatures for what they are. The submission forced on inferior, objectified groups precisely by hierarchy and objectification is taken to be the proof of inherent inferiority and subhuman capacities.

Fourth, subordination is *violence*. The violence is systematic, endemic enough to be unremarkable and normative, usually taken as an implicit right of the one committing the violence. In my view, hierarchy, objectification, and submission are the preconditions for systematic social violence against any group targeted because of a condition of birth. If violence against a group is both socially pervasive and socially normal, then hierarchy, objectification, and submission are already solidly in place.

The role of violence in subordinating women has one special characteristic congruent with sex as the instrumentality of subordination: the violence is supposed to be sex for the woman too—what women want and like as part of our sexual nature; it is supposed to give women pleasure (as in rape); it is supposed to mean love to a woman from her point of view (as in battery). The violence against women is seen to be done not just in accord with something compliant in women, but in response to something active in and basic to women's nature.

Pornography uses each component of social subordination. Its particular medium is sex. Hierarchy, objectification, submission, and violence all become alive with sexual energy and sexual meaning. A hierarchy, for instance, can have a static quality; but pornography, by sexualizing it, makes it dynamic, almost carnivorous, so that men keep imposing it for the sake of their own sexual pleasure—for the sexual pleasure it gives them to impose it. In pornography, each element of subordination is conveyed through the sexually explicit usage of women: pornography in fact is what women are and what women are for and how women are used in a society premised on the inferiority of women. It is a metaphysics of women's subjugation: our existence

delineated in a definition of our nature; our status in society predetermined by the uses to which we are put. The woman's body is what is materially subordinated. Sex is the material means through which the subordination is accomplished. Pornography is the institution of male dominance that sexualizes hierarchy, objectification, submission, and violence. As such, pornography creates inequality, not as artifact but as a system of social reality; it creates the necessity for and the actual behaviors that constitute sex inequality. . . .

The Sex Panic
and the Feminist Split

NADINE STROSSEN

Nadine Strossen is the president of the American Civil Liberties Union. She is Professor of Law at New York Law School and has practiced, written, and lectured extensively in the areas of constitutional law, civil liberties, and international human rights. Her book, Defending Pornography: Free Speech, Sex, and the Fight for Women's Rights *(New York: Scribner, 1995) was named by* The New York Times *a "notable book" of 1995. She has been twice named to* The National Law Journal's *list of the 100 most influential lawyers in America.*

The American feminist movement's battle over censorship—those who favor legal limits on pornography versus those who oppose them—has escalated dramatically in the past year [1993]. . . . Anti-porn feminists have won significant courtroom, campus, and public-relations victories in the past year. . . . Anticensorship feminists—who've long maintained that it is people, not books or pictures, that harm women, and that women have historically been targets of censure when censorship is condoned—find their ideological opponents' growing influence alarming.

MAUREEN DEZELL, journalist[1]

Excerpted from Nadine Strossen, "The Sex Panic and the Feminist Split," Chapter 1 of *Defending Pornography: Free Speech, Sex, and the Fight for Women's Rights* (New York: Scribner, 1995), 17–33. Reprinted by permission of the author.

"Pornography" Is a Dirty Word

The term "pornography" is ordinarily reserved for sexually explicit words and images whose sole purpose is sexual arousal. However, literature, art, sex education and information about women's sexuality are often attacked—and suppressed—as "pornography." Recently, "pornography" has been employed by certain feminists as though sexually explicit expression is inherently "subordinating" or "degrading" to women (and as though these terms are themselves not subject to disagreement).

LEANNE KATZ, Executive Director
National Coalition Against Censorship[2]

People have very different definitions of the term "pornography," but it has become a convenient weapon, just as "communism" was during the McCarthy era, to brand any person or work with whose ideas the censor disagrees.

MARJORIE HEINS, Director
American Civil Liberties Union
Arts Censorship Project[3]

"Pornography" is a vague term, which *Webster's International Dictionary* defines as "a depiction (as in writing or painting) . . . of erotic behavior designed to cause sexual excitement."[4] In short, it is sexual expression that is meant to, or does, provoke sexual arousal or desire.

The term has no legal definition or significance. The category of sexually oriented expression that the Supreme Court has held to be subject to restriction is labeled "obscenity." In recent times, the word "pornography" has assumed such negative connotations that it tends to be used as an epithet to describe—and condemn—whatever sexually oriented expression the person using it dislikes. As one wit put it, "What turns *me* on is `erotica,' but what turns *you* on is 'pornography'!" Likewise, Walter Kendrick's comprehensive 1987 study of the subject, *The Secret Museum: Pornography in Modern Culture*, makes clear that the term "pornography" consistently has been applied to whatever sexual representations a particular dominant class or group does not want in the hands of another, less dominant class or group.[5]

Indeed, the dread *P* word has been used still more loosely and pejoratively, to tar *any* disfavored idea or expression. A striking—and ironic—example of this phenomenon is contained on the jacket of Catharine MacKinnon's 1993 book *Only Words*. Reinforcing fears about the vague, expansive bounds of the "pornography" that MacKinnon and her allies seek to suppress, the book jacket blurb by law professor Patricia Williams castigates criticism of MacKinnon's ideas as "intellectual pornography."

Even the so-called Meese Pornography Commission, which issued its controversial report in 1986, did not attempt to define the term. In contrast, the

procensorship feminists use this stigmatized word to underscore that they seek to suppress a category of sexual expression that is, in theory, distinguishable from the category banned under traditional "obscenity" laws. Essentially, "obscene" speech is sexual speech that the community deems "immoral," whereas in model legislation drafted by MacKinnon and **Dworkin,** "pornography" is defined as the "sexually explicit subordination of women through pictures and/or words."[6]

Although various supporters of the feminist procensorship faction have proposed slight variations on the MacKinnon-Dworkin definition of pornography, the core concept is always the same—sexual expression that allegedly demeans women. In 1992, for example, the Canadian Supreme Court issued a decision that Catharine MacKinnon hailed as a victory for women (it apparently was influenced by a brief she had coauthored). In that case, entitled *Butler v. the Queen,*[7] Canada's high court interpreted the Canadian obscenity laws as embodying the MacDworkin concept of pornography and hence outlawed materials that are "degrading" or "dehumanizing" to women.

Throughout this book, I use the term "pornography" to refer to the sexually oriented expression that MacKinnon, Dworkin, and their supporters have targeted for suppression. As I show, though, this definition is so amorphous that it can well encompass any and all sexual speech.

"Sex" Is Also a Dirty Word

> This culture always treats sex with suspicion. . . . Sex is presumed guilty until proven innocent.

> GAYLE RUBIN, anthropologist[8]

Although the strange bedfellows in the current campaign against sexual speech—Meese, MacKinnon, and their respective allies—employ some differing rhetoric in their unified call for censoring sexually oriented expression, they sound many common chords, notably that sex and materials that depict or describe it inevitably degrade and endanger women. In short, the war on sexual expression is, at bottom, a war on sex itself, at least as far as women are concerned. Because the philosophy of leading antipornography, procensorship feminists reflects a deep distrust of sex for women, such feminists are, in my view and in the view of others, aptly labeled "antisex."

Taken together, the traditional and feminist antipornography, antisex crusaders appeal to a broad gamut of the ideological spectrum in both the government and the public. They pose an unprecedented danger to sexual expression, which has always been uniquely vulnerable in the United States, as well as to the concept that the First Amendment protects such expression. Moreover, their attacks have been alarmingly successful.

We are in the midst of a full-fledged "sex panic," in which seemingly all descriptions and depictions of human sexuality are becoming embattled. Right-wing senators have attacked National Endowment for the Arts grants for art whose sexual themes—such as homoeroticism or feminism—are allegedly inconsistent with "traditional family values." At the opposite end of the political spectrum, students and faculty have attacked myriad words and images on campus as purportedly constituting sexual harassment. Any expression about sex is now seen as especially dangerous, and hence is especially endangered. The pornophobic feminists have played a very significant role in fomenting this sex panic, especially among liberals and on campuses across the country.

The fear of sexual expression has become so high-pitched lately that it even has deterred an AIDS clinic from giving out information about combating the deadly spread of the virus. In Oklahoma City, the American Civil Liberties Union (ACLU) represented a doctor who was prosecuted for displaying a safe-sex poster on the windows of his AIDS clinic, which was located in an area frequented by gay men. Yet public health experts maintain that the allegedly illegal and offensive image in the poster—a man wearing a condom—is an important instrument in the life-or-death campaign to halt the spread of HIV. Although the charges were dismissed, the city has threatened further prosecutions, thus deterring the clinic from mounting similarly explicit educational displays in the future.[9]

Society's wariness toward sex is highlighted by contrasting it with the greater societal tolerance toward violence. This dichotomy is especially vivid in the media and mass culture, where violent depictions are far more accepted than sexual ones. The contrast was aptly capsulized by Martin Shafer, a top executive at a film production company, when he noted, "If a Man touches a woman's breast in a movie, it's an R rating, but if he cuts off a limb with a chain saw, it's a PG-13."[10]

Because the domain of sexual expression, always a difficult terrain, has lately been laced with land mines placed by diverse enemies, it has become more treacherous than ever. Not surprisingly, artists, academics, and others are increasingly deterred from entering and exploring this potentially explosive—but also rich, wonderful, and important—territory.

All over the country, artists say that they dare not pursue sexual themes for fear that their work will be perceived as too controversial to be funded or displayed. Indeed, outraged officials and citizens alike have indignantly demanded the defunding and deposing from display of art with a wide range of sexual themes; lately it seems that even a mere sexual connotation, no matter how subtle, is vulnerable.

In our current epidemic of erotophobia, even images of nude or seminude bodies in wholly nonsexual contexts have been attacked. For example, in 1993, Vermont officials hung bedsheets over a mural that artist Sam Kerson had painted in a state building's conference room. One press account described the mural, which was commissioned to mark the five-hundredth anniversary of

Christopher Columbus's voyage, as "a politically correct rendition of Columbus and his men arriving in the New World, battle-axes and crucifix raised, ready to oppress the natives."[11] But the painting was not politically correct enough for a number of female employees, who complained that its depictions of bare-breasted native women constituted sexual harassment. Because the mural could not be removed without destroying it, the state resorted to the bedsheet "solution."

In 1992, a painting of the classical seminude statue the *Venus de Milo* was removed from a store in a Springfield, Missouri, shopping mall because mall managers considered the topless masterpiece "too shocking."[12] The painting of the ancient Greek sculpture, which was carved about 150 B.C., and which stands in a place of honor in Paris's Louvre museum, was replaced by a painting of a woman wearing a long, frilly dress.

Another example of a famous artistic masterpiece that has been suppressed in the current sex panic is *The Nude Maja,* or *Maja Desnuda,* by the celebrated Spanish painter Francisco de Goya. In 1992, Pennsylvania State University officials removed a reproduction of this acclaimed work from the front wall of a classroom following a complaint by English professor Nancy Stumhofer that it embarrassed her and made her female students "uncomfortable."[13]

No matter that the reproduction hung, along with reproductions of other masterpieces, in a room used for art history classes. No matter that university officials offered to move the painting to a less prominent position in the classroom, such as the back wall. No matter that they also offered to remove the Goya from the classroom altogether whenever Professor Stumhofer taught there, or even to relocate her classes to another classroom. No. Apparently, nothing short of extirpating the work from all campus classrooms would purge its taint, from her perspective.[14] And the university capitulated. As writer Nat Hentoff commented, at that Penn State campus the administration defines sexual harassment as "anything that makes people uncomfortable about sexual issues."[15]

Moving even beyond nudity or partial nudity, the sex panic has engulfed certain forms of clothing that some observers might deem provocative. In a 1994 *Ms.* magazine discussion on pornography, writer Ntozake Shange described one such situation that she said was "very heavy on my heart":

> I was on the cover of *Poets & Writers* and I wore a pretty lace top. In the next two issues, there were letters asking if *Poets & Writers* is now a flesh magazine—why was I appearing in my underwear? Bare shoulders are exploitation now?[16]

In response, **Andrea Dworkin,** another participant in the *Ms.* discussion, confirmed that she would indeed see Shange's photograph as exploitation: "It's very hard to look at a picture of a woman's body and not see it with the perception that her body is being exploited."

Whether the stigmatizing epithet of choice for particular protesters happens to be "pornography" or "sexual harassment," the result is the same: the conclusory label intimidates campus officials and others who should defend artistic expression, so they instead suppress it. Objecting to another such suppressive incident, which occurred at Vanderbilt University in 1993, Vanderbilt art professor Marilyn Murphy said: "Human sexuality has been a recurring theme in art since antiquity. Visual arts is the most misunderstood discipline on this campus and on college campuses everywhere."[17]

Liza Mundy, a writer who has chronicled campus attacks on art with sexual themes, has concluded that "MacKinnonite ideas underlie many" such attacks, noting the irony that many of these battles "pit feminist students against feminist artists." At the University of Arizona in Tucson, students physically attacked a group of photographic self-portraits by graduate student Laurie Blakeslee, which were displayed in the student union. The alleged offense? Blakeslee had photographed herself in her underwear. In Mundy's words, "Young women and men influenced by crusading law professor Catharine MacKinnon—and these are in the ascendance on many campuses—believe that . . . sexually explicit imagery create[s] an atmosphere in which rape is tolerated and even encouraged."[18]

An essential aspect of women's right to equal opportunity in employment and education is the right to be free from sexual harassment. `What is troubling, though, is the spreading sense—perpetuated by the feminist anti-pornography movement—that *any* sexual expression about a woman, or in her presence, *necessarily* constitutes such harassment. This presumption is stated expressly as the basis for the sweeping sexual harassment codes that are becoming increasingly common on campuses.

Syracuse University, for example, adopted a sexual harassment code in 1993 that prohibits not only "requests for sexual relations combined with threats of adverse consequences" if refused, and assaultive acts such as "pinching or fondling," but also nonassaultive, vaguely described acts such as "leering, ogling and physical gestures conveying a sexual meaning," and loosely described expressions including "sexual innuendoes, suggestive remarks, [and] sexually derogatory jokes." What all of these seemingly disparate behaviors have in common, the code informs us, "is that they focus on men and women's sexuality, rather than on their contributions as students or employees in the University."[19]

But this should not be an either-or choice, should it? Are women not—along with men—sexual beings, as well as students or employees? Is women's sexuality really incompatible with their professional roles? Is it really increasing women's autonomy, options, and full-fledged societal participation to posit such an incompatibility? Have we not learned from history, and from other cultures, that the suppression of women's sexuality tends to coincide with the suppression of women's equality? And that when women's sexuality has been banished from the public sphere, women themselves are also banished from key roles in that sphere?

Far from advancing women's equality, this growing tendency to equate any sexual expression with gender discrimination undermines women's equality. Women are, in effect, told that we have to choose between sexuality and equality, between sexual liberation and other aspects of "women's liberation," between sexual freedom and economic, social, and political freedom. This dangerous equation of sexual expression with gender discrimination, which is at the heart of the feminist antipornography movement, is a central reason that movement is so threatening to the women's rights cause. . . .

Women Having It All: Free Speech and *Equality*

> From a feminist perspective, there is no choice between equality and freedom of expression; they are two sides of the same coin, and cannot be played off against each other any more than we can separate mind and body.
>
> THELMA McCORMACK, Director, York
> University Centre for Feminist Studies[20]

Since free expression about sexual issues is critically important to the women's rights cause, it is ironic that those feminists who advocate curbing such expression say they do so out of concern for women's rights. They define as pornography, and seek to suppress, sexually explicit expression that "subordinates" or "degrades" women, on the theory that this expression causes discrimination and violence against women. They argue that free speech protection for pornography is antithetical to women's rights, and therefore that we have to compromise the constitutional free speech guarantee to advance the constitutional equality guarantee. This was the major theme, for example, of Catharine MacKinnon's 1993 book *Only Words*. She declares: "The law of equality and the law of freedom of speech are on a collision course in this country."[21]

In fact, though, this line of argument is pernicious and wrongheaded. In our society, founded on the interlinked goals of liberty and equality, we all are entitled to both freedom of speech and equal opportunity under the law. Moreover, these two ideals are mutually reinforcing.

In the women's rights context, freedom of speech consistently has been the strongest weapon for countering misogynistic discrimination and violence, and censorship consistently has been a potent tool for curbing women's rights and interests. Freedom of sexually oriented expression is integrally connected with women's freedom, since women traditionally have been straitjacketed precisely in the sexual domain, notably in our ability to control our sexual and reproductive options. Accordingly, during the first wave of feminism in this century, Margaret Sanger, Mary Ware Dennett, and other pioneering birth control advocates were prosecuted (and, in some cases, convicted, fined, and

imprisoned) for disseminating birth control information. Significantly, this information was held to violate *antiobscenity* statutes. Such laws were used not to promote women's equality, but rather, to erode it.

Because the American Civil Liberties Union, since its founding, has represented many women's rights activists whose free speech has been throttled—including Sanger and Dennett—its opposition to the antipornography laws endorsed by some feminists is grounded in the organization's long-standing commitment to women's rights, as well as in its consistent defense of free speech. In opposing an antipornography ordinance that Indianapolis enacted in 1984, modeled on one drafted by Dworkin and MacKinnon,[22] the ACLU argued that the law "unconstitutionally introduced gender-based discrimination into the First Amendment." As the ACLU's brief explained:

> The ordinance . . . presumes a natural and inevitable vulnerability of (weaker) women to the unbridled and voracious sexual appetites of (stronger) men and accordingly promises to "protect" all women. As in the past, the cost of "protection" is the perpetuation of gender-based stereotypes and the denial to women of sexually explicit material which may itself benefit women by providing information about sexuality, sexual functions, or reproduction. . . . While it is undoubtedly true that many women are victims of male violence . . . the attempt to [justify] widespread censorship on the false stereotypical assumption that all women are unable to resist male domination . . . is precisely the type of sex-based protectionism that inhibits the evolution of genuine equality between the sexes.[23]

All censorship measures throughout history have been used disproportionately to silence those who are relatively disempowered and who seek to challenge the status quo. Since women and feminists are in that category, it is predictable that any censorship scheme—even one purportedly designed to further their interests—would in fact be used to suppress expression that is especially important to their interests.

That prediction has proven accurate in our neighboring country of Canada, which in 1992 adopted the definition of pornography advocated by MacKinnon, Dworkin, and other procensorship feminists: sexually explicit expression that is "dehumanizing" or "degrading" to women.[24] The Canadian authorities have seized upon this powerful tool to suppress lesbian and gay publications and feminist works, and to harass lesbian and gay bookstores and women's bookstores.

With Friends Like These, Who Needs Enemies?

The widespread misperception that Dworkin and MacKinnon speak for feminists generally concerning sexual speech is fostered by their own divisive rhetoric, which suggests that their censorship campaign is the one and only

feminist position. Catharine MacKinnon has stated that "Pornography, in *the* feminist view, is a form of forced sex . . . an institution of gender inequality" (emphasis added).[25] Moreover, Dworkin and MacKinnon have charged that those who disagree with them are not true, but "liberal, so-called" feminists.[26] MacKinnon has compared feminists who oppose censorship to "house niggers who sided with the masters," and has denounced a leading feminist anticensorship group, the Feminist Anti-Censorship Taskforce (FACT): "The labor movement had its scabs, the slavery movement had its Uncle Toms and Oreo cookies, and we have FACT."[27] In the same vein, Dworkin has condemned feminists who maintain that the constitutional free speech guarantee extends to sexual speech as "politically self-righteous fellow travelers of the pornographers."[28]

Leanne Katz, executive director of the National Coalition Against Censorship, recently described "the extraordinary name-calling tactics" that the procensorship feminists brandish against anticensorship feminists:

> Opposition to their activities is called "slander," and "hate campaigns"; we are charged with being manipulated by "pimps," with being mouthpieces of pornographers. We are accused of being indifferent to violence against women, the Uncle Toms of patriarchy. It is apparently unthinkable that one might care about women and *therefore* oppose censorship.[29]

The procensorship feminists' views that women who disagree with them are being manipulated as tools of "pimps" or "pornographers," and are not thinking for ourselves, conveys at least as subordinating or degrading a view of women as does the pornography they decry. One example of the procensorship feminists' patronizing, "maternalistic" view of their anticensorship counterparts was provided by Norma Ramos, general counsel of Women Against Pornography. Commenting about me in a *Vogue* magazine article in 1992, Ramos said, "The ACLU . . . uses its women to further its antifeminist agenda. When Strossen became an apologist for the pornographers, she passed their litmus test to become president."[30]

In a letter to the editor of *Vogue*, writer Marcia Pally, founder and president of Feminists for Free Expression, responded to Ramos's remarks:

> I was especially edified by comments from Norma Ramos, of Women Against Pornography. Without them, I might never have known that Strossen, a Phi Beta Kappa Radcliffe graduate and editor of the *Harvard Law Review* . . . was a puppet—"used" by ACLU men. . . . Ramos is right: any woman who disagrees with Ramos's own views on sexual material must be a stooge. How foolish to believe that Strossen, a professor at New York Law School, could think for herself, or that her contributions to [various scholarly journals] were anything but sad efforts to pass the "litmus test" of male colleagues. How silly, when it has so long been known that women are muddle-minded pawns. I wonder only that Ramos failed to report that Strossen slept her way to the top.[31]

The Anticensorship, Prosex Feminists

If you love freedom and like sex, censorship is bad news.

KATHLEEN PERATIS
Women's Rights Attorney[32]

Contrary to the MacDworkinites' image of a unified front, many feminist women disagree with their implacably negative analysis of sexual expression, and reject their calls for censoring it. Moreover, contrary to the MacKinnon-Dworkin line that to dissent from their views reflects an elevation of free speech principles over principles of women's equality, many feminist women oppose censoring sexually oriented speech specifically from a feminist perspective; we believe that censorship would not promote women's rights, but, to the contrary, would undermine them. Therefore, the proposed feminist antipornography laws are doubly flawed: they would undermine both free speech and equality. . . .

Feminist opponents of censorship include leading activists, artists, psychologists, scholars, writers, and women (and men) from all other walks of life. . . . [A]ll share a commitment to both free speech and equality, and a belief that suppressing pornography would subvert, rather than promote, efforts to counter misogynistic violence and discrimination. . . .

NOTES

[1] Maureen Dezell, "Porn Wars," *Boston Phoenix,* 2–8 July 1993.

[2] Leanne Katz, introduction to *New York Law School Law Review Symposium: The Sex Panic,* a special issue of the *Review* based on speeches at its same-titled 1992 symposium (forthcoming).

[3] Marjorie Heins, "A Public University's Response to Students' Removal of an Art Exhibit." (speech given at the University of Michigan Law School, Ann Arbor, Mich., 16 October 1993).

[4] *Webster's Third New International Dictionary of the English Language,* unabridged, Philip Babcock Gove, ed. (Springfield, Mass.: Merriam-Webster, 1986), p. 1767.

[5] Walter Kendrick, *The Secret Museum: Pornography in Modern Culture* (New York: Viking, 1987), p. 239.

[6] Andrea Dworkin, "Against the Male Flood: Censorship, Pornography, and Equality," *Harvard Women's Law Journal* 8 (1985): 1–29, at 25.

[7] *Butler v. the Queen,* 1 S. C. R. 452 (1992, Canada).

[8] Gayle Rubin, "Thinking Sex: Notes for a Radical Theory of the Politics of Sexuality," in *Pleasure and Danger: Exploring Female Sexuality,* ed. Carole S. Vance (Boston: Routledge & Kegan Paul, 1984), pp. 267–319, at p. 278.

[9] Arts Censorship Project, *Year End Report* (New York: American Civil Liberties Union, 1992), p. 13.

[10] Bernard Weinraub, "Despite Clinton, Hollywood Is Still Trading in Violence," *New York Times,* 28 December 1993.

[11] Quoted in Dave Gram, "Columbus Mural Brings Charges of Harassment," Associated Press, 29 May 1992.

[12] Chris Bentley, "Mall Nixes Artwork as Shocking," Springfield (Mo.) *News-Leader,* 5 March 1992.

[13] Nat Hentoff, "Sexual Harassment by Francisco Goya," *Washington Post,* 27 December 1991.

[14] Nancy C. Stumhofer, "Goya's `Naked Maja' and the Classroom Climate," *Democratic Culture,* 3, no. 1 (1994): 18–22, at 19.

[15] Hentoff "Sexual Harassment by Francisco Goya."

[16] Ntozake Shange, in "Where Do We Stand on Pornography?" (Roundtable), *Ms.,* January/February 1994, pp. 32–41, at p. 34.

[17] Joyce Price, "Breast Fetish Brouhaha Rocks Staid Vanderbilt," *Washington Times,* 6 March 1993.

[18] Liza Mundy, "The New Critics," *Lingua Franca,* September/October 1993, pp. 26–33, at p. 27

[19] Syracuse University, *Responding to Sexual Harassment at Syracuse University,* 8 October 1993, p. 1.

[20] Thelma McCormack, letter to the editor, *Chicago Tribune,* 28 September 1993.

[21] Catharine MacKinnon, *Only Words* (Cambridge, Mass.: Harvard University Press, 1993), p. 71.

[22] Indianapolis-Mercer County, Indiana, General Ordinances Nos. 24 and 25 (1984), amendments to Code of Indianapolis and Marion County, Chapter 16, "Human Relations and Equal Opportunity."

[23] Brief of the American Civil Liberties Union, Indiana Civil Liberties Union, and the American Civil Liberties Union of Illinois, amici curiae, *Hudnut v. American Booksellers Association* (filed in 7th Cir. 1985), p. 28.

[24] *Butler v. the Queen,* 1 S. C. R. 452 (1992, Canada).

[25] Catharine MacKinnon, "Not a Moral Issue," *Yale Law and Policy Review* 2 (1984): 321–345, at 325.

[26] Catharine MacKinnon, "More Than Simply a Magazine: *Playboy's* Money," in *Feminism Unmodified* (Cambridge, Mass.: Harvard University Press, 1987), p. 145.

[27] Catharine MacKinnon, quoted in Pete Hamill, "Women on the Verge of a Legal Breakdown," *Playboy,* January 1993, p. 186.

[28] Andrea Dworkin, "Pornography: The New Terrorism," *New York University Review of Law and Social Change* 8 (1978–79): 218.

[29] Leanne Katz, "In the Realm of the Censors," *In These Times,* 7 March 1994, pp. 24–25.

[30] Quoted in Patrick Cooke, "Defending the L-Word," *Vogue,* December 1992, pp. 156–160, at p. 158.

[31] Marcia Pally, letter to the editor under heading "Feminist Addenda," *Vogue,* February 1993, p. 58.

[32] Kathleen Peratis, letter to Nadine Strossen, 29 November 1993.

The Female Nude: Pornography, Art, and Sexuality

LYNDA NEAD

Lynda Nead teaches in the Department of Art at Birkbeck College, University of London. Her books include: The Female Nude: Art, Obscenity, and Sexuality *(London and New York: Routledge, 1992),* Law and the Image: The Authority of Art and the Aesthetics of Law *(Chicago: University of Chicago Press, 1999), and* Victorian Babylon: People, Streets, and Images in Nineteenth-Century London *(New Haven: Yale University Press, 2000).*

To my mind art exists in the realm of contemplation, and is bound by some sort of imaginative transposition. The moment art becomes an incentive to action it loses its true character. This is my objection to painting with a communist programme, and it would also apply to pornography.
 (Kenneth Clark, testimony to the Longford committee on pornography)

The evidence given by **Kenneth Clark,** one of the world's leading art historians, to Lord Longford's committee on pornography in Britain in 1972 is just one fragment of a vast body of discourses that has been produced on the subject of pornography over the last few decades.[1] The Longford committee was a privately sponsored investigation that claimed to represent public opinion. Its report, published in the form of a mass-market paperback and launched in a blaze of publicity, fuelled the pornography debate in Britain in the 1970s. From the seventies onwards, feminists, moral crusaders, governments, and various other pressure groups have presented their views on the issue, with the result that pornography has become one of the most fiercely and publicly contested areas within contemporary cultural production.[2]

Perhaps one of the most disabling limitations of much of this public debate has been the attempt to look at pornography as a discrete realm of representation, cut off and clearly distinct from other forms of cultural production. This perspective is frequently attended by the view that the pornographic resides *in* the image, that it is a question of content rather than form, of production rather than consumption. Even when pornography is defined in terms

Excerpted from Lynda Nead, "The Female Nude: Pornography, Art, and Sexuality," *Sex Exposed: Sexuality and the Pornography Debate,* eds., Lynne Segal and Mary McIntosh. (New Brunswick, NJ: Rutgers University Press, 1993) 280–94. Reprinted by permission of the author.

of its circulation, as a matter of audience expectations, markets, and institutions, it is still separated off as though it exists in isolation and can be understood outside of its points of contact with the wider domain of cultural representation.

To suggest that pornography needs to be examined in relation to other forms of cultural production, however, is not to move towards the position that claims that *all* of patriarchal culture is therefore pornographic. It is simply to argue that we need to specify the ways in which pornography is defined and held in place. We need to get behind the common-sense notions of pornography in order to uncover the processes by which the term has been defined and the historical changes in its meaning. At any particular moment there is no one unified category of the pornographic but rather a struggle between several competing definitions of decency and indecency. . . .

One of the most significant ways in which pornography is historically defined is in relation to other forms of cultural production; we know the pornographic in terms of its difference, in terms of what it is not. The most commonplace opposition to pornography is art. If art is a reflection of the highest social values, then pornography is a symptom of a rotten society; if art stands for lasting, universal values, then pornography represents disposability, trash. Art is a sign of cleanliness and licit morality, whereas pornography symbolizes filth and the illicit. In this cultural system, aesthetic values readily communicate sexual and moral values. This is the basis of Kenneth Clark's testimony, in which art and pornography are defined in terms of their effects on the spectator. Art is pacifying and contemplative, whereas communist painting and pornography incite the viewer to action and therefore cannot belong to the realm of high artistic culture.[3]

Although conventionally art and pornography are set up in this oppositional relationship, they can be seen instead as two terms within a greater signifying system that is continually being redefined and includes other categories, such as obscenity, the erotic, and the sensual. All these terms occupy particular sexual and cultural spaces; none of them can be understood in isolation, since each depends on the other for its meaning. From this position we can begin to examine the changing historical relationships between the terms and the ways in which the boundaries between these categories have been and continue to be policed in order to maintain the aesthetic and the pornographic as a necessary ideological polarity in patriarchal society.

The Female Nude: Policing the Boundaries

It is often at the very edge of social categories that the work of definition takes place most energetically and meaning is anchored most forcefully. For art history, the female nude is both at the centre and at the margins of high culture. It is at the centre because within art-historical discourse paintings of the nude

are seen as the visual culmination of Renaissance idealism and humanism. This authority is nevertheless always under threat, for the nude also stands at the edge of the art category, where it risks losing its respectability and spilling out and over into the pornographic. It is the vagueness and instability of such cultural definitions that make these marginal areas so open and precarious. Since pornography may be defined as any representation that achieves a certain degree of sexual explicitness, art has to be protected from being engulfed by pornography in order to maintain its position as the opposition to pornography. In other words, through a process of mutual definition, the two categories keep each other and the whole system in place. Categories such as the erotic and the sensual play an important role as middle terms in the system—defining what can or cannot be seen, differentiating allowable and illicit representations of the female body, and categorizing respectable and non-respectable forms of cultural consumption.

Within the history of art, the female nude is not simply one subject among others, one form among many, it is *the* subject, *the* form. It is a paradigm of Western high culture with its network of contingent values: civilization, edification, and aesthetic pleasure. The female nude is also a sign of those other, more hidden properties of patriarchal culture—that is, possession, power, and subordination. The female nude works both as a sexual and as a cultural category, but this is not simply a matter of content or some intrinsic meaning. The signification of the female nude cannot be separated from the historical discourses of culture—that is, the representation of the nude by critics and art historians. These texts do not simply analyse an already constituted area of cultural knowledge; rather, they actively define cultural knowledge. The nude is always organized into a particular cultural industry and thus circulates new definitions of class, gender, and morality. Moreover, representations of the female nude created by male artists not only testify to patriarchal understandings of female sexuality and femininity, they also endorse certain definitions of male sexuality and masculinity.

In Britain in the 1970s, the discourse of critics and art historians was implicated in a radical redefinition of sexuality. In the art world, there were renewed efforts to pin down the female nude in high art so as to free it from debasing associations with the sexual. These efforts were countered by other attempts to implicate the images of high culture in the pornographic. In the 1980s context created by AIDS, political conservatism and religious revivalism, the debate regarding sexuality and representation that took place in the 1970s has taken on a renewed significance. The boundaries between art and pornography continue to shift and to raise complex issues for feminist cultural and sexual politics. . . .

Historically, high culture has provided a space for a viable form of sexual representation: that which is aestheticized, contained, and allowed. In the 1970s, this site had to be reinforced and shored up. The differences between paintings of the female nude and `pin-ups', glamour photography, soft- and

hard-core porn had to be redefined. During this period the British Library cat-alogued the 1976 edition of **Kenneth Clark's** high-art survey, *The Nude*, in the general stacks, but relegated Arthur Goldsmith's *The Nude in Photography* and Michael Busselle's *Nude and Glamour Photography* to the special locked cases.[4] The special cases are reserved for books that are prone to theft or dam-age and include commercial or titillating representations of sex—in other words, books that are regarded as an incitement to action rather than con-templative reading. In the 1970s, photographs of the female nude were clearly seen to fall within these guidelines; but the images included in Clark's text escaped the contaminating associations of pornography and could be con-sulted without fearful consequences to either the book or the reader. In this way the classifications of the British Library map on to the conventional op-position of high and low culture, of fine art versus mass media.

Within traditional aesthetics, the painting has a peculiar status. Valued as an authentic and unique object, the singular product of a special act of cre-ativity, the painting is, as Victor Burgin writes, `part holy relic, part gilt-edged security'.[5] In contrast, the material and cultural value of the photograph is re-duced by its reproducibility, and the photograph carries none of the conno-tations of human agency and cultural dignity. Unlike the connoisseur of high art, the consumer of photographic art does not possess a unique object, and within the polarity of high and low art, the photograph is devalued as the product of mass technology, popular and vulgar.

Thus, paintings of the female nude such as those illustrated in Clark's book were set apart physically as well as symbolically from photographic images of the female nude. With obscenity as the focus of sexual regulation, high art had to be maintained as an edifying, moral, and privileged form of cultural consumption. Emphasis was placed on the nude as an ideal form that em-bodies perfection, universality, and unity. These conventions were in opposi-tion to the codes and functions of pornography—fragmentation, particularity, titillation. Above all else, paintings of the female nude had to be closed off from any associations with commercialism or sexual arousal. Refusing the connotation of commodity, the discourse of high art retreated into a vocabu-lary of contemplation and aesthetic response. . . .

But other art historians during the 1970s did not seek to keep high art as a discrete, desexualized category. In fact, they deliberately sought to break open and redefine the category's boundaries and to address directly the represen-tation of the sexual within paintings of the female nude. Far from being a sep-arate plane of activity, art, they claimed, participates in the social definition of male and female sexuality. Three of these texts, all of which were produced outside the mainstream of art history, reveal the competing definitions that were thrown up by the issue of cultural representation and sexuality during this period.

John Berger's *Ways of Seeing*, first published in 1972, established a funda-mental distinction between female nakedness and nudity. Whereas the nude

is always subjected to pictorial conventions, `To be naked', he writes, `is to be oneself.'[6] In this framework, Berger juxtaposes European oil paintings with photographs from soft-porn magazines, identifying the same range of poses, gestures, and looks in both media. The particularity of the medium and cultural form is not important. What matters is the repertoire of conventions that *all* nudes are believed to deploy, irrespective of historical or cultural specificity. . . .

Linda Nochlin's feminist essay `Eroticism and Female Imagery in Nineteenth-Century Art', also published in 1972, represents one voice from the women's movement, which during this period addressed the construction of patriarchy in high culture.[7] Nochlin shares Berger's analysis of the female nude as a patriarchal image for male consumption, but she goes much further, rejecting the idea of the personal erotic imagery of individual male artists in favour of a social basis for the sexual definitions established in images of the female nude. She also points to the absence of any public imagery for women's desires and calls for an available language to express women's erotic needs. This call for female erotica was part of a much wider demand by members of the women's movement during the early 1970s. . . .

Another effort to redefine sexuality and sexual pleasure in relation to the visual arts can be seen in Peter Webb's *The Erotic Arts*, first published in 1975. The book is a paradigm of the sexual libertarianism that emerged in the late 1960s and continued into the 1970s, particularly within certain sections of the gay liberation movement. For Webb, sexual freedom was synonymous with social freedom, and sexual liberation was the first step towards social revolution. Webb challenged directly the anti-pornography lobby and obscenity trials of the early 1970s, which set up liberation in opposition to the authoritarian morality of censorship. However, he was also keen to isolate a category of erotic art from that of pornography:

> Pornography is related to obscenity rather than erotica and this is a vital distinction. Although some people may find a pornographic picture erotic, most people associate eroticism with love, rather than sex alone, and love has little or no part to play in pornography . . . Eroticism, therefore, has none of the pejorative associations of pornography; it concerns something vital to us, the passion of love. Erotic art is art on a sexual theme related specifically to emotions rather than merely actions, and sexual depictions which are justifiable on aesthetic grounds.[8]

Webb assumes an essentialist model of human sexuality, conceiving of it as a driving, instinctive force that must find expression through either legitimate or illegitimate channels. In his attempt to distinguish erotic art and pornography, he relies on a familiar set of oppositions: love versus sex, aesthetic value versus bad art, and feeling or emotion versus action. Again, as with the arguments of Clark and Berger, there is a juggling of aesthetic

and moral criteria in order to justify one category of representation and in-
validate another.[9]

The Female Nude and Sexual Metaphor

In the three examples considered above, the authors directly address the issue
of sexual definition in cultural representation, but they do so from different
political and moral standpoints. In the mainstream of art history, however,
the approach is more indirect: sex has to be implicit rather than explicit in
order to keep the art/contemplation coupling intact and to maintain the con-
ventional polarity of art and pornography. Within traditional aesthetics, the
language of connoisseurship has developed as an expression of aesthetic
judgement, taste, and value. The way language is mobilized in discussions of
paintings of the female nude allows us to assess the role of sexual metaphor
in recent art criticism.

As cultural commodities, oil paintings have been relished by critics and
art historians, and the practice of applying paint to canvas has been charged
with sexual connotations. Light caresses form, shapes become voluptuous,
colour is sensuous, and the paint itself is luxuriously physical. This repre-
sentation of artistic production supports the dominant stereotype of the male
artist as productive, active, controlling, a man whose sexuality is channelled
through his brush, who finds expression and satisfaction through the act of
painting.[10] The artist transmutes matter into form. The canvas is the empty but
receptive surface, empty of meaning—naked—until it is inscribed and given
meaning by him. Surface texture is thus charged with significance; the marks
on the canvas are essential traces of human agency, evidence of art, and also
signs of sexual virility, a kind of masculine identity.

These phallic and sexual metaphors take on an astonishing resonance
when the painting is of a female nude. The artist transmutes matter into the
form of the female body—the nude, ideal, perfect, the object of contempla-
tion and delectation. Within the discourse of art history, sex is written into de-
scriptions of paint, surface, and form. The category of art does not permit a
sexuality that is an obvious or provocative element, but such sexuality *can* be
articulated in the discussion of a particular painting's handling and style.
The sexual, then, is distanced from the subject represented on the canvas and
is defined instead through the metaphorical language of connoisseurship.
Lawrence Gowing, for example, describes a small female figure in a Matisse
interior as `abandon[ing] herself to the colour'.[11] In *Nude Painting,* Michael
Jacobs refers to Titian's *Nymph and Shepherd,* in which `the dynamics of flesh
and blood are revealed in their rawest state, all distracting movement, colour
and meaning are stripped away by the rigorous harshness of the artist's late
style'.[12] And Malcolm Cormack describes a Veronese in which `the whole is

a riot of the senses where the sensuous mode of expression emphasises the theme'.[13] . . .

Thus, pictures of the female nude are not about female sexuality in any simplistic way; they also testify to a particular cultural definition of male sexuality and are part of a wider debate around representation and cultural value. The female nude is both a cultural and a sexual category; it is part of a cultural industry whose languages and institutions propose specific definitions of gender and sexuality and particular forms of knowledge and pleasure.

The relationship between art and pornography as illustrated by the British discourse explored here begins to reveal the ways in which cultural and aesthetic designations are mapped on to the moral and sexual values of Western patriarchal culture generally. To date, the popular debate about pornography in both Britain and America has focused on a limited and rather too familiar set of issues. At the centre is the issue of legal censorship. Debate about censorship has become polarized between those who advocate state intervention to ban pornographic material and those who invoke the right of individual freedom of choice, particularly as it is reflected by the private consumption of pornography as opposed to its public display. Supporters of state intervention argue that at issue is the safety of women, that pornographic representations incite violence against women. Yet social investigation, empirical research, statistics, and personal testimony have been used both to endorse and to refute the links between pornography and acts of sexual violence.[14] Besides the ambiguities concerning these investigations and their conclusions, some of the social effects of pornography, such as women's fear, embarrassment and anger, cannot be measured and accounted for in any straightforward way.

The parallels between the poles of this debate and the poles of the pornography/art debate are striking. Both debates focus on the impetus to action as a criterion for classification of images of the female body. Art critics argue over the merits of sensual or erotic images, and those who would either regulate or deregulate pornography argue over the implications of a patriarchal representation of female and male sexuality. These parallels suggest that the relationship between representation and reality, image and action, is not going to be resolved by tugging empirical data backwards and forwards between positions. Rather, the meanings of eroticism and obscenity, sensuality and sexuality, art and pornography, change over time, their boundaries shaped by the forms and institutions of culture and society. Thus, censorship is only a provisional strategy by which to `contain' patriarchal culture; it is a categorization that reflects pornography's present definition as outside the norm, as deviant, hidden culture. Only by continuing to examine the complexity with which such categorizations as pornography and art map out broad cultural notions of the licit and the illicit and societal notions of male and female sexuality will we come to a more subtle understanding of the implications of images of the female body.

NOTES

This article first appeared in *Signs: Journal of Women in Culture and Society 15*, 2 (1990).

[1] Quoted in Lord Longford, *Pornography: The Longford Report* (London: Coronet, 1972), pp. 99–100.

[2] The published material on pornography is extensive, so it is difficult to extract a handful of texts that accurately represent the debate. A very useful selection of British feminist writings is reprinted in Rosemary Betterton, ed., *Looking On: Images of Femininity in the Visual Arts and Media* (London and New York: Pandora, 1987), pp. 143–202.

[3] It is Kant's theory of the self-contained aesthetic experience that is at the bottom of all this, but in Clark's usage it becomes simplified and popularized, an accessible formula for cultural definition (see Immanuel Kant, *Critique of Aesthetic Judgement*, transl. J.C. Meredith [Oxford: Clarendon, 1911]).

[4] Kenneth Clark, *The Nude* (Harmondsworth: Penguin, 1976); Arthur Goldsmith, *The Nude in Photography* (London: Octopus, 1976); Michael Busselle, *Nude and Glamour Photography* (London: Macdonald, 1981).

[5] Victor Burgin, *The End of Art Theory: Criticism and Postmodernity* (London: Macmillan, 1986), p. 42.

[6] John Berger, *Ways of Seeing* (London: BBC & Penguin, 1972), p. 54.

[7] Linda Nochlin, `Eroticism and Female Imagery in Nineteenth-Century Art', in Thomas B. Hess and Linda Nochlin, eds, *Woman as Sex Object: Studies in Erotic Art, 1730–1970* (London and New York: Allen Lane, 1972), pp. 8–15. For a detailed discussion of this collection of essays, see Lise Vogel/Fine Arts and Feminism: The Awakening Conscience', *Feminist Studies 2,1* (1974), pp. 3–37.

[8] Peter Webb, *The Erotic Arts* (London: Secker& Warburg, 1975), p.2.

[9] Interestingly, both Webb and Berger argue that oriental art offers honest and frank representations of sex as opposed to the repressed and unhealthy sexuality of Western bourgeois art. In this way, they support the racist mythology of the unrestrained sexuality of non-European races and perpetuate the particular art-historical version of the ideology of primitivism.

[10] For an important discussion of the metaphor of penis-as-paintbrush, see Carol Duncan, `The Esthetics of Power in Modern Erotic Art', *Heresies 1* (1977), pp. 46–60.

[11] Lawrence Gowing, *Matisse* (London: Thames & Hudson, 1979), p. 63.

[12] Michael Jacobs, *Nude Painting* (Oxford: Phaidon, 1979), p. 24.

[13] Malcolm Cormack, *The Nude in Western Art* (Oxford: Phaidon, 1976), p. 25.

[14] In the social sciences there have been many publications on the relationship between exposure to images and resulting action. The publication in Britain of the Minneapolis public hearings on pornography (1983) endorsed the link between the use of pornographic material and acts of sexual violence; see *Pornography and Sexual Violence: Evidence of the Links: The Complete Transcript of Public Hearings on Ordinances to Add Pornography as Discrimination against Women: Minneapolis City Council, Government Operations Committee, December 12 and 13, 1983* (London: Everywoman, 1988).

CHAPTER 19

Public Funding for the Arts

In the late 1980s several highly controversial exhibitions sparked an intense national debate about whether the federal government, in the guise of the National Endowment for the Arts, ought to be in the business of funding the arts—particularly art that many people considered pornographic or sacrilegious. Proponents of free speech and creative freedom clashed with defenders of public decency and taxpayers' rights. Some people asked whether aesthetics or politics was at the heart of the debate.

By 1995, NEA appropriations were severely cut. The NEA's ability to support controversial art was substantially curtailed, but the debate continued. Paul Goldberger argues for continued public support of controversial art even though most people don't like it, because he believes the best art is the art that challenges us. Joseph Epstein counters that what some call "challenging" others consider obscene, just plain mediocre, or an attack on our basic values—certainly *not* our best art.

Why is there such heated debate about funding the arts, especially when so little money is at stake? The government supports the sciences with appropriations thousands of times larger with very little comment. Why are the arts different? Is it possible they matter more than we think?

To Earn Subsidies, Must Art Be Useful? Must It Be Sweet?

PAUL GOLDBERGER

Paul Goldberger is an award-winning critic and preservationist. He received a Pulitzer Prize in 1984 for his work as architecture critic of The New York Times *where he remained until 1997. His book,* The Skyscraper *(New York: Alfred A. Knopf), was published in 1981. Today he writes about architecture, historic preservation, and urban planning for* The New Yorker *as well as other periodicals.*

"All art is quite useless," wrote Oscar Wilde, but of course he never encountered the National Endowment for the Arts, which is predicated on the premise that the arts are the most useful thing in the world. They solve social problems, they keep people happy, they make communities shine with enthusiasm and best of all, they inject a shot of money into sagging economies. The arts establishment in the United States operates on a nearly messianic certainty that the arts are not merely good, but good for you.

Is it really so? Surely the economic impact of the arts is real. The explosion of interest in culture in the United States over the last generation has turned the arts into a potent industry. Study after study shows the multiplier effect of arts dollars, sowing prosperity all through the economy. The Metropolitan Museum is now the most popular tourist attraction in New York, where big exhibitions fill not only its own coffers but also those of hotels and restaurants. People clamor to get seats for major events at Lincoln Center and Carnegie Hall. The arts are for everyone, and everyone seems to be for the arts.

Except, of course, on Capitol Hill, where the new Republican Majority, building on years of discomfort among conservatives about Federal support of the arts, seems increasingly hostile to keeping the National Endowment in business. The endowment's entire appropriation is only $167 million, but no $167 million anywhere in the entire Federal budget is debated with such intensity. To the endowment's opponents, this comparatively tiny sum of money is a vast boondoggle, a pork barrel for the cultural elite. To the endowment's supporters, it is anything but a gift to the elite; it is money that spreads the

Paul Goldberger, "To Earn Subsidies, Must Art Be Useful? Must It Be Sweet?" *The New York Times,* 11 January, 1995, C13, Copyright © 1995, The New York Times Co. Reprinted by permission.

pleasures of art around and assures that the experience of culture will be accessible to all.

The situation is rife with paradoxes, not the least of which is the way in which the arts establishment has tried to save its skin by portraying art as sweet and lovable, leaving to the endowment's opponents a much more realistic view of art as challenging and difficult. Both sides claim to represent the democratic ideal, which is why $167 million, which is a mere fly speck in the Federal budget, is given such overwhelming symbolic importance by both sides. The endowment's minuscule budget, less than half of what it costs to keep Lincoln Center going for a year, less than a quarter of what the city of Berlin spends on arts subsidies annually for a population that is less than 2 percent of that of the whole United States, is often portrayed as the crucible for the future of the arts in this country.

End the endowment and we will stop the free ride for unpopular artists and get back to the good kind of art that pays for itself, goes the conservative argument. We end the endowment at our peril, retorts the other side; without it, the arts will be finished and we will become a nation of philistines.

The likelihood is that the sky will neither fall nor rise if the endowment's modest appropriation disappears. Art will go on, as it always has. But if the endowment is sharply cut or eliminated altogether, the nation will be sending an important signal about its attitude toward culture, which is that it expects it to play by the rules most other things do, and pay for itself.

It sounds, on the surface, as if it couldn't be more fair. Why shouldn't culture do what other things do, and take care of itself? The only problem is that it doesn't work, as history proves. Culture has never been able to support itself. There is a reason that the popes and the Medicis hired Michelangelo, that royalty paid Mozart to write concertos, that the histories of creativity and of patronage are intimately intertwined. The marketplace has never been a testing ground for artistic validity; history shows few correlations between what is popular enough to pay for itself and what is good enough to last.

Subsidizing art runs against the grain of American independence, the tradition of self-reliance that seems so often to tie into populism. But that very populist instinct often contradicts what art strives to do, which is not to coddle but to challenge. Great art is rarely created with popularity in mind, and when it manages to achieve tremendous appeal, it is often nothing more than a miraculous accident.

Surely the saddest aspect of this moment is the way in which the arts establishment, to fight the political opposition it faces, has been forced to retreat into a position of defending the popularity of art and denying its challenge. Jane Alexander, the earnest and determined chairwoman of the National Endowment for the Arts, has labored mightily to convince Congress and the voters that the endowment is spreading sweetness and light throughout the country, that art is bringing happiness to all who are touched by endowment grants.

But the Republicans are not so quick to buy this, and maybe they are right. They know the arts at their most vital are something other than sugar-coated candy. The arts often undermine, they often seek to be subversive to established orders, and the opposition to the endowment wants to protect the country from this evil or at least make sure that government funds play no part in propagating it. Picasso may be easy to swallow now, but he wasn't in 1910. Why should our tax dollars support the next crazy radical to come down the pike?

The ultimate paradox is that now, at a time when public interest in the arts is greater than ever, the arts establishment has come to promote what is fundamentally an anti-intellectual view of culture, while the right-wing opposition operates from a more sophisticated view. The opponents of the endowment who complain loudly about the homoerotic photographs of Robert Mapplethorpe or the urine-drenched crucifix of Andres Serrano, hostile though they may be to any esthetic messages in these works, are actually more accepting of the notion that art consists of ideas and not merely pretty pictures, that it is more than entertainment and that it often seeks to challenge society's standards.

The arts establishment, engaged in the act of trying to protect the economic interests of cultural organizations and institutions that depend on masses of people attending, has increasingly been blurring the line between art and entertainment. These supporters of the arts endowment increasingly see culture in terms of what is consumed, not in terms of what is created. How else to protect their turf? Yet in doing so, they abandon to the other side the very view of art that they should be holding most dear, a recognition of art as creativity and challenge.

Today, as advocates attempt to save the endowment by portraying art as democratic, accessible and unthreatening, it is left to their opponents to see it in terms of creativity, and to admit the tremendous, terrifying power that art at its most intense can possess.

What to Do About the Arts?

JOSEPH EPSTEIN

Joseph Epstein is a contemporary essayist. He is the former editor of the American Scholar, *and his work has been published in that journal as well as in* The New Yorker *and the* Hudson Review, *among others. Recent collections of his essays include* Narcissus Leaves the Pool *(New York: Houghton Mifflin Co., 1999) and* A Line Out for a Walk *(New York: Norton, 1996). He teaches writing and literature at Northwestern University.*

. . . Supporters of the NEA [National Endownment for the Arts], those who like the system as it now is, talk a good deal about the economic soundness of federal support for the arts. They trot out the following numbers: federal support for the arts costs the taxpayer only 64 cents a year, whereas the figure in Germany is $27 and in France and Canada it is $32. Every dollar awarded by the NEA in grants attracts $11 from state and local arts agencies, corporations, and private parties. There are 1.3 million jobs in the arts; if you add tourism, ticket revenues, and other money-making activities, this creates something like $37 billion in economic activity and brings in $3.4 billion in federal taxes. The arts, the argument goes, are good for the economy. So shut up, and eat your arts.

Not only have other nations throughout history supported the arts, NEA publicists maintain, but future generations will judge us by the extent to which we support the arts as "the finest expression of the human condition." (Ah, Mapplethorpe! Ah, humanity!) When, they remind us, Congress established the NEA in 1965, it noted:

> An advanced civilization must not limit its efforts to science and technology alone but must give full value and support to the other great branches of scholarly and cultural activity in order to achieve a better understanding of the past, a better analysis of the present, and a better view of the future.

The arts, therefore, are not only good for the economy, they serve the purposes of moral uplift. So shut up and eat your arts.

To hear its advocates tell it, the NEA enriches community life, stimulates local economies, supports the promising young, makes culture available to

Excerpted from Joseph Espstein, "What to Do About the Arts?" *Commentary* 99, No. 4 (1995), 23–30. Reprinted from *Commentary*, April 1995, by permission; all rights reserved.

the masses, works with "at-risk" youth, satisfies a deep demand for art among the American people—the NEA is in fact good for everything but growing hair. The arts are good for the city, good for the country, good for everyone. So shut up and eat your arts.

But—aside from all these magnificent side-effects—what, exactly, do the arts *do?* Here we return to the same old litany. **Paul Goldberger,** the cultural-news editor of the *New York Times,* a paper that has a great deal to say about what in contemporary art gets serious attention, answered the question by writing that "what art strives to do . . . is not to coddle but to challenge." In other words, painters who mock your religion, playwrights who blame you for not doing enough for AIDS, poets who exalt much that you despise, opera composers who make plain that your politics are vicious—all this is by definition art, and, whether you like it or not, it is good for you. So go eat your arts out.

The NEA might have been spared much anguish if someone truly knowledgeable had been in a position of leadership. But in its 30-year history it has never had a chairman with anything approaching an understanding of the arts. The specialty of Nancy Hanks, the first chairman, was charming Congressmen to support the agency it had founded in 1965. Her successor, Livingston Biddle, was a platitudinarian, who to this day likes to expatiate on his slogan that "the arts mean excellence"; one need only listen to him for two minutes to cease believing in art and excellence both. Biddle was followed by Frank Hodsoll, an intelligent and capable civil servant who, when it came to the arts, was clearly learning on the job. John Frohnmayer, the Bush administration's man, brought to the job enormous ambition exceeded only by ignorance of the ways of politicians and artists alike. The current chairman, Jane Alexander, an actress and hence technically an artist herself, has been running a rescue operation; she apparently thinks the way to do this is to talk about her wide travels in which she finds that the people of the United States could not be happier with all the art the federal government has helped to pay for, and to remind everyone that the arts are good for our souls.

One cannot but wonder what it might be like to have someone in a position of leadership who knows what the point of the arts is. But who of any standing would want to take on the job? In the current political climate, he would find himself locked between radical artists shouting censorship and conservative Congressmen crying obscenity. His efforts could only come to grief.

That the future of the National Endowment for the Arts is in peril ought not to be surprising. What people at the NEA and those who accept grants from it have never seemed to realize is that they are sponsoring and producing *official* art, just as surely as the academic painters in France or the socialist-realist novelists in the Soviet Union produced official art. That our official art is against the society that sponsors it does not make it any the less official. But given the obscenity and the mediocrity and the politicization of so much

of this art, government sponsorship of it has come to seem intolerable, and there is now talk of closing down the Endowment.

Should that be done? Any serious scrutiny of the NEA must begin with the stipulation that politically motivated art ought not to be underwritten by taxpayer money. (The argument that all art is ultimately political is greatly exaggerated; it is a question of degree, and everyone knows it.) Nor for their part should artists upon receiving a grant be asked to accept any condition that will inhibit them, such as not offending any segment of the population. Since these criteria cannot be satisfied in the case of grants to individual artists, and especially those on the "cutting edge," my own sense is that it would be better if all such grants were eliminated: better for the country and, though they are likely to hate it, better, finally, for artists.

In one of his essays the eminent cultural historian Jacques Barzun makes a distinction between "public art" and all other kinds. Individual artists, he believes, should fend for themselves, as artists have always done; I agree with him. But then there is public art, by which Barzun means museums, opera houses, orchestras, theaters, and dance troupes. "If as a nation," he writes, "we hold that high art is a public need, these institutions deserve support on the same footing as police departments and weather bureaus."

William F. Buckley, Jr. has supplied a corroborating argument derived, for conservatives, from the most impressive of all possible sources. It was Adam Smith who, in Buckley's words, "counseled that free societies are obliged to contribute state funds only for the maintenance of justice, for the common defense, and for the preservation of monuments." It is only a small stretch, Buckley suggests, to claim that a great many artistic works qualify as monuments.

I agree with that, too—but only in theory. In a different political-cultural climate—less confrontational and litigious—one could easily imagine a place for a federal presence in the arts. The government could contribute to preserving art: it could help to maintain the costs of museums in financial difficulty and ease the financial strain entailed in the performance and exhibition of established and often difficult art that does not figure to have a wide following. Some valuable art cannot realistically hope to survive in the marketplace, ever, and some of the good things the NEA historically helped to do are not likely to be done by private philanthropy—bringing in art from abroad, underwriting costly exhibition catalogues, helping small but serious local musical and dance groups get under way. There are other things, too, that the federal government would perhaps be in the best position to accomplish, if the political climate were not so deliberately abrasive.

Proponents of the NEA point to the fact that most West European governments do support the arts, without great tumult, for the perfectly legitimate reason that they feel a responsibility to their national cultural heritage and to culture generally. But there would not have been a great tumult in the United States, either, if the NEA's advocates, artists' lobbying groups, and artists

themselves had not felt the need to justify the mediocre, the political, and the obscene. These justifications have even extended to the argument that *not* to receive an NEA grant is to be the victim of censorship. When Karen Finley and other performance artists were denied an NEA grant in 1990, they took their case to the courts on this basis, and won. As long as such things go on—and there is no reason to believe that they will not—the federal government would do better to remain outside the arts altogether.

When the abolition of the NEA is currently discussed, many people talk about turning the task over to the states. But the effect of this would most likely be to enlarge state bureaucracies, and art selected for support on the state level is likely to be even more mediocre, and no less political, than that selected on the federal level. The prospect of "devolution" is thus not one that ought to fill anyone with optimism.

It does, however, seem doubtful that, if government divorces itself from the arts, private philanthropy will pick up the whole tab. People who run large artistic institutions—museums, symphony orchestras—seem to agree that the new generations of the wealthy have shown themselves less gener-ous than their forebears: the philanthropic impulse is not, evidently, a ge-netic one.

This is unfortunate. Although money has its limitations in the arts, there is no question that it also has its distinct uses. In my own time on the NEA Council I sensed that if an art was weak, there was nothing that the injection of money which was finally all the NEA or any federal program had to offer—could do to strengthen it. If, on other hand, an art was strong, as dance was in the middle 1980's, money could help in small but real ways to support it in its vibrancy. Many dancers, for example, work a 26-week season, or less, and hence are unemployed half the year; and, in a profession that almost guarantees injury, few dance companies are able to offer health insurance. Although nothing was done to rectify either of these situations during even the palmiest days at the NEA, the answer in both instances was fairly simple—money.

Other things that seem eminently justifiable are also not likely to be picked up by private philanthropy. The NEA has sent dance and theatrical and mu-sical groups into rural and backwater parts of the country, so that people, and especially the young, could have an opportunity to see live performance, which, even in a television age, has its own magic. Arts education in the lower grades, which has been gradually yet seriously slipping in recent decades, is something that needs attending to. Private philanthropy is unlikely to step in here, too.

All that having been said, however, it still remains the case that if the Endowment were shut down, the arts would probably for the most part not be drastically affected. In some instances, fresh patrons would step forward to fill the financial gaps; in others, cutbacks in production and exhibition schedules would have to be made; in a minor number of cases, smaller

institutions—literary magazines, design projects, local music groups—might go under. But much as the NEA and its advocates would like everyone to think otherwise, the presence of the Endowment is not crucial to the artistic life of this country. This may be a good time to lie low and have no arts policy whatsoever. After all, we had an artistic life—a much richer and more distinguished one—before we had an NEA.

Thanks in part to the NEA, we are now in an age of artistic surfeit. To provide only a single depressing statistic, I read somewhere that there are currently 26,000 registered poets in the United States. Where, it will be asked, do they register? With the Associated Writing Programs, I gather, which are chiefly made up of teachers of writing, who are even now busy producing still more poets, who will go on to teach yet more poets, who will . . . so that in twenty years' time we will have 52,000 registered poets. Degas, more than a century ago, remarked: "We must discourage the arts." What might he say today?

CHAPTER 20

The Museum

For many of us, the art museum is the only place we see art. In this sense the museum has enormous power and authority; it determines what art is seen by most people, even what is defined as art. If a museum shows it, it must be art. Carol Duncan argues that contrary to our expectations, museums are not neutral arenas, but rather promote certain attitudes about art. Hilton Kramer on the other hand, believes museums uphold the highest expression of aesthetic standards, and he warns that they are being damaged by concessions on the part of museums to "ideological advocacy." Neil Harris reviews the current state of American museums and finds them at a "historic peak" of power, prominence, and prestige, but, at what cost? Have recent economic and programmatic challenges caused irrevocable shifts in their traditional functions and turned them into just more public entertainment centers?

The Art Museum as Ritual

CAROL DUNCAN

Carol Duncan writes on modern and contemporary art issues. Her books include The Aesthetics of Power: Essays in Critical Art History *(Cambridge and New York: Cambridge University Press, 1993) and* Civilizing Rituals: Inside Public Art Museums *(London and New York: Routledge, 1995). She teaches in the School of Contemporary Arts at Ramapo College of New Jersey.*

. . . Art museums have always been compared to older ceremonial monuments such as palaces or temples. Indeed, from the eighteenth through the mid-twentieth centuries, they were deliberately designed to resemble them. One might object that this borrowing from the architectural past can have only metaphoric meaning and should not be taken for more, since ours is a secular society and museums are secular inventions. If museum facades have imitated temples or palaces, is it not simply that modern taste has tried to emulate the formal balance and dignity of those structures, or that it has wished to associate the power of bygone faiths with the present cult of art? Whatever the motives of their builders (so the objection goes), in the context of our society, the Greek temples and Renaissance palaces that house public art collections can signify only secular values, not religious beliefs. Their portals can lead to only rational pastimes, not sacred rites. We are, after all, a post-Enlightenment culture, one in which the secular and the religious are opposing categories.

It is certainly the case that our culture classifies religious buildings such as churches, temples, and mosques as different in kind from secular sites such as museums, court houses, or state capitals. Each kind of site is associated with an opposite kind of truth and assigned to one or the other side of the religious/secular dichotomy. That dichotomy, which structures so much of the modern public world and now seems so natural, has its own history. It provided the ideological foundation for the Enlightenment's project of breaking the power and influence of the church. By the late eighteenth century, that undertaking had successfully undermined the authority of religious doctrine—at least in western political and philosophical theory if not always in practice. Eventually, the separation of church and state would become law. Everyone knows the outcome: secular truth became authoritative truth;

Excerpted from Carol Duncan, "The Art Museum as Ritual," Chapter 1 in *Civilizing Rituals: Inside Public Art Museums* (New York and London: Routledge, 1991), 7–17. Reprinted by permission of the publisher.

religion, although guaranteed as a matter of personal freedom and choice, kept its authority only for voluntary believers. It is secular truth—truth that is rational and verifiable—that has the status of "objective" knowledge. It is this truest of truths that helps bind a community into a civic body by providing it a universal base of knowledge and validating its highest values and most cherished memories. Art museums belong decisively to this realm of secular knowledge, not only because of the scientific and humanistic disciplines practiced in them—conservation, art history, archaeology—but also because of their status as preservers of the community's official cultural memory.

Again, in the secular/religious terms of our culture, "ritual" and "museums" are antithetical. Ritual is associated with religious practices—with the realm of belief, magic, real or symbolic sacrifices, miraculous transformations, or overpowering changes of consciousness. Such goings-on bear little resemblance to the contemplation and learning that art museums are supposed to foster. But in fact, in traditional societies, rituals may be quite unspectacular and informal-looking moments of contemplation or recognition. At the same time, as anthropologists argue, our supposedly secular, even anti-ritual, culture is full of ritual situations and events—very few of which (as Mary Douglas has noted) take place in religious contexts.[1] That is, like other cultures, we, too, build sites that publicly represent beliefs about the order of the world, its past and present, and the individual's place within it.[2] Museums of all kinds are excellent examples of such microcosms; art museums in particular—the most prestigious and costly of these sites[3]—are especially rich in this kind of symbolism and, almost always, even equip visitors with maps to guide them through the universe they construct. Once we question our Enlightenment assumptions about the sharp separation between religious and secular experience—that the one is rooted in belief while the other is based in lucid and objective rationality—we may begin to glimpse the hidden—perhaps the better word is disguised—ritual content of secular ceremonies.

We can also appreciate the ideological force of a cultural experience that claims for its truths the status of objective knowledge. To control a museum means precisely to control the representation of a community and its highest values and truths. It is also the power to define the relative standing of individuals within that community. Those who are best prepared to perform its ritual—those who are most able to respond to its various cues—are also those whose identities (social, sexual, racial, etc.) the museum ritual most fully confirms. It is precisely for this reason that museums and museum practices can become objects of fierce struggle and impassioned debate. What we see and do not see in art museums—and on what terms and by whose authority we do or do not see it—is closely linked to larger questions about who constitutes the community and who defines its identity.

I have already referred to the long-standing practice of museums borrowing architectural forms from monumental ceremonial structures of the past. Certainly when Munich, Berlin, London, Washington, and other western

capitals built museums whose facades looked like Greek or Roman temples, no one mistook them for their ancient prototypes. On the contrary, temple facades—for 200 years the most popular source for public art museums[4]— were completely assimilated to a secular discourse about architectural beauty, decorum, and rational form. Moreover, as coded reminders of a pre-Christian civic realm, classical porticos, rotundas, and other features of Greco-Roman architecture could signal a firm adherence to Enlightenment values. These same monumental forms, however, also brought with them the spaces of public rituals—corridors scaled for processions, halls implying large, communal gatherings, and interior sanctuaries designed for awesome and potent effigies [Figure 28].

Museums resemble older ritual sites not so much because of their specific architectural references but because they, too, are settings for rituals. (I make no argument here for historical continuity, only for the existence of comparable ritual functions.) Like most ritual space, museum space is carefully marked off and culturally designated as reserved for a special quality of attention— in this case, for contemplation and learning. One is also expected to behave with a certain decorum. In the Hirshhorn Museum, a sign spells out rather fully the dos and don'ts of ritual activity and comportment. Museums are normally set apart from other structures by their monumental architecture and clearly defined precincts. They are approached by impressive flights of stairs, guarded by pairs of monumental marble lions, entered through grand doorways. They are frequently set back from the street and occupy parkland, ground consecrated to public use. (Modern museums are equally imposing architecturally and similarly set apart by sculptural markers.) . . .

Thus far, I have argued the ritual character of the museum experience in terms of the kind of attention one brings to it and the special quality of its time and space. Ritual also involves an element of performance. A ritual site of any kind is a place programmed for the enactment of something. It is a place designed for some kind of performance. It has this structure whether or not visitors can read its cues. In traditional rituals, participants often perform or witness a drama—enacting a real or symbolic sacrifice. But a ritual performance need not be a formal spectacle. It may be something an individual enacts alone by following a prescribed route, by repeating a prayer, by recalling a narrative, or by engaging in some other *structured* experience that relates to the history or meaning of the site (or to some object or objects on the site). Some individuals may use a ritual site more knowledgeably than others— they may be more educationally prepared to respond to its symbolic cues. The term "ritual" can also mean habitual or routinized behavior that lacks meaningful subjective context. This sense of ritual as an "empty" routine or performance is not the sense in which I use the term.

In art museums, it is the visitors who enact the ritual.[5] The museum's sequenced spaces and arrangements of objects, its lighting and architectural details provide both the stage set and the script—although not all museums do

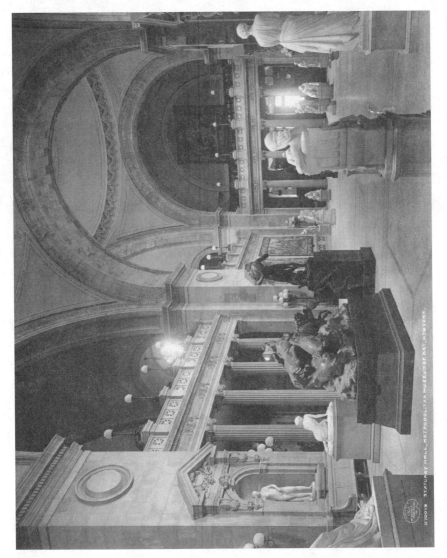

Figure 28. Richard Morris Hunt, Statuary Hall, The Metropolitan Museum of Art, NYC, c. 1907. Photo: © Bettmann/CORBIS.

this with equal effectiveness. The situation resembles in some respects certain medieval cathedrals where pilgrims followed a structured narrative route through the interior, stopping at prescribed points for prayer or contemplation. An ambulatory adorned with representations of the life of Christ could thus prompt pilgrims to imaginatively re-live the sacred story. Similarly, museums offer well-developed ritual scenarios, most often in the form of art-historical narratives that unfold through a sequence of spaces. Even when visitors enter museums to see only selected works, the museum's larger narrative structure stands as a frame and gives meaning to individual works. . . .

We come, at last, to the question of art museum objects. Today, it is a commonplace to regard museums as the most appropriate places in which to view and keep works of art. The existence of such objects—things that are most properly used when contemplated as art—is taken as a given that is both prior to and the cause of art museums. These commonplaces, however, rest on relatively new ideas and practices. The European practice of placing objects in settings designed for contemplation emerged as part of a new and, historically speaking, relatively modern way of thinking. In the course of the eighteenth century, critics and philosophers, increasingly interested in visual experience, began to attribute to works of art the power to transform their viewers spiritually, morally, and emotionally. This newly discovered aspect of visual experience was extensively explored in a developing body of art criticism and philosophy. These investigations were not always directly concerned with the experience of art as such, but the importance they gave to questions of taste, the perception of beauty, and the cognitive roles of the senses and imagination helped open new philosophical ground on which art criticism would flourish. Significantly, the same era in which aesthetic theory burgeoned also saw a growing interest in galleries and public art museums. Indeed, the rise of the art museum is a corollary to the philosophical invention of the aesthetic and moral powers of art objects: if art objects are most properly used when contemplated as art, then the museum is the most proper setting for them, since it makes them useless for any other purpose. . . .

Nowhere does the triumph of the aesthetic museum reveal itself more dramatically than in the history of art gallery design. Although fashions in wall colors, ceiling heights, lighting, and other details have over the years varied with changing museological trends, installation design has consistently and increasingly sought to isolate objects for the concentrated gaze of the aesthetic adept and to suppress as irrelevant other meanings the objects might have. The wish for ever closer encounters with art have gradually made galleries more intimate, increased the amount of empty wall space between works, brought works nearer to eye level, and caused each work to be lit individually.[6] Most art museums today keep their galleries uncluttered and, as much as possible, dispense educational information in anterooms or special kiosks at a tasteful remove from the art itself. Clearly, the more "aesthetic" the installations—the fewer the objects and the emptier the surrounding walls—the more sacralized

the museum space. The sparse installations of the National Gallery in Washington, DC, take the aesthetic ideal to an extreme, as do installations of modern art in many institutions. As the sociologist César Graña once suggested, modern installation practices have brought the museum-as-temple metaphor close to the fact. Even in art museums that attempt education, the practice of isolating important originals in "aesthetic chapels" or niches—but never hanging them to make an historical point—undercuts any educational effort.[7] . . .

NOTES

[1] Mary Douglas, *Purity and Danger,* London, Boston, and Henley, Routledge & Kegan Paul, 1966, p. 68.

On the subject of ritual in modern life, see Abner Cohen, *Two-Dimensional Man: An Essay on the Anthropology of Power and Symbolism in Complex Society,* Berkeley, Cal., University of California Press, 1974; Steven Lukes, "Political Ritual and Social Integration," in *Essays in Social Theory,* New York and London, Columbia University Press, 1977, pp. 52–73. Sally F. Moore and Barbara Myerhoff, "Secular Ritual: Forms and Meanings," in Moore and Myerhoff (eds.), *Secular Ritual,* Assen/Amsterdam, Van Gorcum, 1977, pp. 3–24; Victor Turner, "Frame, Flow, and Reflection: Ritual and Drama as Public Liminality," in *Performance in Postmodern Culture,* Michel Benamou and Charles Caramello (eds.), Center for Twentieth Century Studies. University of Wisconsin-Milwaukee, 1977, pp. 33–55: and Turner, "Variations on a Theme of Liminality," in Moore and Myerhoff, op. cit., pp. 36–52. See also Masao Yamaguchi, "The Poetics of Exhibition in Japanese Culture," in 1. Karp and S. Levine (eds.), *Exhibiting Cultures: The Poetics and Politics of Museum Display,* Washington and London, Smithsonian Institution, 1991, pp. 57–67. Yamaguchi discusses secular rituals and ritual sites in both Japanese and western culture, including modern exhibition space. The reference to our culture being anti-ritual comes from Mary Douglas, *Natural Symbols* (1973), New York, Pantheon Books, 1982, pp. 1–4, in a discussion of modern negative views of ritualism as the performance of empty gestures.

[2] This is not to imply the kind of culturally or ideologically unified society that, according to many anthropological accounts, gives rituals a socially integrative function. This integrative function is much disputed, especially in modern society (see, for example, works cited in the preceding notes by Cohen, Lukes, and Moore and Myerhoff, and Edmond Leach, "Ritual," *International Encyclopedia of the Social Sciences, vol.* 13, David Sills (ed.), Macmillan Co. and The Free Press, 1968, pp. 521–526.

[3] As Mary Douglas and Baron Isherwood have written, "the more costly the ritual trappings, the stronger we can assume the intention to fix the meanings to be" (*The World of Goods: Towards an Anthropology of Consumption* (1979), New York and London, W. W. Norton, 1982, p. 65).

[4] See Nikolaus Pevsner, *A History of Building Types,* Princeton, N. J., Princeton University Press, 1976, pp. 1–18 ff.; Niels von Hoist, *Creators, Collectors and Connoisseurs,* trans. B. Battershaw, New York, G. P. Putnam's Sons, 1967, pp. 228 ff; Germain Bazin, *The Museum Age,* trans. J. van Nuis Cahill, New York, Universe Books, 1967, pp, 197–202; and William L. MacDonald, *The Parthenon Design, Meaning, and Progeny,* Cambridge, Mass., Harvard University Press, 1976, pp, 125–32.

[5] I would argue that this is the case even when they watch "performance artists" at work.

[6] See, for example, Charles G. Loring, a Gilman follower, noting a current trend for "small rooms where the attention may be focused on two or three masterpieces" (in "A Trend in Museum Design," *Architectural Forum,* December 1927, yet. 47, p. 579).

[7] César Graña, "The Private Lives of Public Museums," *Trans-Action,* 1967, vol.4. no.5, pp. 20–25.

The Assault on the Museums

HILTON KRAMER

Hilton Kramer is a prominent conservative art critic and cultural commentator. He was chief art critic and art news editor for The New York Times. *He is currently editor and publisher of* The New Criterion, *which he founded. His recent books include* The Twilight of the Intellectuals: Culture and Politics in the Era of the Cold War *(Chicago: Ivan R. Dee, Publisher, 1999) and* The Betrayal of Liberalism: How the Disciples of Freedom and Equality Helped Foster the Illiberal Politics of Coercion and Control *(Chicago: Ivan R. Dee, Publisher, 1999), an anthology of essays from* The New Criterion, *edited with Roger Kimball.*

The political thought police have now come to the American art museum. For some years they have been making their presence felt in the museum world in numerous ways, demanding—and usually getting—concessions and preferments in the name of gender, race, ethnicity, and the many other items that constitute the current agenda of multiculturalism, "diversity," and politically correct ideas. But the damage to aesthetic standards remained, for the most part, limited in scope as far as the mainstream activities of most of our museums are concerned. Museum administrators might be quick to surrender the pages of exhibition catalogues to the new political orthodoxy . . . but the exhibitions themselves were mounted with a minimum of political distortion. The signs of a growing political militancy and of a liberal tendency to succumb to its imperatives were already plentiful, to be sure—and they were proving to be increasingly costly to the museums—but with the exception of two principal areas of museological activity, politics had not yet succeeded in capsizing the programs of our major institutions. The situation was getting worse by the day, but it had not yet become the kind of catastrophe that had overtaken the humanities departments in our colleges and universities.

The two principal exceptions to this development in the museum world were (1) the entire field of contemporary art, which was coming to play an ever larger role in the affairs of a great many museums; and (2) that whole congeries of programs, publications, symposia, entertainments, classes, and workshops that goes by the name of "education" in the museums. It was in these two areas of museum work that the new political orthodoxy scored its initial

Excerpted from Hilton Kramer, "The Assault on the Museums," *The New Critierion* 9 (March 1991): 4–8. Reprinted by permission of the author.

victories and quickly acquired an immense, transfiguring influence. The reasons are anything but obscure. A good deal of the most fashionable new art of the 1980s was, in one way or another, openly "activist" and political in character. It shunned aesthetic issues in favor of ideological advocacy, and this kind of art met with a prompt and enthusiastic response in the museums and the art market, which were now more eager than ever to embrace whatever was guaranteed to be chic and "enlightened"—which is to say, politically correct—in contemporary art. The response of the museums to this development was scarcely distinguishable from that of the media, which the curators of contemporary art came more and more to worship, envy, and emulate. For the new breed of curatorial hustlers and their patrons among the dealers and collectors, an interest in artistic standards had come to seem outmoded, reactionary and certainly not fun, and they were supported in this view by the critics who readily consigned the concept of "quality" to the dustheap of history so that the new (political) standards would prevail with unchallenged authority.

As for the enterprise that passes for "education" in most of our museums, this had largely become a scene of intellectual disgrace long before the political thought police arrived to transform it into a sanctuary for propaganda and indoctrination. In this area, it was often a case of politics filling an intellectual void. The last thing one can expect to receive from the educational program of an American art museum today is an informed and disinterested course of instruction in the mysteries and glories of a great work of art. The whole notion of connoisseurship—of learning to distinguish the qualities of one work of art from another, and thus to acquire a knowledge of what a work of art is and of what its particular attributes and powers consist of, especially, in relation to other works of art of its kind—this whole approach to the understanding of art is now deemed to be indefensibly elitist. It stands opposed to the doctrine of "diversity," which requires us to believe that distinctions of value and achievement in art are nothing but a political racket designed to protect the interests of white male heterosexual artists in the West.

Forgotten, or at least discarded, in this assault on distinctions of value and achievement is the very purpose that the institution of the art museum was designed to serve—the purpose of distinguishing and preserving what informed judgment found to be the best in art, the highest accomplishments of their kind. This was the aesthetic and cultural ideal the art museum was created to uphold. That it did not always uphold this ideal without error or misjudgment does nothing to diminish the importance or the value of the ideal itself. And the fact is, the historical record abundantly vindicates the principal judgments that have been made about the artistic achievements of the past. New knowledge, new discoveries, new ideas inevitably modify these judgments and lead to revisions of taste and value, but it is the function of such revisions to serve this basic ideal more faithfully, not to topple it and lay waste its efficacy and integrity. Implicit in this ideal *is* an elitist belief that in

art, as in other branches of human endeavor, some things *are* better than others—that there *are* highs and lows in the accomplishments of mind and imagination—and that it is the function of the art museum as an institution to aid us in understanding this distinction and in making the highest of these accomplishments a permanent part of our existence.

It is precisely this ideal and the kind of aesthetic intelligence essential to its realization that is now under attack from the political thought police. Taking their cues from the successful assault mounted by their ideological allies on the study of the arts and the humanities in the college and university classrooms of the nation, these militant advocates of the new political orthodoxy have accelerated the campaign to add the major art museums to their already impressive list of conquests. To judge by some recent developments, they are once again supported by their friends in the media in this effort to install the Big Brother agenda of multiculturalism, "diversity," and politically correct ideas as the only permissible program for the museums. And we are not speaking here of an occasional exhibition or an "outreach" department or some marginal appointments—the sops by means of which the liberal leadership of our museums has attempted in the past to placate and accommodate political demands regarded by their professional staffs as inimical to the highest functions and standards of their institutions. We are talking about radical change—a virtual cultural revolution—in the kind of programs and staffing and fundamental values that determine the very nature of the art museum and its role in the life of culture and society. . . .

The Divided House
of the American Art Museum

NEIL HARRIS

Neil Harris is the Preston and Sterling Morton Professor of History at the University of Chicago. His distinguished research and teaching focuses on the evolution of American culture—high and popular. He has strong interests in the history of the built environment; the social history of art, design, and technology; and the character of art collecting. His most recent book Building Lives *(New Haven: Yale University Press, 1998) examines the social and cultural roles of buildings in the United States.*

Measured by almost any quantitative criterion, the American art museum stands at a historic peak of institutional power and prominence. Rising attendance figures, growing collections, building expansions, renovations, new foundations, busy home pages, interactive display systems, enlarged memberships, enormous endowment campaigns, splendid gifts, and continuous press coverage all testify to a handsomely enhanced status within American cultural, social, and economic life. "Fueled by a powerful national economy and aided by management policies put into effect over the past decade, museum growth appears, by some indices, to be a verifiable `boom,'" declares a recent article in Museum News. "There's an explosion," agrees one Philadelphia museum director, who is quoted in the same article.[1] Business leaders, politicians, and newspaper editorials alike honor the museum as a force in the health of local economies and as a source for social integration.[2] Merchandisers acknowledge the energy of museum product management and promotion, particularly the tactics associated with special exhibitions.[3] Scholars have become frequent and energetic contributors to an eruption of symposia, lecture series, texts, and catalogs sponsored by museums and heavily subsidized by them. Foundations and corporate sponsors systematically underwrite ambitious exhibition programs. And activists praise museums as exemplars of the special American system of cultural philanthropy, blending tax-subsidized private giving with shifting levels of public support, which

This essay is a condensed version of an article that included historical background. The original article is available in "The Divided House of the American Art Museum," *Daedalus* 128, no. 3 (Summer 1999), 33–56. Condensed and reprinted by permission of the author.

serve variously to support existing needs or energize new departures. Even current controversies, exciting so much media attention, demonstrate the newsworthy status of American museums. . . .

With gains, of course, come costs. And critiques. Criticism of museums . . . is not new. The size, wealth, internal arrangements, and architecture of museums, as well as the inherent decontextualization of museum exhibits, had attracted hostility in the nineteenth century and certainly in the early twentieth century. The gargantuan temples of the early twentieth century were labeled by some critics "dignified disasters"; their organization of exhibits resembled nothing more than a "Minotaur's labyrinth," ran one, not atypical, complaint; museum policies were condemned as socially aloof and indifferent.[4] Some educators fumed about museum failures to acknowledge contemporary needs and interests, while others condemned large-scale collecting as the poisoned fruit of capitalism.

But such charges, however numerous, were embedded within a broadly positive set of endorsements. The museum, in theory at least, seemed to epitomize the best of civilization. Reflecting high standards of scholarship or connoisseurship, selfless giving, and a democratic interest in self-improvement, it apparently transcended political and social divisiveness. The criticism of the last few decades has been far more fundamental.

Accompanying the dizzying rise of museums in public awareness have been a series of challenges, some mounted by scholars, some by museum administrators and curators, some by members of the public, and some by competitors. Collecting policies, exhibition planning, governance, financing, institutional arrangements, hours of opening, fee charging, commercial exploitation, interpretive stances, even cultural legitimacy itself have stimulated assaults. They have not necessarily been consistent. Museums have been labeled racist, revisionist, hegemonic, elitist, politically correct, mercenary, greedy, and self-serving. Responding to their growing sets of critics, many American museums sound a defensive note rather than basking in their growing influence. . . .

Have [introspection and criticism changed art museums]? From the standpoint of governance and maybe even of staffing, perhaps not all that much, despite the recent boom and growth in size. But in many other ways they have changed quite a lot. American museums today, building on the last several decades, claim new and unprecedented levels of support as well as increased attendance and a great number of user-friendly programs. They are active suitors of new audiences, they partner with a variety of civic and cultural organizations, they welcome gifts and exhibitions of classes of objects they once dismissed as irrelevant or unimportant, they tackle themes that are socially relevant and court controversy, and they promote and merchandise themselves with impressive aggressiveness. They seem unashamed of their mimicry of business corporations and willing to experiment with aggressive systems of outreach. Who or what has been responsible for these shifts? And what difference have they made to the museum as a social institution?

It is difficult to know precisely when to date the reinvention of the American museum or where to locate its shift toward active audience development. But signs of awareness can be found even in the 1950s and early 1960s that the stable serenity of the museum world could not go on forever.

One source for all this was economic. . . . Financial pressures spawned a number of effects. . . . [including] a turn to government, at every level—local, state, and federal—for increased support. . . . But museum financial [needs] were affected only marginally by public subsidies. More fundamental was the need to create larger constituencies of supporters and to increase revenues through increased attendance and the sale of goods and services. . . .

. . . As museums coped with larger crowds and as the consumer market grew in scale and ambition, there came a realization that the [museum] shop could become a major source of profit. Books, catalogs, articles of clothing, reproduced antiques, sometimes actual antiques, craft objects, greeting cards, jewelry, clothing accessories, and novelties of all kinds (many, but not all, based on museum collections, but not necessarily on the host museum's collection) filled the shelves of these stores and, in time, the pages of mail-order catalogs.[5] The museum visit became part of a larger buying experience. In fact, many museum stores were strategically located so that visitors could patronize them without actually entering the museum. So active would museum stores become over the next few decades that their tax-exempt status, [especially] in satellite sites, became the subject of special inquiries.

That museums could become shopping destinations, dependent upon patronage, not only in stores but in restaurants and cafeterias as well, meant they would need to develop exhibition strategies to support the visitor numbers these services required for effectiveness. The string of blockbusters in the 1970s and 1980s included shows featuring the art of ancient Egypt, Vatican collections, gold from the Caucasus, and Impressionist masters. These became news stories and media events because of the unprecedented crowds they attracted. Blockbusters brought in new members (at least for a time) and new visitors, and some of them soon attracted corporate sponsorship as well. In their quest for support, museums had begun to court large corporations and their foundations, which found exhibition patronage to be a powerful instrument of beneficent publicity. Some museum officials worried that blockbusters eclipsed the museum's more ordinary functions (and permanent collections), overemphasized the value of large numbers, consumed far too much revenue and staff time, degraded the viewing experience with uncomfortable and inappropriate crowding, and set institutions on boom-or-bust cycles. But the publicity, the income, and the sense of serving a public far larger than the museum's customary constituencies proved too enticing to be resisted most of the time. Museum facades began to resemble movie theater marquees, more and more of them now sporting banners that proclaimed current temporary exhibitions. Because of their limited durations, such exhibitions ensured, as certainly as theaters did with their changing programs, returning patrons eager to see the next show. . . .

By the 1990s some museum shows had achieved the complex planning levels of major trade fairs, with tie-ins to hotels, restaurants, railroads, and airplane systems; they yielded impressive benefits to local businesses and municipal tax revenues. They were also graphic evidence of the museum's involvement with the larger life of the community. It was difficult to charge museums with standoffishness and withdrawal when hundreds of thousands of visitors would make their way, in just a few weeks, to particular cities simply because of their interest in a museum exhibition. In some cities, museums seemed more significant than professional sports franchises, or at least more lucrative. The income generated by very popular shows served to subsidize, of course, more scholarly, specialized, or recondite exhibitions that otherwise would have been difficult to support. . . .

What could not be denied, . . . were the gains of energy, drama, excitement, newsworthiness, prestige, and membership (not always a permanent gain) that blockbuster shows added to their host museums. And this, in turn, strengthened the credentials of museums as they applied to governments for further support. . . .

[Nevertheless] charges of elitism, of catering to wealthy, well-educated audiences with attractions subsidized by public money, continued to attract the attention of critics and newspaper editorialists, determined to put a halt to federal funding. On the other hand, often coming from the same mouths, were complaints about crass commercialism, philistine exploitation of artistic masterpieces, vulgarity, Disney-like imitations, technological hype, and concentration upon the bottom line. Museum directors could legitimately claim bewilderment at being told, simultaneously, to avoid the public trough and stand on their own two feet, but not to resemble too closely the commercial world that, after all, had to show a profit.

But ballyhoo and elitism are far from exhausting the list of current challenges. Controversial shows—on art, history, and science alike—have, while testifying to museum willingness to confront social relevance, also stimulated attacks and efforts to distinguish the museum from the school or university, as a site not for contesting and debating truth but one that more appropriately celebrates consensual values. While not a universal view by any means, the notion that exhibitions are more difficult to argue with than lectures or written texts is a popular one. If museum displays are by nature more authoritarian than the printed page, and if their visitation is more heterogeneous and more vulnerable than the classroom, some critics see all the more reason for them to rise above the vortex of scholarly interpretation and stick to clearly established facts, whatever their limitation.[6]

Still others challenge museums on issues of ownership and possession. Newspaper exposés paint respected institutions as complicit abettors of a series of crimes: theft, smuggling, and expropriation of property among them. Whether accused of the purchase or acceptance of classical antiquities with dubious provenance, the display of treasures smuggled out of Latin America or

Southeast Asia, or the presentation of art expropriated from its rightful owners by Nazi officials, museums are forced to defend both their policies and their integrity and to investigate more effectively the provenance of everything they own or exhibit.

There are some who take a different line, attacking museums for taking the path of least resistance in their quest for attention, abjectly obeying the elaborate surveys and planning strategies that are designed to increase attendance, funding, and popularity. Instead of setting standards, they assert, museums are responding to them, dumbing down exhibits and labels, relying upon elaborate (and expensive) orientation films, audio tours, and interactive terminals—anything to avoid concentrating upon the fundamental if difficult experience of confronting objects on their own. The expanded educational staffs, the elaborate school and family programs, the broad range of social activities intended to market the museum to new audiences, all have aroused the scorn of purists who accuse museums of becoming therapy centers or adopting the techniques of Disney, Nike, and Universal Studios.[7]

Actually, of course, these are among the museum's competitors for patronage and attention, particularly among the young. Even while museums have gained so impressively in size, numbers, and influence during the past three decades, their growth has been dwarfed by the explosive advance of entertainment, destination marketing, theme parks, professional sports, and other recreational outlets. The fact that the boundaries separating museums from commerce, hospitality, and entertainment institutions are more porous today merely reflects the pervasive presence of these powerful forces that do indeed shape expectations for exhibitry.

There are grounds for wondering, then, just how significant a cultural and social force museums have become. The rhetoric of both their promoters and their critics suggests levels of influence and power that they may not possess. The exaggerated tirades of an earlier day, created by those who persistently labeled museums morgues, mausoleums, charnel houses, and institutions dead to the world around them, are complemented by contemporary assignments of responsibility for sustaining the class structure, spreading racism, and protecting the canonized narratives of Western civilization. Only the university rivals the museum among contemporary institutions in its simultaneous position of prestige and vulnerability to criticism. But the university, unlike the museum, gives credentials to its consumers and shapes their careers as well as their values.

What are we to make, then, of the position of museums in modern American life? Do they shape anyone's values, validate anyone's identity, impose any lasting sort of order? Their significance is clear for scholars, students, connoisseurs, and enthusiasts. But for most ordinary visitors, has the American museum shed its traditional functions of yielding pleasure, diversion, and status? Does it continue to store and highlight broadly valued objects? How are we to measure the impact of the museum experience, or even to talk about

so diverse a universe of institutions in any categorical way? Something has happened, these last thirty years particularly, but just what that is remains unclear. Finding that out will continue to defy our patience, our energy, and, above all, our ingenuity.

NOTES

[1] As quoted in Jane Lusaka and John Strand, "The Boom—And What To Do About It," *Museum News* 77 (November/December 1998): 57. The article brings together some of the statistical support for the notion of a "Golden Age" of museums.

[2] See, for example, the series of articles published in a special section of *The New York Times* ("Museums," *New York Times*, 21 April 1999) for evidence of the art museum's transforming urban influence.

[3] Among a raft of recent analyses see Julie Connelly, "The Impressionists Sure Move the Merchandise," *New York Times*, 21 April 1999, D2.

[4] For such critiques, some from inside the art-museum community, see Henry W. Kent, "Museums of Art," *Architectural Forum* 47 (December 1927): 584; Fiske Kimball, "Museum Values," *American Magazine of Art* 19 (September 1928): 480; and Forest H. Cooke, "Culture and Fatigue: Some Reflections on Museums," *Century* 111 (January 1926): 291–296.

[5] For an amusing and often ironic examination of the museum store and its authority see the essays, illustrations, and glossary in Gottfried Fliedl, Ulrich Giersch, Martin Sturm, and Rainer Zendron, eds., *Wa(h)re Kunst: Der Museumshop als Wunderkammner. Theoretische Objete, Fakes und Souvenirs, Werkbund-Arcbiv*, Bd. 26 (1997).

[6] For an extended critique of one contemporary museum's effort to deliver and package the facts, see Richard Handler and Eric Gable, *The New History in an Old Museum: Creating the Past at Colonial Williamsburg* (Durham and London: Duke University Press, 1997).

[7] The "biggest problem facing art museums today" is the "emerging `consensus,' among politicians, community activities, funding sources, and engaged academics that the art museum is first and foremost a social institution, an active educational center with a mandate to encourage therapeutic social perspectives for learning about and appreciating the visual arts." James Cuno, "Money, Power and the History of Art," *Art Bulletin* 79 (March 1997): 7.

CHAPTER 21

Culture Wars and the Canon

Over the past two decades multicultural studies have become prominent components of college and university curricula. To conservative critics, such as Dinesh D'Souza, this recent focus on diversity is actually about "political correctness" and comes at the cost of "students not knowing the rudiments of their own culture." D'Souza suggests romanticization—even manipulation—in the way "other" cultures are taught.

D'Souza and his fellow cultural conservatives assume the best achievements of Western culture—the "rudiments" that every well-educated person should know something about—are pretty obvious. They are works of literature, art, music, philosophy, and politics and "have stood the test of time." Gill Perry explains this idea of "indisputable quality"—the "canon"—as it applies to art, and introduces some of the questions implicit in this concept.

To Lucy Lippard the traditional canons of Western culture are based on narrow, elitist notions of quality and have been the tools for ethnocentric exclusion. Although recognizing that the art of "other cultures" will challenge conventional ideas of aesthetic quality, Lippard argues that these changes are almost inevitable in our increasingly diverse society.

In our age of rapid demographic changes and increasing globalization, what is important for students to learn, their own heritage or that of other cultures?

The Multicultural Challenge

DINESH D'SOUZA

Dinesh D'Souza is a research fellow at the American Enterprise Institute for Public Policy Research, a conservative think tank in Washington, D.C. He is the author of the 1991 controversial bestseller, Illiberal Education: The Politics of Race and Sex on Campus *(New York: The Free Press, 1991). His most recent books include a biography of Ronald Reagan,* Ronald Reagan *(New York: Simon & Schuster, 1997) and* The Virtue of Prosperity: Finding Values in an Age of Techno-Affluence *(New York: Free Press, 2000). His articles on culture and politics have appeared in* Harper's, Vanity Fair, The Wall Street Journal, The New York Times *and other periodicals.*

I must plead guilty to being an American. I am not a native American—I am in fact an Indian American, not to be confused with an American Indian—I can see why poor Columbus was mixed up on all of this. Before I began my research on colleges and universities, I was the campus renegade, an editor of the infamous *Dartmouth Review,* which has been involved in a kind of tenure skirmish with the university administration. Tonight, however, I would like to address a great debate that has erupted on the American campus. It is a debate that goes by many names that will be familiar to you. Most often the debate is described with the words "pluralism," "multiculturalism" or "diversity." I would like to focus on the debate on the curriculum. Probably that is the most germane aspect of the university crisis.

What Students Do Not Know

The debate about multiculturalism and the curriculum erupted a few years ago with the publication of Allan Bloom's book *The Closing of the American Mind* and E.D. Hirsch's book *Cultural Literacy.* The theme of these books was very simple: young people are graduating from our best colleges and universities, private and public, and they are not well versed in the basic ingredients of Western civilization. They do not know the rudiments of their own culture, their own history, their own literature and so on. Critics of Bloom and Hirsch argue that it is not enough to know Western civilization, it is equally important

Dinesh D'Souza, "The Multicultural Challenge," *Vision and Values* 3, no. 3 (September 1995), 1–7. Reprinted by permission of Grove City College, Grove City, PA.

(if not more important) for young people to know non-Western cultures as well. It is not enough to know Plato's *Republic;* one must also know the *Koran.*

The debate as it developed became a somewhat disappointing exercise because it is impossible to adjudicate the competing claims of two books like the *Republic* and the *Koran.* They are books of radically different social, religious, political and cultural contexts. How can one possibly compare them? Of course, the real problem in our universities, a problem endemic in the United States, is that a lot of our young students are graduating having read **neither** Plato nor the *Koran.* There is a dismal ignorance of both Western and non-Western culture.

A second point that erupted in the Bloom debate was the issue of whether Western civilization was coming to an end. Is it teetering on the edge of an abyss? Now personally, I don't think this is a big problem. Some of you know the question once posed to my countryman Mahatma Gandhi, who was asked, "What do you think of Western civilization?" and he replied, "I think it would be a good idea." Western civilization is here to stay, but there is more serious debate about equity, about standards, about fairness, about quality and about equality.

Multiculturalism at Stanford

A few years ago I spent a lot of time at Stanford University attending courses in the University's much hailed new "multicultural curriculum," which had replaced Stanford's earlier Western civilization requirement. The old requirement emphasized fifteen books from Plato to T.S. Eliot. The new multiculture requirement kept some of these texts but introduced new works as well. I was not interested in criticizing the emphasis on non-Western cultures—Asian or Indian. To try to illustrate how these programs fall into problems in practice, I will describe what I think was going on, something that I think is not unique to Stanford but is in fact a much broader problem.

As I sat in the Stanford classroom I found that the professors were giving a portrait of the non-Western world and of India, in particular, that really bore no resemblance to what I, as a native, knew and experienced growing up there. The Third World was being portrayed inaccurately as part of the Stanford multicultural curriculum. But why?

Many activists on campus who want to modify or change or renovate the curriculum, do so based upon the suspicion that Western culture is irremediably tainted. They say it is a culture that has been historically very oppressive. It has perpetrated institutional racism, sexism and heterosexism, for instance. The argument continues that we have to look to non-Western cultures to broaden our perspective and to perhaps find a better alternative to the bigoted history of the West. Many activists animated by this hope look abroad, to Asia, Africa and Latin America. And what do they find? If they look with some

degree of rigor they find that **non-Western** cultures are quite inhospitable to many of their basic political passions.

Non-Western Cultures—The Problems

First, non-Western cultures have a very poor tradition of racial equality. In India, for example, there is a terrible legacy of the caste system. Second, women are treated very badly in many if not most Third World cultures. I think of such practices as dowry, the veil, women needing permission to drive in Saudi Arabia, the genital mutilation of women in parts of Africa and so on. When I was a student in India we had a proverb that went like this: "I asked a Burmese why after centuries of following their men, the women now walk in front. The reason, he explained, was that since the war there remained many unexploded land mines." The point is that non-Western cultures have a low view of women. Third, homosexuality is a crime or an illness and is so classified in the medical journals of many Third World countries. In summary, cultures do not cooperate when it comes to the racial, the gender, the sexual orientation views or inclinations of the multiculturalists in the West.

Moreover, although non-Western cultures have produced great books and these books can and should be studied, they tend to reflect the ideas, the temper, the ideology, perhaps even the prejudice of non-Western cultures. So, if one looks at a book like the *Koran*, which is clearly the powerful text of one of the world's great religions, it may be found to be very emancipating. Yet, there is no denying that the *Koran* does embody a clear vision of male superiority. The *Tale of Genji*, the great Japanese classic of the 11th century, is a celebration of hierarchy, of ritual, of the aristocratic virtues. It seems to be a rejection of Western egalitarianism. The Indian classics, the *Baghavad Gita*, the *Upanishad*, the *Gitanjali* by Tagore, are a celebration of transcendental virtues. They are a rejection of Western secularism and perhaps even of separation of church and state. The point I am trying to make is that non-Western classics tend to be politically **in**correct. They tend not to ratify the political sympathies of "multiculties," as Tom Wolfe calls them. And so the activists who look for other cultures to demonstrate their agendas are in a dilemma. They ought to criticize non-Western cultures and denounce them for being even more retrograde and bigoted than the West. Of course, this option is politically impossible. As seen by the multiculturalists, these non-Western cultures are victims of imperialism and racism. They have suffered enough.

The prevailing view in the academy is that these cultures do not need criticism or harsh scrutiny; what they do need is celebration or elevation. So justifiable criticism of non-Western cultures is rejected in most of the multicultural approaches. The result is what I sometimes call a "bogus multiculturalism" by which I mean a multiculturalism that does not pay much attention to what non-Western cultures are really like. What one has is a multiculturalism

that tends to view non-Western cultures through the lens of Western political ideology.

And so, at Stanford, at the University of Michigan, at Dartmouth and elsewhere, in a multicultural course, one is much less likely to read the *Analects* of Confucius or the *Upanishad*. It is much more likely that one will read the journals of a Peruvian lesbian. I do not mean, of course, to understate the importance of Peruvian lesbianism as a global theme, but the point is that this is not particularly representative of the experience of Latin America or the Third World. Is this the best that has been thought and said in Latin America? No. What one is getting in effect is an ideology which is less a reflection of non-Western cultures and more a reflection of the politics of Stanford professors—those Stanford professors who are interested in issues of race, gender or sexual orientation.

Creating An Authentic Multicultural Program

What I would like to see is an authentic multiculturalism—a multiculturalism that reflects the best tradition in the West, a tradition of openness to other cultures and a tradition of self-criticism toward Western institutions. Such a curriculum would be fairly easy to establish if colleges had rigorous requirements. But since the 1960s many of our colleges and universities have diluted requirements so that there is very little that all students must take. In this atmosphere of mostly electives, with perhaps only one or two courses that are part of the required general education curriculum, the battle over which books get included in this curriculum becomes extremely bitter and, I might add, extremely political.

Any authentic multicultural curriculum must begin at home. We begin with our own civilization. This is not a unique or ethnocentric point. It is true of any culture. If one met an educated young man from China, a graduate of the University of Beijing, and he said, "I have never heard of Confucius, but I am an expert on Mark Twain," this would be strange. One expects others to know something about their own civilization. The fact is that in the United States young graduates get out of our best colleges and they do not know very much about the American founding. They haven't read *The Federalist Papers*. They have very little familiarity with the texts of the Western tradition. They are innocent of the most basic precepts of the Bible. They do not know much about the Civil War; they haven't read Lincoln's Second Inaugural Address, and they know very little about civil rights movements. Before Spike Lee's movie about Malcolm X, I saw a television clip of a young man from a fine American university who was quoted as saying that he was very excited to encounter the text of the American civil rights experience because he was particularly enthusiastic about the writings of Malcolm the Tenth! So there is this fairly pervasive ignorance that makes multiculturalism to some degree a remedial project.

How can this be remedied? To begin with, our colleges and universities must teach our young people things that the high schools should have taught, but in fact have not. One reason for this failure is that it is difficult to assemble a sensible and rigorous curriculum, because the traditional curriculum is under fierce attack for being biased. It is said to be biased in favor of white males and against everyone else—women, minorities, persons of color, natives of the Third World and so on. This is quite a serious proposition that should be considered for a moment. Is the curriculum, in fact, biased in this notorious way? Let us consider, as an example, the case of Isaac Newton. Newton was a white male. He may have been a heterosexual. But of course none of this has anything to do with the truth of his theory of gravity. It is, in fact, the case that if you jump out of a tall tower in Bombay, you plummet to the ground. My point is simply that the criticism in this case clearly confuses the origins of Newton with the content of his ideas.

Although this is an example from science, by extrapolation one can ask similar questions about other books and other ideas. William Shakespeare was a white male, but so were countless other poets who composed in Elizabethan England. Why do young people read Shakespeare? Why was he considered so great? Was it because a small cabal of white males got together and said he is whiter than any of us or more masculine? Clearly, Shakespeare's appeal is a result of his sonnets and plays which are profound enough to make his work surpass that of other lesser works.

What we are moving toward in the curriculum, in some places more than others, is a kind of weird cultural Olympics, in which every group is approaching the reading list and asking the question, "What did my guys do?" Now this is a strange question. Why? Because it contains a very strong assumption that books and ideas and knowledge and entire civilizations which existed hundreds if not thousands of years ago, are now the exclusive ethnic property of small groups of individuals who happen to be living today. In other words, there is a sense in which knowledge is now subject to an ethnic patent. It is almost as though young white guys get up in the morning and have a big smile on their face when they look in the mirror because Homer wrote the *Iliad*. This strange concept is that knowledge, in some sense, belongs to particular groups. This is alien to, or hostile to, the very basic principle of liberal learning, a principle that, as I understand it, is not based upon freezing ideas and knowledge into race and class and gender categories, but upon exploring ways in which we can emancipate ourselves from this provincialism.

Liberal education involves a lot of navigating across these boundaries of race, class and culture. It is a search for a universal point of view, however elusive, from which we can gain a critical perspective on both the past and the present, on both our culture and on other cultures as well. For example, suppose I decide to take as my inspiration, my role model, Martin Luther King, even though he was a black man, an African American. So what? Martin Luther King got many of his ideas from my countryman, Gandhi. Gandhi got

some of his ideas in England and in South Africa in a tradition of nonvio-
lence and civil disobedience. Some of those ideas about civil disobedience
had their roots in Thoreau. So liberal education, if you will, is about making
empathetic crossings of cultural frontiers. It is an effort to learn from others
who are not like us.

The Triumph of the West

Now this debate comes at a unique moment in history. If one looks at the
world map a hundred years ago, virtually the entire globe was under the
physical supervision of the West. The twentieth century was supposed to be
different; it was supposed to be the era of decolonization, the shrinking of
Western power, the emergence of non-Western power—and so it has been.
But as we come to the end of the twentieth century a kind of strange reversal
is occurring. For most of the century, non-Western cultures gained their free-
dom animated by understandable hostility to the West, a hostility based on a
long history of colonialism and racism. Non-Western cultures have said: "We
cannot embrace the West; we must find another way," and some of them
looked to Marxism, to the Soviet and the Chinese experiments. Most non-
Western cultures have not embraced communism; they have looked to what
they call the third way or the nonaligned movement, an effort to find some
middle ground or third path that would avoid the excesses of both socialism
and capitalism.

The fact is that as we come to the end of the century, we encounter a cata-
clysm, a surprise. What we see is the sudden implosion and collapse of com-
munism and Marxism—the virtual discrediting of socialism as an ideology.
Suddenly it appears that there is no alternative to what I would call a West-
ern, liberal, constitutional, entrepreneurial, democratic system. There are a
few pockets of bellicose resistance—Islamic fundamentalism, perhaps Aus-
tralian aboriginalism—but the fact is that we are all Westerners now. This has
created an enormous intellectual dilemma for a whole generation of Western
progressive intellectuals and Third World intellectuals who have found it im-
possible to embrace the West and yet who now find themselves in a position
in which there seems to be no alternative to the West.

Challenge to Teachers

For professors in particular I think the challenge is one of standing against
the tide, because there is a strong tide. Young people and students are in a
very poor position to resist the tide because they are vulnerable. But for pro-
fessors who do have some position of strength, there is a moral responsibil-
ity to attempt to liberate this debate from its orthodoxies.

Now I realize that this is a very difficult enterprise. A lot of times when I speak on campuses professors will say to me, "Well, it is all very well for you to say all this. The fact is that you are not a white male, and none of what you have said here this evening could we have said." This is true, and to some degree it reflects the enormously rigid quality of the political debate on race and culture. There is a sense in which whites and white males are morally excommunicated from articulating their views. That in itself is unhealthy. But my counsel is one of encouraging a kind of imaginative subversion, a sort of Socratic puncturing of the existing accepted ideas through a kind of wry questioning that has to deconstruct some of these taboos. We might remember, in conclusion, the words of that dead, white male, Robert Frost, who said, "Two roads diverged in the wood and I, I took the one less travelled by, and that has made all the difference."

What Is the Canon?

GILL PERRY

Gill Perry is a Senior Lecturer in Art History at the Open University in Great Britain. She was co-author of the third in the Open University's series about modern art and its interpretation: Primitivism, Cubism, Abstraction: The Early Twentieth Century *(New Haven: Yale University Press, 1993). She is the editor of* Gender and Art *(New Haven: Yale University Press, 1999), the third in their new series of six books,* Art and its Histories. *She is also the author of* Women Artists and the Parisian Avant-Garde *(Manchester, U.K.: Manchester University Press, 1995).*

Many art historians have offered definitions of what `art' means. Although as a group we are, of course, concerned with the visual arts (as distinct from other arts such as music, drama and literature), no lasting consensus has been reached. I am not seeking to resolve an issue which has been endlessly debated by art historians, art critics and philosophers over the last few centuries. I want rather to map out some different approaches to the problem in order

Excerpted from Gill Perry and Colin Cunningham, *Academies, Museums and Canons of Art* (New Haven, CT: Yale University Press, 1999), 12–17. Copyright © The Open University. Reprinted by permission of the publisher.

to explore the close but complex relationship which has existed between concepts of `art' and the idea of a `canon' of art.

Perhaps the narrowest definition of art, which was certainly in circulation in western societies during the eighteenth and nineteenth centuries, describes works which are perceived to be `great' or aesthetically superior to other artefacts produced by society. This attribute of `greatness' is fundamental to the idea of the canon. . . .

The word `canon' derives from the Greek for rule or measuring stick. At its simplest it merely means `the standard' by which something may be measured. This is to leave open precisely what attributes (for example, size, beauty?) are being measured—an ambiguity that this book goes on to examine. However, some eighteenth and nineteenth-century conceptions of art suggested an appropriate measure should be its `aesthetic value', sometimes called its `quality'.

The word canon, as it is used today with reference to works of art, builds on these two ideas of `aesthetic value' and `one standard'. When people speak of `the canon of art', they usually mean a body of works that have passed a (rather ambiguous) test of value. Despite its inherent ambiguity, the idea of a canon has assumed the air of spurious precision: it has come to mean a body of works deemed to be of indisputable quality within a particular culture or influential subculture. Only a few of those works classed as `art' within a society are generally perceived to make up a revered canon. For example, some paintings may be seen to be indisputably works of art though judged by a majority to be of mediocre quality. In this case they are unlikely to be defined as `canonical' in the sense of setting the standard of what a particular culture is going to view as `great' art [Figure 29].

There are two additional points of definition here; . . . First, there are changes over time to, and disagreements at any one time about, the list of great works. Second, in order to acknowledge the shifting nature of the canon, art historians tend to qualify their references to it. Thus we find `the modern canon', `the canon of high art' or `the academic canon'. Such distinctions register the view that there are in fact a variety of canons and not one monolithic `canon of great art'. . . . [W]hen we talk of `the canon of western art', we are referring rather loosely to an evolving body of works and names in the history of western art rather than to a single, unchanging list.

. . . [P]owerful cultural institutions in Britain and France sought to affirm and buttress canonical status for works of so-called high art. . . . [T]his notion originated in western academic theory[1] when it was used to separate the idea of a higher or more elevated practice of art (usually painting and sculpture) from the so-called lesser arts such as the decorative arts, applied design, crafts and popular art. Building on this concept of high art, some art historians have identified a `great' western tradition of art from (to take a few examples) the sculpture of Greek and Roman antiquity through to Italian Renaissance masters such as Michelangelo and Leonardo da Vinci, sixteenth-century northern

Figure 29. Jack Ziegler, "One Week Only! The 100 Greatest Paintings of All Time." © 2000 The New Yorker Collection from cartoonbank.com. All Rights Reserved.

`masters' such as Rembrandt, and seventeen century French classicists[2] like Poussin. The nineteenth and twentieth centuries witnessed the emergence of a so-called modern canon of the French Impressionists through to artists such as Cézanne, Picasso, Matisse and others more recent. The fame of these artists, often referred to as `masters' (there are few `mistresses' among them!), rests on knowledge of an *oeuvre* (an artist's body of work) that has been researched and constructed by scholars using the techniques of connoisseurship. . . .

But these are just a few of many names which we could single out on the grounds of enduring popularity and continuing economic and aesthetic value which their works are seen to hold. In selecting certain names to represent a tradition of `great' art, we are assuming that there is broad agreement within our culture on issues of aesthetic value, that there is a shared attribute of `greatness' which defines and distinguishes certain works from other forms of art. However, as soon as we start to examine the reasons for each artist's inclusion in this canonical list, we find that too tight a definition begs more questions than it answers. If we look closely at the work of artists with enduring status as `great', we will find that there are many inconsistencies in terms of the criteria for inclusion. For example, while Poussin's canonical status is often largely attributed to his classicism, Rembrandt's appeal seems to have been based on very different values: his tendency to break with some of the conventions of western art, and the relative informality and psychological insights of his portraits. Moreover, many of the works that we now identify as belonging to a modern canon of the late nineteenth and early twentieth centuries were certainly not universally admired when they were first exhibited. It is now part of the mythology of modern art history that artists such as Monet and Picasso suffered negative criticism and poverty during their early careers. . . .

While the practices of connoisseurship have tended to assume the existence of a tradition of `great' art, more recent forms of art history have questioned the principles upon which dominant notions of `great' art are based. Many exponents of what we loosely label `the new art history' have asked questions about the ideological sources of cultural and aesthetic values. They have asked questions such as: who decides which artists and works of art will be more highly valued than others? What political, economic or historical factors might govern those decisions?

Influenced by these debates, some art historians working today employ a broad concept of `the visual arts' which includes a range of art forms and artefacts we perceive with (and are made to be perceived by) our visual sense. These may include objects varying from painting, sculpture and architecture through to graphic art, applied design, the decorative arts, film, advertisements, photography and so on. It has also been argued that a broader understanding of the label `art' enables study of visual artefacts from a range of cultures. The canonical traditions of `great' art which are explored and analysed in this book are specific to western culture, and are founded on values and

beliefs which form the cultural, philosophical, political and religious basis of that culture. Many of those values are not easily adapted to analyse or understand the visual artefacts of non-western societies founded on different cultural and aesthetic principles. As students of western art history, the criteria we apply in an analysis of, for example, a painting by Poussin will probably not provide many clues as to the religious, ritualistic or aesthetic meanings of a work of Australian Aboriginal art. . . .

. . . [T]he values which have underpinned the establishment and evolution of the western canon . . . have increasingly been opened up to scrutiny, yet certain works seem to continue to engage the interest of the public and to sustain some kind of reputation as `great' art (although the grounds for this may vary). Artists such as Leonardo da Vinci or Picasso (to take only two examples) continue to attract volumes of academic and popular publications, and their exhibitions continue to draw huge crowds. Clearly the reasons for their appeal are complex, and will depend at least partly on the decisions and preferences of exhibition organizers, museum curators, publishers, publicists and so on. But does the continuing popularity of such works reveal that the western cultural tradition merely reproduces its own value systems? In other words, are our criteria of judgement ultimately determined by a political and social culture from which we cannot escape? Can art have some kind of relative autonomy from the cultural context within which it was produced? Can some art works generate critical debate and reflection which actually help to sustain their value through history as objects to be enjoyed or engaged with? These are difficult and open questions which have been much debated by art historians during recent years. . . .

We have seen that the methods by which art should be interpreted and the boundaries of the field of art itself are subjects of on-going debate. And one of the key concerns of more recent approaches to art history has been a questioning of the received canon of western art. . . . [T]he notion of a canon is in fact variable and contested, and may imply quite different values within different cultures. A canon is never a closed system.

NOTES

[1] Academic theory refers to the ideas promulgated by academies of art in Italy, France and Britain. . . .

[2] Classicists followed the art and architecture of Greek and Roman antiquity and conformed to its models. . . . [T]he introduction to this book briefly explains the importance of the classical tradition to the western canon. Part I explores how the values underpinning the classical tradition changed when confronted with new discoveries in ancient art.

Mapping

LUCY LIPPARD

Lucy R. Lippard is a prominent writer and pioneer in feminist and multicultural art criticism. She has written fourteen books on contemporary art and artists as well as numerous articles. She has organized and curated over forty exhibitions around the world. Lippard is a contributing editor to Art in America *and writes a column on art and politics for* Z *magazine. She is on the board of the Center for Constitutional Rights. Her most recent books,* The Lure of the Local: Senses of Place in a Multicentered Sociey *(New York: New Press, 1997) and* On the Beaten Track: Tourism, Art and Place *(New York: New Press, 1999), expand her approach to art to include the experience of environments.*

. . . This is a time of tantalizing openness to (and sometimes untrustworthy enthusiasms about) "multiculturalism." The context does not exist for a nice, seamless narrative and probably never will. I can't force a coherence that I don't experience, and I write with the relational, unfixed feminist models of art always in the back of my mind. As the East Indian scholar Kumkum Sangari has observed, we are now "poised in a liminal space and an in-between time, which, having broken out of the binary opposition between circular and linear, gives a third space and a different time the chance to emerge."[1] I write in what white ethnographer James Clifford has called "that moment in which the possibility of comparison exists in unmediated tension with sheer incongruity . . . a permanent ironic play of similarity and difference, the familiar and the strange, the here and the elsewhere"; and I have tried, as he suggests, not to "explain away those elements in the foreign culture that render the investigator's own culture newly incomprehensible."[2]

I have followed the lead of Henry Louis Gates, Jr., and others in putting the term "race" in actual or implied quotation marks, with the understanding that this is a historical rather than a scientific construct. Race is still commonly used when culture is meant, to connote, as Gates observes, some unspecific essence or feeling, the "ultimate, irreducible difference between cultures, linguistic groups, or adherents of specific belief systems which—more often than not—also have fundamentally opposed economic interests." Although arbitrary and biologically unsupportable, it is carelessly used "in such a way as

Excerpted from Lucy R. Lippard, "Mapping," Introduction to *Mixed Blessings: New Art in a Multicultural America* (New York: The New Press, 1990), 3–17. Reprinted by permission of the author.

to *will* this sense of *natural* difference into our formulations. To do so is to engage in a pernicious act of difference, one which exacerbates the complex problem of cultural or ethnic difference, rather than to assuage or redress it."[3] The word "racism," alas, describes a social phenomenon that is less questionable.

The fact that almost all of the artists whose work is discussed here are people of color, or "mixed race," is, however, no coincidence. Without minimizing the economic and psychological toll of racism in this country, and without exaggerating the strengths that have resulted in survival, it is still possible to recognize the depth of African, Native American, Asian, and Latino cultural contributions to an increasingly confused, shallow, and homogenized Euro-American society. The exclusion of those cultures from the social centers of this country is another mixed blessing. Drawn to the illusory warmth of the melting pot, and then rejected from it, they have frequently developed or offered sanctuary to ideas, images, and values that otherwise would have been swept away in the mainstream.

It is only recently that the ways different cultures cross and fail to cross in the United States have come under scrutiny. More or less taken for granted for two hundred years, the concept of the monotone meltdown pot, which assumed that everyone would end up white, is giving way to a salad, or an *ajiaco*—the flavorful mix of a Latin American soup in which the ingredients retain their own forms and flavors.[4] This model is fresher and healthier; the colors are varied; the taste is often unfamiliar. The recipe calls for an underdetermined simmering period of social acclimation.

Demographics alone demand that a society change as its cultural makeup changes. But the contemporary artworld, a somewhat rebellious satellite of the dominant culture, is better equipped to swallow cross-cultural influences than to savor them. Its presumed inventiveness occurs mainly within given formal and contextual parameters determined by those who control the markets and institutions. It is not known for awareness of or flexibility in relation to the world outside its white-walled rooms. African American and Latino American artists have been waiting in the wings since the '60s, when political movements nurtured a new cultural consciousness. Only in the '80s have they been invited again, provisionally, to say their pieces on a national stage. In the early '80s the presence of Asian Americans as artists was acknowledged, although they too had been organizing since the early '70s. Ironically, the last to receive commercial and institutional attention in the urban artworlds have been the "first Americans," whose land and art have both been colonized and excluded from the realms of "high art," despite their cultures' profound contributions to it.

The boundaries being tested today by dialogue are not just "racial" and national. They are also those of gender and class, of value and belief systems, of religion and politics. The borderlands are porous, restless, often incoherent territory, virtual minefields of unknowns for both practitioners and theoreticians. Cross-cultural, cross-class, cross-gender relations are strained, to say

the least, in a country that sometimes acknowledges its overt racism and sexism, but cannot confront the underlying xenophobia—fear of the other—that causes them. Participation in the cross-cultural process, from all sides, can be painful and exhilarating. I get impatient. A friend says: remember, change is a process, not an event.

Affirmation of diversity does not automatically bring happy endings. Many of the artists in this book, like their colleagues in the fields of literature, music, theater, and cinema, make art that is profoundly critical of the host society. They often refuse not only the images and the values imposed on them, but also the limitations of a "high art" that disallows communication among certain mediums and contexts. . . .

Ethnocentrism in the arts is balanced on a notion of Quality that "transcends boundaries"—and is identifiable only by those in power. According to this lofty view, racism has nothing to do with art; Quality will prevail; so-called minorities just haven't got it yet. The notion of Quality has been the most effective bludgeon on the side of homogeneity in the modernist and postmodernist periods, despite twenty-five years of attempted revisionism. The conventional notion of good taste with which many of us were raised and educated was based on an illusion of social order that is no longer possible (or desirable) to believe in. We now look at art within the context of disorder—a far more difficult task than following institutionalized regulations. Time and again, artists of color and women determined to revise the notion of Quality into something more open, with more integrity, have been fended off from the mainstream strongholds by this garlic-and-cross strategy. Time and again I have been asked, after lecturing about this material, "But you can't really think this is Quality?" Such sheeplike fidelity to a single criterion for good art—and such ignorant resistance to the fact that criteria can differ hugely among classes, cultures, even genders—remains firmly embedded in educational and artistic circles, producing audiences who are afraid to think for themselves. As African American artist Adrian Piper explains:

> Cultural racism is damaging and virulent because it hits its victims in particularly vulnerable and private places: their preferences, tastes, modes of self-expression, and self-image. . . . When cultural racism succeeds in making its victims suppress, denigrate, or reject these means of cultural self-affirmation [the solace people find in entertainment, self-expression, intimacy, mutual support, and cultural solidarity], it makes its victims hate themselves.[5]

One's own lived experience, respectfully related to that of others, remains for me the best foundation for social vision, of which art is a significant part. Personal associations, education, political and environmental contexts, class and ethnic backgrounds, value systems and market values, all exert their pressures on the interaction between eye, mind, and image. In fact, cross-cultural perception demands the repudiation of many unquestioned, socially received criteria and the exhumation of truly "personal" tastes. It is not easy to get people

to think for themselves when it comes to art because the field has become mystified to the point where many people doubt and are even embarrassed by their own responses; artists themselves have become separated from their audiences and controlled by the values of those who buy their work. Art in this country belongs to and is controlled by a specific group of people. This is not to say that there isn't art being made and loved by other people, but it has not been consecrated by a touch of the Quality wand; many of those whose tastes or work differ from mainstream criteria are either unaware of their difference or don't dare argue with the "experts"; others, who devote themselves to dissent, remain largely unheard due to official and self censorship.

One of the major obstacles to equal exposure is the liberal and conservative taboo against any and all "political" statements in art, often exacerbated by ignorance of and indifference to any other cultural background or context. Sometimes there is a condescending amazement that powerful work can actually come from "foreign" sources. Good or competent mainstream art by people of color is often greeted either with silence or with cries of exaggerated pleasure: "Well, what do you know, here's art by an Asian (or African or Latino or Native) American that doesn't fit our stereotypes!" (or the low expectations held for it). The dominant culture responds like condescending parents whose children have surprised them, affording a glimpse of the darker facets of future separation and competition. . . .

Recent cracks in the bastions of high culture now allow a certain seepage, the trickle-up presence of a different kind of authenticity that is for the moment fundamentally unfamiliar and therefore genuinely disturbing. Advocates of cultural democracy, of respect for differences and a wider definition of art, are often taunted with the specter of "the lowest common denominator." But art does not become "worse" as it spreads out and becomes accessible to more people. In fact, the real low ground lies in the falsely beneficent notion of a "universal" art that smoothes over all rough edges, all differences, but remains detached from the lives of most people. The surprises lie along the bumpy, curving side roads, bypassing highways so straight and so fast that we can't see where we are or where we are going. Bruce Chatwin tells the story of an Australian aboriginal man trying desperately to "sing" or pay homage to the individual features of the land he is driven through by truck at such a speed that both sight and song are blurred beyond recognition.[6]

Modernism opened art up to a broad variety of materials and techniques as well as cultures. Nevertheless, knowledge of one's sources, respect for the symbols, acts, or materials sacred to others cannot be separated from the artistic process, which is—or should be—a process of *consciousness*. Well-meaning white artists and writers who think we are ultra-sensitive often idealize and romanticize indigenous cultures on one hand, or force them into a Western hegemonic analysis on the other hand. And while it is difficult *not* to be moved by the antimaterialism, spirituality, formal successes, and principled communal values of much traditional art, there is no "proper" or "politically correct"

response by white artists that does not leave something out. But there is a difference between homage and robbery, between mutual exchange and rape. I am not suggesting that every European and Euro-American artist influenced by the power of cultures other than their own should be overwhelmed with guilt at every touch. But a certain humility, an awareness of other cultures' boundaries and contexts, wouldn't hurt. Not to mention a certain tolerance of those with different concerns. As white Australians Tony Fry and Anne-Marie Willis note:

> The so-called cultural relativism of the First-World art world that encourages difference is in reality a type of ethnocentrism, for while the value system of the other is acknowledged as different, it is never allowed to function in a way that would challenge the dominant culture's values. . . . difference is constructed almost exclusively on a binary model and is therefore bound up with the West's internal dialogues and is a manifestation of its crises and anxieties.[7]

Among the pitfalls of writing about art made by those with different cultural backgrounds is the temptation to fix our gaze solely on the familiarities and the unfamiliarities, on the neutral and the exotic, rather than on the area in between—that fertile, liminal ground where new meanings germinate and where common experiences in different contexts can provoke new bonds. The location of meaning too specifically on solider ground risks the loss of those elements most likely to carry us across borders.

. . . Postmodern analysis has raised important questions about power, desire, and meaning that are applicable to cross-cultural exchange (although there are times when it seems to analyze everything to shreds, wallowing in textual paranoia). The most crucial of these insights is the necessity to avoid thinking of other cultures as existing passively in the past, while the present is the property of an active "Western civilization."

Both women and artists of color are struggling to be perceived as subject rather than object, independent participants rather than socially constructed pawns. Since the late '60s, the feminist movement's rehabilitation of subjectivity in the face of the dominant and loftily "objective" stance has been one model in the ongoing search for identity within so-called minority groups. It is precisely the false identities to which deconstructionism calls attention that have led women and people of color to an obsession with self-definition, to a re-creation of identity from the inside out. On the other hand, overemphasis on static or originary identity and notions of "authenticity" imposed from the outside can lead to stereotypes and false representations that freeze non-Western cultures in an anthropological present or an archeological past that denies their heirs a modern identity or political reality on an equal basis with Euro-Americans. . . .

Yet I'm inclined to welcome any approach that destabilizes, sometimes dismantles, and looks to the reconstruction or invention of an identity that is both new and ancient, that elbows its way into the future while remaining

conscious and caring of its past. Third World intellectuals, wherever they live, are showing the way toward the polyphonous "oppositional consciousness," or the ability to read and write culture on multiple levels, as Chela Sandoval puts it,[8] or to "look from the outside in and from the inside out," in the words of bell hooks.[9] Maxine Hong Kingston says in *The Woman Warrior*, "I learned to make my mind large, as the universe is large, so that there is room for paradoxes."[10]

At the vortex of the political and the spiritual lies a renewed sense of function, even a mission, for art. The new fuels the avant-garde, where "risk" has been a byword. But new need not mean unfamiliar, or another twist of the picture plane. It can mean a fresh way of looking at shared experience. The real risk is to venture outside of the imposed art contexts, both as a viewer and as an artist, to live the connections with people like and unlike oneself. When culture is perceived as the entire fabric of life—including the arts with dress, speech, social customs, decoration, food—one begins to see art itself differently. In the process of doing so, I have become much more sensitive to, and angered by, the absence of meaning in many of the most beautifully made or cleverly stylized art objects. When it is fashionable for artworld insiders to celebrate meaninglessness and the parodists operate on the same level as the parodied, perhaps only those who have been forced outside can make a larger, newly meaningful contribution.

The negation of a single ideal in favor of a multiple viewpoint and the establishment of a flexible approach to both theory and practice in the arts are not the tasks of any single group. Stylistically the artists in this book share little. But they have in common an intensity and a generosity associated with belief, with hope, and even with heating. Whether they are mapping, naming, telling, landing, mixing, turning around, or dreaming, they are challenging the current definitions of art and the foundations of an ethnocentric culture. . . .

NOTES

[1] Kumkum Sangari, "The Politics of the Possible," *Cultural Critique* no. 7 (Fall 1987), p. 176.

[2] James Clifford, *Predicament of Culture: Twentieth-Century Ethnography, Literature and Art*. (Cambridge: Harvard University Press, 1988), p. 146.

[3] Henry Louis Gates, Jr., *"Race, " Writing and Difference* (Chicago: University of Chicago Press, 1986) (Essays originally published under the same title as a special issue of *Critical Inquiry*, vol. 12, no. 1, 1985), p. 5.

[4] I like these terms better than the Canadian "mosaic," which sounds frozen into place.

[5] Adrian Piper, "Ways of Averting One's Gaze," 1987 (unpublished).

[6] Bruce Chatwin, *The Songlines* (New York: Viking, 1987).

[7] Tony Fry and Anne-Marie Willis, "Aboriginal Art: Symptom or Success!" *Art in America* (July 1989), pp. 114–15.

[8] Chela Sandoval, quoted in Kaplan, "Deterritorializations," p. 187.

[9] bell hooks, *Feminist Theory: From Margin to Center* (Boston: South End Press, 1984), p. 27.

[10] Maxine Hong Kingston, *The Woman Warrior* (New York: Vintage Books, 1977), p. 35.

CHAPTER 22

The Art History Course

Writer Scott Heller reports that art history is "not what it used to be," especially when it comes to art history courses. Many colleges and universities are dropping the standard "surveys" that introduced students to names, dates, and images of canonical artists and works of art in favor of courses that present debates, new approaches, and specialized topics. Are students being shortchanged by the new methods, as critic Roger Kimball argues? Are they failing to learn to discriminate about quality, to appreciate the role of tradition and style in creating art, or to learn about the highest achievements of their culture? Is the new emphasis on "visual culture" undermining students' understanding of art itself? Is the "New Art History" merely a set of "fashionable ideologies" that will fade, or does it represent substantive changes that will ultimately create a stronger, more relevant discipline? What is the purpose of art history anyway?

What Are They Doing to Art History?

SCOTT HELLER

Scott Heller writes about books, film, and culture for various publications. He is a national correspondent for The Chronicle of Higher Education.

A DECADE AFTER THE RAUCOUS WAR OF APPROACHES WITHIN ART HISTORY, THE FIELD IS CALM. THE ONCE INSURGENT METH-ODS—MARXISM, FEMINISM, GAY AND LESBIAN THEORY, SEMI-OTICS, AND NOW "VISUAL CULTURE"—ARE FIRMLY PART OF THE ACADEMIC MAINSTREAM.

Somewhere outside, the culture wars may rage, but here in a cramped lecture hall in the basement of Harvard University's Arthur M. Sackler Museum, there's work to do. Harvard's version of the introductory art-history course is just beginning. Students need to be placed in discussion sections, the slide carousel double-checked, and the speaker system tested. Inside the projection booth, Professor Norman Bryson combs his hair.

You wouldn't know from this typical back-to-school tumult that Harvard has struggled even to offer this class, a staple of the humanities on nearly every college campus. Between 1990 and 1993, Harvard gave up on the idea of an art-history survey at all—in large part, Bryson explains, because professors no longer believed it could be taught. The field had grown too large, having come to embrace non-Western work and arts once seen as unworthy of study. The standard two-semester race from ancient to medieval, Renaissance to modern art just wouldn't do anymore. The course's unwieldiness, combined with the students' tendency to doze off to the whir of the slide projector, had given the class its nickname: "Darkness at Noon."

Only when Professor **Henri Zerner** drew up plans for a scaled-down, one-semester-long version that abandons chronology did Harvard again offer the course, now called Art and Visual Culture: Introduction to the Historical Study of Art and Architecture. These days, students are literally sitting in the aisles, balancing notebooks and photo-copied handouts on their laps. Team-taught this semester by Bryson and Zerner, the course concentrates on introducing

Scott Heller, "What Are They Doing to Art History?" *ARTnews,* 96, no. 1 (1997): 102–105. Reprinted by permission of the author.

students to the history of methods and debates in the field, rather than asking them to memorize names, dates, and works of art.

Today the topic is architecture. Instead of tracing a detailed history, Bryson has a simpler goal in mind: explaining that buildings have meaning, that they're built to convey messages about their societies. "It's not that radical really, but in a way it is for us," says Bryson. "We wanted to introduce architecture, not in terms of form but in terms of social use."

To make his point, Bryson analyzes two structures, the fifth-century B.C. Parthenon in Athens and a 20ᵗʰ-century mud home common among the Batammaliba people of Togo, West Africa. With a slide of the Parthenon on the screen behind him, Bryson describes the building's history, especially its elaborate sculptural program of friezes and relief sculptures, touching on the way in which Greeks depicted male and female nudity. But instead of analyzing the sculpture in terms of style and technique, he lectures on how the arrangement of the figures spells out a "civic ideology" that values Greek over Asian culture, marriage over unregulated sexuality.

He then shifts gears, putting up two slides of the Batammaliba home. Though it is vastly different from the Parthenon, Bryson wants to draw out similarities: that the house serves as a kind of temple in Togo's egalitarian village communities, its various components echoing parts of the body; that, like the Parthenon, it provides a ritualized way for a community to pass on its values. "Their house becomes a dramatization of the history of its inhabitants," says Bryson.

Not everyone in the fine-arts department buys the new approach. Bryson has a ready list of faculty members who want no part of Art and Visual Culture. Yet the course has achieved a kind of success: a set of professors has agreed to teach it, and undergraduates seem to like it. Since the course began, there has been an increase in students selecting fine arts as their major.

Like other disciplines in the humanities—history and literary studies, for example—art history is not what it used to be. Founded in the United States by a small coterie of immigrant scholars, among them **Erwin Panofsky,** who came to this country in the 1930s, it was grounded in connnoisseurship, the practice of making distinctions of quality based on close scrutiny of artistic styles.

With the passing of the leading lights and their students, and the social and political upheavals of the 1960s, art history has branched out to include a variety of approaches, all of which compete with connoisseurship. And once-reviled "low" or popular culture is now considered appropriate for study alongside "high" or fine-art culture. The watershed moment in the ascendance of this "new art history" came in 1980 with the appointment of the Marxist art historian T. J. Clark to a position in the fine-arts department at Harvard, until then known as a bastion of connoisseurship.

Always a small and relatively conservative field, art history has proven surprisingly elastic, stretching to accommodate the new without breaking—so far. As the century draws to a close, relative calm prevails, with self-examination

and consolidation the order of the day. Today, rather than waging a war of approaches, art historians seem willing to let a thousand flowers bloom. Marxism, feminism, gay and lesbian theory, semiotics—all have their advocates. There's even a renewed interest in esthetic theory. People are rereading Kant and thinking again about why a work of art brings with it certain pleasures.

A book like *12 Views of Manet's 'Bar'* (Princeton University Press, 1996) epitomizes today's agree-to-disagree spirit. In it, Bradford R. Collins, professor of art history at the University of South Carolina, Columbia, asks a dozen prominent scholars to weigh in on *A Bar at the Folies-Bergère*. "People are very cautious now to try and make it clear that this is only one reading, there are others," explains Collins. Cambridge University Press is coming out with its own one-work-many-approaches series, devoted to artists like Raphael and Rembrandt.

This shift in emphasis is too timid for Anne Higonnet, an associate professor of art history at Wellesley College and a biographer of Berthe Morisot. Higonnet wrote an essay for the Manet collection that was rejected. She's frankly not surprised, since her piece was entitled "On Not Writing About Manet's *A Bar at the Folies Bergère*."

"The point of my essay was that I no longer worked on that kind of subject—one painting by one canonical painter," she says. "For me it's not the starting point for inquiry anymore."

Lately, like many other scholars, Higonnet's perspective has broadened. She is increasingly entranced with something called "visual culture." One of those everything-and-nothing terms that gets academics excited, visual culture has become an umbrella for scholars of art history, film studies, social history, literature, philosophy—even optical science. They are interested in how ways of seeing predominated at certain periods of time among certain groups of people.

For example, the explosion of images in the late 20$^{\text{th}}$ century—not merely on gallery and museum walls but also in advertising, the media, and popular culture—has affected the way in which people perceive their physical, social, and cultural environment. But consider the turn-of-the-century city: how might the streetcar, which first moved bodies through space mechanically, have affected people's ways of seeing? Scholars look for evidence across the field, instead of focusing on a single object or type of object.

In several recent books, Bryson and others have argued for visual-culture studies. At the University of Rochester in the late 1980s, he helped establish a Ph.D. program in visual-and-cultural studies, the only one of its kind in the nation. Not for long—the University of California at Irvine has similar plans. Meanwhile, a number of universities, such as Northwestern, Stanford, and the University of Texas, introduce undergraduates to art as one among several media, peppering their courses with the study of film, illustration, and photography.

Renaissance sculpture and Impressionist painting still figure at the College Art Association's annual meetings. But visual culture's impact can be felt

there, too. This year's conference (1997) in New York next month will have a session on Walt Disney and American visual culture. Last semester Harvard offered courses in Chinese and French visual culture. More and more books are being published on the subject. There are some 50 current and forthcoming volumes. A book on visual culture, W. J. T. Mitchell's *Picture Theory: Essays on Verbal and Visual Representation,* received the association's Charles Rufus Morey award for the best book of 1995. "Visual culture pursued to its logical conclusion is not a tweaking of art history," says Higonnet. "It's a fundamental disruption."

To those who side with her, this is a wonderfully liberating time. "Beautiful stuff is still beautiful," says Janet A. Kaplan, a professor at Moore College of Art and Design in Philadelphia and the new editor of the College Art Association's magazine *Art Journal.* She cites the 1995 Cézanne retrospective at the Philadelphia Museum of Art. "But that doesn't mean I don't want to talk about O. J. [Simpson], to talk about the media. I have a set of skills and I want to apply them." And so she will, in an upcoming article on the print media's portrayal of black men during the Simpson murder trial and Supreme Court Justice Clarence Thomas's confirmation hearings.

That's fine for *Art Journal,* which despite its academic sounding name is a glossy magazine that appeals as much to artists as to art historians. But the appearance of Norman Rockwell in the association's flagship quarterly, *The Art Bulletin,* last month (in an article on images of white masculinity in the artist's *Saturday Evening Post* illustrations) may well change the reputation of a publication known for its stodginess.

That essay appeared near the end of Nancy J. Troy's three-year term as *The Art Bulletin's* editor, during which time the journal gave over the front of the book to lively roundtables on the history and politics of the discipline. Her successor, **John T. Paoletti** of Wesleyan University, promises more in the way of change. Though his first issue won't appear until later this year, he has begun to review manuscripts and wants articles that are shorter, more provisional, more "cage-rattling." Art historians need to produce work that is of interest beyond the narrow province of a particular period or genre, he says. "I know it'll make people jump up and scream bloody murder," says Paoletti of the Rockwell piece. "But you know what? I've started teaching Norman Rockwell in my 20th-century class. A hell of a lot more people saw Norman Rockwell than saw Jackson Pollock" [Figure 30].

Not that the new art histories have gone down smoothly with the public at large. Professors who've thrown out the survey courses, at campuses like Harvard, Swarthmore College, and the University of California at Santa Barbara, say that students often don't like the change, especially at first. They still want to hear the story of art from beginning to end. Perhaps it's comforting in a world that seems fragmented, dissonant, inexplicable. "The fact that there's no clear sequence—it doesn't have to be chronological—is problematic to them," admits Laurie Monahan, the chief teaching fellow for Harvard's Art

Figure 30. Norman Rockwell, *The Connoisseur*, 1962. Norman Rockwell Museum at Stockbridge, Stockbridge, MA. Photo: © The Curtis Publishing Company.

and Visual Culture course. "The course works as an introduction to looking for them," she adds. "I don't know if it's giving them a good image base they can hang on to."

Other criticism of the new methods comes from an unlikely source. The editors of the journal *October* are frankly suspicious of art history's flirtation with visual culture. Founding editor and Columbia University professor of art history Rosalind Krauss contends that in the name of visual culture, students are not being trained in the skills necessary to interpret works made in different media. "Students in art history graduate programs don't know how to read a work of art," she laments. "They're getting visual studies instead—a lot of paranoid scenarios about what happens under patriarchy or under imperialism."

If any journal considers itself on the cutting edge of critical discourse, it is *October.* Yet Krauss sounds very much like scholars on the other side of the political spectrum in her worries about visual culture. "We don't see art solely as social illustration or as ideological fodder," says **Bruce Cole,** a professor of fine arts at Indiana University. "There has to be a basis on which one builds, a factual basis that uses evidence and standards. Art historians can do things that sociologists can't."

He and other professors interested in traditional approaches to art history are banding together to form an alternative to the 14,000-member College Art Association. The Association for Art History, as it is called, will make room for this group of traditionalists at its own scholarly conferences. After a year of discussions, the group has little to show for itself except a name, but Cole isn't deterred. "I think that statistical evidence doesn't bear out this seismic shift in the way art history is done, despite the impression otherwise," says Cole.

Numbers can't capture where art history is heading, but they do tell one story—that of cutbacks in programs and resources as the culture of corporate downsizing reaches higher education. "We may be on the verge of another fundamental reorganization of how a university does business," says James D. Herbert, associate professor of art history at the University of California at Irvine. "The days [when a] university can be imagined without limits are over." Now is the time for departments to specialize in kinds of art or aspects of visual culture, rather than believe they can cover the waterfront, he argues. "If art history isn't asking these questions, we may be the same as classics departments were after the 19ᵗʰ century—still there, but shunted aside," says Herbert.

Indeed the Rochester program pioneered by Bryson and his colleagues has used such reasoning successfully, gaining more support from the university at a time when other graduate programs have been shrunk or cut entirely.

Wellesley's Higgonet welcomes the change, whatever the cause. "I see a defunct and useless field collapsing," she says, "and a much stronger, much more important field emerging."

Introduction to *Tenured Radicals*

ROGER KIMBALL

Roger Kimball is a prominent cultural critic. His book, Tenured Radicals: How Politics has Corrupted Our Higher Education *(New York: Harper Collins, 1990) helped define the issues of the conservative vs. liberal cultural debates of the 1990s. He is the managing editor of* The New Criterion *and writes for various other publications, including* The Wall Street Journal, Commentary, *and* The American Spectator. *Among his most recent books are* Experiments Against Reality: the Fate of Culture in the Postmodern Age *(Chicago: I. R. Dee, 2000) and* The Long March: How the Cultural Revolution of the 1960s Changed America *(San Francisco: Encounter Books, 2000).*

I

It is no secret that the academic study of the humanities in this country is in a state of crisis. Proponents of deconstruction, feminist studies, and other politically motivated challenges to the traditional tenets of humanistic study have by now become the dominant voice in the humanities departments of many of our best colleges and universities. And while there are differences and even struggles among these various groups, when seen from the perspective of the tradition they are seeking to subvert—the tradition of high culture embodied in the classics of Western art and thought—they exhibit a remarkable unity of purpose. Their object is nothing less than the destruction of the values, methods, and goals of traditional humanistic study. . . .

Whether one turns to Princeton University's Elaine Showalter, who has called for a "complete revolution" in the teaching of literature in order to enfranchise "gender as a fundamental category of literary analysis," or to Houston Baker, the Albert M. Greenfield Professor of Human Relations at the University of Pennsylvania and president of the Modern Language Association in 1992, who touts the black power movement of the 1960s as a desirable alternative to the "white Western" culture he sees enshrined in the established literary canon, or to Duke University's Fredric Jameson, who propounds a

Excerpted from Roger Kimball, "Introduction," *Tenured Radicals: How Politics Has Corrupted Our Higher Education* (Chicago: Ivan R. Dee, Publisher, 1998), 1–12. Reprinted from the revised edition by permission of the author.

Marxist vision of criticism that takes the "extreme position" that "the political perspective" is the "absolute horizon of all reading and all interpretation," one finds a thoroughgoing animus to the traditional values of Western thought and culture. . . .

The same is true—albeit in a more rarefied way—of the legions of deconstructionists, post-structuralists, and other forbiddingly named academics who congregate in departments of English, French, comparative literature, history, and other disciplines. With their criticism of the "logocentric" and "phallocentric" Western tradition, their insistence that language always refers only to itself, and their suspicion of logic and rationality, they exhibit a species of skepticism that is essentially nihilistic and deeply at odds with the ideals of a liberal arts education—ideals, it must be added, that also underlie the democratic institutions and social life of the West. The conviction uniting these disparate groups received dramatic expression recently at Stanford University when Jesse Jackson and some 500 students marched chanting, "Hey hey, ho ho, Western culture's got to go." The influential philosopher Richard Rorty, a professor at the University of Virginia and himself an influential champion of everything chic and postmodern in the humanities, accurately summed up the situation when he noted that "a new American cultural Left has come into being made of deconstructionists, new historicists, people in gender studies, ethnic studies, media studies, a few left-over Marxists, and so on. This Left would like to use the English, French, and Comparative Literature Departments of the universities as staging areas for political action."[1]. . .

II

In this war against Western culture, one chief object of attack within the academy is the traditional literary canon and the pedagogical values it embodies. The notion that some works are better and more important than others, that some works exert a special claim on our attention, that "being educated" requires a thoughtful acquaintance with these works and an ability to discriminate between greater and lesser—all this is anathema to the forces arrayed against the traditional understanding of the humanities. The very idea that the works of Shakespeare might be indisputably greater than the collected cartoons of Bugs Bunny is often rejected as "anti-democratic" and "elitist," an imposition on the freedom and political interests of various groups.[2]

At many colleges and universities, students are now treated to courses in which the products of popular culture—Hollywood movies, rock and roll, comic strips, and the like—are granted parity with (or even precedence over) the most important cultural achievements of our civilization. Typical is the philosopher Stanley Cavell's seminar at Harvard University on the movies of Katharine Hepburn and Spencer Tracy or a recent graduate course at Columbia University on Victorian and modern British literature that repeatedly

took time to ponder the relevance of the pop singer Bruce Springsteen and the television series "Star Trek" to the issues at hand. Instead of aspiring to gain a thoughtful acquaintance with (as the Victorian poet and critic Matthew Arnold famously put it) "the best that has been thought and said," these new forces in the academy deliberately blur the distinction between high culture and popular culture. They pretend, to quote Houston Baker again, that choosing between Pearl Buck and Virginia Woolf, for example, or between Shakespeare and Jacqueline Susann is "no different from choosing between a hoagy and a pizza." Professor Baker added, "I am one whose career is dedicated to the day when we have a disappearance of those standards."[3]

Even the most cursory glance at what passes for humanities offerings at colleges and universities across the country will serve to corroborate these impressions. With a few notable exceptions, our most prestigious liberal arts colleges and universities have installed the entire radical menu at the center of their humanities curriculum at both the undergraduate and the graduate level. Every special interest—women's studies, black studies, gay studies, and the like—and every modish interpretative gambit—deconstruction, poststructuralism, new historicism, and other varieties of what the literary critic Frederick Crews aptly dubbed "Left Eclecticism"—has found a welcome roost in the academy, while the traditional curriculum and modes of intellectual inquiry are excoriated as sexist, racist, or just plain reactionary.[4]

Thus what began as an intoxicating intellectual spree at a few elite institutions—places such as Yale, Johns Hopkins, Brown, and certain campuses of the University of California—has quickly spread to many other institutions. This metastasis is indeed one of the most troubling developments in the story of the crisis of the humanities.

Increasingly, second- and third-tier schools are rushing to embrace all manner of fashionable intellectual ideologies as so many formulas for garnering prestige, publicity, and "name" professors (and hoping thereby to attract more students and other sources of income) without having to distinguish themselves through the less glamorous and more time-consuming methods of good teaching and lasting scholarship. One case in point is Duke University, which in the late 1980s and 1990s conducted a tireless—and successful—campaign to arm its humanities departments with assorted radicals from the Marxist literary critic Fredric Jameson, to Barbara Herrnstein Smith, Stanley Fish, and Eve Kosofsky Sedgwick, author of "Jane Austen and the Masturbating Girl," a founding document in the annals of "Queer Theory."

It has often been observed that yesterday's student radical is today's tenured professor or academic dean. The point of this observation is not to suggest that our campuses are littered with political agitators. In comparision to the situation that prevailed in 1968, when colleges and universities across the country were scenes of violent demonstrations, the academy today seems positively sedate. Yet if the undergraduate population has moved quietly to the Right in recent years, the men and women who are paid to introduce students

to the great works and ideas of our civilization have by and large remained true to the emancipationist ideology of the sixties.

III

Indeed, it is important to appreciate the extent to which the radical vision of the sixties has not so much been abandoned as internalized by many who came of age then and who now teach at and administer our institutions of higher education. True, there is no longer the imminent prospect of universities being shut down or physically destroyed by angry radicals. But when one considers that the university is now supplying many of those erstwhile radicals with handsome paychecks, a pleasant working environment, and lifetime job security, then their quiescence is perhaps not so very extraordinary.

Besides, why shouldn't they act contentedly? To an extent unimaginable just a decade or two ago, their dreams of radical transformation have been realized. Even if we leave aside the enormous changes that have occurred in social life at our institutions of higher learning, it is patent that the transformation of the substance and even the goals of the typical liberal arts program has been staggering. Who could have guessed that the women's movement would have succeeded in getting gender accepted as a "fundamental category of literary analysis" by departments of literature in nearly every major university? Who could have guessed that administrators would one day be falling over themselves in their rush to replace the "white Western" curriculum of traditional humanistic studies with a smorgasbord of courses designed to appeal to various ethnic and racial sensitivities? Who could have predicted that the ideals of objectivity and the disinterested pursuit of knowledge would not only be abandoned but pilloried as products of a repressive bourgeois society? No, the radical ethos of the sixties has been all too successful, achieving indirectly in the classroom, faculty meeting, and by administrative decree what it was unable to accomplish on the barricades.

The political dimension of this assault on the humanities shows itself nowhere more clearly than in the attempt to restructure the curriculum on the principle of "equal time." More and more, one sees the traditional literary canon ignored as various interest groups demand that there be more "women's literature" for feminists, "black literature" for blacks, "gay literature" for homosexuals, and so on. The idea of literary quality that transcends the contingencies of race, gender, and the like, or that transcends the ephemeral attractions of popular entertainment is excoriated as naïve, deliberately deceptive, or worse.

One recent example is "Vision 2000," a document prepared by the women's studies programs at the University of Massachusetts at Amherst and the five other land-grant universities of New England. Under the guise of promoting "diversity" and "gender equity," "Vision 2000" advocates the transformation

of these six universities into radical feminist fiefdoms in which "gender equity"—i.e., "equal numbers of men and women" in every program and subject area, from business administration and biology to physics and zoology—would be enforced by college administrators. "Faculty whose students identify their courses, teaching styles, and mentoring as failing to be inclusive," the document warns, "do not receive teaching prizes, satisfactory teaching evaluations, or merit raises." As the commentator John Leo noted in his report on "Vision 2000," three of the five university presidents—in Vermont, Maine, and New Hampshire—have already signed on to its recommendations "in spirit."[5]

The insinuation of political imperatives into higher education shows itself in other, more subtle, ways as well. At many colleges and universities today, traditional precepts about the methods and goals of humanistic study are rejected as hopelessly *retardataire*. Basic questions such as "What does it mean to be an educated person?" are no longer entertained as worthy of serious attention. *Reading* is no longer seen as an activity that aims at construing the meaning of books and ideas, but as an elaborate interpretative game that seeks to expose the impossibility of meaning. And—as anyone with even a passing acquaintance with the products of the new academic scholarship knows—*writing* no longer means attempting to express oneself as clearly and precisely as possible. On the contrary, writing is pursued as a deliberately "subversive" activity meant to challenge the "bourgeois" and "logocentric" faith in clarity, intelligibility, and communication. Mas'd Zavarzadeh, a follower of the French deconstructionist Jacques Derrida, put it bluntly when he declared in a review of a rival critic that "his unproblematic prose and the clarity of his presentation" were "the conceptual tools of conservatism."[6] Even more disturbing is the widely commented-on phenomenon of "political correctness," in which demands for ideological conformity have begun to encroach on basic intellectual and social freedoms. At many campuses across the country, university administrations have enacted "anti-harassment" rules that provide severe penalities for speech or action deemed offensive to any of a wide range of officially designated "victims." Ostensibly designed to prevent sexual, ethnic, and racial harassment, these rules actually represent an effort to enforce politically correct attitudes by curtailing free speech. By now, examples of political correctness on campuses and elsewhere in American society are legion. **Dinesh D'Souza's** book *Illiberal Education: The Politics of Race and Sex on Campus* is only the best-known compendium of examples.[7] At one campus, the entire press run of a conservative student newspaper was stolen and destroyed because it contained an editorial that offended the sensibilities of some black students. At Smith College, a brochure is distributed to incoming students rehearsing a long list of politically incorrect attitudes and prejudices that will not be tolerated, including the sin of "lookism," i.e., the prejudice of believing that some people are more attractive than others. At the University of Pennsylvania, when a student on a panel for "diversity education" wrote a

memorandum to her colleagues in which she expressed her "deep regard for the individual and . . . desire to protect the freedoms of all members of society," a university administrator responded by circling the passage just quoted, underlining the word "individual," and commenting "This is a `RED FLAG' phrase today, which is considered by many to be RACIST. Arguments that champion the individual over the group ultimately privileges [sic] the `individuals' belonging to the largest or dominant group."[8] Such examples could be multiplied indefinitely. What they portend is nothing less than a new form of thought control based on a variety of pious New Left slogans and attitudes. . . .

IV

The institutionalization of the radical ethos in the academy has brought with it not only an increasing politicization of the humanities, but also an increasing ignorance of the humanistic legacy. Instead of reading the great works of the past, students watch movies, pronounce on the depredations of patriarchal society, or peruse second- or third-rate works dear to their ideological cohort; instead of reading widely among primary texts, they absorb abstruse commentaries on commentaries, resorting to primary texts only to furnish illustrations for their pet critical "theory." Since many older professors have themselves been the beneficiaries of the kind of traditional education they have rejected and are denying their students, it is the students themselves who are the real losers in this fiasco. Presumably, they enrolled in a liberal arts curriculum in the first place because they wished to be educated; alas, after four years they will find that they are ignorant of the tradition and that their college education was largely a form of ideological indoctrination. It may well be the case that the much-publicized decline in humanities enrollments recently is due at least in part to students' refusal to devote their college education to a program of study that has nothing to offer them but ideological posturing, pop culture, and hermetic word games.

The issues raised by the politicization of the humanities have application far beyond the ivy-covered walls of the academy. The denunciations of the "hegemony" of Western culture and liberal institutions that are sounded so insistently within our colleges and universities these days are not idle chatter, but represent a concerted effort to attack the very foundations of the society that guarantees the independence of cultural and artistic life—including the independence of our institutions of higher education. Behind the transformations contemplated by the proponents of feminism, deconstruction, and the rest is a blueprint for a radical social transformation that would revolutionize every aspect of social and political life, from the independent place we grant high culture within society to the way we relate to one another as men and women. It is precisely for this reason that the traditional notion of the humanities and the established literary canon have been so violently attacked

by *bien pensants* academics: as the cultural guardians of the ideals and values that Western democratic society has struggled to establish and perpetuate, the humanities also form a staunch impediment to the radical vision of their new academic enemies.

It is my aim in *Tenured Radicals* to expose these recent developments in the academic study of humanities for what they are: ideologically motivated assaults on the intellectual and moral substance of our culture. . . . In order to give as concrete and specific a picture as possible, I have not scrupled to spare the reader many examples of academic absurdity. . . .

To those of my readers who may have heard of the developments I discuss but have not had occasion to become acquainted with them firsthand, I regret to report that the situation is far worse than they are ever likely to have imagined.

NOTES

[1] Quoted in Sidney Hook, "Civilization and Its Malcontents," *National Review,* 13 Oct. 1989, pages 30–33; this quotation, page 33.

[2] For a wide-ranging critique of this attack on intellectual standards, see *In Defense of Elitism* by William A. Henry, III (New York: Doubleday, 1994) and my review essay of Henry's book, "What's Wrong with Equality?" in *The New Criterion,* Oct. 1994, pages 4–10.

[3] Joseph Berger, "U.S. Literature: Canon Under Siege," *The New York Times,* 6 Jan, 1988.

[4] Although I have occasion to cite Professor Crews and his notion of "Left Eclecticism" more than once in *Tenured Radicals,* it is worth noting that in his subsequent writings Crews has been careful to distance himself from conservative critics of the trends he himself criticizes. Thus in a collection of essays on American fiction, he dismisses "such cultural nostalgics as William Bennett, Allan Bloom, Lynne Cheney, and Roger Kimball" as "people who conceive of the ideal university as a pantheon for the preservation of great works and great ideas" and who "implicitly subscribe to a `transfusion' model of education, whereby the stored-up wisdom of the classics is considered a kind of plasma that will drip beneficially into our veins if we only stay sufficiently passive in its presence." Professor Crews goes on to assure his readers that he wants "keen debate, not reverence for great books." Never mind that none of the critics he cites, including myself, has ever endorsed anything like the simplistic "transfusion" model conjured up here; nor do any of the critics he cites wish to replace "keen debate" with unquestioning "reverence." The main point is that, like many academics, Professor Crews is willing to countenance "keen debate" only when it comes from certified segments of the academic brotherhood. Interlopers—especially conservative interlopers—are to be excluded from participating, keenly or otherwise, in the discussion. See Frederick Crews, *The Critics Bear It Away: American Fiction and the Academy* (New York: Random House, 1992), page xiv.

[5] John Leo, "No Takeovers, Please," *U.S. News & World Report,* 19 Jan. 1998, page 13. "Vision 2000" is available from the Women's Studies Program at the University of Massachusetts at Amherst.

[6] Quoted in John Ellis, *Against Deconstruction* (Princeton: Princeton University Press, 1989), page 10.

[7] Dinesh Souza, *Illiberal Education: The Politics of Race and Sex on Campus* (New York: The Free Press, 1991). See also Richard Bernstein, *Dictatorship of Virtue Multiculturalism and the Battle for America's Future* (New York: Knopf, 1994) for many additional examples of the baneful effects of political correctness on campus.

[8] Alan Charles Kors, "It's Speech, Not Sex, the Dean Bans Now," *The Wall Street Journal,* 12 Oct. 1989.

Afterword

In 1959 Arnold Hauser wrote:

> Works of art . . . are like unattainable heights. We do not go straight towards them, but circle round them. Each generation sees them from a different point of view and with a fresh eye; nor is it to be assumed that a later point of view is more apt than an earlier one. Each aspect comes into sight in its own time, which cannot be anticipated or prolonged; and yet its significance is not lost, for the meaning that a work assumes for a later generation is the result of the whole range of previous interpretations.[1]

The readings in *Critical Perspectives* were originally written over the course of several decades of tumultuous cultural change. Many of them were grounded in the heated events of the day: the Cold War, the civil rights movement, student protests, feminism, and more recently protests against political correctness and cultural relativism. If, in some cases, their tone seems strident, how could it have been otherwise?

From the vantage point of the new millennium, those events and the fervor of the associated debates seem suddenly and strangely distant. A truce (or at least a cease-fire) seems to have been declared in the Culture Wars, and, after thirty years, the New Art History seems no longer so new.

In the same way that present-day politicians appear to be racing for the political middle, post-postmodern art history may seem to be returning to a more temperate traditionalism. However, Hauser is probably right: we can't repeal the experiences of past generations—they have been thoroughly absorbed into our own points of view.

Many of the most radical causes of the last half century have now become mainstream: today's post-feminism takes for granted its feminist foundations, multiculturalism is part of our daily lives, and the former barrier

between high culture and popular culture has been dismantled as thoroughly as the Berlin Wall. We no longer blindly presume the autonomy of art or of its institutions. In art history we remain skeptical that there is a single, fixed, correct interpretation for a work of art. Rather, interpretations depend on critical perspectives.

NOTE

[1]Arnold Hauser, "The Scope and Limitations of a Sociology of Art," *The Philosophy of Art History* (London: Routledge, 1959), 3.